EFFIGIES & ECSTASIES

ROMAN BAROQUE SCULPTURE AND DESIGN IN THE AGE OF BERNINI

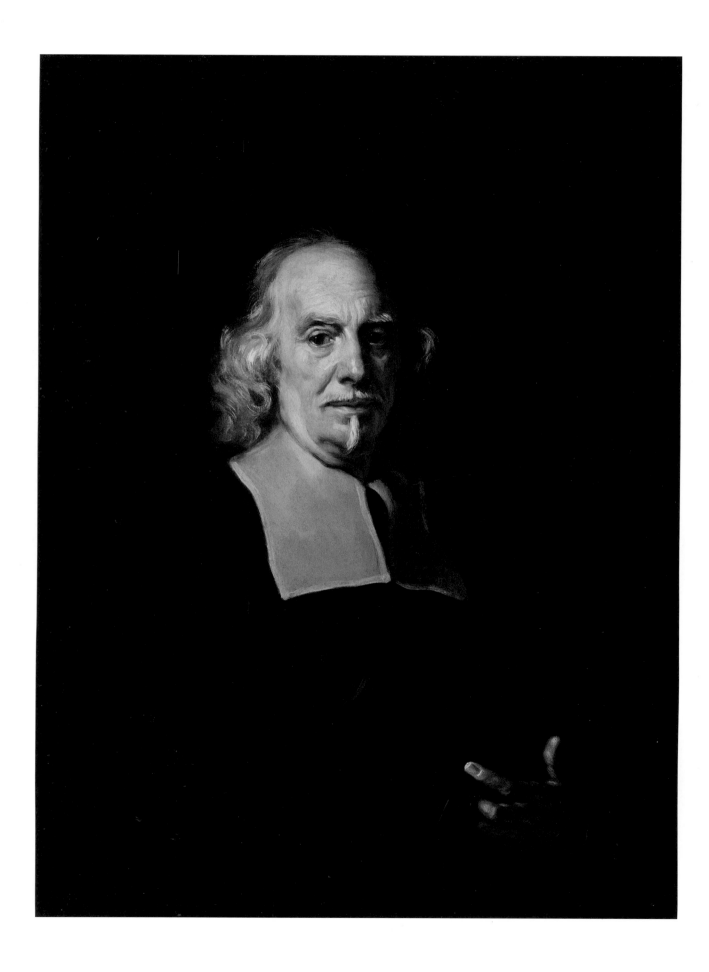

Effigies & Ecstasies

ROMAN BAROQUE SCULPTURE AND DESIGN
IN THE AGE OF BERNINI

EDITED BY AIDAN WESTON-LEWIS

NATIONAL GALLERY OF SCOTLAND

MCMXCVIII

THIS EXHIBITION WAS
CURATED BY TIMOTHY CLIFFORD
AND AIDAN WESTON-LEWIS,
NATIONAL GALLERIES
OF SCOTLAND

Published by the Trustees
of the National Galleries of Scotland
for the exhibition *Effigies & Ecstasies:
Roman Baroque Sculpture and Design in the Age of Bernini*
held at the National Gallery of Scotland, Edinburgh
25 June – 20 September 1998

© Trustees of the National Galleries of Scotland
ISBN 0 903598 83 3

Designed by Dalrymple
Typeset in Sumner Stone's Arepo and Cycles typefaces
Printed by BAS Printers, Over Wallop

Front cover:
Gianlorenzo Bernini, *Bust of Monsignor Carlo Antonio dal Pozzo*
photo: Antonia Reeve
cat.no.22

Back cover: Alessandro Algardi and Giovanni Francesco Grimaldi
Two Kneeling Angels Supporting a Reliquary above an Altar
cat.no.138

Frontispiece: Giovanni Battista Gaulli, called Baciccio
Portrait of Gianlorenzo Bernini
cat.no.7

SUPPORTED BY

THE HENRY MOORE FOUNDATION AND

BANCA DI ROMA

Banca di Roma
is an award winner under the Pairing Scheme
(the National Heritage Arts Sponsorship Scheme)
for its support of this exhibition.

The Pairing Scheme is a Government Scheme
managed by ABSA (Association for Business
Sponsorship of the Arts).

LENDERS
TO THE EXHIBITION

Her Majesty The Queen

The Trustees of the Berkeley Will Trust

Birmingham Museums and Art Gallery

The Burghley House Collection

The Syndics of the Fitzwilliam Museum, Cambridge

The Cobbe Collection

Richard Compton

The Trustees of the National Museums of Scotland, Edinburgh

University of Edinburgh, The Torrie Collection

Sir Brinsley Ford CBE FSA

University of Glasgow, Hunterian Museum and Art Gallery

Howard Hodgkin

The Trustees of the British Museum, London

Colnaghi Drawings, London

University of London, Courtauld Institute Galleries

The Trustees of the National Gallery, London

The Museum of the Order of St John, London

The Trustees of the Victoria and Albert Museum, London

Manchester City Art Galleries

His Grace the Duke of Marlborough

The Visitors of the Ashmolean Museum, Oxford

Christ Church Picture Gallery, Oxford

Private Collectors who wish
to remain anonymous

Foreword and Acknowledgements

'A little before my Comming to the Citty', wrote the English diarist, John Evelyn, during his visit to Rome in 1644, 'Cavaliero Bernini. Sculptor, Architect, painter & Poet ... gave a Publique Opera (for so they call those Shews of that kind) where in he painted the seanes, cut the Statues, invented the Engins, composed the Musique, writ the Comedy and built the Theater all himself.'

Our exhibition, mounted to celebrate the quatercentenary of Bernini's birth, marks a further British homage, albeit at a considerable distance of time, to the genius who shaped baroque Rome over the course of sixty years. First and foremost a sculptor, Gianlorenzo Bernini (1598–1680) was a multi-talented prodigy who also practised as a painter, architect and urban planner, designer of decorative arts and of temporary structures for festivals, funerals, and the theatre. His early portrait busts and mythological groups in marble, carved mostly for Scipione Borghese, nephew of Pope Paul V, already showed a command of the human form in motion and a technical sophistication rivalled only by the greatest sculptors of classical antiquity. From the accession of Maffeo Barberini to the papacy in 1623 as Urban VIII, Bernini worked for a succession of powerful papal families – the Pamphili, Chigi, Rospigliosi, and Altieri – who harnessed his talents above all in the promotion of the Catholic faith. He transformed St Peter's and created the Piazza in front of it, graced innumerable Roman squares with highly inventive fountains and monuments, and designed several small but richly articulated baroque churches. He died nine days before his eighty-second birthday during the pontificate of Innocent XI, the eighth pope he had served. Shortly before Bernini's death his right arm became paralysed, causing him to observe that it was only fair to rest it since it had worked so hard during a long life.

Bernini's connection with Scotland is not immediately obvious, save for the presence in the National Gallery of Scotland of his early masterpiece, the marble bust of *Carlo Antonio dal Pozzo, Archbishop of Pisa*. We have taken this as the starting point of our exhibition, in which Presbyterian Edinburgh meets Bernini and his contemporaries – Algardi, Cortona, Borromini, Duquesnoy and Gaulli – who together represent the supreme exponents of the art of Catholic Counter-Reformation Rome. The National Gallery not only houses works by many of these artists, but also many paintings that would have been familiar to Bernini. Most notably, during his Parisian sojourn in 1665 Bernini repeatedly expressed a most profound admiration for Poussin's series of *Seven Sacraments*, then in the possession of his guide, Chantelou, and now on long-term loan to the Gallery from the Duke of Sutherland.

Sadly, the most tangible link between Bernini and Britain – his great bust of King Charles I – was destroyed in the fire at Whitehall in 1698, but we are able to include a recently rediscovered contemporary cast from the face. More familiar to a British audience is Van Dyck's *King Charles I in Three Positions*, now at Windsor Castle, which was painted expressly to provide a likeness for Bernini to copy. The King's portrait bust seems to have been ordered through Queen Henrietta Maria's impeccable contacts in Rome. Her godfather was Pope Urban VIII, and the negotiations were handled through his nephew Cardinal Francesco Barberini protector of the English and Scots in Rome and through George Con of Aberdeen, who was a member of Cardinal Francesco's household and was the Queen's confessor. Indeed, this commission followed hard upon attempts by the Earl of Angus, a Catholic nobleman who had sent his kinsman Sir Robert Douglas to Rome in 1633, to press the Cardinal to urge the King's conversion to Catholicism. Bernini was later approached by Con to provide a companion bust of the Queen herself, again after portraits by Van Dyck. According to the diary

of the English sculptor Nicholas Stone, who had interviewed Bernini in Rome on 22 October 1638, Bernini declined the commission for the Queen's bust as he was opposed to doing any further busts from paintings: 'if thaire were best pictures done by the hand of Raphyell yet he would nott undertake to doe itt'. Happily, despite the absence of these royal busts, we do have Bernini's splendid sculpted portrait of the foppish and extravagant Thomas Baker, a gentleman from Suffolk, who may have been instructed to supervise the transport of Van Dyck's portrait of the King to Bernini in Rome.

Bernini was born the same year as his rival, Alessandro Algardi (1598–1654), who moved from Bologna to Rome in 1625. Like Bernini, he was a multi-talented genius, but he excelled as a portrait sculptor. Moreover, he had little of the baroque flutter of his rival and proved more to the taste of British eighteenth-century connoisseurs and artists like Robert Adam and Joseph Nollekens. By good fortune, this exhibition contains one of his supreme masterpieces, the bust of *Monsignor Antonio Cerri* from Manchester City Art Gallery. Britain is blessed with fine holdings of drawings by him and by his and Bernini's contemporaries, whether working as sculptors, painters, or designers.

We have deliberately limited this show to works from British public and private collections and, with remarkably few exceptions, have been able to borrow most of what we wanted. A few highly relevant works – such as Bernini's magnificent fountain group of *Neptune and Triton* and the very fragile terracotta bust of *Cardinal Paolo Emilio Zacchia* by Algardi, both in the Victoria and Albert Museum – unfortunately could not be lent for reasons of size and vulnerability. Nor, of course, could the exhibition contain great papal tombs or whole Roman churches and palaces, but it can convey something of the exuberance and vitality of this very special flowering of the arts in seventeenth-century Rome.

We would like to express our gratitude to the following people who have contributed in one way or another to the realisation of this exhibition and its catalogue: Charles Alabaster; Maureen Attrill; Malcolm Baker; Janet Balmforth; Luca Baroni; Donal Bateson; Lisa Beaven; Mark Blackburn; Alan Borg; François Borne; Helen Braham; Anthea Brook; Mariagiulia Burresi; Andrew Burnett; Virginie Bustamante; Francesco Cagliotti; Mungo Campbell; Béatrice Capaul; Rosalie Cass; Hugo Chapman; Arabella Cifani; Rosalyn Clancey; Amanda Claridge; Martin Clayton; Jane Clifford; Alec Cobbe; Ruth Cohen; Marco Collareta; Robin Compton; Robert Cooper; Robin Crighton; Lucy Cullen; John Culverhouse; Jane Cunningham; Robert Dalrymple; Taco Dibbits; Alan Donnithorne; James Draper; Isabel Drummond; Paul Duffie; Martin Durrant; Rhoda Eitel-Porter; Godfrey Evans; Michael Evans; Jane Farrington; Gabriele Finaldi; David Finn; Geoffrey Fisher; Gillian Forrester; Sarah Frances; Burton Fredericksen; Terry Friedman; Peter Fusco; Lorna Goldsmith; Alvar Gonzáles-Palacios; Meg Grasselli; Richard Gray; Antony Griffiths; Katherine Griffiths; Alessandro Grifoni; William Griswold; Mario Guderzo; Cinzia Bursill Hall; Michael Hall; Dennis Harrington; Colin Harrison; Eyan Hartley; Catherine Heathcock; Richard Hemphill; Rudolf Hiller; Richard Hodges; Simon Howard; Sarah Hyde; Paola Imperiale; Catherine Johnston; Donald Johnston; Mark Jones; Richard Knight; Alastair Laing; Susan Lambert; Giampiero Lucchesi; Neil MacGregor; Duncan Macmillan; Vera Magyar; Tommaso Manfredi; Sandra Martin; Malcolm McLeod; Manuela Mena; Jonathan Mennell; Franco Monetti; Jennifer Montagu; Theresa-Mary Morton; Peta Motture; Aileen Nesbit; Stephen Ongpin; Stefano Oriano; Caroline Paybody; Nicholas Penny; Miranda Percival; Aurelia Pratolini; Gudrun Raatschen; Janice Reading; Christina Riebesell; Louise Rice; Teresa Riggio; Hugh Roberts; Jane Roberts; Duncan Robinson; Andrew Robison; Joe Rock; Steffi Röttgen; Henrietta Ryan; Cristiana Romalli; Nicolas Schwed; Mhairi Scott; David Scrase; Michael Shapiro; Michael Simpson; Janet Skidmore; Elizabeth Smallwood; Thyrza Smith; Donatella Sparti; Olivia Stamm-Ferrier; Timothy Standring; Dianne Stein; Anne Steinberg; Andreas Stolzenburg; John Sunderland; Luke Syson; Yvonne Tan Bunzl; Paul Taylor; Anchise Tempestini; Edoardo Testori; Nicole Tetzner; Barbara Thompson; Nicholas Turner; Andrés Úbeda de los Cobos; Alexandra Vear; Enzo Virgili; Alexandre Wakhevitch; Tracey Walker; David Ward; Philip Ward-Jackson; Jo Whalley; Catherine Whistler; Christopher White; Adam Williams; Paul Williamson; Pamela Willis; Timothy Wilson; Sarah Wimbush; John Winter; Robert Winter; Sir Marcus Worsley; David Wright and Brian Young.

Special thanks are due to all those who have written contributions for the catalogue, often at short notice: Charles Avery; Christopher Baker; Christopher F. Black; Patrizia Cavazzini; Axel Christoph Gampp; David

Howarth; Desmond Shawe-Taylor; Elizabeth Sladek; Francesco Solinas; Anna Tummers and, above all, to Karin Wolfe in Rome and Emma Stirrup in Edinburgh for their unflagging support and enthusiasm for every aspect of this project.

At the National Galleries of Scotland, particular thanks are due to Janis Adams; Anne Buddle; Nicola Christie; John Dick; Dave Ewan; Suzanne Greig; Lee Hunter; Valerie Hunter; Morag Kinnison; Julia Lloyd Williams; Margaret Mackay; Keith Morrison; Scott Robertson; Mhairi Mackenzie-Robinson; Sheila Scott; Paul Shackleton; Katrina Thomson; Anne-Marie Wagener; John Watson; Jim Wheeler; and to the Handling Team and Technicians. The exhibition has been organised, and its catalogue edited, by Aidan Weston-Lewis, Assistant Keeper at the National Gallery of Scotland, and we are particularly grateful for all his hard work.

The National Gallery of Scotland is deeply grateful to the Henry Moore Foundation, to the Banca di Roma, to ABSA, and to John Lewis, for their financial support of this enterprise, and to Justerini & Brooks Ltd for generously agreeing to sponsor the private view. His Excellency Dr Paolo Galli, Italian Ambassador to the Court of St James, has lent invaluable support and has kindly consented to open the exhibition.

Lastly, we express our profound thanks to the many lenders whose generosity has made this exhibition possible, above all to Her Majesty The Queen, who graciously agreed to lend virtually all of the highly important group of drawings by Bernini and Algardi in the Royal Library. The Trustees of the Victoria and Albert Museum have also been exceptionally generous in agreeing to part temporarily with works of the highest importance.

TIMOTHY CLIFFORD
Director, National Galleries of Scotland

MICHAEL CLARKE
Keeper, National Gallery of Scotland

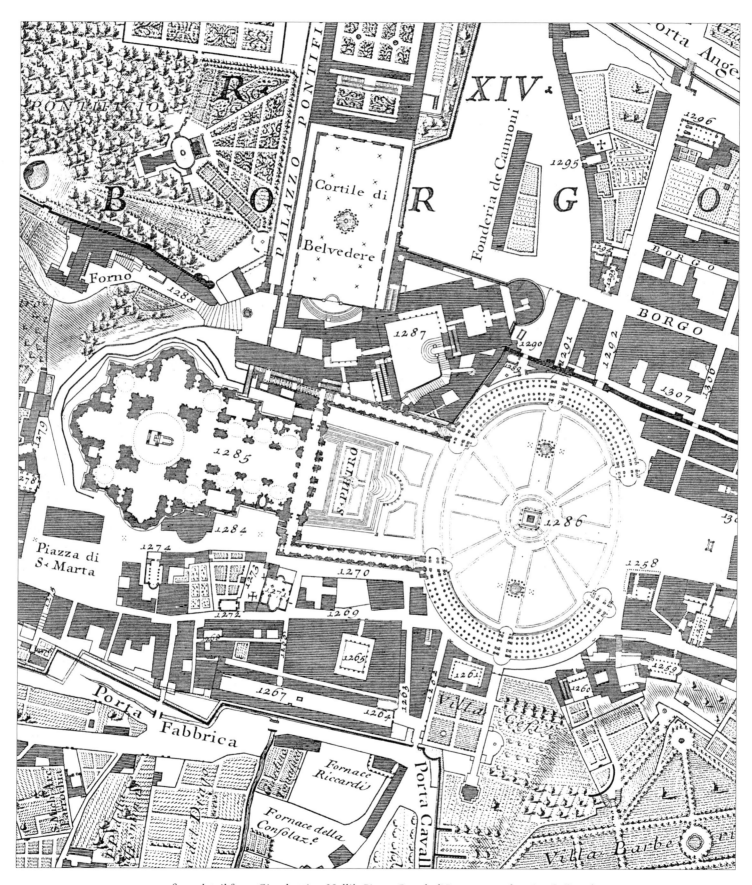

fig.1: detail from Giambattista Nolli's *Pianta Grande di Roma*, 1748, showing St Peter's

CHRISTOPHER F. BLACK

'Exceeding every expression of words': Bernini's Rome and the Religious Background

For much of the period covered by this exhibition, Rome was a dynamic, expanding city, despite an often gloomy economic scene in Europe as a whole.[1] Through public policies and private initiatives much time, effort and money was expended on an open expression of religious fervour and enthusiasm, with the aim of demonstrating the vitality of a revived and now largely self-confident Roman Catholic Church, following the challenges of Protestantism in the previous century. Rome was to be presented as the Eternal City it claimed to be, fit to lead a world church and welcome those coming on pilgrimage. By way of compensation for the diminishing power of the Papacy on the international stage, it was conceived that Rome might maintain a high profile and a degree of influence through an ostentatious display of its religious, charitable and cultural credentials. Pope Alexander VII in particular pursued a vision of Rome embellished as a theatre for the rhetorical display of her merits.[2] While this policy might be interpreted as a cynical sham, and the resulting artistic exuberance as excessive, costly showmanship detrimental to the needs of the inhabitants of the Papal State, it was undoubtedly underpinned by intense and genuine religious feeling, of the kind exemplified in later life by Gianlorenzo Bernini himself.

Notwithstanding bouts of grim plague, as in 1656, Rome expanded across the surrounding hills throughout this period to accommodate its burgeoning population. From a resident population of about 45,000 in 1550, it reached the 100,000 mark after a major influx during the economic crisis of the 1590s, and numbered about 140,000 by 1700. The city had recovered fairly swiftly from the trauma of the 1527 Sack of Rome by disgruntled soldiers of the Imperial army, and from the wider challenges of Protestantism and the Ottoman Empire. Successive popes consolidated their power in a reformed and more respectable Rome, protected by a more centralised

Papal State. Cardinals may have had less power in consistory, but it was increasingly accepted that they would display their wealth and status not only in acts of charity and ecclesiastical patronage, but in the construction of grand private palaces and more generally in the exercise of cultural leadership. News reports (*avvisi*) commented favourably on the huge debts left by some cardinals on their deaths as a reflection of the munificence and lavish patronage appropriate to their position. Their households and a burgeoning bureaucracy for the Church and Papal State swelled the numbers in the city. They were joined by ambitious provincials who sought to develop their careers in Rome itself, by underemployed peasants affected by a shift from arable to pastoral farming, and by those wishing to escape the banditry rife through the Papal State.[3]

The image of a caring city attracted immigrants. When religious orders and lay confraternities established and publicised charitable institutions, hospitals and funds to assist the poor, they created further incentives for the indigent, deserving or otherwise, to flock to Rome. Church and institutional leaders, spiritual advisers and polemicists were torn between the pressure to expel recent immigrants (especially able-bodied beggars and prostitutes) during economic crises, and the propaganda and spiritual benefits that accrued from a more charitable approach. Much was made in this period of the efficacy of 'good works' in the salvation of the souls of both donors and recipients.[4]

The expanding population required new housing, churches and charitable institutions to serve its physical and spiritual needs. Much of the expansion took place across undeveloped terrain between the edge of the medieval city and the ancient Roman walls and gates that had once embraced a million people. The process of clearing land for new development revealed classical and Early

Christian ruins, which in turn provided new ideas for architectural construction and decoration. Enthusiastic and increasingly systematic study of ancient buildings and artefacts by leading intellectuals such as the Oratorian historian Cesare Baronio (1538–1607) and Cassiano dal Pozzo (1588–1657) had a demonstrable influence on artists like Bernini, Pietro da Cortona and Poussin.

Geographically, Rome in the seventeenth century may be seen as having four major subdivisions (fig.1). The Vatican, with the new basilica of St Peter's and the dependant Borgo area stretching to Castel Sant'Angelo, was naturally dominated by the reigning pope, his family and entourage, and the ecclesiastical needs of the world Church. Across Ponte Sant'Angelo, tucked into a bend in the river, lay the heart of the old medieval city. This curved northwards round the east bank to Porta del Popolo, the northern gateway, and stretched south-eastwards beyond the Pantheon and the Campidoglio to the

Colosseum and San Giovanni in Laterano (which was the Pope's Cathedral, in his role as Bishop of Rome). The Campidoglio or ancient Capitol provided the civic governmental centre; the commercial heart of the city below boasted the *palazzi* of many of the old Roman noble families. During the seventeenth century, the most lavish patronage was concentrated on the churches in the locality, both old and new. It was in this area that the popular new religious orders – Jesuits, Oratorians and Theatines – had established their headquarters and their mother churches from the 1560s onwards.

Along the west bank of the Tiber, south of the Vatican, the Trastevere constituted a third area, a fairly self-contained artisan locality, which was nevertheless home to some notable aristocratic families, such as the Mattei, Muti and Albertoni. The important Franciscan church of San Francesco a Ripa – which houses Bernini's celebrated chapel of the Blessed Ludovica Albertoni (see cat.no.124

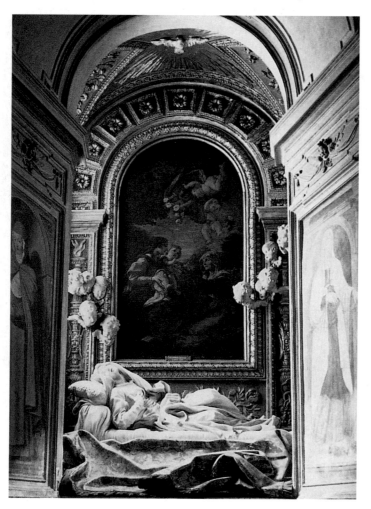 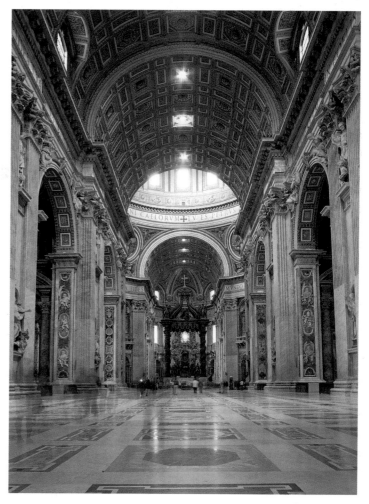

left fig.2: Gianlorenzo Bernini, *The Blessed Ludovica Albertoni*, Altieri Chapel, San Francesco a Ripa, Rome
right fig.3: The Nave of St Peter's, looking West towards the *Baldacchino* and the *Cathedra Petri*, Rome

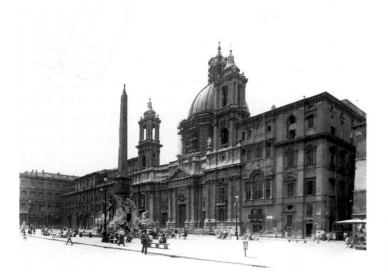 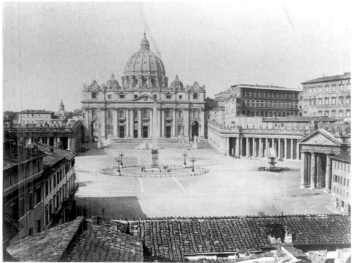

left fig.4: Piazza Navona, with the Four Rivers Fountain and the Church of Sant'Agnese, Rome
right fig.5: St Peter's and its Piazza, Rome

and fig.2) – is located here, as is San Crisogono, which was rebuilt in the 1620s under Scipione Borghese's patronage. A fourth area around and to the east of the Quirinal, stretching as far as Michelangelo's Porta Pia, was the scene of much development during our period, with new housing for the expanding population and splendid *palazzi* and villas for recently enriched papal families such as the Peretti Montalto, the Ludovisi and the Barberini (see cat.nos.41 and 80). The district was dominated by the Quirinal Palace, an increasingly lavish residence (to which Bernini contributed), providing security and commodious living for papal families, as medals for Urban VIII and Alexander VII proudly proclaimed (see cat.nos. 82–3). Not far away we find some of the most attractive small-scale baroque churches in the city: Bernini's Jesuit Noviciate of Sant'Andrea al Quirinale, Borromini's San Carlino and, beyond, Santa Maria della Vittoria, with Bernini's Cornaro Chapel (fig.6).

When Gianlorenzo Bernini arrived in Rome as a boy in about 1605, the basic replanning of Rome had already taken place. Successive popes from Alexander VI (reg. 1492–1503), and culminating with Sixtus V (reg. 1585–90), had laid out the main thoroughfares that remained the skeleton structure of Rome until the Fascist period. City gates were now better linked to markets for commercial traffic, and straight roads facilitated the development of new housing. Many routes were created to connect the major Christian and classical sites, to ease movement of large processions of clerics, lay confraternities and groups

of pilgrims between the main religious centres. Sixtus, whose plans were largely put into effect by his engineer-architect Domenico Fontana (1543–1607), envisaged impressive architecture on route, and spectacular vistas terminated by obelisks or church façades. By the early seventeenth century there nevertheless remained many opportunities for architects and designers (and their ostentatious patrons) to add palaces, churches and oratories to enhance the city's outward splendour. Pope Alexander VII, in particular, took up the challenge of further rationalising and beautifying the city.[5]

Improving water supplies for the expanding population and constructing fountains made for good propaganda. By renovating ancient aqueducts, Popes Sixtus V and Paul V, in particular, had brought clean running water to most parts of central Rome. The Acqua Felice was watering the Capitol and the Quirinal Hill by 1588, and was later extended to the Piazza Barberini, where Bernini constructed his Triton fountain (see cat.no.97). The Acqua Vergine served the Piazza del Popolo from 1572 and was extended into the heart of the city to supply the area of the Pantheon, and the Piazze Mattei, Colonna and Spagna, including the Palazzo Pamphili al Corso (see cat.nos.105–6) and the Trevi Fountain. From about 1611 the Acqua Paolina, Paul V's pride, watered the areas around the Piazza Farnese, Sant'Andrea della Valle, and most spectacularly the Piazza Navona (fig.4), where Bernini created his *Four Rivers Fountain* and *Fontana del Moro* (see cat.nos.98–100), and which could be flooded for

grand aquatic displays. Immediately on the election of Giambattista Pamphili as Pope Innocent X in 1644, the Piazza Navona became the centre of propagandistic festivities celebrating the papal family and the Church (see cat.no.118).[6]

For most of the seventeenth century it was the popes and their immediate relatives who provided the major impetus for building, decoration and display in Rome. Their predominance was governed both by access to funds, and by their personal interest in guiding how that money would enhance on the one hand the prestige of the Catholic Church and the spread of its doctrines, and on the other the reputation of the Papacy, and especially the papal family. The complex symbolism of the final version of the *Baldacchino* over St Peter's tomb (see cat.nos.58–62) shows quintessentially how Urban VIII and Bernini saw all these aspects interlocking in one spectacular monument. On a smaller scale, the selection of medals in this exhibition illustrates how popes wanted their image linked to major church building enterprises; but also with newly canonised saints whose spiritual virtues and teaching qualities offered worthy models for emulation. According to Gianlorenzo Bernini's first biographers, Filippo Baldinucci and his own son Domenico, Popes Urban VIII and Alexander VII gave Bernini easy access to their person, facilitating co-operative planning of the major projects. Alexander VII's cryptic diaries document his regular discussions with Bernini and, to a lesser extent, Pietro da Cortona and Borromini, over building projects.[7]

The image-making and propaganda may have enhanced the reputation of the Church and Papacy, uplifted pilgrims, offered employment to many Roman workers and craftsmen, and contributed in no small measure to the beauty of the city we see today, but there were sufferers, especially elsewhere in the Papal State, where resources were plundered. There were complaints from within Rome against the extravagance of spendthrifts like the Cardinal-nephew Scipione Borghese, the Barberini family as a whole, and Alexander VII, who left grandiose plans incomplete as money ran out. Pope Innocent XI – more intent on frustrating Louis XIV of France, or attacking Turkish armies abroad (see cat.no.157) and heretics in northern Italy – finally turned against the cultural extravagances. He prevented the completion of the Berninian Colonnade for St Peter's, and discouraged what he saw as more useless decoration by the Jesuits in the

Gesù, even though the King of Spain was paying. This Pope wanted no extravagant memorials for himself; and his puritanism led him to persuade Bernini to mask the nudity of his statue of *Truth* on Alexander VII's tomb in St Peter's.[8]

The new basilica of St Peter's dominated the Roman religious scene (figs.3 and 5). It was the show-case for the Catholic Church and the Papacy, and therefore for designers and decorators intent on exceeding the power of the word. St Peter's and its challenges were central to much of Bernini's thinking and creativity.[9] For all the showiness and extravagance, the mixing of politics and religion, that has often shocked visitors, much that was taught, demonstrated and worshipped there expressed deeply felt beliefs, doctrines and Christian codes of conduct. Issues such as teachings on the Eucharist and the adoration of the Host, the importance of relics and the cult of saints, attitudes to a philanthropic life and a good death, are central to a discussion of artistic developments in St Peter's, and recur again and again in religious art of this period.

The foundation stone of the new St Peter's had been laid in 1506. By about 1614 the basic structure of this enormous edifice had been completed, and the remnants of the old basilica had disappeared. The centralised Greek cross plan, initiated by Bramante and partly fulfilled by Michelangelo, had been modified into a Latin cross. An extended nave was created by Carlo Maderno so that the basilica would be more suitable for large crowds of the faithful. The single most important religious site in Rome, to which all from near and far should be attracted, was now ready for decoration. Its completion and embellishment within and without posed significant challenges, stirred strong emotions, and polarised architects and commentators into opposing camps.

Bernini was to be closely involved in this project until his death, although even he suffered some serious setbacks. Urban VIII and later Alexander VII took a keen interest in developments and sometimes intervened directly. Well before his official appointment as Architect of St Peter's on Maderno's death in 1629, Urban VIII had commissioned Bernini to design a permanent *Baldacchino* or canopy over the presumed burial place of St Peter, immediately under the dome. Central to planning of the new basilica had been the idea of continuity with the old, and this could best be expressed by giving emphasis to St Peter's burial location, thus reaffirming the direct apos-

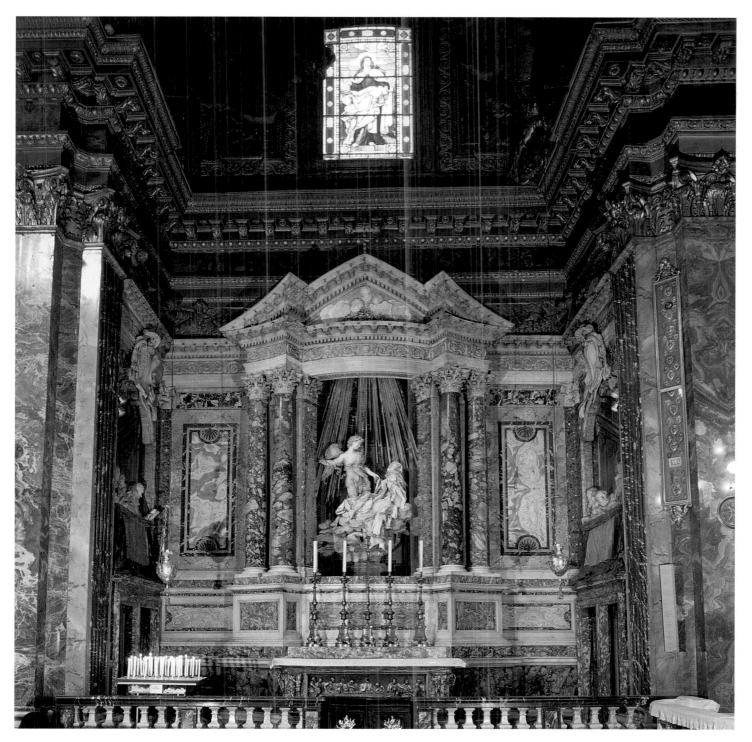

fig.6: Gianlorenzo Bernini, *Cornaro Chapel*, Santa Maria della Vittoria, Rome

tolic papal succession down to the present day. As the new building emerged, so the site became protected and marked by a canopy. Maderno produced a temporary canopy in 1606, and first he, and then Bernini and Borromini, were involved in progressively elaborate plans for a more permanent structure. The final result cleverly pays

simultaneous homage to the apostolic succession, to the old basilica (through the form of the spiral columns) and to the patron Urban VIII Barberini, whose heraldic bees crawl over its surface.

Simultaneously, Bernini took charge of the refurbishment of the crossing of St Peter's. The twisted ('Salo-

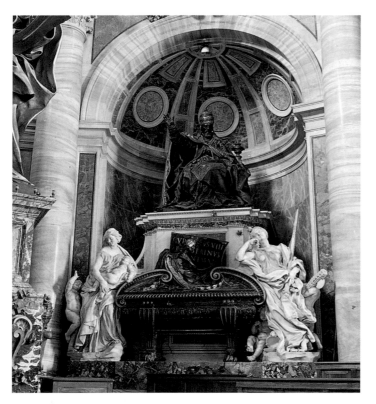 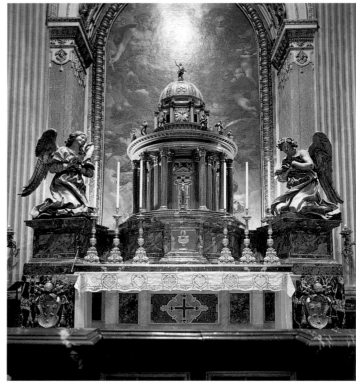

left fig.7: Gianlorenzo Bernini, *Tomb of Urban VIII*, St Peter's, Rome
right fig.8: Gianlorenzo Bernini, *Altar of the Cappella del SS. Sacramento*, St Peter's, Rome

monic') columns of the *Baldacchino* find an echo in each of the surrounding piers, where paired columns retained from the old St Peter's frame tabernacles housing some of the basilica's most venerated relics. A monumental statue of the saint relevant to each relic was commissioned for the niches below the tabernacles. Bernini himself carved the superb statue of *St Longinus*; *St Veronica*, *St Andrew* and *St Helena* were commissioned from Francesco Mochi, François Duquesnoy and Andrea Bolgi respectively. Another relic, part of the chair of St Peter, was incorporated at the heart of one of Bernini's most original and dazzling creations, the *Cathedra Petri* (1656–66), which was installed in the apse of the church (see cat.nos.69–72). This major undertaking was carried out with the help of some thirty-five collaborators, though Bernini was closely involved at every stage. The faithful viewing the *Cathedra Petri* from the nave of St Peter's (the decoration of which, incidentally, was also executed under Bernini's control, for the 1650 Jubilee year) would have seen it at least partially framed by the columns of the *Baldacchino* (fig.3).

Moving outside, Bernini's least happy episode in relation to St Peter's was his abortive attempt to erect bell-towers at either side of the façade. These had always been planned, although the form they should take was circumscribed by the need to retain a clear view of Michelangelo's revered dome. Propagandist medals and prints advertised successive proposals but when construction began, structural miscalculations caused a crack to appear in Maderno's façade and, following hostile criticism, the project had to be abandoned.

More successful was Bernini's restructuring of the space in front of St Peter's and the entrance to the basilica. Alexander VII took an active interest in this project and wrote with pride in his diary of 'our planning' of the Colonnade with Bernini.[10] The original plan was for an enclosed arena, with a central segment inserted between the two principal arcs of the Colonnade, leaving relatively narrow gaps to admit processions and carriages (see cat.nos.64–7). The design as executed is frequently likened to the open arms of the Church welcoming the faithful, a notion which indeed seems to have inspired Bernini's thinking. Well over a hundred gigantic statues honouring Christian saints were executed by Bernini's entourage, at least some of them to his designs, to adorn the Colonnade and the façade of the church (see cat. no.68).

In addition to these public contributions, the two most charismatic of his papal patrons, Urban VIII and Alexander VII, commissioned Bernini to design their own tombs for St Peter's, replete with flattering personifications of their virtues, as well as overt reminders of their mortality (figs.7, 9 and 10). And while Bernini dominated the scene under these two popes, his rival Alessandro Algardi did execute two important works for St Peter's celebrating past papal heroes and defenders of the faith: the tomb of the briefly-reigning Pope Leo XI, which was a private (non-papal) commission in the 1630s (see cat.no.63); and, during the pontificate of Innocent X, a monumental relief of *The Encounter of Pope Leo I and Attila*.[11]

What marked out the Catholic faith from that of the various Protestant sects was its interpretation of the sacrament of the Eucharist. Catholics upheld the doctrine of transubstantiation, the belief in the real presence – that Christ's body became a real part of the consecrated Host. A new emphasis on the sacrifice of Christ, the presence of the flesh in the bread of the Host, and most importantly its display for veneration by the laity, had thus become the central platform of Catholic reformers. However radical some of these reformers may have been about other aspects of religious art and decoration, there were justifications – as Carlo Borromeo had argued in his *Instructiones* on building and church decoration (1577) – for lavish expenditure on marble, precious stones and gilding to create altars dedicated to the reserved Host, for tabernacles or ciboria to house it, and for monstrances to show it. The visibility of the high altar from the nave, the need to

'protect' it from the main body of the church and to provide adequate space for celebrants, became important considerations in church design. The Cappella del SS. Sacramento and its altar in St Peter's (fig.8), conceived under Urban VIII but only completed under Clement X in time for the 1675 Jubilee, was thus an extremely important commission, and one which exercised the ingenuity of its extremely devout designer, Bernini, over a protracted period (see cat.nos.73–6).[12]

Outside St Peter's, new religious orders and lay confraternities (or brotherhoods) played significant roles in Rome's religious life. They were important patrons of religious art and music, but they also had a major impact on religious beliefs, and on how these were expressed and communicated. The three most significant new orders in Italy – the Jesuits, the Oratorians and the Theatines – had different profiles, roles and attitudes, though they all participated in public life and had regular contact with the laity.[13] They competed for the allegiance of the rich and powerful to sponsor their teaching and philanthropic work, and fund their building projects; and for the adherence of the wider community to attend their services and accept their spiritual advice. By the late sixteenth century the Jesuits were prepared to advise and assist anybody, and involved themselves in everything from counselling noble women and reforming prostitutes, to educating prisoners and lecturing in the most advanced universities and colleges.

By the early seventeenth century, work on the mother churches of these new orders was well under way,

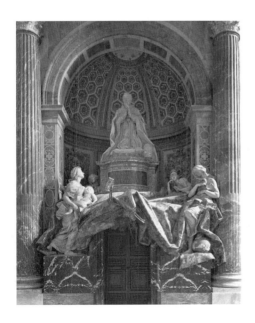 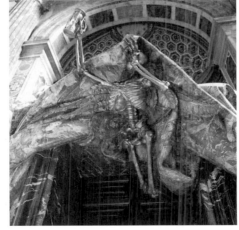 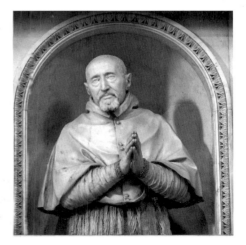

left fig.9: Gianlorenzo Bernini, *Tomb of Alexander VII*, St Peter's, Rome
centre fig.10: Detail of figure 9, showing Death
right fig.11: Gianlorenzo Bernini, *Bust of Cardinal Roberto Bellarmino*, Il Gesù, Rome

although the Theatine church, Sant'Andrea della Valle, lacked a façade (see cat.no.77) and conventual buildings attached to the Oratorians' Santa Maria in Vallicella (or Chiesa Nuova) were still to be built (see cat.no.81). A great deal remained to be done during our period regarding the decoration of naves, domes and apses, and the embellishment of individual chapels, which were typically under the patronage of private families. Algardi, for example, secured the hugely important commission to execute the funerary urn of St Ignatius for the left transept of the Jesuit mother church, the Gesù, and also designed the tomb of Antonio Cerri for one of the chapels there (see cat.no.28). Bernini was a regular worshipper in the Gesù, a devotee of Ignatius's *Spiritual Exercises* and later in life a close friend of the General of the Order, Giovanni Paolo Oliva.[14] His first commission for the Gesù was to execute the bust of the reforming Jesuit theologian Cardinal Roberto Bellarmino (fig.11); he later designed the tomb slab of Cardinal Pio da Carpi for the pavement of the tribune (see cat.no.113) and was instrumental in securing for his protégé Baciccio the commission to fresco the apse, dome and nave of the church.

The new religious orders became leading advocates of a policy of harnessing the arts in the service of religion. The publication of the decrees of the Council of Trent in 1564 led to a more puritanical attitude towards visual art and music in churches and chapels. In his *Discorso intorno alle imagine sacre e profane* of 1582, the reforming Archbishop of Bologna, Cardinal Gabriele Paleotti, had called for a new appropriate religious art that would suitably instruct, enthuse and arouse correct religious emotions. The Theatines, Oratorians and subsequently the Jesuits all espoused the rhetorical use of the arts to instruct and arouse emotions, as well as to assist religious contemplation.[15] By the mid-seventeenth century, this attitude was to find supreme visual expression in such projects as Bernini's Cornaro Chapel (fig.6), and the exuberant fresco decorations by Pietro da Cortona in the Chiesa Nuova, and by Baciccio in the Gesù.

Confraternities were central to religious and social life for many in Rome, from cardinals to the destitute.[16] Of medieval origins, confraternities brought mainly lay people together under certain rules to promote their collective spiritual life in this world, to ease the transition to the next, and pray for the souls of the departed. Though primarily for men, some had women members, and there were a few women-only sororities. Catholic reform promoted a major blossoming and diversification of confraternities in Rome. By the late sixteenth century they were involved in such charitable activities as running hospitals, orphanages and refuges for the vulnerable, in providing dowries for poor virgins to marry respectably, and in seeing to the decent burial of the abandoned and destitute. They participated in the administration of prisons, as well as escorting condemned prisoners to execution and bailing out indebted ones. Confraternities also took care of parish churches and their altars, ensured that the Sacrament was duly respected, promoted the cult of the Rosary, and helped pay for candles and lamps, organs and church decorations. While many were based in major collegiate churches like San Lorenzo in Damaso, or smaller parish churches, some had their own well-decorated oratories, such as San Giovanni Decollato or SS. Crocefisso di San Marcello. Many Roman confraternities were also arch-confraternities, networking with confraternities elsewhere, providing model statutes, and acting as hosts to brethren coming to Rome on pilgrimage.

Increasingly reformers contemplated how pilgrims might best be attracted to the city's shrines and be cared for and impressed while in Rome so they would return home with favourable reports. Jubilee years every twenty-five years from 1550 boosted this campaign, becoming increasingly elaborate in their celebrations, and drawing ever larger crowds from afar. For the 1575 Jubilee the arch-confraternity of SS. Trinità, which was particularly concerned with accommodating pilgrims (see cat.no.116), hosted about 170,000 pilgrims (each given board and lodging for an average of three days), while over 200,000 came to Rome in 1600. The initiation or completion of building or decorative projects could be affected by an imminent Jubilee. The 1625 Jubilee, for instance, prompted the consecration of St Peter's, the expansion of the hospital of SS. Trinità, and Bernini's major restoration of the church of Santa Bibiana (see cat.nos.78–9). For the 1650 Jubilee, San Giovanni in Laterano was given a major facelift under Borromini's direction, and the main part of the Jesuits' second church, Sant'Ignazio, was completed. The Piazza del Popolo and the roads radiating from it were redeveloped in preparation for the 1675 influx of pilgrims.[17]

Preparation for death, involving contemplation of death and purgatory and eventual release into Paradise, were major preoccupations of confraternities and of the wider religious community, but it is misleading to portray

the mood of the period as excessively morbid. The worst excesses of fear-creation were formulated by a few peculiar Jesuit and Capuchin preachers and confessors.[18] A whole literature had been developed since the early fifteenth century on the *ars moriendi* ('the art of dying'), and this tradition had been reinvigorated in the late sixteenth century by the Jesuits, and particularly by Cardinal Roberto Bellarmino (1542–1621). Much emphasis was placed on the need to prepare for death in life, through good works, moral behaviour, contemplation and contrition. Well-conducted preparation in this life would reduce or eliminate the pains of death, the duration of purgatory and maybe secure an early passage of the soul to Paradise.

Bernini encapsulated these concerns in his testament with the words: 'As death is the fearful point from which depends an Eternity either of good or of punishment, it behoves a person to think of living properly in order to die properly'.[19] For the second half of his life, Bernini was an active member of a confraternity preoccupied with preparation for death, the *Bona Mors* ('Good Death'), which was based at the Gesù, and he engaged in intense debates on this subject with his Oratorian nephew Francesco Marchese, and with the Jesuit Giovanni Paolo Oliva.

In seventeenth-century Rome visual reminders of death in the form of skeletons and skulls were everywhere – in sculptural decoration, book illustrations and prints – and they recur repeatedly in Bernini's imagery, notably, and in very animated form, on his great tombs of Urban VIII and Alexander VII (fig.10). The latter Pope, immediately following his election, commissioned Bernini to produce a marble skull and coffin that was to be kept in his bedroom as a permanent reminder of his mortality. The terracotta *bozzetto* in this exhibition attributed to Bernini (cat.no.123), which shows Time, carrying a coffin marked with skull and cross-bones, being stopped by Death, might possibly be connected with the artist's own association with confraternities that escorted funerals.

Religious leaders emphasised the need for proper burial of the dead. While the poorest in society were assisted in this by confraternities, the richest spared no expense on elaborate funeral processions, spectacular commemorative catafalques, lavish tombs and monuments, and anniversary commemorations. The skills of some of the best-established artists in the city, including Bernini, Sacchi, Grimaldi, Algardi and Girolamo Rainaldi, were engaged on the production of ephemeral funeral decorations and catafalques (see cat.nos.128–33).[20] These structures were often widely publicised in printed reports (*relazioni*) and prints, enhancing the reputation of their creators as well as that of the deceased. They also influenced the design of some more permanent structures.

Funerary chapels and tomb sculpture were part of a longer-lasting tradition of elaborate commemoration. Just as Catholic reformers increasingly emphasised the seamless interaction of the living and dead, this world and the next, so designers and sculptors of tombs strove to blur these distinctions and make the dead seem more alive. Bernini's intense, almost ecstatic effigy of Gabriele Fonseca in San Lorenzo in Lucina is a supreme illustration of this trend (fig.12). The interaction of the living and dead is also amply demonstrated by many of the monuments in the church of Gesù e Maria on the Corso, executed in the 1680s by various hands under the control of the architect Carlo Rainaldi.[21]

Other spectacular temporary decorations were created in connection with the cult of the Eucharist. Amidst some controversy, campaigns, spearheaded by the Jesuits, were mounted to encourage the laity not only to adore, but to confess and receive the Eucharist more frequently than the obligatory annual communion at Easter. Corpus Christi processions, organised by sacrament confraternities such as those based at San Lorenzo in Damaso and San Giovanni in Laterano, and often involving elaborate portable banners and paintings and accompanied by music, were one expression of this new emphasis on the Eucharist (see cat.no.127). Another was the Quarantore, or Forty-Hours Devotion, the most elaborate spectacle for the adoration of the Host created in seventeenth-century Rome.

Initiated in Milan in 1527, this ceremony was brought to prominence in Rome by Philip Neri in the 1550s, was spread by his Oratorians, and was taken up with enthusiasm by Capuchins, Jesuits and lay confraternities. These devotions usually involved having the Host prominently on display continuously for forty hours (though sometimes the display period was spread over a longer period, with the church closed for part of the night). People would be encouraged to come and adore for a period, often in confraternity-led groups, to hear sermons and homilies, listen to some music, maybe sing a *Te Deum*, and perhaps receive the Host. Elaborate perspectival back-

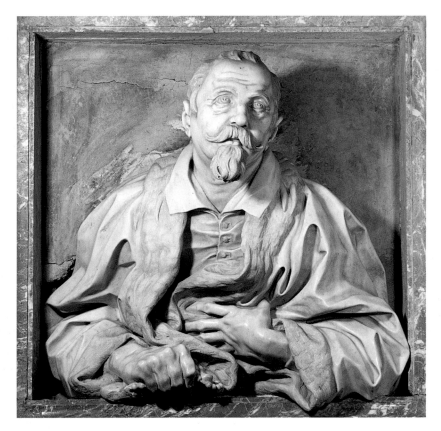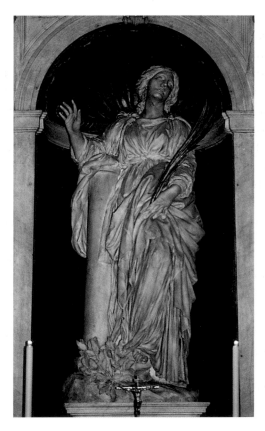

left fig.12: Gianlorenzo Bernini, *Portrait of Gabriele Fonseca*, San Lorenzo in Lucina, Rome
right fig.13: Gianlorenzo Bernini, *Sta Bibiana*, Santa Bibiana, Rome

drops were sometimes constructed around the altar, with huge angels and other figures, lit by complex interactions of candles, lamps and reflecting mirrors (see cat.no.126). One in the Gesù in 1610 involved 2,300 lamps and 500 candles, while another designed by Bernini in 1628 for the relatively restricted space of the Pauline chapel in the Vatican consisted of a dramatic perspective of the Glory of Paradise, lit by 2,000 lamps.[22]

In contrast to these spectacular innovations, the cult of saints was a standard and traditional part of Catholic teaching, albeit one that had been severely attacked by Protestant reformers. The sixteenth century had been a fallow period in the creation of new saints and the beatification of possible contenders, but early in the new century the Church entered a period of enthusiastic recognition of recent saintly contributors to the Catholic revival. Beatifications and canonisations called for lavish ephemeral celebrations, and prompted the commissioning of paintings and sculpture to honour them more permanently.[23] The canonisation in 1610 of Carlo Borromeo, former model archbishop of Milan, was a landmark in the new policy, and the campaign which led to his recogni-

tion was innovative in its use of visual imagery to broadcast his virtues as charitable worker and penitent (rather than his reputation as a strict disciplinarian). The multiple canonisations on 22 March 1622 of the Jesuits Ignatius Loyola and Francis Xavier, the founder of the Oratorians, Philip Neri, and the Carmelite reformer Teresa of Avila, dramatically celebrated the newly revitalised cult of saints (see cat.no.153). The fifth saint canonised on that day, the thirteenth-century Isidore, subsequently patron saint of Madrid, was a Spanish peasant of simple faith, whose inclusion among the more recent candidates may have had a political dimension.[24] The visionary Teresa of Avila (1515–82), the subject of one of Bernini's best known sculptural groups (fig.6), was a controversial figure in her own lifetime who narrowly escaped condemnation by the Spanish Inquisition. She was singled out for beatification (1614) and canonisation for reforming the Carmelite order and advocating the ideals of poverty, but it was the more mystical aspects of her life, the heavenly visions and the pains and ecstasies of the love of God which she vividly described in her autobiography, that inspired Bernini's group in the Cornaro Chapel. Beatifications and

canonisations were increasingly celebrated both to boost particular approaches to Catholic Reform, and to satisfy the political aspirations of different nations still loyal to Rome and St Peter. If the 1622 canonisations mainly honoured Spaniards, the beatification (1662) and canonisation (1665) of St François de Sales (1567–1622) mollified French interests at a delicate international moment (see cat.nos.154–5). The honour was nevertheless well deserved, for François de Sales was an influential spiritual adviser, the founder of the Visitandines or Salesian Sisters (a female order devoted to welfare and education), and a model bishop who had helped convert Protestants in the Chablais. The canonisation of Peter of Alcantara (1469–1562) in 1669 aimed to please both the Spanish and Portuguese and to highlight the virtues of an ascetic and recluse, an expert on prayer, who also tried to reform the Franciscan Observants, and had supported St Teresa of Avila. He was paired ceremonially, and on the single commemorative medal (cat.no.156), with the Florentine noblewoman Maria Maddalena dei Pazzi (1566–1607), an ascetic nun who experienced many visions and ecstasies, and who had made a speciality of cajoling ecclesiastical leaders when they were slow to implement reforms.

The beatification in 1671 of Ludovica Albertoni (1473–1533), an ancestor of the reigning Pope Clement X, inspired the ever-shrewd Bernini to produce his monument to her in San Francesco a Ripa without payment (see cat.no.124). She had been celebrated as a Roman noblewoman who on widowhood became a 'living saint' (*beata*), the 'Mother of the poor' in the Trastevere.[25] Depicted in ecstasy on receipt of the last rites, Bernini's interpretation reflected his interest in the efficacy of receiving the Host, and showed a positive attitude towards her (and his own) impending death.[26]

The long-standing veneration of relics as part of the cult of saints showed no signs of abatement in this period, as Bernini's planning of the crossing in St Peter's exemplified. The cult generated much employment for sculptors, metalworkers and gem-cutters, who were required to design reliquaries of a magnificence befitting the objects they were to house, replete with angels or cherubim to draw attention to them. Often ignored or glossed over in accounts of Baroque art, the importance of such objects for the religious life of seventeenth-century Rome should not be underestimated.[27]

The discovery of relics as Rome was excavated and ancient churches were renovated inspired new cults, injected exisiting ones with new energy, and generated new funds for more elaborate building and decoration. For example, restoration of the old church of Santa Bibiana in 1624 unearthed her remains, and caused Urban VIII to sponsor a more extravagant renovation. Bernini was commissioned to design a new façade and portico (see cat.no.78), and a statue of the saint for a niche behind the high altar (fig.13), while Pietro da Cortona painted scenes from her life and martyrdom (cat.no.79). When Pietro da Cortona started renovating the old church of SS. Luca and Martina for the painters' Academy of St Luke, the hoped-for relics of Sta Martina were discovered and Cardinal Francesco Barberini agreed to pay for a new church designed by Pietro – his architectural masterpiece.

Protestant opponents to the Roman Catholic church placed great weight on the literal meaning of the biblical Word of God. In combating heresy and enthusing the faithful, baroque Rome produced great preachers skilled in the exposition of biblical texts, not least of whom was Bernini's mentor Padre Oliva. Just as such preachers themselves played elaborately with words, so they encouraged artists to exceed every expression of words. Bernini's *Sta Bibiana*, open-lipped in her heavenly vision, communicates with the faithful as well as with God, enthralled in an ineffable religious experience which the beholder is encouraged to share. The rhetoric of Bernini's religious art, and that of many of his contemporaries, was designed to emphasise the interconnections of this world and the next through a direct appeal to the senses and the emotions. The religious art of this period, as this exhibition exemplifies, encouraged the faithful to contemplation, to action through good works, to imitate the deeds and steadfastness of the saints, and to prepare for death and the afterlife.

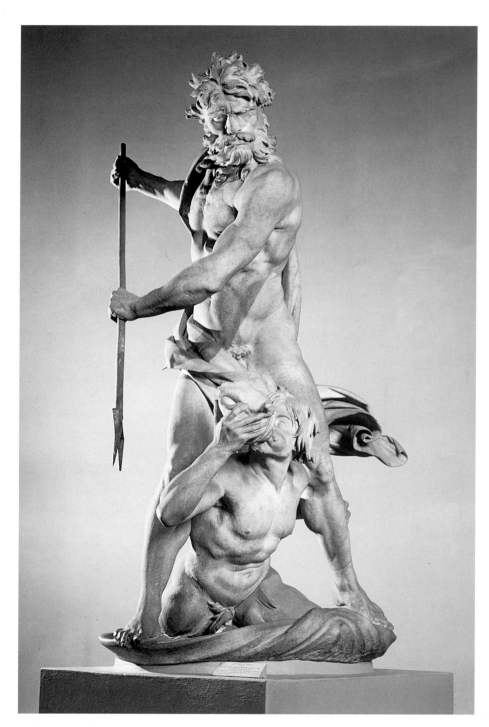

fig.14: Gianlorenzo Bernini, *Neptune and Triton*, Victoria and Albert Museum, London

CHRISTOPHER BAKER

Bernini: A Mercurial Life and its Sources

On the morning of 28 November 1680 Gianlorenzo Bernini received the blessing of Pope Innocent XI Odescalchi from one of his chamberlains just before dying, apparently from a stroke. He was in his eighty-second year, and according to his son Domenico, mourning 'was universal in the city of Rome, which recognised its majesty greatly enhanced by his indefatigable labours'.[1]

Few artists could claim such a lifetime of rich, innovative and sustained work, or indeed to have made an impact on an entire city. Bernini's creations did not just have local consequences though, but became a European phenomenon. He pushed back the conventional boundaries of sculpture and architecture to produce previously unimagined effects which were by turns grand, dynamic and deeply moving, and accelerated the process of making Rome the rejuvenated capital of the Catholic world. This involved entirely re-thinking how to enrich St Peter's as a great reception centre for pilgrims and, in an astonishing variety of smaller sculpted monuments, how to propagate the decrees of the Council of Trent, which had reasserted the importance of papal supremacy, the sacraments, and the lives of the saints. Furthermore, as a court artist Bernini also met and surpassed the demands made upon him. These ranged from executing portraits, monumental tombs and fountains, to designing ephemeral decorations for the theatre, opera or carnival. He also planned firework displays and banquets – in fact the entire paraphernalia of wonder and spectacle which promoted the papacy and its allies.

What sort of man could achieve so much? From behind this very visible artistic career, which seems at first so untroubled and uniformly pious, Bernini emerges as a complex and charismatic personality. When young he was precocious, obsessive about his work, and capable of passion and condoning violence. He also appears, through less well known activities such as writing com-

edies and penning acerbic caricatures, as witty and mischievous. As he matured he became urbane, charming and devout, defensive about his family, able to command formidable executive skills, and someone whose company was valued by his patrons almost as much as his works.

Such a terse character study can be drawn from the evidence of his sculpture, supplemented by a wealth of written sources. There are, however, few autobiographical clues about his opinions and outlook; Bernini was not a prodigious letter-writer like Rubens, or a poet like Rosa, and nor did he create carefully crafted self-portraits, such as those of Poussin, which through their attributes allude to a deeply held set of values. So to a large extent we have to see him through the eyes or words of others, and judge the merits of their perspectives. Among these commentaries, it is necessary to make a clear distinction between the public, secondary biographies – which often border on hagiography of the sort you might expect to be associated with one of the saints Bernini depicted – and the more private types of primary testimony. The latter tend to deal with specific events, and take the form of inscriptions, contracts, correspondence, travellers' accounts, inventories of collections, diaries and court transcripts. One acts as a check on the other, and only when they are brought together does one acquire a reasonably judicious portrait of the man and the artist.

The two key public biographies which give an overview of his career were published after Bernini's death; the first to appear was written by the Florentine Filippo Baldinucci (1624–96) and printed in 1682;[2] and the second, by the youngest of the sculptor's sons, Domenico Stefano Bernini (1657–1723), was published in 1713.[3] In many respects they are very similar, and it has frequently been assumed that Domenico's book was little more than a re-working of Baldinucci's, but close textual analysis

has resulted in the persuasive suggestion that in fact Domenico's account is very probably the source for both biographies.[4] He of course knew Bernini in his later years, had access to family documents and lore, and was a professional writer who produced a four volume *History of all the Heresies*, rather than just someone delivering a eulogy for a beloved father.

Domenico deftly succeeded in balancing a clear sense of pride in the sculptor's achievements with a very informative account of the shape of his career. So, for example, on the one hand he outlines the circumstances of Bernini's most celebrated and notorious commission, the Cornaro Chapel in Santa Maria della Vittoria, but also includes a verse in praise of it written by one of the sculptor's other sons, Monsignor Pier Filippo Bernini.[5] The result is not a work of fiction – we know this because many details are corroborated by other sources – but a biography which conforms with models about how to construct an artist's life as formulated in the previous century by Vasari (and based in turn on ancient conventions about histories of 'great' men);[6] it becomes an exemplary history, with incidents and works described in order to illustrate various positive aspects of Bernini's achievement. Domenico does not even shy away from outlining Bernini's temporary fall from favour at the beginning of the reign of Innocent X Pamphili in the 1640s, because it makes his subsequent triumph all the greater: he recalls Bernini's elegant, assured observation that 'Rome sometimes sees dimly, but never loses her sight'.[7]

The dramatic ascent of Bernini's career conveniently lent itself with little difficulty to formulating such an account, allowing his son to plot the transition from the first stirrings of technical facility to the divinely inspired climax of a long, productive life. In Bernini's case, innate skill could also be woven with social recognition to confirm status, as he was held in high esteem by popes and monarchs, so again following a pattern set by the most exalted artists of the recent past – Michelangelo and Titian. It is no accident that Domenico recalls Urban VIII's declaration on meeting the young Bernini for the first time: 'This child will be the Michelangelo of his age'.[8] What emerges from the ensuing account of Bernini's relationship with his patrons is that it was a symbiotic one; the sculptor needed them to realise his ambitions, and through his work and status their role was glorified. In a very real sense he became their Michelangelo, and consequently was never a mere serv-

ant of the papacy, but a trusted ally who was fêted, and quickly forgiven on the rare occasions that he disappointed.

It was such high regard that prompted the commissioning of Baldinucci's biography, which was written for the famous convert to Catholicism, Queen Christina of Sweden.[9] She lived in Rome, and with the typical vehemence of a convert was drawn to the greatest artistic advocate for her new faith; as she put it in a letter to Angelo Morisini: 'I have such a high opinion of the said Bernini that I gladly take every opportunity to do him a good turn, for he has proved himself the greatest and most outstanding man in his craft who ever lived'.[10] Her celebratory tone was carried over into Baldinucci's account, but it was not in his nature simply to write a hymn to the artist. He was a formidable historian, biographer and connoisseur who had a serious concern for the veracity of his sources, and as well as looking to Domenico, he turned to figures such as Giulio Cartari, one of Bernini's pupils, for information.[11] Furthermore, he worked extensively for the Florentine Grand-ducal court, where he would have been intimately acquainted with at least two works by Bernini – a painted *Self-portrait* in the famous Medici 'Galleria di Autoritratti'(fig.21), and the marble bust of *Costanza Bonarelli*, which arrived in Florence in 1645 (fig.15).[12]

Baldinucci had been educated by the Jesuits, and Bernini, particularly later in life, was drawn to the Jesuit cause. This coincidence may help explain the sensitivity with which the biographer carried out his task. He says that in his maturity Bernini behaved 'more like a religious than a secular man', who continued 'for forty years to frequent the special devotions celebrated … by the Jesuits in Rome',[13] and he makes considerable use of his vocation when describing the merits and often tremulous, visionary spirituality of his work from the 1640s onwards. However, although such observations provide valuable insights, in many ways his book is most memorable because of the erudite technical and aesthetic appreciation he brought to his analysis. Baldinucci had built up an important collection of drawings for Cardinal Leopoldo de' Medici, and notes that examples of Bernini's draughtsmanship would 'merit a worthy place' within it. In addition, in the year before his biography was published, he wrote a dictionary of artistic terms, *Vocabolario toscano dell'arte del disegno* (1681). In view of this experience, it is not surprising that he was able to apply a prag-

matic, authoritative approach to his commentary and, for example, to describe the sculptor's graphic work in which 'one notes a marvellous symmetry, a great sense of majesty, and a boldness of touch that is really a miracle'. Baldinucci also discusses how Bernini's mastery of materials resulted in the sensual appeal of his sculptures: 'Before Bernini's and our own day there was perhaps never anyone who manipulated marble with more facility and boldness. He gave his works a marvellous softness...'. Most importantly, later in the same passage he articulates one of the central aspects of Bernini's vision:

'The feeling is widespread that Bernini was one of the first to unite architecture with sculpture and painting in such a manner that together they make a beautiful whole [*bel composto*] ... His usual words on the subject were that those who do not sometimes go outside the rules never go beyond them.'

This description of the *bel composto* has subsequently become a fundamental motif in almost all serious discussions of Bernini's commissions, like the Cornaro Chapel (fig.6), in which such a synthesis was realised.[14]

The artist's willingness to 'go outside the rules' meant that not all *seicento* biographers treated Bernini with such respect or admiration. Most importantly, Giovanni Pietro Bellori (1613–96) did not even include him in his famous *Le Vite de' pittori, scultori, ed architetti moderni*, which was published in Rome in 1672. His silence on the subject of the sculptor is, however, very eloquent as it attests to his championing of the classicising strands in Roman art. Bellori's heroes were the Carracci, Poussin and Algardi, while for him Bernini, Borromini and Pietro da Cortona were flamboyant rebels who denied tradition. Bellori worked as Queen Christina's librarian, but with this bias she could hardly turn to him to celebrate her favourite sculptor; the Tuscan Baldinucci, with his less dogmatic approach, offered a far more attractive service.[15] By omitting Bernini from his personal pantheon, Bellori contributed significantly to the posthumous decline in the artist's critical fortunes, because his writings were to prove so influential; he provided a whole canon of taste with which the individual apologists Baldinucci and Domenico Bernini could not compete. The biographer as theorist, rather than the biographer as historian proved more powerful at a time when a theoretical grounding for aesthetic discussions was coming to be all important with the rise of the academies.[16] What

Bellori started, Johann Winckelmann and his followers in the eighteenth century continued – not an open attack on the values Bernini represented, but a codification of the opposite position, which implied condemnation of any deviation from the 'purity' of classicism in visual and ethical terms. The generation that idolised Canova had little time for Bernini.

For different reasons the later reception of his work was even more negative: John Ruskin considered that it represented 'base feeling', and was, quite simply, in very bad taste. The slow rehabilitation of the sculptor's reputation in Italy, France and Britain was eventually achieved, however, as the power of academic dogma has been broken down from the outset of this century. This opened the way for art historians' researches – most notably the work of Fraschetti, Wittkower and later Lavin –

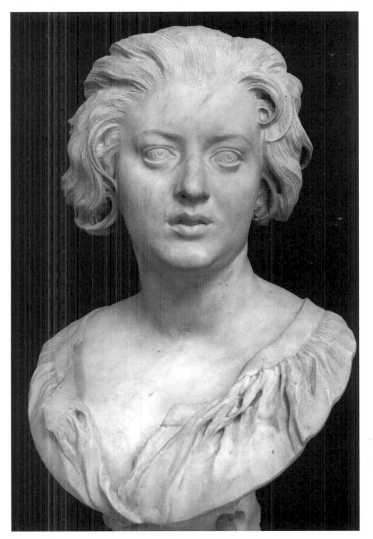

fig.15: Gianlorenzo Bernini, *Bust of Costanza Bonarelli*, Galleria Nazionale del Bargello, Florence

which was followed by popular appeal.[17] Consequently, almost every aspect of Bernini's life and work has been analysed and re-appraised. Among the broader conclusions that this has led to is the notion that he did not represent such a clean break from classical ideals as Bellori would have us believe: the polarisation of seventeenth-century Italian art into 'Baroque' and 'Classical' camps has proved to be in many respects a literary or historiographical creation which crumbles on closer analysis. It has become apparent that although Bernini was a revolutionary in various ways, he was also capable of developing a profound respect for tradition. In fact, such respect formed the fundamental basis for his work, and manifested itself through his deep appreciation of the famous examples of ancient sculpture in the Vatican collections, his public proclamation of admiration for Raphael, and by his being overwhelmed when studying the work of Bellori's ally, the supposed arch-classicist Poussin.

Reappraisal of more practical aspects of Bernini's work has also led to a number of adjustments about the way in which the artist is perceived (not all of which are comfortable). Recent research has been particularly effective in providing a corrective to the image handed down by Baldinucci that Bernini – especially in his early years – was a lone, toiling genius: we know now, for example, that some of the most virtuosic passages in his famous *Apollo and Daphne* were the result of the work of his assistant Giuliano Finelli (see cat.no.43).[18] What has emerged, in this and in many other cases – not least because of the sheer scale and quantity of his output – is that to enact Bernini's conceptions the collaboration of a large number of highly skilled specialists was required.[19] This does not belittle his achievement, but it means that it has become necessary constantly to differentiate between the designer and executant when studying his work.

Developing a more balanced view of Bernini's life has also been attended by an acute irony, because as he is taken seriously once again and respectfully analysed, the polite veneer of Bernini's 'official' biographies has been peeled back to reveal the grit of his private and family life, with all its joys and unsavoury details. In this respect the discrepancies between the biographies and primary sources are brought into sharp focus by the notorious affair Bernini had with Costanza Bonarelli, the wife of his assistant Matteo, who had entered his workshop in 1636 and collaborated on the *Tomb of Countess Matilda* in St Peter's. Bernini painted and sculpted her – the latter exer-

cise resulting in one the most disconcertingly vital and energised of all his portrait busts (fig.15). The split between Bernini and Costanza was noted with some candour by Domenico, but the precise nature of the incident was suppressed because of a son's loyalty:

'He was inflamed with desire for this woman, because of whom, if he remained in part culpable, he nevertheless succeeded in being declared a great man and one excellent in art. Either jealous of her or losing his head for another reason (since love is blind), he imposed upon one of his servants, giving him I know not what affront, though for having been public and damnable, it followed that he ought to be penalised with no negligible punishment. The Pope, apprised of the deed, ordered that the servant be exiled, and through his chamberlain, he sent to the Cavalier an absolution for his crime written on parchment on which appeared a eulogy of his virtue...'.[20]

In this version of events the 'deed' and 'crime' remain completely unexplained. However, court records reveal the gruesome truth: Bernini saw his brother Luigi leave Costanza's house early one morning, assumed she had been unfaithful to him and attacked Luigi with an iron bar before ordering his servant to disfigure Costanza with a knife.[21] It is perhaps too easy to impose on Bernini a division between the excesses of youth and wisdom of maturity, but this incident – which seems more akin to an escapade of Caravaggio – does appear to have marked a turning point. As Baldinucci explained, from this period onwards the artist became increasingly devout, and in the following year, 1639, on the advice of the Pope, he married Caterina Tezio, the daughter of a member of the Curia, with whom he seems to have enjoyed a long, stable relationship. They had eleven children of whom four boys and five girls survived to adulthood. Caterina died in 1673, and curiously, by contrast with the unforgettable image of Costanza, there is no surviving portrait of her by the artist.

Family problems, the details of which once again do not appear in the published biographies, impinged on a second and last occasion on Bernini's public life, and showed that his reputation was not unassailable: in 1670 his brother Luigi was caught brutally abusing a young boy within the precincts of St Peter's, and fled to Naples. Bernini was temporarily disgraced and had to pay fines and persuade his most powerful allies, including Queen Christina, to petition the Pope in order to reinstate his position.[22]

Sources beyond the formal versions of Bernini's life, as well as providing such damning information, also deliver a counterbalance, in the form of a *Diary* which records the sculptor's brief visit in 1665 to Paris, and reveals much about his ingenuity and eloquence. The French trip was instigated by Louis XIV and his chief minister Colbert, who wanted to enjoy the prestige of having Bernini submit plans for the completion of the Louvre. The *Diary* which documents it was written by the learned French courtier, Paul Fréart, Sieur de Chantelou (1609–94), who had been appointed as Bernini's companion and guide by the King. It was first published in 1885, and remains one of the most lively and telling documents about seventeenth-century court culture.[23] Chantelou was a renowned connoisseur and collector who spoke Italian, had visited Rome in 1640 in order to bring Nicolas Poussin (who became a lifelong friend) to Paris, and became a *maître-d'hôtel* to the king, and so was an astute choice to accompany Bernini during his five month French sojourn. He carried out his task conscientiously, and his *Diary* has a great freshness, being jounalistic rather than literary in tone, and was never intended for public consumption, although it reflects a self-awareness that these were momentous events and worthy of record. His memorable description of Bernini's appearance (cited in full in the entry to cat.no.5), which reflects the contemporary belief that you can read 'the mind's construction in the face' is more compelling than many of the visual portrayals of him.

There are also a number of incidental observations that Chantelou makes which provide valuable crumbs of evidence about Bernini's habits and character: he was enjoying a siesta when Colbert first arrived for an audience; he strongly recommended regular reading *On the Imitation of Christ* by Thomas à Kempis; he could become depressed at the end of a day's sculpting; and that he carefully affected modesty when dealing with patrons, as a screen for a prickly self-assurance and passion about the value of his work. This social skill had no doubt evolved after years of balancing calculated deference with ambition at the papal court.

The sculptor is depicted in Chantelou's account of his private moments as opinionated, exacting and flamboyant, and a man whose wit and inventiveness leaves a lasting, positive impression on his companion, even though the backdrop was a visit which promised so much and resulted in the delivery of very little in terms of tangible work. There was a personal rapport between Bernini and the King, but the sculptor had a low opinion of French art, was not wary of expressing it, and fired the jealousy of native artists who ultimately carried out the architectural project he was supposed to design. On his return to Rome he left behind a great deal of resentment and one of the greatest of all Baroque portraits – his marble bust of Louis, now at Versailles, the creation of which is exhaustively plotted in the *Diary*.

Chantelou's generally favourable impression of Bernini's life in France can be effectively juxtaposed with quite a different version of events provided by Charles Perrault in his memoirs, which were posthumously published in 1759. Perrault was assistant to Colbert in 1665, and his sharp view of the sculptor is flavoured by a powerful combination of personal antipathy and anti-Italian sentiment: 'It is my firm opinion that as an architect [Bernini] was only fit for scenic designs and theatrical apparatus. Monsieur Colbert, on the other hand, wanted precision'.[24]

Opinions of this sort could be expressed openly in Paris, but in Rome they often had to be cloaked in anonymity because of Bernini's power. He provided a number of targets for critics over and above the problems in his private and family life, and the evidence we have about their protestations once again creates an antidote to the glowing record created by Domenico Bernini and Baldinucci, according to which the sculptor's work perfectly matched the aspirations of almost all of his contemporaries. The extraordinary extent of his influence, titles and role as an adviser on the invariably vexed subject of who should receive certain commissions inevitably fuelled discontent. In addition, opponents could revel when things went wrong – such as during the fiasco in the early 1640s over the *campanili* of St Peter's he designed, which began to crumble and had to be torn down.

Criticism became more intense during the last third of Bernini's life, as a mood of greater austerity developed in Rome, and the sheer flamboyance of his work was increasingly considered out of step with current taste.[25] One of the most compelling and cutting of all the jibes made against him was a tirade, which is recorded in a manuscript in the Vatican, about the *Equestrian Statue of Constantine* which the sculptor unveiled in 1670 at the foot of the Scala Regia (see fig.16).[26] The unknown author describes it as a 'beastly centaur' and goes on to advise 'The Cavaliere Bernini to avoid forever as an unfortunate

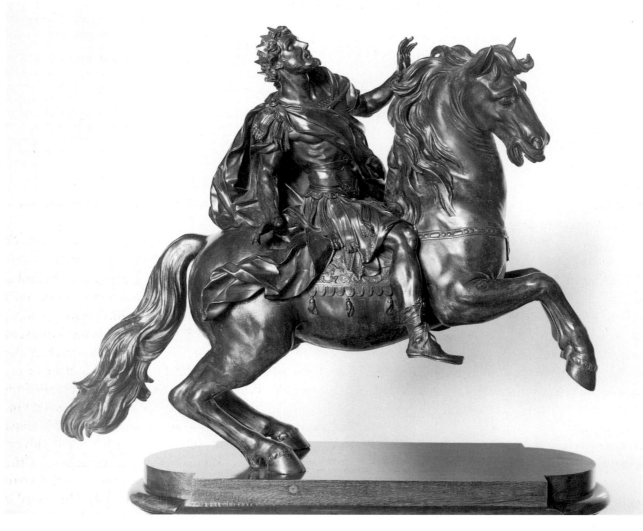

fig.16: Gianlorenzo Bernini, Bronze reduction of the *Equestrian Statue of Constantine*, Ashmolean Museum, Oxford

arena the church of Saint Peter's where on the rocks of both architecture and sculpture he has always been ship-wrecked'. Such vitriol coincided with publically expressed concern over the cost of his works. In the same year, the municipal authorities in the city reportedly drew up a resolution complaining to the Pope about the inordinate expense of Bernini's commissions,[27] a criticism that was not unfounded, in view of the startling fact that a chapel by Bernini could cost more than an entire church by Borromini.[28]

The sculptor retained his position in spite of these attacks, but they heralded the very chilly critical environment which was in place by the time Domenico published his laudatory account of his father's life in 1713.

Even a brief survey such as this shows that Bernini had an unerring ability to prompt extremes of admiration or condemnation in those around him. For Bellori and Perrault, he was either unworthy of serious attention or damnable, while for Baldinucci and Domenico Bernini he soared above all his contemporaries. The 'lives' of Bernini have therefore not just proved valuable for elucidating the shape of his career and opinions, but have become weapons in the enduring battle over his reputation. And because he had such a profound influence on *seicento* Rome, imprinting his ebullient and complex personality on the fabric of the city, that battle has proved a significant means of moulding our changing perception of a whole era in its history.

DAVID HOWARTH

Bernini and Britain

The first recorded British response to Bernini occured in the summer of 1635, in connection with the commissioning, by Queen Henrietta Maria, of the bust of Charles I, lost in the fire which destroyed Whitehall Palace in 1698.[1] The interest Charles I took in the project was matched by the Barberini family whose head, Maffeo, had been elected Pope as Urban VIII in 1623. Urban VIII had a close personal interest in the British royal family since Henrietta Maria was his god-daughter. For his part, Charles was keen to enjoy the *kudos* of having his likeness made by the most famous living Italian sculptor, who had begun to stamp his personality on Rome more decisively than anyone since the Emperor Augustus.

The earliest reference to the bust occurs in a letter of 13 June 1635 when Gregorio Panzani, the special papal envoy to Henrietta Maria, reported that 'the king is extremely satisfied about the papal permission given to Bernini to execute the bust'.[2] The bust itself (see cat. no.26) was rapturously received at Oatlands Palace outside London by both Charles I and Henrietta Maria on the night of 27 July 1637. Within a year Henrietta Maria had commissioned Van Dyck to prepare her portrait so that it too could act as a model for her bust, which was also to have been by Bernini. In fact, three separate portraits of her were painted for this purpose – of which fig.18 shows one – unlike the single canvas showing *Charles I in Three Positions* (fig.17). Civil War unfortunately intervened, and it never materialised. Had the commission been accomplished, the pair would have been unique as the only example of a living husband and wife sculpted by Bernini. Although Henrietta Maria was denied her bust, she had the consolation of possessing one piece by Bernini which was peculiarly her own, for there was a reliquary of St Helena designed by him in her private chapel at Denmark (later Somerset) House. Sadly, no visual record of it appears to have survived, and it was

presumably destroyed by the Puritans when they ransacked the chapel.[3]

Something can be learned of the motives of both Bernini and Urban VIII in connection with this, the sculptor's first likeness of a European monarch. Nicholas Stone was the most talented English sculptor of Bernini's generation, and he was markedly ambitious for his sons, who were also sculptors. His son Nicholas had been sent to Italy and was taken on as a studio assistant in the Bernini workshop. Nicholas the Younger's diary of his years in Italy records that in October 1638 he called on Bernini who, though apparently ill in bed, received him warmly and immediately asked what was said of his bust in England. Stone told Bernini that it had been universally admired, 'nott only for the exquisitenesse of the worke but the likenesse and nere resemblance itt had to the King countenannce'.[4] Bernini then asked how well it had travelled and how it was displayed, and told Stone that he had taken as much trouble over the packing as he had over the carving.

Charles I may have instructed Thomas Baker (1606–1658) to take Van Dyck's portrait of *Charles I in Three Positions* to Bernini in Rome, to serve as the model for his bust.[5] In 1638 Baker pulled off the remarkable feat of persuading Bernini to carve his own bust (fig.19, cat.no.27) by offering so much money Bernini could not refuse. Although the critical reception of the Baker bust has been mixed, it was certainly admired by the portrait painter Sir Peter Lely, in whose collection it is recorded after the Restoration. Urban VIII was irritated when he heard about the Baker commission because he feared that if knowledge of it reached the English court, Henrietta Maria would be upset. Only after much importuning through her representative George Con had Henrietta Maria persuaded the Vatican to grant Bernini license to carve her husband's bust. Now, impertinently, this 'supercilious

dandy' threatened to upset a carefully constructed web of mutual compliments.

The diarist John Evelyn was a passionate royalist and inveterate recorder of great works of art. After coming down from Oxford, he avoided the Civil War by travelling in Europe during the 1640s, and what he has to tell us of Rome between November 1644 and May 1645 represents the most detailed response we have of any Englishman to the multitude of works by Bernini in the city.

Evelyn's *Diary* is decidely starched compared to Pepys's and so it comes as something of a relief to encounter in it an indecent story connected with Bernini:

'At the very upmost end of the Cathedral are divers stately monuments, especialy that of Urban the VIIIth, amongst all which there is one observable for two naked incumbent figures of an old, and a young woman, upon which last, there now lies a covering, or apern of brasse, to cover those parts, which it seems occasioned a pigmalian Spanyard to be found in a lascivious posture, so rarely to the life was this warme figure don.'[6]

Astonishingly, Evelyn seems to have seen every publicly accessible work by Bernini. What appealed to him most was the great Borghese holding of early Berninis. These had a very special place in his heart, as is clear from a poem Evelyn wrote when, or so he tells us, turning his horse, he looked back on Rome for the last time on 18 May 1645:

'Chast Daphne's limbs into the Laurel shoote,
Whilst her swift feete the amorous Center roote;
How the rude bark invades her virgin Snow
And dos to that well timber'd body grow!'[7]

There is no mention in the *Diary* of the bust of Charles I. Although it survived for only another sixty years, both the memory of the marble and its source, the Van Dyck *Charles I in Three Positions*, achieved immortality as poignant reminders of the King's sufferings. For Tories of the nineteenth century, the remote record of the original Bernini became something of an icon. In the light of the cult status of the lost bust, it is interesting that the cast in the exhibition is framed by wings like a cherub's head (cat.no.26). Needless to say, these had not featured in the original. By making the head 'air-borne' in this way, the votary, whoever he was, has transformed a portrait *tout simple*, into an apotheosis, if not an ascension. This is wish fulfilment by one who may have been recalling the King's last words: 'I go from a corruptible to an incorruptible crown, where there will be no more trouble'.[8]

Isaac Disraeli, *littérateur* and father of the Prime Minister, summoned up the ghost of things past when he

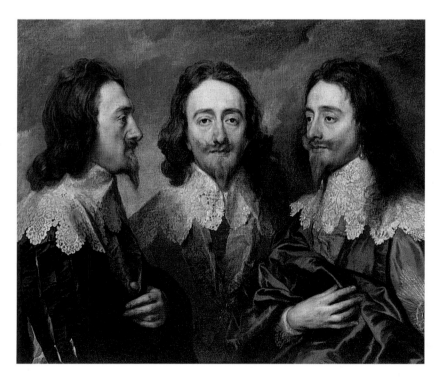 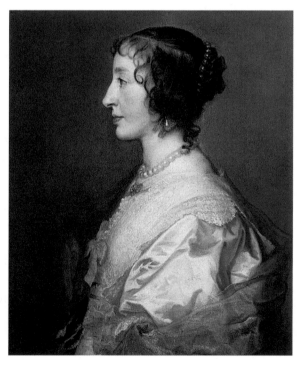

left fig.17: Sir Anthony van Dyck, *Charles I in Three Positions*, Royal Collection, Windsor Castle
right fig.18: Sir Anthony van Dyck, *Queen Henrietta Maria*, Royal Collection, Windsor Castle

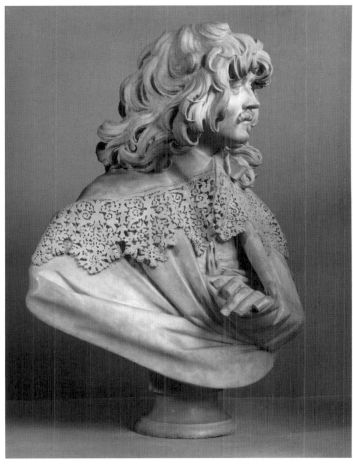

fig.19: Gianlorenzo Bernini, profile view of the *Bust of Thomas Baker*, Victoria and Albert Museum, London.

wrote, with no apparent foundation in fact, of Bernini's reaction to the Van Dyck triple portrait as it was unveiled in his studio:

'he [Bernini] exclaimed that he had never seen a portrait whose countenance showed so much greatness and such marks of sadness: the man who was so strongly charactered and whose dejection was so visible was doomed to be unfortunate.'[9]

Thus did romantically-inclined Englishmen credit Bernini with setting Charles I on that *Via Dolorosa* which led to his martyrdom on the scaffold in 1649. However, there were two major late seventeenth-century artists working in Britain whose admiration for Bernini had nothing to do with a cult of martyrdom or the affectations of Romanticism.

George Vertue, the first historian of art in Britain, recorded in one of his notebooks how Sir Godfrey Kneller, dissatisfied with Rembrandt as a teacher, went south to seek out Bernini with whom he 'was much in esteem'.[10]

This cannot be taken at face value, although Kneller may have encountered Bernini in extreme old age. In Kneller's paintings there are certainly an intriguing number of references to free-standing sculpture and fountains by Bernini, of which the most substantive is the portrait of the sculptor Grinling Gibbons (St Petersburg, Hermitage Museum). Gibbons grasps an upturned cast of the head of Proserpina from Bernini's group of *Pluto and Proserpina* (see cat.no.40), while spanning the cast with a pair of dividers. This has been interpreted as an allegory of reason (the dividers), taking the measure of the sensual (Proserpina), to suggest man's need to control his baser instincts.[11]

Georgian grand tourists, and by then artists too, seem to have found Bernini's sculpture difficult, if not impossible. Settled prejudice against the excesses of the Counter-Reformation, with which Bernini was so closely identified, partly accounts for the lack of either a sustained or a favourable response to Bernini during the eighteenth century. Although in 1822 George IV was persuaded to buy the Van Dyck triple portrait which had been brought to England from the Palazzo Barberini in 1802, for the most part the Hanoverians saw Rome as a nest of seditious intrigue. During the course of the eighteenth century, the last of the Stuarts had had their tombs parked alongside Bernini's most exuberant funerary monuments in St Peter's and this had served to reinforce the conviction that the sculptor had served too well an institution which had certainly represented a threat to the Glorious Revolution of 1688. The extent to which Rome was divided into hostile camps after the Battle of the Boyne and James II's precipitate flight to the Continent is indicated by George Berkeley, son of the celebrated philosopher, William. George noted in 1718 how Jacobite and Hanoverian grand tourists frequented different coffee-houses while staying in the city.[12] Sectarian divisions made for difficulties, then, in seeing Bernini objectively. Indeed it was not until the twentieth century, when the monarchy had lost much of its power and religion had become largely a matter of indifference, that Bernini's true greatness first began to be appreciated in Britain. This shift in taste was above all the achievement of the great German art historian Rudolf Wittkower, whose catalogue raisonné of Bernini's drawings (with Heinrich Brauer) paved the way for what remains the standard monograph on the sculpture. The first appreciative essay in English on Bernini was by Lord Balcarres, whose book *The Evolution of Italian*

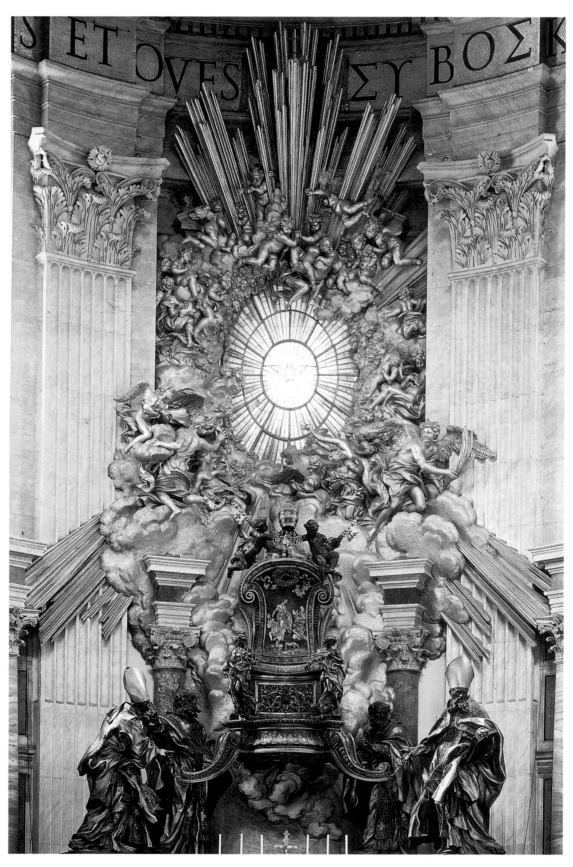

fig.20: Gianlorenzo Bernini, *The Cathedra Petri*, St Peter's, Rome

Sculpture (1909), is noteworthy for its exceptional breadth. Although when confronted with the 'excesses' of Bernini Balcarres shared something of that predictable British reserve about the sculptor, the book is nevertheless remarkable because Bernini is accorded a central place for the first time in art criticism written in English. Balcarres wrote:

'Bernini had carried plastic brilliance to its utmost limit.; ... he could render in marble what Donatello would not have dared to attempt in terracotta, while enlarging the whole sphere of sculpture as a vehicle for the artistic interpretation of emotions ... Bernini was supreme in Europe...'.[13]

Two hundred years before Balcarres published his appreciation of the power, if not the purity, of Bernini, preconceptions of an earlier generation effectively made tourists turn their backs on his sculptures. Bernini's aesthetic had become profoundly unfashionable within eighty years of the sculptor's death.

James Byres, 'a Scotch lad studiant in painting', became the leading British *cicerone* in mid eighteenth-century Rome, despite what English clients regarded as his unfortunate habit of addressing them in 'the Ayberdeen Deealact'. Despite Byres's unrivalled knowledge of all that Italy had to offer, he positively shunned Bernini, describing his figures as 'monstrously charactered'.[14] Whilst Byres was conducting Edmund Gibbon around the sites of Rome in 1764, the Glaswegian-born novelist Tobias Smollett was entering St Peter's. He recorded his estimation of Bernini's *Cathedra Petri* (fig. 20) as 'a heap of puerile finery, better adapted to an Indian Pagod, than to a temple built upon the principles of Greek architecture'.[15]

However, attitudes towards Bernini were beginning to change. In 1785, Thomas Jenkins, the most successful and unscrupulous of all the resident British dealers in Rome during the eighteenth century, acquired the sculpture (mainly antiquities) from the Villa Montalto-Negroni, including Bernini's *Neptune and Triton* (fig.14 and cat.nc. 41), which passed from Jenkins to Charles Townley and then to Sir Joshua Reynolds.[16] Eventually Sir Joshua's executors sold it to the sculptor Nollekens. Nollekens was taking a decided risk since he made the purchase on behalf of Lord Yarborough without actually informing his client. Doubtless, however, Nollekens's claim that the *Neptune and Triton* was 'the finest piece of modern sculpture existing' prevailed, for the group next appeared in the Octagon at Yarborough's house in Chelsea.[17]

As President, Reynolds was required to lecture to the students of the Royal Academy. He would range over the history of art with remarkably catholic and generous taste, though what he had to say about Bernini represented a distinctly cautionary tale. Nevertheless, Reynolds did acknowledge, if only implicitly, the seductive powers of a sculptor whose influence upon impressionable minds he regarded as potentially subversive. Although Reynolds appears to have been overly critical, he has the distinction of being the first English writer to acknowledge the artist as a figure of real significance.

Reynolds first refers to Bernini in his *Fourth Discourse* of December 1771. where he deplored the 'mean expression' in the early *David*, which the sculptor had completed for Cardinal Scipione Borghese in early 1624 (see cat.no.42). Bernini had hit upon the novelty of making David bite his lower lip at the moment of incredible tension when discharging the stone from his sling. This was too much for poor Reynolds who told his audience: 'This

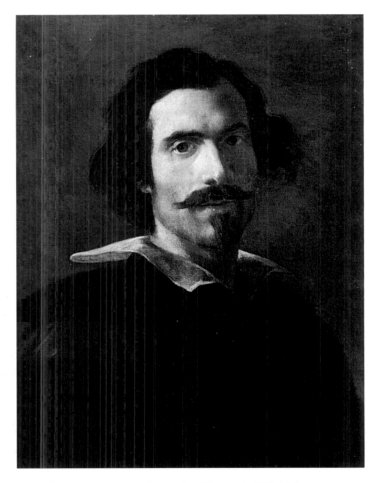

fig.21: Gianlorenzo Bernini, *Self-portrait*, Uffizi, Florence

expression is far from being general, and still further from being dignified'.[18]

Nine years later Reynolds again cautiously crept up to a Bernini in the form of a cast of the head of Neptune from the *Neptune and Triton*. If the 'meaness' of David had worried him in 1771, by 1780, in the *Tenth Discourse* specifically dedicated to sculpture, it was the deplorable way in which Bernini had tousled the hair which prompted Reynolds to talk about the:

'mischief produced by this attempt of representing the effects of the wind. The locks of hair are flying abroad in all directions, insomuch as that it is not a superficial view that can discover what the object is which is represented, or distinguish those flying locks from the features, as they are all of the same colour, of equal solidity, and consequently project with equal force. The same entangled confusion which is here occasioned by the hair, is produced by drapery flying off; which the eye must, for the same reason, inevitably mingle and confound with the principal parts of the figure.'[19]

These comments represent the most extensive criticism of Bernini published in Britain up to that time. Yet they betray a flaw in the appreciation of the sculptor which extends to the very core of the marble. What Reynolds says is antipathetic to all that Bernini stood for. Before leaving the seductive effects of the *Neptune and Triton* for the more assured graces of the *Apollo Belvedere*, Reynolds declared that a work of art must be seen 'without any ambiguity, at the first glance of the eye'. If this apothegm opened the eyes of students to Neoclassicism, assuredly it closed them to such Bernini masterpieces as the Raimondi Chapel in San Pietro in Montorio (*c.*1640–47), the *Ecstasy of St Teresa* (fig.6), and the *Blessed Ludovica Albertoni* (fig.2), in all of which gradual perception is intergral to the process of appreciation.

Bernini then, was too 'Catholic' for Protestants in Rome and too dangerous for students in London. Nevertheless, British sculptors had been influenced by him. John Bushnell was one. Bushnell was a Restoration sculptor who worked in Venice in the 1660s on the *Tomb of Alvise Mocenigo*, where such features as the deep undercutting of the drapery suggests that he had certainly studied the *St Longinus* from the quartet of statues Bernini had organised for the crossing of St Peter's.[20] But there was a more intimate connection.[21] Bushnell carved two statues of *Charles I* and *Charles II*, which were installed in 1673 on the Cornhill façade of the second Royal Exchange in the

City of London. The lost Bernini bust was the model for the head of the Royal Exchange *Charles I*. But then what of the drapery? It too is deeply cut, and it flows and sways with all the emotion of Bernini's four Doctors of the Church, which flank the symbolic papal throne in the *Cathedra Petri* (fig.20) – the same monument, finished in 1669, to which Smollett would later take such exception.

The great bust of Sir Christopher Wren, carved by Edward Peirce in 1673 as a present for Oxford University, is an authentically baroque image which has no precursor in English sculpture. It has been suggested that its style may have been dictated by Wren, who had certainly seen the bust of Louis XIV (1665) at an early stage of the carving, since he had been in France at the same time as Bernini, and had met him.[22] In the 1680s the Danish sculptor Caius Gabriel Cibber, made a statue of Charles II for Soho Square in London, where the figure of the king was surrounded by personifications of the four chief rivers of England. Described as 'old fathers with long wett beards', the execution of the Thames, Humber, Tyne and Severn may have left much to be desired, but the idea was an ambitious one which derived from Bernini's *Four Rivers Fountain* (fig.22). Twenty years later, Bernini's sentiments had penetrated remote valleys of the Scottish Borders to inspire Scotland's finest baroque funerary monument. John Nost's exuberant tomb for the Duke of

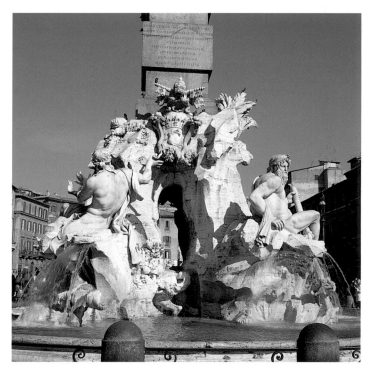

fig.22: Gianlorenzo Bernini, *Four Rivers Fountain*, Piazza Navona, Rome

Queensberry, 1711, (fig.23) at Durisdeer in Dumfries and Galloway, has putti whose marble tears are pure Bernini. Six years earlier, Francis Bird (1667–1731), who incidentally owned a cast of the face of Charles I taken from Bernini's original, had been inspired by the levitation of St Teresa for his half-length figure of Sir Orlando Gee (Isleworth Parish Church, West London, 1705). Gee emerges from his pulpit, animated features enhanced by the great play Bird has made with hands, scroll and periwig. These features are all deeply cut, to emulate that abiding paradox central to Bernini's vision which was his marriage of vitality and death. Whoever carved the *Monument to William Hewer* (d. 1715) in St Paul's, Clapham, London – and it may have been Bird too – used Bernini's *Monument to the Blessed Maria Raggi* (1643) as his matrix.[23]

Louis François Roubiliac (1702–62), arguably the most talented sculptor ever to work in Britain, had had a master who had been a pupil of Bernini, though Roubiliac himself was not to see Bernini's work until he travelled to Rome in 1752, twenty-two years after he had moved from his native Lyon to London. Roubiliac's encounter with Bernini, though late, was far from cursory. Returning from Rome, Roubiliac bumped into Reynolds in Switzerland and, according to Reynolds, was at one and the same time, both rhapsodic and despondent. He talked animatedly of 'the captivating and luxuriant splendour of Bernini', whilst exclaiming 'By God my own work looked to me meagre and starved [compared to Bernini's], as if made of nothing but tobacco pipes'.[24]

Roubiliac's great monument to the Duchess of Montagu (St Mary's, Warkton, Northamptonshire, 1754) is, in its lay-out, indebted to Bernini's *Tomb of the Contessa Matilda* (St Peter's, 1634–7). Seven years later, when embarking on his daunting monument to *Joseph and Lady Elizabeth Nightingale*, 1761 (fig.24), Roubiliac again turned to Bernini for inspiration, this time to his *Tomb of Alexander VII* (St Peter's, 1671–8). But whereas Death hovers near Alexander VII who, unaware, quietly prays, Roubiliac's Death comes from out of the vault to point his spear at Nightingale supporting the corpse of his wife. Capturing a boldness Bernini missed, Roubiliac has denied his couple that steadfast consolation of faith by which, for Bernini, religion overcomes death. What is a triumph for Bernini is a terror for Roubiliac. Roubiliac's dialogue with Bernini extended predictably enough to his portrait of *Charles I* (London, Wallace Collection), which may well have been based on a cast of

Bernini's original which belonged to George Vertue.

Four years after the Nightingale monument, Bernini's reputation was affected for a generation at least by the appearance in Britain of Johann Joachim Winckelmann's treatise on ancient art, translated by the painter Henry Fuseli as *Reflections on the Painting and Sculpture of the Greeks* (1765).

The great neoclassical sculptor John Flaxman delivered a series of lectures to students of the Royal Academy from 1810. In his tenth lecture, Flaxman declared:

'Even Bernini, whose reputation was so great in his time, can be praised only for his Apollo and Daphne, and for the ease and nature of his portraits. His larger works are remarkable for presuming airs, affected grace, and unmeaning flutter.'[25]

But, as appears to have been the case with Reynolds too, Flaxman seems to have said one thing in public only to have felt something quite different in private. When he had travelled in Italy (1787–94), he had made a series of very beautiful drawings of Bernini's tombs in St Peter's. In these he had shown his appreciation of how Bernini, to use Flaxman's own words, was intent 'to represent such aerial affects, as break down the boundaries of painting and sculpture and confound the two arts'. Flaxman had chosen soft chalk to simulate the effect of light on the Bernini tombs.[26] Perhaps, though, it was not a case of two Flaxmans, public and private, but just the abandonment of an early enthusiasm. What is more certain, however, is that Flaxman came to refer in public to Bernini's 'unmeaning flutter' because of Bernini's close identity with what was thought still to be an abhorrent religious system.

Something of a revival in the fortunes of Bernini's artistic reputation occurred when the sculptor Sir Richard Westmacott addressed the subject of post-Renaissance sculpture in his influential, *Handbook of Sculpture, Ancient and Modern*, published in Edinburgh in 1864. Much of what Westmacott had to say has a familiar ring. We are confronted with that sort of schizophrenia about Bernini which had prevailed in Britain for close on a century. Westmacott robustly informed his audience:

'That he [Bernini] was an artist of unquestionable genius cannot be denied, yet no one probably did more to precipitate the fall of sculpture than Bernini'.

Yet Westmacott then went on to praise the *Apollo and Daphne*; indeed, he actually illustrated the group, which

nobody had done before. More startling still was Westmacott's praise for 'The Extacy of Sta. Teresa', which hitherto had constituted decidely strong meat for English tastes. After complaining about how difficult it was 'to discover the principal figure', Westmacott was prepared to concede that there were 'some passages of great beauty'. Nevertheless, the fact remained that Bernini had actually 'ruined the art he professed'.[27]

John Ruskin was the first British art critic to reach a mass audience, and his passions and prejudices did more to create a national taste than any English writer before or since. But when it came to Bernini, Ruskin simply went into a state of denial. There are just two passing references to him in the entire twenty-four volumes of Ruskin's collected writings – both exclusively to his architecture.

Flaxman's private admiration for Bernini's painterly effects alerts us to the existence in Britain since the eighteenth century of a number of Bernini's drawings. The *Design for the Tomb Slab of Cardinal Carlo Emanuele Pio da Carpi* (cat.no.113) is one of a sizeable group of Italian baroque drawings acquired precociously, before he was twenty, by Thomas Coke, 1st Earl of Leicester (1697–1759), who was in Italy from 1714–18. More remarkable still was the corpus of *seicento* drawings acquired for George III by the Scotsman James Adam in 1762. Among them were over a hundred sheets then ascribed to Bernini, of which nearly half are now accepted as autograph works.

Bernini has received a begrudging, confused response in Britain, and perhaps this is the place to suggest why. The key surely lies in that preference for the *Apollo and Daphne* which we have noted. Of all Bernini's works, this is the one which most nearly approximates to a neoclassical aesthetic. The English, and perhaps the British at large, have had a temperamental preference for reticence and the suppression of emotion – states of being wholly alien to Bernini, the greatest of all baroque sculptors. Jonathan Richardson, so variously gifted in the arts as in literature, writing at a time when Bernini's stock was at its lowest, claimed that his countrymen had a special relationship with the classical world. Although Richardson was not thinking of Bernini, perhaps we should when we read:

'No nation under Heaven so nearly resembles the ancient Greeks and Romans as we. There is a haughty carriage, an elevation of thought, a greatness of taste, a love of liberty, a simplicity, and honesty among us, which we inherit from our ancestors, and which belongs to us as Englishmen'.[28]

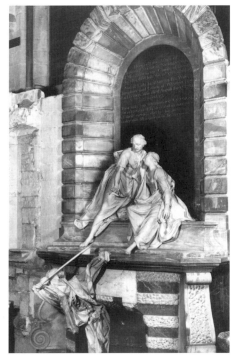

left fig.23: John Nost, *The Queensberry Monument*, Durisdeer, Dumfriesshire
right fig.24: Louis François Roubiliac, *Monument to Joseph and Lady Elizabeth Nightingale*, Westminster Abbey, London

TIMOTHY CLIFFORD

Roman Decorative Arts in the Age of Bernini

The sharply compartmentalised division between the fine and applied arts which is so apparent today would have been little understood by Bernini and his contemporaries, for baroque artists were concerned with unity. A work of art was still a work of art, whether you knelt before it in pious devotion, wore it, or were driven in it pulled by four white horses. That special talent for *disegno* required of an artist meant that he should be capable of painting altarpieces, planning and erecting buildings, carving marble sculptures, and designing coins and medals, pageant costumes, and even elaborate firework displays. The concept of the universal man enjoyed a revival during the Baroque, and such diverse talents were admired – indeed expected – of the greatest artificers. This was true not only of Italy; Rubens and Charles Lebrun were perhaps the most industrious multi-talented artists north of the Alps, but one must not overlook British *virtuosi* like Inigo Jones and Christopher Wren. As one scholar has recently observed: 'In any discussion of the sculptor as designer, it is important to remember that the leading figures in the profession devoted a great deal of their time to the design of minor, even minimal, objects.'[1]

A century earlier in Italy, Michelangelo had excelled as sculptor, painter, and architect, and it was to his example as the supreme artist that Bernini aspired. He was certainly considered by his contemporaries as a sort of 'Michelangelo reborn', which makes the eclipse of his reputation in the eighteenth and nineteenth centuries all the more difficult to understand. It is as 'Michelagnolo restituito' that Bernini is introduced in Filippo Baldinucci's biography of the artist, written just after Bernini's death and dedicated to Queen Christina of Sweden.[2] Baldinucci even repeats the prophetic remark of Cardinal Maffeo Barberini, later Pope Urban VIII, about the youthful Bernini: *Speriamo, che questo giovaretto debba*

diventare il gran Michelagnolo del suo secolo. ('Let us hope that this young man becomes the great Michelangelo of his century').[3]

This widespread recognition of Bernini's genius was commemorated in old age by the beautiful portrait medal of him commissioned by Louis XIV from Chéron (cat no.6), with a group of allegorical maidens on the reverse representative of Painting, Sculpture, Architecture, and Mathematics, and around them the motto: *Singularis in singulis, in omnibus unicus* ('Remarkable in his singularity, in everything unique'). Even allowing for the Tuscan prejudice of Filippo Baldinucci, who saw Bernini as Michelangelo's artistic heir, the fact of Bernini's pre-eminent position in seventeenth-century Italy, and especially in Rome, is undeniable. It was this fame that encouraged Louis XIV to call the artist to Paris in 1665 to design the new Louvre. He was only there for five months, but during that time, in addition to his work on the Louvre, he designed a library for the King and a theatre at the Tuileries, advised on the cascade at St Cloud, carved the great marble bust of the King (with an elaborate gilt-bronze and enamel allegorical base), made a number of presentation drawings of religious subjects, and designed a new altar for the Val-de-Grâce, a staircase for the Hôtel d'Aumont, a tomb for Richelieu, and a frame for his son Paolo Bernini's marble sculpture of *The Christ Child Playing with a Nail from the Cross*.[4]

This exhibition and publication cannot hope to provide anything but a limited reflection of Bernini's achievement, for it is to Rome that the admirer must go, where the marble and bronze funeral monuments, the colonnades, fountains, obelisks, churches, and chapels crowd in upon the pilgrim, testifying to one man's contribution to changing the appearance and apparatus of the Eternal City. God was in the details, and Bernini left nothing to chance. His son Domenico wrote of his father:

'In every work, of whatever kind, that he was asked to do, no matter now small it was, he would devote to it all his application, and in its own way a design for a lamp would receive as much study as a noble building, because he held that in their perfection all arts are equal, and that whoever could achieve beauty in a little object, would achieve equal beauty in a major or large undertaking.'[5]

Many of Bernini's drawings survive, and he is particularly well represented in British print rooms, but many more of his coarser notational chalk studies, like those in Leipzig and Düsseldorf, must once have existed. He must also have made a very large number of *bozzetti* in wax or clay, the majority of which are now lost.[6] Nor do any of his catafalques, festival floats, and items associated with banquets or made of precious metals survive. Enough is now known about Bernini's complex studio practice for us to acknowledge that, despite the survival of a large body of accounts, letters, and drawings, we can seldom name or recognise the individual hands that made the finished drawings or carved the marble details, or cast and gilded the metalwork. This testifies to the success of Bernini's rigorous training methods and the tight control he maintained within the workshop. Frequently it is difficult, if not impossible, to distinguish where his autograph involvement takes over from that of his assistants.

Items designed and modelled by Bernini were often made outside his workshop. A crucifix, for instance, was commissioned from Bernini for St Peter's, for which he had an ivory pedestal with precious stones made by the goldsmith Marco Chiavacci, whom he paid on 20 March 1628.[7] A reliquary of St Helena, of gold and silver set with rubies, was ordered in 1636 by Cardinal Francesco Barberini for Queen Henrietta Maria of England from the goldsmith Francesco Spagna (1602–42), to the design of Bernini.[8] A massive silver bowl made by Francesco Perone in 1643 for Cardinal Antonio Barberini followed a Bernini design.[9] A magnificent silver-gilt cradle encrusted with jewels and with an embroidered satin coverlet was designed by Bernini and presented in May 1653 by Olimpia Maidalchini to her daughter-in-law, the Princess of Rossano; it was estimated to be worth about four thousand *scudi*.[10] We also know that a silver altar frontal executed to Bernini's design, with *The Assumption of the Virgin Mary*, was made for Reggio Cathedral, and that there was a silver bust of *St Eustace* for the Church of Sant' Eustachio in Rome.[11] Sadly, none of these precious objects has survived.

In 1640 Bernini was designing frames for the Barberini, and again in 1665 a frame was given to the Queen of France.[12] Documents also show that he supplied a model for six fire-dogs, each with a metal mask, for Cardinal Flavio Chigi; commissioned in 1678, they were completed by 30 August 1680.[13] He was also in demand for catafalques for the exequies of Pope Paul V, Carlo Barberini, Muzio Mattei, and the Duc de Beaufort (see cat.nos.128, 132–3). In 1639 he designed a float with a representation of the Santa Casa di Loreto, and he made another, carved with allegorical figures, for Prince Agostino Chigi in 1658.[14] Bernini's designs for ephemeral decorations, masque designs, firework displays, 'Forty hours devotions', and festival arches do not really fall within the remit of this essay, but they were numerous, and should not be overlooked in any assessment of his multi-faceted talents.

When Queen Christina of Sweden, after her abdication, entered Rome in 1655, Pope Alexander VII Chigi presented her with a coach, a litter, a sedan chair, and a harness for mules and horses. The elaborately-carved coach had been designed by Bernini, and he was present when the Queen came to look at it in the Belvedere Garden. With feigned modesty, Bernini told her that 'if anything is bad, that is my work', to which Queen Christina replied 'then none of it is yours'. In fact, this was not far from the truth, for it has been pointed out that 'the drawings had been prepared by Giovanni Paolo Schor, the models made by Ercole Ferrata, and the execution carried out by a host of workmen'.[15]

Bernini became a close friend of Alexander VII, whom he met, as we know from the Pope's diary, on a very regular basis.[16] It is this diary that provides an excellent primary source for our knowledge of Bernini's involvement in a myriad of artistic schemes, with the topics that they discussed ranging from medal designs and the *Cathedra Petri* to the great Colonnade of St Peter's. As Bernini's responsibilities increased, so he became rather less involved in the finer detail of some of the applied art commissions. A key assistant to whom he delegated such tasks was Giovanni Paolo Schor, called 'Tedesco' (1614–74), who in turn was imitated by Giovanni Battista Lenardi (1656–1704), a competent but dry draughtsman who, having little artistic personality of his own, pasticed, as required, the artistic ideas of Schor, Ciro Ferri (1634–89) and Giovanni Francesco Romanelli (c.1610–62).

Paul Fréart de Chantelou, the French courtier who was chosen by Louis XIV to attend to Bernini during his visit to France in 1665, wrote in his *Diary* on 10 October 1665:

'After dinner, while we were warming ourselves before the fire, the Abbé Buti and the Cavaliere [i.e. Bernini] went back to the subject of Giovanni Paolo Tedesco; how he was just the man who could be most useful here as he had an inexhaustible fund of invention that he could apply to anything. "Do you want a coach?", he would say, and straightaway design one, "or a chair or some silverwork …?". [17]

Bernini was recommending Schor, in particular, because the great sculptor may have become wearied by the courtiers in France repeatedly requesting favours of him to design a multitude of fripperies, including even lace, and Bernini considered Tedesco the perfect man for these jobs. Both Bernini and Schor did occasionally design textiles, as drawings traditionally ascribed to both of them in the Gabinetto Nazionale delle Stampe, Rome, demonstrate. For example, a design for a rich silk stole worked with the Chigi-Della Rovere *imprese* of Pope Alexander VII corresponds to a bill in the state archives of 14 July 1655, described as 'con disegno del Sig. Cav.r Bernini'. [18]

Bernini very probably designed a spectacular painted and giltwood stand for his marble statue of *St Lawrence on the Gridiron*, now in the Contini Bonacossi Collection in Florence. [19] The stand consists of a writhing tree-trunk issuing from a rocky mound, to which are attached burning faggots. We know he also designed an elaborate organ-case for Sta Maria del Popolo to the commission of Alexander VII (fig.25). The case, bracketed high on the wall, has the pipes elegantly entwined with the branches of the Chigi-Della Rovere oak. [20] In a bill for work carried out in the Vatican Palace by the German carver Antonio Chiccari (Kicker), there is an item recording the carving of the stairs to the Cappella Segreta with roses and lilies entwined according to the design of the Cavaliere (*conforme il disegno del Cavalliere*). The bill, counter-signed by Bernini, is dated 30 September 1656. [21] We also know that Bernini designed and modelled the gilt metal finials at the corners of the roof of his own carriage (see cat.no.44), and a chair for ex-Queen Christina of Sweden, made for her when she feasted with Pope Alexander VII. [22]

The most spectacular item that Bernini designed for the Queen was a stupendous looking-glass, for which an autograph drawing survives at Windsor (cat.no.150). It showed *Time Drawing Back a Curtain to Reveal Truth*, a

theme which recalls Bernini's own monumental marble sculpture of the same subject, of which only Truth was carved. We know the looking-glass was executed, because the Swedish Count Nicodemus Tessin the Younger saw it in her palace. [23] In Bernini's day the technology was not available to produce large sheets of mirror-glass, so he designed this *tour de force* with the draperies masking the joints in the glass. With its reminder of passing time, such a looking-glass would hardly – it might seem – have been a tactful or flattering embellishment for the Queen; in spite of apparently being an enthusiastic lover, she was graced with a distinctly large nose and was no beauty. If, however, we recall that Queen Christina's emblem was the sun, and that the sun is the emblem of Truth, the conceit becomes intelligible and appropriate. In its final form the looking-glass stood on a base supported by tritons, but sadly none of this has come down to us.

Alexander VII, the Queen's friend and protector, was

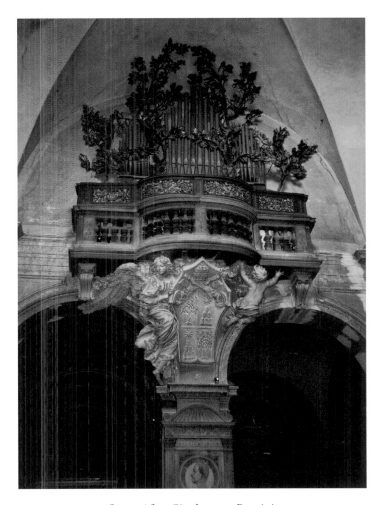

fig.25 After Gianlorenzo Bernini,
Organ-case, Santa Maria del Popolo, Rome

left fig.26: Studio of Gianlorenzo Bernini, *Design for a Candlestick,*
Windsor Castle, Royal Library

right fig.27: Gianlorenzo Bernini, *Candlestick,*
Chigi Chapel, Santa Maria del Popolo, Rome

as a draughtsman and mason. Borromini's contribution to the re-design of Rome should not be underestimated, with familiar triumphs like the little church of San Carlo alle Quattro Fontane, the cupola and campanile of Sant' Andrea delle Fratte, the university church of Sant'Ivo della Sapienza (see cat.no.87), and the Oratory of San Filippo Neri (see cat.no.81). In his *Opus Architectonicum* he described in detail the furniture that he designed for the Chiesa Nuova.[25] His buildings were quirky and stylishly brilliant, while Borromini himself was notoriously ill-tempered and difficult and suffered fits of hypochondria and depression. Although as a younger man he had collaborated successfully with Bernini on the *Baldacchino* in St Peter's (see cat.nos.58–60), he later became insanely and irrationally jealous of him. During a bout of depression in 1667, he took his life by impaling himself on his sword. He had many architectural competitors apart from Bernini, like Carlo Rainaldi (1611–91) and Carlo Fontana (1641–1714), both of whom sometimes turned their talents to designing chimney-pieces, tables, fonts, candelabra, and the more ponderous architectural items of furniture. Many of Fontana's drawings for the *arti minori* works are in the Royal Library at Windsor.[26]

We still know very little about who was responsible for the sumptuous and sculptural parade furniture that is such a familiar feature of the Roman baroque interior. There survives a great series of monumental tables (*tavoli da muro*) in the Galleria Colonna, with rich marble slabs supported by Moorish slaves sheltering among massive and luxuriant scrolls. Others, in private Roman collections, incorporate addorsed sphinxes or bearded tritons gambolling with putti.[27] They all, however, depend more or less on Bernini's example.

Even the painter Domenichino (1581–1641), in many respects so conservative, was widely admired as a designer – whether for the nave of Sant'Ignazio or the façade of Sant'Andrea della Valle. He appears to have designed the bronze candlesticks in Santo Spirito in Sassia, the stucco decoration of Santa Maria in Trastevere, a series of wall monuments, notably that for Cardinal Girolamo Agucchi in San Giacomo Maggiore in Bologna, and a throne chair, probably also for Cardinal Agucchi.[28]

Far more interesting and significant were the designs for applied art objects made by the painter and architect Pietro da Cortona (1596–1669), and his accomplished pupil, Ciro Ferri (1634–89). If Cortona had never painted a fresco cycle, an altarpiece, or a portrait, his reputation

constantly calling upon Bernini for designs. A large series of handsome candlesticks – plain, profile moulded, with their bases embellished with Chigi *imprese* – were devised by Bernini for St Peter's around 1657, and a fine Bernini workshop drawing for one of them survives at Windsor (figs.26–7). The model was also re-used for the Chigi Chapel in Santa Maria del Popolo. The Pope then commissioned Bernini to supply him with a bronze lamp for this chapel, which consists of three flying putti supporting the Virgin's crown, surmounted by Chigi stars. From payments, we know that it was modelled by the Flemish sculptor Peter Verpoorter, cast by Francuccio Francucci, and gilded by Francesco Perone. Nevertheless, in the Pope's own diary for 16 July 1657, we read: 'Yesterday we saw the bronze lamp made for the chapel in the Popolo *by Bernini*'.[24]

Bernini's chief architectural rival was Francesco Borromini (1599–1667). He came from northern Italy, arriving in Rome in 1619, and working at first with his kinsman Carlo Maderno, then the architect to St Peter's,

would still be assured by his achievements as an architect – the Villa del Pigneto for the Sacchetti family, the church of Santi Luca e Martina, the dome of San Carlo al Corso, and the façades of Santa Maria della Pace (see cat.no.86) and Santa Maria in Via Lata. Bernini was uneasy about Cortona, and is reported to have remarked: 'What is wrong with the designs of Cortona – who is by the way a very able man – is that although he says they may cost 500 or 600 crowns, once you were embarked on the project it would mount up to 2,000 or 3,000'.[29] Cortona, one of the most robust and elegant draughtsmen of his day, designed much the same repertoire as Bernini. In addition, however, he designed tapestries, and from 1627 performed a key design role for the tapestry works set up in Rome by Cardinal Francesco Barberini, nephew of Urban VIII.[30] His talented pupil, Ciro Ferri, can be difficult to disentangle artistically from his master, and the same is true, although to a lesser extent, of the less gifted Cortona pupil, Giovanni Francesco Romanelli.

Cortona and his followers tackled not only tapestry cycles but also reliquaries, candlesticks, fonts, coaches, frames, tables, and book illustrations, as is attested by the large corpus of their drawings in the Gabinetto Nazionale delle Stampe, Rome, and elsewhere.[31] The Cortona 'camp' evidently kept a weather-eye on Bernini, and their work can sometimes betray a debt to him. On some other occasions, Cortona's ideas certainly influenced that other major rival of Bernini, but close friend of Cortona, the sculptor Alessandro Algardi (1598–1654).

Algardi, born in the same year as Bernini, came from Bologna to Rome in 1625. Competition must have been hard for him, since Pope Urban VIII, who had known and patronised Bernini long before he ascended to the papacy, provided him with absolute protection for all the major Barberini commissions, and appointed him Architect of St Peter's in 1629. In his *Life* of Guidobaldo Abbatini, Giovanni Battista Passeri, who was undoubtedly jealous of Bernini, wrote of the latter: 'that dragon who ceaselessly guards the orchards of the Hesperides made sure that no-one else should snatch the golden apples of papal favour, and spat poison everywhere, and was always planting prickly thorns of slander along the path that led to rich rewards'.[32]

For some considerable time after his arrival in Rome, Algardi was mainly employed restoring antique sculpture and providing designs and models for small-scale works in silver and bronze. Giovanni Pietro Bellori, the great champion of classicism, wrote in his *Lives of the Painters, Sculptors, and Architects* (1672) that Algardi 'wasted his best years and the prime of his life in making little models of clay and wax … models of putti, little figures, heads, crucifixes, and ornaments for silversmiths'.[33] But as has recently been pointed out, 'it is precisely this Bellorian attitude which has misdirected attention away from those works which are the most entirely personal, the most inventive, and the most expressive of Algardi's true vision'.[34]

Algardi was, like Bernini, involved in many aspects of the arts, albeit that his contribution was on a rather lesser scale. He designed buildings, stucco vaults and catafalques, and carved great tombs, reliefs, altarpieces, and a multitude of busts, statues, and fountains. A significant difference between the approach of Bernini and Algardi was that Bernini usually made drawings for his *arti minori* projects, but passed them on to be worked up by others in his studio, while Algardi actually made the preparatory models.

Algardi modelled putti, various figures of Christ for crucifixes, angels supporting monstrances and reliquaries, and lamps, both in Bologna and for his Bolognese patrons when he arrived in Rome. A grand cupboard, in the style of Pietro da Cortona, was made for Pietro Boncompagni, and given to the church of Santa Maria in Vallicella on 15 May 1640.[35] The ornamental elements seem to depend on models by Algardi, and there are indeed close parallels with the frames around the relief by Algardi on the *Urn of St Ignatius Loyola* in the Gesù. He also supplied models for male terminal figures, cast in bronze to support a great jasper table-top inherited by Prince Marcantonio Borghese. The bronze work was cast between 1633 and 1637 by Gregorio de' Rossi and Giovanni del Duca. This table still survives, having had its stretcher altered and strengthened at the end of the eighteenth century, and is now in a private collection in Rome.[36]

During the pontificate of Urban VIII, Algardi was largely denied Barberini commissions. However, from this period two finely-wrought and intricate drawings exist for the richly-ornamented prow of the galley 'Urbano', evidently named after Urban VIII (see fig.28). It has been very plausibly suggested that these drawings, one in Vienna and the other formerly at Holkham Hall, were commissioned by Alessandro Zambeccari of Bologna, a known Algardi patron, who was Prior of the Order of Malta and from 1543–6 Lieutenant-General of the Papal

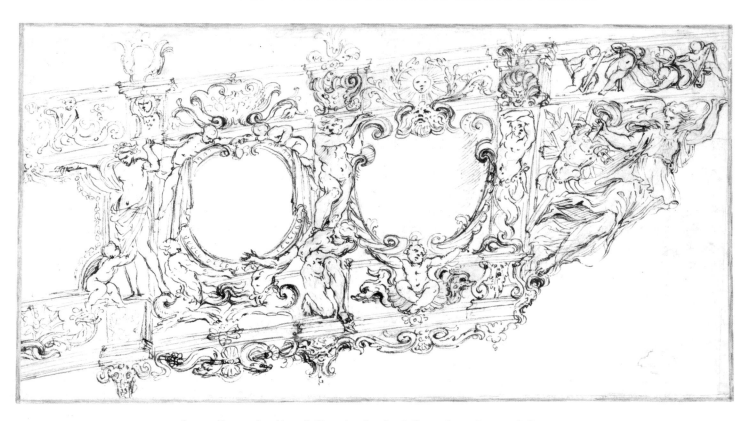

fig.28: Alessandro Algardi, Drawing for the Galley *Urbano*, Private Collection

Fleet.[37] The richly historiated frieze around the prow was to have included, in three zones, a series of shaped reserves or medallions, showing views of the Forte Urbano, Castel Sant'Angelo, and the harbour of Civitavecchia, supported by tritons, putti, and slaves, with a lesser frieze below of shells, Barberini bees and suns, and dolphins, and above fighting merfolk and the name 'Urbano' inhabited by gambolling putti. The scheme, depending for format on the cove of the Farnese Gallery, looks back for its repertoire to Tibaldi, while the drawing style is reminiscent of Cortona. No such galley called the 'Urbano' appears in contemporary lists of the papal fleet, and it is assumed that the ship for which these very complex presentation drawings were made was never built.

When on 15 September 1644 Giovanni Battista Pamphili, who was no friend of the Barberini, was elected Pope as Innocent X, there were new opportunities for papal patronage for Algardi. Innocent, however, was very careful with his money, and certainly at the outset had little interest in the arts. The notion that as the Pamphili Pope was elected, Bernini went out of favour and Algardi came in, is a well-worn cliché which may hold true for the beginning of his papacy, but in fact both sculptors were later to enjoy Pamphili patronage.

The charge on the shield of the Pamphili was a dove with an olive-branch in its beak and, *in chief*, three fleurs-de-lys. Fleurs-de-lys, doves, and olive-branches in delightfully inventive combinations became a familiar artistic feature of Innocent's papacy (1644–55). A little ivory relief from the National Museums of Scotland (cat.no. 143) shows two putti standing, holding up the papal tiara and keys that are partly veiled by a fringed cloth of honour. All the attributes on this relief are Pamphili, and the composition may depend on a model by Algardi. Algardi certainly designed and modelled two finials, in the form of vases, cast in brass and gilded, for the back of the Pope's chair. There is a fine drawing relating to this project (cat.no.144), and a bill dated 2 April 1648 for 120 *scudi* from the founder, Pier Francesco Fiocchini, which contains very accurate descriptions to show that the finials were completed faithfully to this Algardi design.[38] In December of the same year, the silversmith Francesco Perone supplied four silver frames incorporating elements from the Pope's arms, to surround religious paintings on copper by Luigi Gentile (see cat. no.142).

It was really not the Pope but his nephew, Cardinal Camillo Pamphili, who was seriously interested in the visual arts and who proved to be a generous patron of

Algardi. For Camillo he almost certainly made a drawing, now in Vienna, of an elaborate balustrade for his bedroom *alcova*, incorporating not only the Pamphili fleurs-de-lys but also a cardinal's hat, allegorical medallions of Night and Dawn, and a dormouse.[39] Much to the displeasure of his uncle, Cardinal Camillo laid aside his scarlet hat on 21 January 1647 to marry Olimpia Aldobrandini, the fabulously rich widow of Prince Paolo Borghese. For this unhappy couple, Algardi made elegant designs for one end of a coach, also now in Vienna, a composition flanked on one side, most appropriately, by a figure of Abundance supporting an upturned cornucopia, and on the other a winged Victory holding a trophy of arms. The figures, linked by a festoon of oak-leaves, were surmounted by a Prince's coronet with, at the bottom centre, a seated putto supporting the Pamphili arms.[40] A drawing for a vase in the Metropolitan Museum of Art, New York, which seems to have been intended for a finial on a coach roof, shows Algardi again playing with the Pamphili arms, but this time incorporating them with those of the Aldobrandini.[41]

Algardi made a number of drawings for vases, of which a curious example from Windsor (cat.no.145) features two satyrs – one holding a goat, the other a human child. It was probably intended to be carved in a hardstone with metal mounts, thus anticipating, by almost a century, similar vases made in France that were intended to stand in the centre of grand giltwood tables.

These designs for the *arti minori* created by painters and sculptors, seem to have reached their zenith with the sumptuous embassy of the Earl of Castlemaine (celebra-

tedly cuckolded by King Charles II) on behalf of King James VII of Scotland (and II of England) to Pope Innocent XI Odescalchi in 1687.[42] The idea of this mission was to persuade the Pope to endorse James's desire to restore the Catholic religion in Britain, and to wage religious war against the Dutch, using France as an ally. Despite its lavishness, the embassy was a failure because the Pope's major enemy was King Louis XIV. Lord Castlemaine's procession to take audience with the Pope, and the banquet he gave afterwards, are all related in detail and lavishly illustrated in a book whose text was written by the Scottish artist John Michael Wright (1636–94), and which was published first in Italian in 1687 as *Ragguaglio della solenne comparsa fatta in Rome ... del Conte di Castlemaine*, and in English the following year.

The Castlemaine embassy arrived at Easter 1686, but the full équipage, which was designed and made in Rome, was not ready until the end of October. The majordomo was Wright, the King's painter, but in reality almost all of the designs were the work of Ciro Ferri, assisted by Lenardi (see fig.29). The procession alone contained three hundred coaches. The coaches in Lord Castlemaine's suite were superlative creations in the Bernini-Algardi tradition. The window-frames in gilt brass for one coach alone cost £100!

The audience with the Pope took place in January 1687, and this was followed by a great banquet held in the Palazzo Pamphili in Piazza Navona. The most memorable features of the banquet were the plethora of exquisite *trionfi* or small sculptural groups, modelled and cast in sugar-paste, that populated the table (see fig.30). Similar

fig.29: Arnold van Westerhout, after G.B. Lenardi,
The Earl of Castlemaine's Coach, etching,
National Gallery of Scotland, Edinburgh

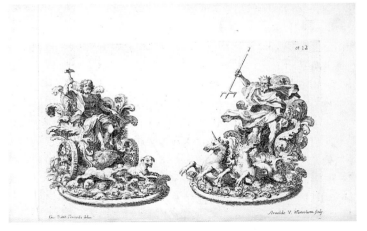

fig.30: Arnold van Westerhout, after G.B. Lenardi,
Sugar Sculptures for the Earl of Castlemaine's Banquet, etching,
National Gallery of Scotland, Edinburgh

groups had been modelled for a banquet given by Pope Clement IX Rospigliosi in 1668 for Queen Christina of Sweden. We know that for a different dinner given for the Queen in 1665, the sugar *trionfi* were modelled by Bernini's able assistant Ercole Ferrata and cast by the sculptor and medallist Girolamo Lucenti.[43] Such sculptures in sugar or marzipan, often decorated with edible gilding, were given away afterwards to the principal guests. The most ambitious *trionfo* at the Castlemaine banquet consisted of a towering concoction seven *palmi* high, representing 'True Religion putting to flight Heresy', the whole composition surmounted by the royal arms. Strikingly, one of the groups represented *Apollo and Daphne* and demonstrated clearly its dependence on the marble group executed for the Borghese by Bernini over sixty years earlier.

Successive popes in this period, and many of the artists they employed, were deeply concerned with the design and issue of medals. Since the pontificate of the Venetian Pope, Paul II Barbo (1417–Pope 1464–71), who was an avid collector of antique coins, jewels, and engraved classical gems, the Papal Mint has regularly cast or struck medals to enhance papal prestige and to mark significant events and achievements. From the early seventeenth century, this practice was formalised with the issue of *annuali* (annual medals) by the Pope on 29 June, the Feast of St Peter and St Paul, with the reverse illustrating the single most important event of the papal year – such as the canonisation of saints, proclamations of doctrine, diplomatic missions, special devotions, and the foundation, renovation, or completion of churches, palaces, fountains or fortresses.[44]

The medal was not an art form restricted to the papacy, for they had also become a familiar element of renaissance propaganda, with, on one side (the *obverse*) profile portraits of princes, *condottieri*, and humanists, and on the other side (the *reverse*) a heraldic or often arcane image, sometimes with a punning or flattering reference to the person who issued the medal. The medal was traditionally signed on the *truncation* of the bust portrait, while an inscription or date often appeared on the reverse in the *exergue* (bottom segment), where, instead of running around the circumference, it read horizontally.

These papal medals were presented at audiences to visiting sovereigns or important personages (as they still are today), laid in foundations, or tossed to the crowds. The nature of the medals' material – gold, silver-gilt, silver, gilt-bronze, bronze, or lead – reflected the status of the gift. As medals were considered essential elements in propaganda, the best artists and sculptors were often involved in their design and execution, while erudite humanists at the papal court provided the texts for the inscriptions. Frustratingly, although signatures on medals identify the professional medallists, they rarely inform us of the designer.

Popes themselves sometimes became personally involved in the creative process. Alexander VII was said by the French Ambassador in 1666 to be 'more concerned with his collection of medallions than with public affairs'.[45] Indeed, he built a new Papal Mint and commissioned Bernini, as we know from drawings and entries in the Pope's diary, to design many of the papal medals. It is now becoming apparent that Algardi, though on a lesser scale, was actively involved in designing such medals (see cat.no.159), as were Borromini (see cat.no.117) and, probably, Cortona.[46]

What bedevils the connoisseurship of medals is that the dies remained with, or were acquired by, the Papal Mint, and throughout the nineteenth century re-strikes, some of excellent quality, were issued, and these can be very difficult to distinguish from the original issue. Sadly, nearly all the papal medals in precious metals in the Vatican were looted by the Napoleonic troops and melted down for bullion. It is especially unusual in this exhibition and publication that nearly all of the papal medals either belonged to King George III (1738–1820) or to Dr John Hunter of Glasgow (1728–93), which all but guarantees that they are early and fine examples. Moreover, an unusually high proportion of the papal medals in the Hunterian Museum in Glasgow (the beneficiary of Hunter's collection) are struck in silver, whereas bronze examples are much more common.

In baroque Rome the arts were considered as a unity, and the experience of designing a sugar-paste *trionfo*, a silver reliquary, a bronze andiron, a papal galley, or a silver medal, had a direct and indivisible relationship to the ideas and procedures informing the 'higher' arts of painting, marble sculpture, and architecture.

Catalogue

EFFIGIES & ECSTASIES

ROMAN BAROQUE SCULPTURE AND DESIGN

IN THE AGE OF BERNINI

CATALOGUE NOTE

Dimensions given are maximum dimensions, with height followed by width (followed by depth, where applicable).

The footnotes to the catalogue entries are on pp.201–15

Birth and death dates are supplied at the top of each entry for all artists except Gianlorenzo Bernini (1598–1680) and Alessandro Algardi (1598–1654).

Unless otherwise specified, all exhibited medals were struck rather than cast.

The subject categories into which the catalogue is subdivided are necessarily loose ones, and are flouted wherever this seemed justified. For example, Pietro da Cortona's study for a fresco in Santa Bibiana (cat.no.79) appears in the architectural section because of its association with the medal commemorating the restoration of that church (cat.no.78).

The initials of the author or authors responsible for each catalogue entry appear at the end of the entry. The contributors are:

CA	Charles Avery
CB	Christopher Baker
PC	Patrizia Cavazzini
TC	Timothy Clifford
AG	Axel Christoph Gampp
DST	Desmond Shawe-Taylor
ES	Elizabeth Sladek
FS	Francesco Solinas
EJS	Emma Stirrup
AT	Anna Tummers
AWL	Aidan Weston-Lewis
KW	Karin Wolfe

Portraits of Bernini, Portrait Drawings and Caricatures

British collections are exceptionally rich in portrait drawings by, or attributed to, Bernini, and as a result it has been possible to bring together an unprecedented number for this exhibition, including a few disputed sheets. In terms of attribution and dating, they are arguably the most problematic group within Bernini's drawn oeuvre. Since several of the issues central to a discussion of the portrait drawings are common to many or all of them, a few general comments are offered here by way of a preface to avoid unnecessary repetition in the individual entries.

The portraits form a distinct group within Bernini's corpus of drawings as a whole – as do the caricatures, and to a lesser degree the academic nudes. They share with the latter the distinction of having all been drawn from the life. With one or two exceptions (see below), they appear, unlike the vast majority of Bernini's drawings, to have been made as independent works of art in their own right, as informal and essentially private records of friends and relatives, which were presumably more often than not given away to the sitter or his family. The masculine is used here advisedly, for of the twenty-five or so extant portrait drawings by Bernini, not one portrays a woman (although there is evidence that

a drawing by Bernini of his wife once existed).[1] Likewise Bernini's self-portraits, both drawn and painted, were presumably presented to his friends, patrons and other admirers. For example, during his visit to Paris he agreed to execute two drawn self-portraits at the request of Colbert and Chantelou.[2] As a result of their special status as finished works to be given away, it is likely that a disproportionately high percentage of Bernini's portrait drawings survives in relation to his output of drawings as a whole.[3]

Bernini, especially as a younger man, was evidently rather pleased with his own appearance, and produced numerous self-portraits as well as using his own features (according to his biographers) to model some of his more expressive early sculptures, such as the *Damned Soul* (Rome, Palazzo di Spagna)[4] and the *David* (fig.63). However, far from clarifying the issue of identification, as one might have hoped, the existence of numerous *bona fide* self-portraits (not to mention portraits of him by others, such as cat nos.3, 6 and 7) seems to have encouraged scholars and collectors in the past to see his likeness in many other of his portrait drawings, which on closer analysis bear little real physiognomic resemblance to him. Of the drawings exhibited here, in addition to

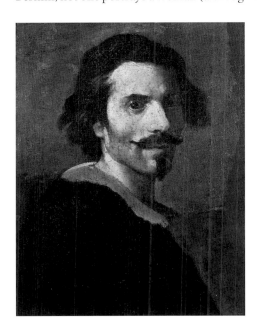

fig.31: Gianlorenzo Bernini, *Self-portrait*, Rome, Galeria Borghese

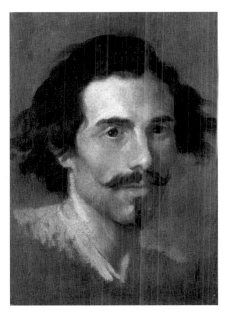

fig.32: Gianlorenzo Bernini, *Self-portrait*, Madrid, Museo del Prado

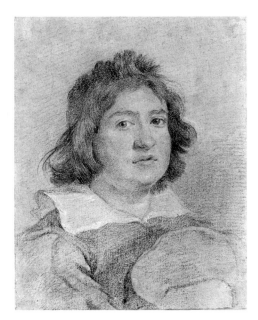

fig.33: Gianlorenzo Bernini, *Portrait of Sisinio Poli*, New York, Pierpont Morgan Library

the four accepted as self-portraits (or copies of self-portraits), no fewer than five others have been considered at some time in the past to record his features too (see cat.nos.9, 11–12, 14 and 17). There are admittedly a few borderline cases, and the issue is complicated by the likelihood that Bernini drew his brothers and other members of his family, who might reasonably be expected to have borne him a family resemblance. The possibility that Bernini may have idealised his own features somewhat, particularly with regard to the shape and size of his nose, further confuses matters (see cat.no.1).[5] He advocated this practice of altering or understating less flattering features to his Parisian audience, provided it did not overly compromise the likeness.[6]

It is of the self-portraits in particular that a fair number of early and often deceptively accurate drawn copies survive, suggesting that there was a considerable demand for images of the great man. In the context of a discussion about good copies that he had in Paris, Bernini offers a salutary warning to the modern connoisseur when he reported that 'once when a pupil of his who drew very well had made a copy of a portrait by him that he had touched up, he himself was unable to tell the original from the copy'.[7]

By reference to his apparent age, Bernini's indisputable self-portraits provide useful stylistic markers for the establishment of an approximate sequence and chronology of the portrait drawings. Four painted self-portraits, two in the Borghese Gallery in Rome (figs.31 and 37), and one each in the Uffizi in Florence and the Prado in Madrid (fig.32), also help to document the way in which Bernini's features matured, although again none of these is dated securely. The estimation of a sitter's age from a portrait is an even trickier business than it is in real life, and it seems sensible therefore to allow for a fairly wide range. By way of illustration, it is here submitted that few people without prior knowledge would accurately estimate the age of the plump and boyish Sisinio Poli at eighteen (fig.33). More useful as regards chronology is the handful of Bernini's portrait drawings of other sitters which can be more or

less firmly dated on external grounds. These consist of the celebrated portrait drawing of Cardinal Scipione Borghese in New York (fig.34), which is invariably connected in the literature with Bernini's execution in 1632 of the marble portrait busts of this sitter still in the Galleria Borghese;[8] the above-mentioned Sisinio Poli (fig.33), the mount of which bears an old inscription dating it specifically to 28 April 1638 (which there is no reason to doubt); a portrait of Ottaviano Castelli (fig.35), which can be dated to the early 1640s by comparison with a dated print of him;[9] and the late profile portrait of Clement X Altieri (fig.44), who occupied the papal throne from 1670 to 1676.[10] The first and last of these sheets are hardly typical of Bernini's portrait drawings as a whole, since they were probably made as part of the preparatory process for works in other media.

A wealth of information about Bernini's method of preparing and carving his portrait bust of Louis XIV is supplied by Chantelou in his diary of the sculptor's visit to France in 1665, and it includes a few interesting references to drawings. During his first session with the King, Bernini posed him, rearranged his hair, and then drew two formal portraits of him, one full-face and the other in profile, which served as initial guides for the clay model for the bust.[11] But he also made numerous rapid and informal portrait sketches of the King from life which were not to be used directly as models for the sculpted features, but rather as *aides-mémoire*, to remind Bernini of the appearance of the King in motion and on the point of speaking (at which time, he believed, sitters revealed themselves at their most characteristic).[12] The occasion of carving the bust of the King of France from the life was clearly an exceptional one, and Bernini's performance probably reveals as much about his talent for the theatre, and his grasp of psychology, as it does about his standard sculptural practice. It would certainly be a mistake to deduce that he approached every portrait commission in this way: only one drawing by Bernini survives of the sketchier type described by Chantelou (fig.34), and we know from other

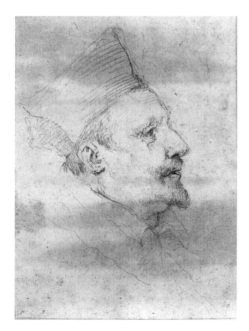

fig.34: Gianlorenzo Bernini, *Portrait of Cardinal Scipione Borghese*, New York, Pierpont Morgan Library

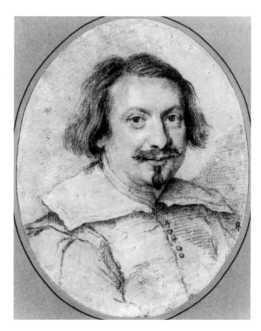

fig.35: Gianlorenzo Bernini, *Portrait of Ottaviano Castelli*, formerly London, Art Market

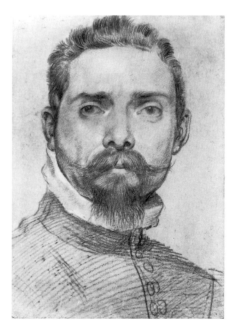

fig.36: Annibale Carracci, *Portrait of a Man*, Vienna, Graphische Sammlung Albertina

sources that he carved at least two splendid busts (see cat.nos.26 and fig.160) on the basis of painted portraits alone, while several others were posthumous portraits.

For a multi-talented artist who was nevertheless first and foremost a sculptor, Bernini's portrait drawings are remarkable precisely for their 'un-sculptural' appearance. The execution of some is surprisingly soft and hesitant (eg. cat.nos.17–18), and one only just manages to emerge from the paper upon which it is drawn (cat.no.19). Only a few of his portrait drawings (eg. cat.nos.2 and 11) exhibit the tautly modelled, strongly three-dimensional quality that one might have expected from a knowledge of his sculpted portraits and, with perhaps one exception (fig.no.44), there is little suggestion of an interest in blocking-out planes in depth and establishing stong chiaroscuro contrasts. To be sure, one might see in a highly finished portrait such as cat.no.2 an equivalent to the intense descriptive naturalism of works such as the Borghese mythologies and some of the portrait busts from the first half of the 1620s, but it remains true that its conception is essentially pictorial rather than sculptural.

As one might expect from an artist whose career spanned seventy years, the portrait drawings, in common with Bernini's drawings in general, display a considerable technical and stylistic range. Broadly speaking, he seems to have preferred red chalk for his portraits earlier in his career, and black chalk later, although there are exceptions.[13] This tendency is also reflected in the relative proportions of red and black chalk used in his drawings *à trois crayons* (using red, black and white chalk together). Bernini seems to have been particularly attracted to the latter technique, which was used for the majority of his portrait drawings. Preoccupied for much of his career with the problem of rendering colour in sculpture,[14] he seems to have relished the relative ease with which varied and subtle colouristic effects could be achieved by juxtaposing and superimposing three simple shades of chalk. Brown hair, for example, is often successfully described by an optical mix of red and black. More subtly, in some of the drawings executed in red chalk alone, two different shades of red were deliberately employed to increase the range of achievable effects. It is perhaps surprising that Bernini, unlike many of his contemporaries, appears rarely if ever to have used blue paper, although in the case of one of the exhibited sheets (cat.no.14) he did apply a lightly tinted wash to the paper before commencing. He was extremely adept at enlivening his portraits with a few strategically placed touches of white chalk, which he typically used rather sparingly. Certain distinctive stylistic hallmarks – such as the use of a fine black chalk line to separate red chalk lips, or around the inner rim of a nostril; the selective dampening of the chalk to achieve a few pronounced tonal contrasts; or the highlighting in white of the tips and edge of a collar alone – are so personal as to encourage one to admit into the corpus of autograph drawings portraits which one might on other stylistic grounds be tempted to exclude (eg. cat.nos.13 and 15).

As to the precedents, the best established, if rather uninspired, portrait draftsman active in Rome in the early seventeenth century was Ottavio Leoni, with whose work Bernini was certainly familiar (see cat.no.1). Leoni's preferred combination of media was black and white chalk on blue paper, but he also produced numerous portraits *à trois crayons*, among them his portrait of Bernini. A few of Bernini's most restrained portraits are superficially reminis-

cent of Leoni's style, but are invariably more penetrating and incisive in their characterisation of the sitter, and more adventurous in their use and combination of the media. Much more important as a precedent for Bernini's portrait drawings are those of Annibale Carracci, an artist whom Bernini had met as a boy and for whom he had the profoundest admiration.[15] The way in which most of Bernini's sitters engage the viewer directly and establish a kind of psychological rapport through eye contact is particularly reminiscent of Annibale's portrait drawings (see fig.36) and, subtly inflected, is one of the key means by which character is communicated. [AWL]

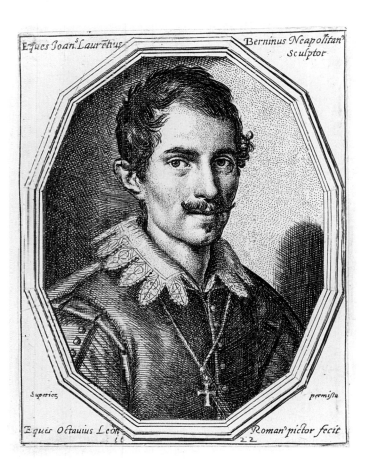

1

OTTAVIO LEONI 1578–1630
Portrait of Gianlorenzo Bernini

Etching, 14.3 × 11.3cm, dated 1622
Inscribed at the top: *Eques Joan.s Laurentius Berninus Neapolitan' / Sculptor*; and below: *Superior permissu / Eques Octavius Leon' Roman' pictor fecit / 1622*.
Edinburgh, National Gallery of Scotland
(P2909)

Leoni's etching portrays the twenty-three-year-old Bernini wearing the cross and chain of the *Cavalieri di Cristo* (Knights of the Order of Christ), an honour conferred upon him in 1621 by Pope Gregory XV Ludovisi for services rendered (in the form of three portrait busts of the Pope). Baldinucci specifies that it was the Pope's nephew Cardinal Ludovico Ludovisi who recommended

49

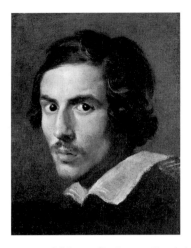

left fig.37: Gianlorenzo Bernini, *Self-portrait as a Young Man*, Rome, Galleria Borghese

right fig.38: Gianlorenzo Bernini, *Portrait of a Young Man, probably a Self-portrait*, Florence, Uffizi, Horne Collection

that the honour be bestowed on Bernini. With its emphasis on the 'Eques' in both image and inscription, and its portayal of the sculptor in untypically smart dress and with much shorter hair than usual, it seems likely that the print was issued specifically to commemorate Bernini's knighthood.

Leoni would have been fully aware that the much younger Bernini was the rising star of the Roman art scene. The two artists shared a common patron, Cardinal Scipione Borghese, whose role in Bernini's early career is legendary, but whose ownership of a large group of Leoni's portrait drawings is less well known. Indeed, Scipione probably owned the preparatory drawing for Leoni's etching of Bernini, for it is one of twenty-seven of Leoni's portrait drawings in an album with a Borghese provenance now belonging to the Biblioteca Marucelliana in Florence.[1]

One must assume that Leoni's portrayal of Bernini provides a reasonably faithful and objective record of his outward appearance at the time, but it provides little hint of the fiery temperament revealed in Bernini's portraits of himself and in written accounts of his earlier years.[2] In fact, it is remarkable precisely for its dissimilarity to the only slightly earlier painted *Self-portrait* in the Galleria Borghese (fig.37). Leoni seems to have been rather generous with regard to the shape of Bernini's nose, which in the Borghese picture has a distinct bump on its bridge (a feature which Bernini himself seems to have been anxious to underplay in later self-portraits). The etching does, however, offer a rare glimpse of one of Bernini's ears, with its distinctive inverted pinna, which lends some weight to the identification of the drawing in the Horne Collection as a youthful *Self-portrait* (fig.38). [AWL]

2
GIANLORENZO BERNINI
Self-portrait

Black and red chalks, sparingly heightened with white chalk,
on off-white paper, 27.5 × 21.5cm
Oxford, The Visitors of the Ashmolean Museum
(P.II.792)

In this justly famous *Self-portrait*, Bernini demonstrates a technical virtuosity without parallel among his drawings to create a powerfully three-dimensional and supremely self-confident image of himself.[1] This impression is enhanced by the placement of his head closer than usual to the viewer, with the edge of the paper clipping his hair at both sides. Although informal in mood, it has rightly been emphasised that portrait drawings of this sophistication could hardly have been dashed off in a few minutes; on the contrary, they would have required hours of patient work.[2] Bernini appears to be in his late twenties or early thirties, which would date the portrait approximately to the second half of the 1620s. It must have been executed at just about the same time as the *Portrait of Bernini in the Guise of St George* (fig.39) attributed to his collaborator Carlo Pellegrini (1605–49).[3] By this time he was firmly established as a favourite of Pope Urban VIII and was engaged on the first stage of his transformation of St Peter's, focussing on the crossing and the Baldacchino (see cat.nos.58–62).

This drawing, and one or two others that can be grouped with it (eg. fig.40), represent the limit of Bernini's attempts at naturalistic description, at the direct approximation of visual appearances. In subsequent portrait drawings he seems progressively to have sought more economical and allusive means for capturing a likeness and describing varied surfaces and textures.

Before the emergence of the present drawing in the 1940s, what is clearly a copy of it in the Gabinetto Nazionale delle Stampe in Rome was widely considered to be an original.[4] [AWL]

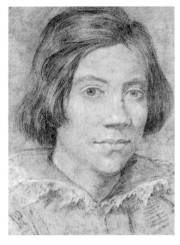

left fig.39: Attributed to Carlo Pellegrini, *Portrait of Gianlorenzo Bernini in the Guise of St George*, Rome, Incisa della Rocchetta Collection

right fig.40: Gianlorenzo Bernini, *Portrait of a Young Man*, Washington, National Gallery of Art (Ailsa Mellon Bruce Fund)

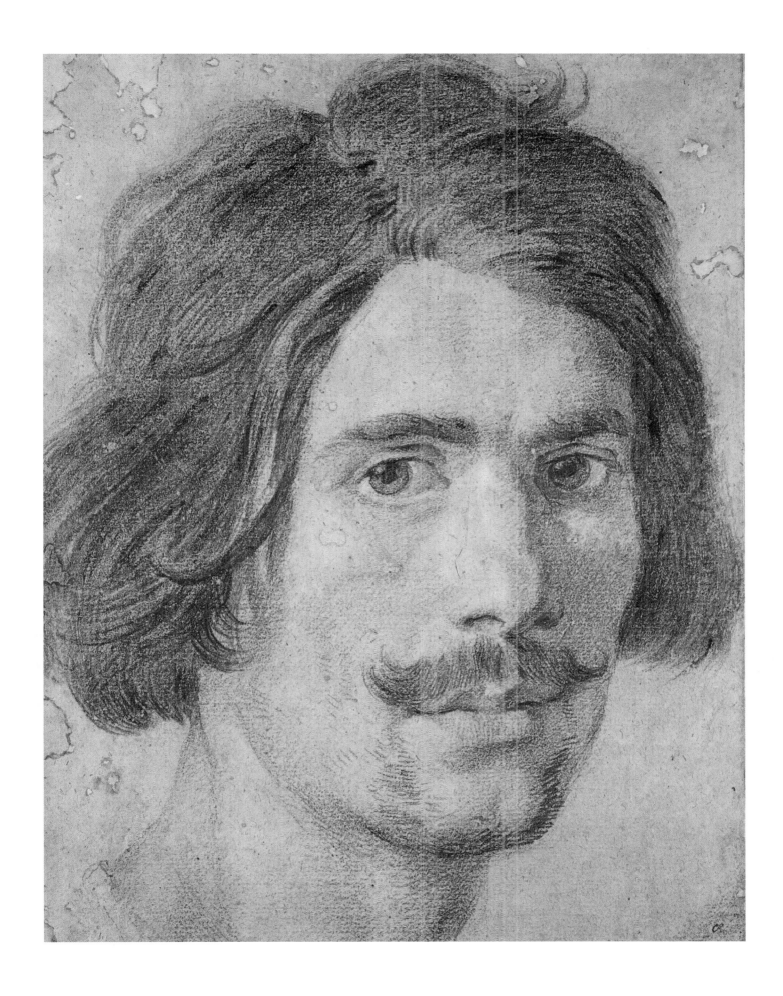

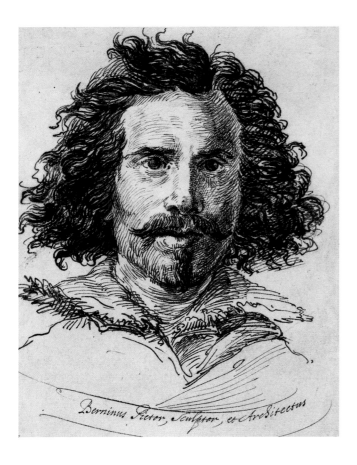

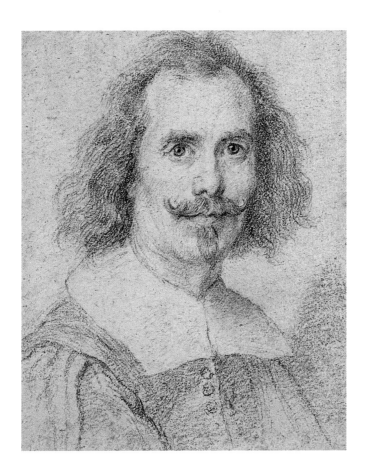

3

ASCRIBED TO SALVATOR ROSA 1615–73
Portrait of Gianlorenzo Bernini
Pen and brown ink on light brown prepared paper, 22.9 × 17.8cm
Inscribed: *Berninus Pictor, Sculptor, et Architectus*
London, British Museum
(PP.5–103)

The high degree of finish and elegant, 'copper-plate' script suggest that this portrait of Bernini may have been made to be etched or engraved, although no corresponding print is known.[1] Bernini appears to be in his mid to late thirties, which would date the image roughly to the mid-1630s, within a year or two, perhaps, of the painted *Self-portrait* in the Uffizi (fig.21). However, the drawing gives the impression that it may have been based on an existing portrait of Bernini, rather than studied from life, and therefore need not necessarily be strictly contemporary.

The traditional attribution of this portrait to Salvator Rosa cannot be correct on stylistic grounds, but it is retained here in the absence of a convincing alternative.[2] A copy of the British Museum drawing is in one of the Chigi albums of drawings, now in the Vatican Library.[3] [AWL]

4

ATTRIBUTED TO GIANLORENZO BERNINI
Self-portrait
Black and red chalks on greyish paper, 22.2 × 17cm
Inscribed on the verso: *Agnese Celeste [...]*
Oxford, The Visitors of the Ashmolean Museum
(P.II.794)

The features are certainly those of Bernini, but the status of the Ashmolean drawing is complicated by the existence of another version of it in the collection at Holkham Hall, Norfolk (fig.41).[1] Careful comparison of the two suggests that, on balance, the Holkham drawing is marginally superior to the Oxford one in terms of quality. However, the treatment of the costume in both appears too hesitant and pedestrian to be by Bernini himself, and neither drawing has the 'punch' of the autograph self-portraits (cat.nos.2 and 5). It seems likely, therefore, that both drawings de-

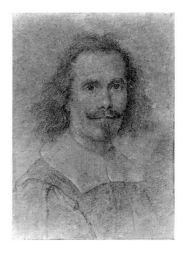

fig.41: After Gianlorenzo Bernini, *Self-portrait*, Holkham Hall, Lord Leicester

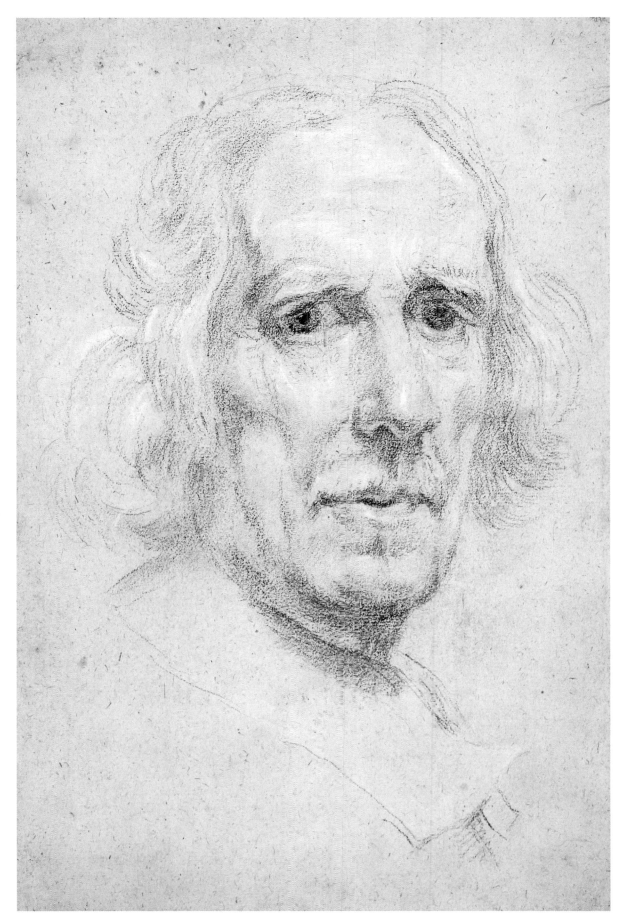

cat.no.5

rive from a now lost prototype by Bernini himself, which probably dated from the late 1640s or early 1650s. It is interesting to note how the minor discrepancies in the handling of the two drawings create a significantly different image of the sitter, who appears older in the Oxford drawing than he does in the Holkham one.

[AWL]

5

GIANLORENZO BERNINI

Self-portrait

Black and white chalks on buff paper, 41.3 × 27.1cm
Windsor Castle, Royal Library
(RL5539)

This drawing, which is usually dated to the mid 1660s,[1] forms a fitting accompaniment, but also a partial corrective, to the description of Bernini's appearance and character recorded by Chantelou in his *Diary*:

'Let me tell you then that the Cavalier Bernini is a man of medium height but well proportioned and rather thin. His temperament is all fire. His face resembles an eagle's, particularly the eyes. He has thick eyebrows and a lofty forehead, slightly sunk in the middle and raised over the eyes. He is rather bald, but what hair he has is white and frizzy. He himself says he is sixty-five. He is very vigorous for his age and walks as firmly as if he were only thirty or forty. I consider his character to be one of the finest formed by nature, for without having studied he has nearly all the advantages with which learning can endow a man. Further, he has a good memory, a quick and lively imagination, and his judgment seems perspicacious and sound. He is an excellent talker with a quite individual talent for expressing things with word, look, and gesture, so as to make them as pleasing as the brushes of the greatest painters can do.'[2]

This was Bernini's public persona, but in the more private context of analysing and recording his own features, he reveals a man who also had doubts and fears. The furrowed brow and heavy eyelids and anxious, almost haunted gaze remind us that he was by all accounts obsessed for much of the second half of his life with the question of his own mortality and redemption (see Christopher Black's introductory essay, pp.16–17).

Comparison with Bernini's much earlier *Self-portrait* from Oxford (cat.no.2) is instructive, for it illustrates well how he had come to adopt a much looser manner in his portrait drawings. The later drawing depends much more for its effect on the broad pattern of *chiaroscuro* (light and shade) than on the fastidious imitation of forms and textures evident in the earlier portrait. It also reveals a more selective approach to characterisation, focussing as it does on the key features: eyes, nose and mouth.

The image of Bernini in the Windsor drawing corresponds quite closely to his features as they appear in the newly discovered portrait of him by Baciccio (cat.no.7), and in the related engraving by Arnold van Westerhout (fig.43). He seems older here, his face and brow more deeply lined, than he does in Baciccio's other portrait of him in Rome (fig.42). This would tend to support the identification of the latter with a 1666 documentary reference (for which see under cat.no.7), and would argue for a dating of the present drawing to a few years later, perhaps around 1670. [AWL]

6

CHARLES-JEAN-FRANÇOIS CHÉRON 1635–1698

Portrait of Gianlorenzo Bernini, 1674

OBVERSE: Gianlorenzo Bernini (1598–1680), in profile to right, with his own hair, balding in front, a cloak thrown about his shoulders; around: *EQVES.IOA.LAVRENT BERNINVS. ETATIS.SVE*; in exergue: *ANNO 76 1674*; signed on truncation: *F. CHERON*
REVERSE: Muses presiding over Sculpture, Painting, Architecture, and Geometry; around: *SINGVLARIS.IN SINGVLIS.IN.OMNIBVS VNICVS.*; in exergue: *F CHERON*
Bronze (cast); 7.35cm diameter
Edinburgh, National Gallery of Scotland
Purchased by the Patrons of the National Galleries of Scotland, 1986
(NG2439)

King Louis XIV commissioned this most flattering medal from his fellow countryman François Chéron to mark his great esteem for the elderly Bernini.[1] The inscription on the reverse of the medal testifies to the artist's reputaton as a universal genius. Louis XIV had called Bernini to France in 1665, and the latter provided de-

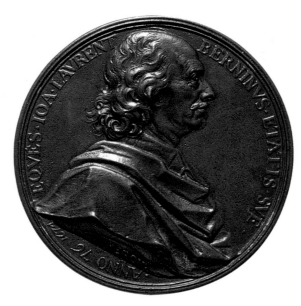

cat.no.6 *obverse*

cat.no.6 *reverse*

signs for the rebuilding of the Louvre (see cat.no.92) and carved a marble bust of the King. Sadly, the Bernini's Louvre project never progressed beyond the elaborate foundations, and the King's later commission for a marble equestrian statue from the sculptor, which arrived in Paris only long after this medal was produced, was far from successful (see cat.nos.108–10).

The fact that this image is dated provides a useful fixed point of reference for the chronology of the later portraits of Bernini. Once allowance is made for the greater formality of the medallic profile, the features closely comparable to the painted portrait by Baciccio exhibited here for the first time (see following entry). Chéron's portrait appears to depend on no known prototype, so it may be assumed that Bernini sat to the medallist, or to a commissioned draughtsman, specifically for this purpose.[2] Indeed, the agitated configuration of the drapery, with its deep troughs and narrow, parallel ridges, is reminiscent of Bernini's own late drapery style, suggesting that the design for the medal may have been produced by an artist in his immediate circle.

An engraving by M. Tüscher of both sides of this medal appears at the beginning of an 1731 edition of Baldinucci's *Life* of Bernini.[3]

[TC]

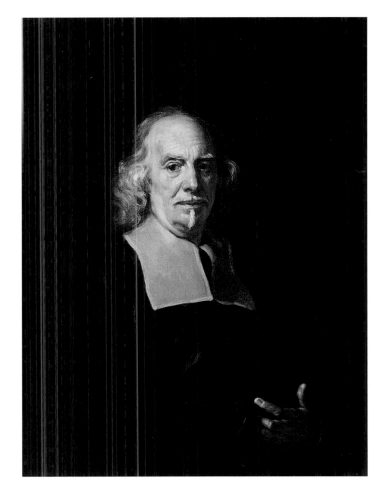

7

GIOVANNI BATTISTA GAULLI, CALLED BACICCIO 1639–1709

Portrait of Gianlorenzo Bernini

Oil on canvas, 99 × 74.5cm
Private Collection

With its penetrating characterisation and vibrant brushwork, this sensitive and sympathetic portrayal of the aged Bernini is an important addition to our knowledge of Baciccio as a portraitist, and one which reflects especially clearly the artist's early study of Van Dyck's portraits in his native Genoa.[1]

From the available evidence, it seems that Bernini sat to his friend and protégé Baciccio on two occasions, several years apart which resulted in two rather differently conceived portraits, of which several replicas and copies survive. The prime version of the earlier of these, in the Galleria Nazionale d'Arte Antica in Rome (fig.42), may well be identical with a portrait of Bernini by Baciccio mentioned in a letter of December 1666, which was used by way of recommendation to illustrate the younger artist's accomplishment in portraiture ('even Bernini has had himself portrayed by him').[2] One might infer from this reference that the portrait was a fairly recent one, in which case Bernini would have been sixty-seven or sixty-eight years old. He certainly seems younger than he does in Bernini's *Self-portrait* drawing from Windsor (cat.no.5), for which a date of around 1670 is here proposed.

We have no certain knowledge of the provenance of the present painting prior to its appearance at auction in 1980, but on the strength of its pictorial qualities alone it can confidently be claimed as the prime version of Baciccio's later portrait of Bernini, and thus as the prototype of the numerous replicas and variants which exist.[3] The formality and rhetoric of the earlier image has here been replaced by a mood of reflection and intimacy, enlivened by flashing highlights and bold touches of impasto. Of special interest is the virtual certainty that this portrait served as the model

for Arnold van Westerhout's engraving (fig.43), which was published in 1682 as the frontispiece to Filippo Baldinucci's *Life* of Bernini, commissioned by and dedicated to Queen Christina of Sweden. An inscription on the engraving credits a painting by Baciccio as its source. Once allowance is made for the reversal of the image, the adaptation to the oval format, and the difference in medium, the printmaker has been remarkably faithful to the original, down to such details as the wayward lock of hair going 'against

left fig.42: Giovanni Battista Gaulli, called Baciccio, *Portrait of Gianlorenzo Bernini*. Rome, Galleria Nazionale d'Arte Antica

right fig.43: Arnold van Westerhout, after Baciccio, *Portrait of Gianlorenzo Bernini*, engraving, London, British Museum

the grain' above the ear, the glancing highlight on the proper left eye-brow (proper right in the print), and the streak of deep shadow between collar and chin. The weakest feature of the engraving is the cross of the Order of Christ, which was added as a posthumous tribute to the Cavaliere: its straight arms fail to follow the undulations of the drapery to which it is ostensibly sewn.

In an annotation to a 1731 edition of Baldinucci's biography of Bernini, the editor, Fausto Amidei, refers to what is presumably this portrait as 'that [made] in the last phase of his life painted by Giovanni Battista Gaulli, and issued as an exsquisite print by Arnold van Westerhout shortly after the death of Bernini' (*quello dell'ultimo stato della sua età dipinto da Gio. Battista Gaulli, e con isquisitezza d'intaglio dato fuori da Arnoldo Wanvesterout poco dopo la morte del medesimo Bernini*).[4] This has been taken to imply that the painting must date from the last year or so of Bernini's life.[5] But the comment was written long after Bernini's death, the phrase 'ultimo stato della sua età' is an imprecise one, and in Baciccio's portrayal of him, with his slightly parted lips, 'speaking gesture' and sparkly eyes, he seems far from moribund, notwithstanding the obvious signs of aging. Compared to Baciccio's portrait of Bernini in Rome (fig.42), the cheeks here have hollowed, and the incipient double-chin has sagged with age into loose flaps of skin – a feature emphasised by the slight twist of the head and brilliantly captured by the artist. A date in the mid 1670s for this portrait seems on balance preferable, perhaps only slightly later than the medal by Chéron (see previous entry), with which meaningful comparison is hampered by the profile view. The artist's appearance is not radically different from that of the Windsor *Self-portrait* (cat.no.5), for which it would be difficult to argue a date much later than 1670 on stylistic grounds (compare, for example, fig.44 and cat.no.8).[AWL]

8

ATTRIBUTED TO GIANLORENZO BERNINI

Self-portrait as an Old Man (recto); *Two Studies of the Head of an Old Man seen from Below* (verso)

Black and yellowish-white chalk (partly oxidised) on buff paper (recto); red chalk (verso), 36 × 24.1cm
There is an illegible black chalk inscription at the lower left.
London, British Museum
(1890–10–13–5)

This drawing has often been published as an autograph self-portrait, but it seems appropriate to raise a question-mark over its status (although not over the identity of the sitter).[1] To be sure, the way the black chalk is handled is very similar indeed to the *Portrait of Clement X* in Leipzig (fig.44), but there is a certain stiffness and hesitation about the execution of the British Museum drawing which seems to betray the hand of a copyist. If so, it must be an extremely accurate copy of a lost original, and was quite possibly made in Bernini's own studio. The weak drawings on the verso of the sheet would tend to support the conclusion that the portrait on the recto is a copy.

Bernini here appears distinctly older and more care-worn than he does in the previous drawing, suggesting that the original from which this portrait was copied must have dated from the final decade of his life, and probably from his last years. What was once presumably a white wash applied over much of the hair has discoloured to a rather unpleasant dirty cream. [AWL]

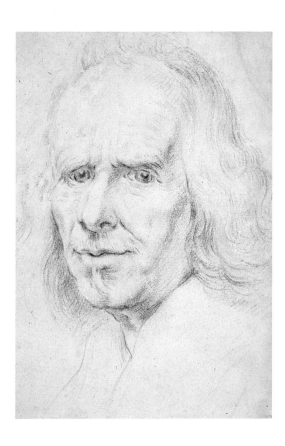

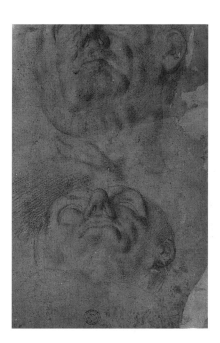

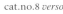

cat.no.8 *verso*

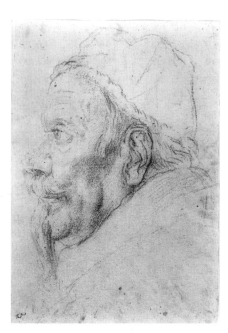

fig.44: Gianlorenzo Bernini,
Profile Portrait of Pope Clement X Altieri,
Leipzig, Museum der Bildenden Künste

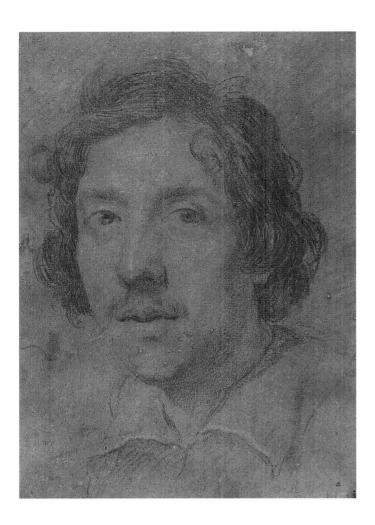

GIANLORENZO BERNINI
Portrait of a Man

Red chalk with touches of white chalk on heavily discoloured buff or off-white paper; a few minor later retouchings in another shade of red chalk,
36.4 × 26.4cm
Numbered at lower right: *170*
London, British Museum
(1897–4–10–10)

The impact of this appealing portrait has been significantly compromised by the heavy discolouration of the paper, but there are no grounds for doubting its authorship.[1] The drawing has frequently in the past been identified as a self-portrait, usually by reference to the early painted *Self-portrait* in the Galleria Borghese (fig.37) and Leoni's etching (cat.no.1).[2] However, compared to these and other slightly later portraits of Bernini (cat.no.2 and fig.39), the sitter here has rather fuller cheeks, a weaker jaw, and a less assertive chin, with little trace of Bernini's distinctive dimple. There is, however, a sufficiently close resemblance to speculate that he may have portrayed here another member of his family.

Bernini injects animation into the sitter by devices such as the tousled hair, oblique gaze and the slightly parted lips. The drawing displays an accomplished but relatively precise and literal touch, which would tend to confirm the date in the first half of the 1620s usually assigned to it. For example, the careful delineation, using a sharpened stick of chalk, of separate strands of hair is patently less sophisticated stylistically than the broader massing of the locks in a later red chalk portrait such as that from the Ashmolean Museum (cat.no.14). On the other hand, the portrait is less hesitant and technically more advanced than drawings such as the probable early *Self-portrait* in the Uffizi (fig.38), the *Portrait of a Boy* in the Brera, Milan,[3] and the unusual *Portrait of a Boy in the Guise of David (?)* at Windsor (fig.45),[4] all three of which must number among Bernini's earliest extant drawings. The last of these reveals weaknesses in the articulation of the figure and the arrangement of the drapery which would tend to confirm an early date, probably well before 1620.

It has been claimed that an unpublished painted portrait attributed to Bernini in a Roman private collection represents the same sitter.[5] What is clearly a copy of the present drawing was on the Italian art market in 1970.[6] [AWL]

fig.45: Gianlorenzo Bernini,
Portrait of a Boy in the Guise of David (?),
Windsor Castle, Royal Library

GIANLORENZO BERNINI
Profile Portrait of a Boy
Red chalk; localised damages retouched in a different shade of red chalk,
22.1 × 15.7cm
Inscribed at the lower left: *Bernini*
London, Private Collection

This highly sensitive portrayal of a pensive boy is one of only two surviving portraits by Bernini which show the sitter in strict profile – an unexpectedly austere choice, perhaps, for so appealing a subject, and a viewpoint normally reserved for more formal portrayals (see fig.44).[1] The treatment of the hair, and the use of fine hatching strokes as well as tonal areas on the boy's nose, cheek and chin, link this portrait stylistically, and therefore chronologically, with the Ashmolean *Self-portrait* (cat.no.2) and the *Portrait of a Youth* in Washington (fig.40). The distinctive parallel hatching strokes on his sleeve are strongly reminiscent of those that appear in the landscape backgrounds of several of Bernini's academic nudes (see cat.nos.38–9). [AWL]

GIANLORENZO BERNINI
Portrait of a Man
Black, red and white chalks on discoloured buff or brown paper,
41 × 26.7cm
Windsor Castle, Royal Library
(RL5540)

It is no doubt the manner in which the sitter is presented, as much as his features, which has encouraged many scholars to identify this drawing as a self-portrait by Bernini.[1]

Specifically, the lively twist of his head in relation to the torso and shoulder (albeit not resolved entirely convincingly) might be explained in terms of the artist peering to his right into a mirror. The features do bear some resemblance to those of Bernini, but the face is altogether rounder and plumper, with less sharply defined cheekbones and jaw, and the hair wavier than Bernini's was.

The drawing shares a great deal of stylistic common ground with the Ashmolean *Self-portrait* (cat.no.2), although its generally looser facture suggests, following the pattern of development proposed here, a slightly later date. Details such as the use of stipples and flecks of the chalk used to suggest stubble, and the brilliant way in which the artist has conveyed the bright, alert eyes, are common to both portraits. The drawing arguably has a more vigorous, chiselled, sculptural quality than any other portrait drawing by Bernini, and it exudes an air of dash and swagger unusual for him. [AWL]

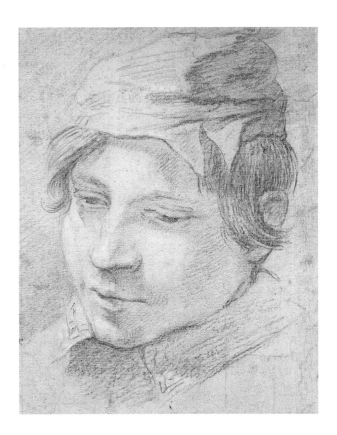

12	13

12
GIANLORENZO BERNINI
Portrait of a Boy

Black, red and white chalks (the latter rubbed and faded) on discoloured
off-white paper, 20.5 × 17.7cm
An irregular strip about 1cm deep at top of sheet missing; black chalk
strokes applied to the backing sheet in this area by a later hand to blend
in with the original drawing.
Windsor Castle, Royal Library
(RL5543)

For this to be a self-portrait by Bernini, as has sometimes been sug-
gested, it would have to have been drawn when he was scarcely
more than twelve or fourteen years old, that is about 1610–12.[1]
There is little physiognomic basis for such an identification, and
the style of the drawing belongs to a much later phase of the artist's
development, perhaps to the first half of the 1630s.[2] The facture is
considerably looser and more impressionistic than the preceding
drawings, with the customary key details picked out with great
economy of means in darker chalk. The almost brusque handling
of the boy's hair and the shading on his jacket is reminiscent of the
Windsor *Portrait of a Man* (see previous entry), while the slightly
faceted, plaque-like modelling of the face is similar to that used in
a portrait formerly with Colnaghi's, London (fig.47). [AWL]

13
ATTRIBUTED TO GIANLORENZO BERNINI
Portrait of a Young Man Wearing a Cap

Two shades of red chalk, heightened with touches of white
(partly oxidised), on buff paper, 24.9 × 19.4cm
Inscribed on the verso (visible in strong light through the backing):
Cavalier Bernini and *S.re Bernini.*
Oxford, Christ Church Picture Gallery
(JBS 621)

The attribution of this attractive drawing to Bernini, which is sup-
ported by the old inscriptions on its verso, has been unjustly
rejected by several scholars.[1] To be sure, several aspects of the pre-
sentation of the sitter are untypical of his portraits, notably the
three-quarters view with the eyes averted downwards rather than
looking out at the viewer. The fact that the boy wears a simple
workman's cap, while not remarkable in itself, also distinguishes
this sheet from Bernini's other portrait drawings. However, the
quiet, reflective mood, and stylistic details such as the treatment of
the wayward hair (with one lock casting a shadow over the brow),
the patchy, almost faceted modelling of the cap and face, the fine
hatching strokes on brow and cheek, and the selective suggestion
of a border to the collar, find parallels in drawings such as the
Windsor *Portrait of a Boy* (see previous entry). The combination in
one drawing of two slightly different shades of red chalk was also
a practice peculiar to Bernini. [AWL]

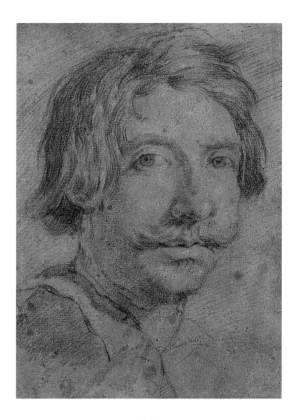

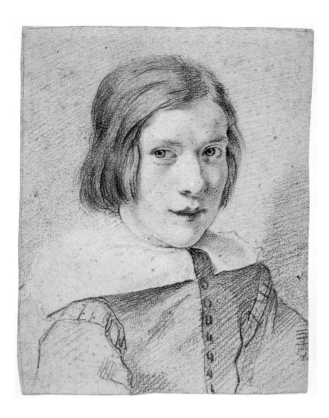

14

GIANLORENZO BERNINI

Portait of a Man with a Bushy Moustache

Red chalk, heightened with some white chalk (partly oxidised), on paper
prepared with a pale greyish wash, 29.9 × 20.8cm
Oxford, The Visitors of the Ashmolean Museum
(P.II.793)

So different are this sitter's features and facial morphology from
those of Bernini that a detailed refutation of the persistent
identification of this drawing as a self-portrait is unnecessary.[1] The
forms, and especially the light and shade, are handled with a
breadth and confidence which suggest a more advanced date than
the Ashmolean *Self-portrait* (cat.no.2), although this sheet is par-
ticularly difficult to place within the sequence of Bernini's portrait
drawings.[2] [AWL]

15

GIANLORENZO BERNINI

Portrait of a Boy

Black, red and white chalks (the white slightly oxidised in places)
on buff paper, 21.7 × 17.2cm
London, British Museum
(1980–1–26–69)

This hitherto unpublished portrait is notable for its excellent state
of preservation and exceptional chromatic richness.[1] Also unusual
for Bernini are the original black chalk framing lines visible at the
top and left edge of the drawing. The treatment of the hair and
face, and the selective emphases supplied by dampening the chalk,
are nevertheless entirely characteristic of him, as is the picking out
in fine red and black chalk of details of the eyes and eyelids, nos-
trils and lips. The almost geometric abstraction of the boy's collar
and jacket, with relatively systematic areas of hatching bordered
by darker, more angular contours, finds close parallels in such
drawings as cat.no.16 and fig.35. The British Museum sheet must
belong to precisely the same moment as the *Portrait of an Elderly
Man* formerly on the London art market (fig.46).[2] Quite where
these sheets fit in the sequence of his portrait drawings is not easy
to establish but a date in the mid-1630s seems possible. [AWL]

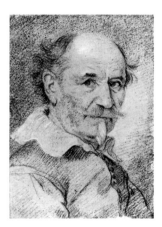

fig.46: Gianlorenzo Bernini, *Portrait of an Elderly Man*,
formerly London, Art Market

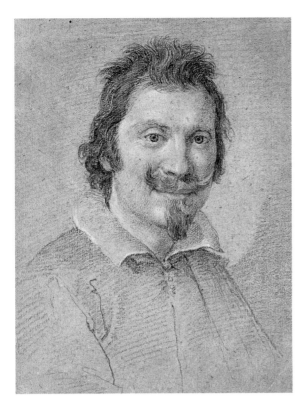 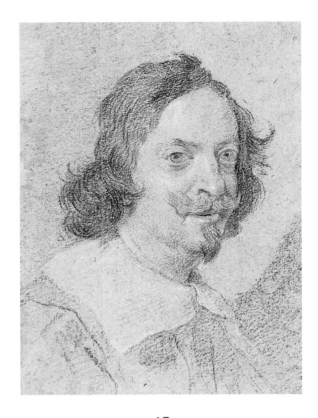

16
GIANLORENZO BERNINI
Portrait of a Man
Black, red and white chalks on buff paper, 25 × 18.5cm
Oxford, The Visitors of the Ashmolean Museum
(P.II.795)

17
GIANLORENZO BERNINI
Portrait of a Man
Black, red and white chalks on buff paper, 20.6 × 15.4cm
Windsor Castle, Royal Library
(RL5542)

Although more conventional in its presentation of the sitter (for example in the truncation of the torso) and slightly more reserved in its handling of the chalks, the execution of this drawing is technically very similar to that of the Ashmolean *Self-portrait* (cat. no.2). An understated and sympathetic portrait, the lively gaze and hint of a smile combine subtly to intimate a sense of genuine friendship between the artist and the sitter.

A *Portrait of a Man with a Moustache and Goatee Beard* which appeared recently on the London art market shows particularly close stylistic affinites with this drawing (fig.47).[1] [AWL]

The rather unattractive, bug-eyed sitter has surprisingly been identified by some scholars as a self-portrait, albeit with the qualification that it was made during or shortly after a severe illness Bernini is reported to have suffered (variously in 1638 or 1641).[1] The heavy reliance on tonal means, with only the softest of contours indicated, is also found in the *Portrait of Sisinio Poli* of 1638, although the overall appearance of this drawing suggests a rather later date. The areas of tone here are flatter and less modulated than in earlier drawings, and the irregular contour of the hair set-off more starkly against the background. The original of the later of the two Ashmolean *Self-portraits* (cat.no.4) may have resembled this sheet technically. [AWL]

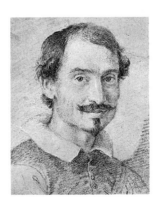

fig.47: Gianlorenzo Bernini, *Portrait of a Man with a Moustache and Goatee Beard*, Private Collection

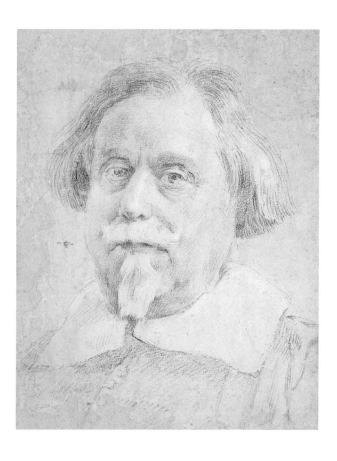

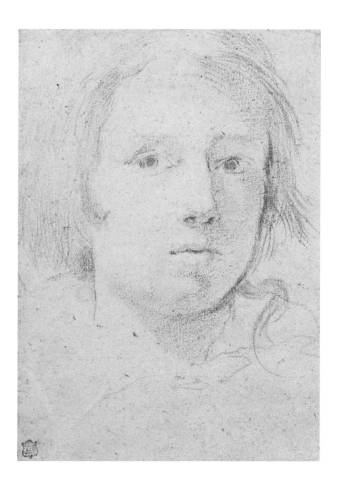

18
GIANLORENZO BERNINI
Portrait of a Man

Black, red and white chalks on off-white paper, 32.7 × 24.4cm
The paper in the background extensively damaged by insects or
silverfish, but this does not affect the drawing proper.
Windsor Castle, Royal Library
(RL5541)

The overall soft and feathery touch evident in this portrait, which gives it something of the appearance of a chalk offset, distinguishes it from all the other portraits exhibited here. Allowing for their difference in function, a tentative analogy with the soft, *sfumato* ('smoky') black chalk studies for the fountains at Sassuolo seems appropriate (cat.nos.101–2).[1] The argument that the style of the collar dates this portrait to around 1630 is undermined by the fact that broad collars of substantially the same type appear in later portraits, including the *Ottaviano Castelli* from the early 1640s (fig.35).[2] White chalk is here used extensively as a local colour to suggest the greying hair and beard, and the white collar, as well as in the rendering of light and shadow. [AWL]

19
GIANLORENZO BERNINI
Portrait of a Boy

Black chalk on buff paper, 25.9 × 18.4cm
Inscribed in ink on the verso in a seventeenth-century hand: *del Cav /
Bernini / pur venuto da / Palermo*
London, Private Collection

Assuming that this haunting portrait sketch is not simply unfinished, it seems appropriate to date it late in Bernini's career, probably to the 1670s.[1] The somewhat patchy application of shading, scant, almost random attention to descriptive detail, and exclusive use of black chalk, all align this sheet with the *Portrait of Clement X* (fig.44) and the copy of the late *Self-portrait* from the British Museum (cat.no.8), although the execution of this less formal portrait is even more summary and spontaneous. [AWL]

20
ASCRIBED TO GIANLORENZO BERNINI
Caricature of a Corpulent Man (front face of mount);
Caricature of a Man and Woman (back of mount)

Front: Pen and brown ink and wash; 28.4 × 19.7cm (including an
addition of *c.*5 mm at top and bottom made at the time of mounting)
A very rubbed and only partly legible black chalk inscription running up
the left edge of drawing: *Originale du Cavallier / Bernein faite in Rome en 74*
(?); also inscribed in pen on an old strip of paper stuck to the mount:
originale désiné de la main du (?)*cavvallie bernin, /* (?)*soculpiteur et
architéque, illustre. 1667. / fecite / Le mardy Gras. ine Roma,* [in a different
hand] */ Fiorentino sc. di Pietro suo padre.*
Back: Pen and brown ink and wash over black chalk; 24.6 × 16cm
Inscribed in ink: *un corno* (next to the man); *si cor mio* (next to the
woman); and at lower left: *Bernini*
London, Courtauld Institute Galleries
(Witt Collection 2274 A & B)

cat.no.20 *front*

cat.no.20 *back*

All early sources credit Annibale Carracci (1560–1609) with having invented true caricature, in the modern sense of a portrait of a real person with particular features and attributes exaggerated or 'loaded' (*caricato* in Italian) for comic effect, although few, if any, autograph caricatures by him survive.[1] It was in connection with the publication of a series of drawings of street vendors by Carracci that what might be termed the first theory of caricature appeared in print during Bernini's lifetime – itself an extremely clever parody of the classic-idealist theory of artistic beauty.[2] Among the artists who took up and developed Carracci's lead in the first half of the seventeenth century were Guercino, Domenichino and Pier Francesco Mola, but it was Bernini who arguably made the most significant contribution to the genre.[3] Again, only a few caricatures from his own hand survive, but many more are known through what appear to be faithful early copies gathered in two albums in the Vatican and the Gabinetto Nazionale delle Stampe in Rome.[4] Of Bernini's autograph caricatures, perhaps the most trenchant and merciless is the one in Leipzig of no less a personage than Pope Innocent XI Odescalchi (*reg.* 1676–89), which must date from the last four years of Bernini's life (fig.48).[5]

Despite the attestation of the old inscriptions, neither of these two drawings, which are clearly by different hands, can be accepted as the work of Bernini himself.[6] The specific assertion that the caricature of a grossly overweight man, apparently about to consume a skewer of meat, was drawn on 'Mardy gras' (Shrove Tuesday) 1667, lends some credence to the inscription, but its style is not consistent with what we know of Bernini's caricatures. The addition of an ink wash, for example, would be unique among Bernini's caricatures, whether original or copies. Uncharacteristic

of Bernini, too, is the sense that this is a parody of an anonymous stranger – almost of a type (fat people in general) – rather than of a specific individual known to him. That this sheet may nevertheless have originated in his circle seems plausible, for the bold penwork of the contours is not entirely dissimilar to that used by Bernini in his caricatures.

The same cannot be said, however, for the drawing on the back of the mount, which has an altogether more anecdotal and narrative character. It evidently shows a rather dismal-looking cuckolded husband (hence the horn or 'corno') being abandoned by his wife who, dressed in her finery and following her heart ('si cor mio'), exits to right in pursuit of her lover. The significance of the snails around the foot of the man is not clear, although it may allude to the idea that he is burdened with the weight of his troubles.

[AWL]

fig.48: Gianlorenzo Bernini, *Caricature of Pope Innocent XI Odescalchi*, Leipzig, Museum der Bildenden Künste

Portrait Busts

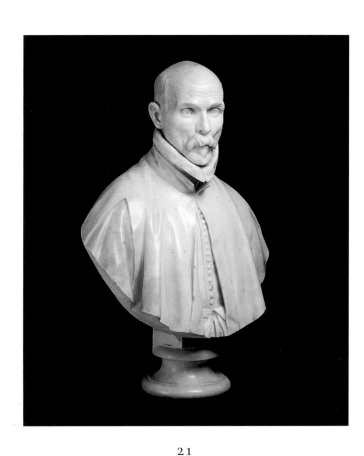

21
WORKSHOP OF GIANLORENZO BERNINI
Bust of Monsignor Pedro De Foix Montoya (died 1630)
Marble; on a circular, moulded socle, 67cm high
London, Howard Hodgkin

The prelate, with bald head, full moustache, and tightly-cropped beard, is shown frontally – head, shoulders, and torso. His head is inclined slightly downwards and he is looking slightly to the left. He wears a Jesuit's habit, with a tunic buttoned at the front and with a high collar, and a sleeveless overgarment buttoned below the neck.

Montoya, a jurist and a native of Seville, arrived in Rome in 1595. In about 1621–2 he commissioned from Bernini a bust for his tomb, which was to be erected in the Spanish national church of San Giacomo degli Spagnuoli.[1] A year or two previously he had acquired a pair of marble busts by Bernini of *Blessed* and *Damned Souls*, which were also placed in San Giacomo, and are now in the Palazzo di Spagna, Rome.[2] Baldinucci reported that when the sculpture was inspected by cardinals and prelates, one of them ex-

claimed: 'This is Montoya petrified!' At that moment Montoya himself appeared and Cardinal Maffeo Barberini greeted him with the words: 'This is the portrait of Monsignor Montoya' and, turning to the piece of sculpture, 'And this is Monsignor Montoya'.[3] Bernini told much the same story many years later in Paris, to Chantelou and the Venetian Ambassador.[4] The original of the Montoya bust, a landmark in Bernini's early naturalistic portraiture, was completed by 1623 (fig.49).[5] In 1631 the autograph bust was placed in a rich tabernacle tomb, the architecture of which was probably designed by Orazio Turriani.[6] The tomb was dismantled in about 1812, and later transferred to Santa Maria di Monserrato.[7]

The copy of the bust exhibited here may date from the early nineteenth century, but details such as the finish of the back would argue for a seventeenth-century origin.[8] Although certainly not autograph, the bust might well have issued from Bernini's studio around 1631, when the tomb was set up; the second bust was conceivably commissioned by the confraternity to whom Montoya had bequeathed his estate. Bernini explained that the Monsignor paid him extremely well, 'but left his portrait in his studio for a long time, without sending for it. He was rather surprised and spoke to several people about it, who explained to him that, as many cardinals and prelates saw the portrait in the studio, this did honour to Monsignor Montoya, for these same cardinals, ambassadors, and prelates stopped their carriages when they saw him in the street to talk to him about it, which pleased and flattered him, as before he had been remarkable in nothing'.[9] This would have allowed ample opportunity for a replica to be carved by one of Bernini's assistants. [TC]

fig.49: Gianlorenzo Bernini, *Bust of Monsignor Pedro de Foix Montoya*, Rome, Santa Maria di Monserrato

22

GIANLORENZO BERNINI

Bust of Monsignor Carlo Antonio dal Pozzo, Archbishop of Pisa (1547–1607)

Marble, 82cm high (including integral socle) 70cm wide
Inscribed around the truncation at the back: *CAR.ANT.PVTEVS
PIS.ARCH.*; and around the socle: *CA.PVT. / ARCHIEP / PISAN.*
Edinburgh, National Gallery of Scotland

Purchased with the aid of the National Heritage Memorial Fund, the
National Art Collections Fund, the Pilgrim Trust, the J. Paul Getty Junior
Charitable Trust, and private donations, 1986
(NG2436)

The bust is carved from a single block of white marble, with slight flecks and striations of blue-black. The prelate is shown with full moustache and trimmed beard, looking three-quarters to his right wearing a *mozzetta* (a short, buttoned clerical cape with a hood) The vertical and horizontal lines of creases, left when the heavy silk *mozzetta* was folded for storage, enliven the bare expanse of drapery and help frame the portrait above. The sitter is wearing a shirt beneath the *mozzetta*, of which the collar is revealed (the tip of the collar at the left has been chipped). He has a sharp, aquiline nose, broad brow, and square jaw, and the receding hair is close-cut. The surface of the marble is highly polished and splendidly preserved although a serious flaw, with discoloured old filling, exists over the upper left arm.

When the newly rediscovered bust was first published in the 1960s, Bernini's characterisation of the sitter was perceptively described in the following terms:

'There is a look of keen intelligence in the face, and a suspicion of humour in and around the eyes is more marked on the left side than on the right. The slightly-parted lips add to the expression of alertness which distinguishes the portrait ... The character and structure of the face are analysed with particular mastery and show great knowledge of the various bony, cartilaginous, and fleshy curves over which the skin pulls or droops'.[1]

The sockets above the eyes are excavated to create a deep shadow, presumably in order to tell from below and at some distance, while the treatment of the iris and pupil is singular. Within its lightly incised rim, the iris is drilled out to form a 'U' shape, leaving the raised pupil attached to the upper edge, which catches the light in such a way as to create an astonishingly vital and life-like effect. This was a device used frequently by Bernini in his portrait busts.

The abbreviated Latin inscriptions at the back (see illustration) and on the socle identify the sitter as Carlo Antonio dal Pozzo, the Archbishop of Pisa. The Latinised form of the sitter's name on the socle is shortened in such a way as to generate a pun: 'The head (*caput*, in Latin) of the Archbishop of Pisa'. Even before the identification of the present bust, it was known that a bust by Bernini 'Di Monsignor del Pozzo' must once have existed because it is listed, without location, by Filippo Baldinucci in his *Life* of the sculptor, dedicated to Queen Christina of Sweden on 5 November 1681, and published the following year.[2] It was remarked upon by Nicodemus Tessin the Younger (1654–1728) when he visited the Dal Pozzo Palace in the Via Chiavari in Rome in 1688: 'a beautiful marble bust of the Bishop of Pisa, Monsignor Carlo Antonio, which Cavaliere Bernini has made'.[3] The architect Robert de Cotte (1656–1753) visited Rome the following year, and in the seventh room of the Palazzo Dal Pozzo he noted a marble bust portrait of the Bishop of Pisa, brother of the Commendatore dal Pozzo, without mentioning the sculptor's name.[4]

The sitter was born on 30 November 1547 in the town of Biella in Piemonte, the son of Francesco Demarchi Romagni, Count of Ponderano, and Amedea Scaglia, daughter of Count Vervensi. He studied law in Bologna, and later met Cardinal Ferdinando de' Medici in Rome, where they became close friends. In 1571, Grand Duke Cosimo I called Dal Pozzo to Florence and appointed him a 'gran consigliere'. On 17 September 1582, Dal Pozzo was invited by Pope Gregory XIII Boncompagni to become Archbishop of Pisa. When Ferdinando succeeded his brother Cosimo as Grand Duke, Carlo Antonio became one of the three most powerful men in Tuscany.

As a patron of the arts, Carlo Antonio was not particularly distinguished or adventurous, although he was responsible for some important commissions. After a disastrous fire at Pisa Cathedral in October 1595, the Archbishop saw to the building's reconstruction. Of the work he ordered, the handsome coffered ceiling of the nave and the set of three great bronze doors, as well as the life-size bronze *Crucifix* on the high altar by Giambologna (1597), are of par-

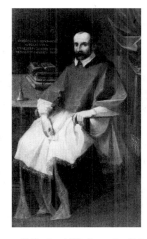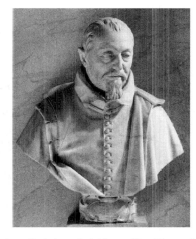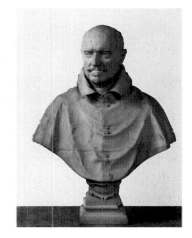

left fig.50: After Ventura Salimbeni(?), *Portrait of Monsignor Carlo Antonio dal Pozzo*, Pisa, Museo di San Matteo *centre* fig.51: Gianlorenzo Bernini, *Bust of Antonio Cepparelli*, Rome, San Giovanni dei Fiorentini *right* fig.52: Gianlorenzo Bernini, *Bust of Cardinal Alessandro Damasceni-Peretti Montalto*, Hamburg, Kunsthalle

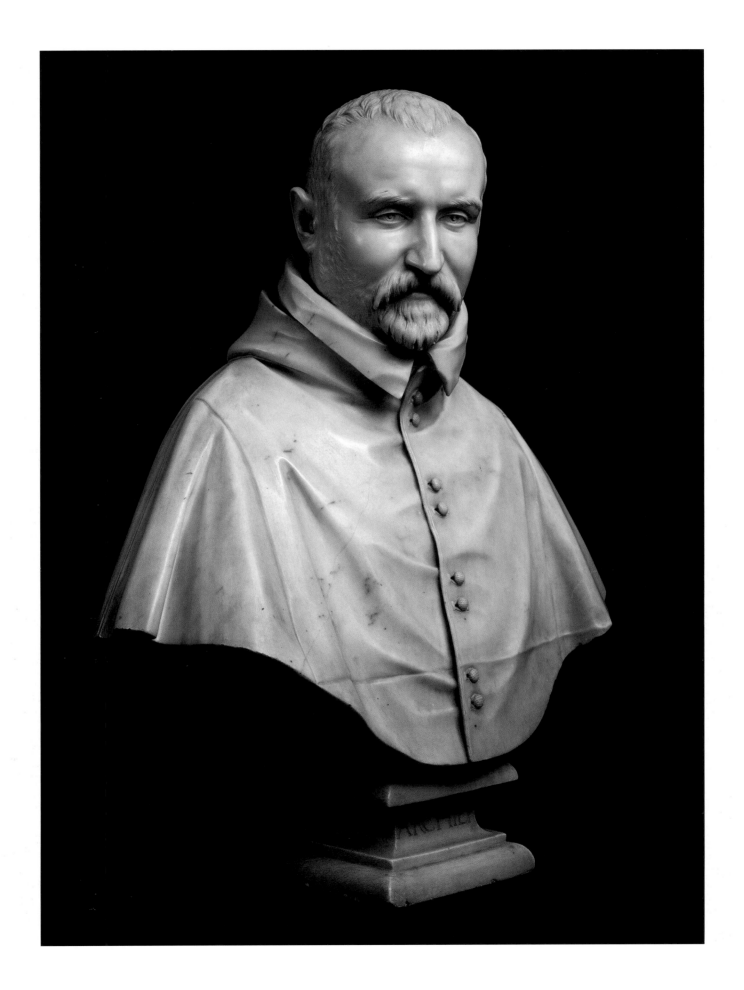

ticular note. Dal Pozzo commissioned three religious pictures from the Pisan artist Aurelio Lomi (1556 – after 1623): a *St Jerome*, dated 1595, for his own splendid funerary chapel in the Campo Santo; an *Adoration of the Magi* for the church of San Domenico in his native Biella (now in the Galleria Sabauda, Turin); and a *Madonna giving her Girdle to St Augustine and St Monica* (Pisa, San Nicola, dated 1595). The latter is of special interest, since it includes donor portraits of Grand Duke Ferdinand I, his wife, Christina of Lorraine, their son, Francesco, and of Carlo Antonio dal Pozzo himself. Carlo Antonio evidently had simple tastes, and from the point of view of cultural history his special importance lies in his having paid for the education in Pisa of his first cousin's elder son, Cassiano dal Pozzo (1588–1657), who was to become the celebrated antiquarian and patron of artists, notably Nicolas Poussin. It was almost certainly Cassiano who later commissioned this marble bust from Bernini, whom he knew.

Carlo Antonio, after a pious and distinguished life, died at Serravezza, Tuscany, on 13 July 1607.[5] It might seem a miracle that Bernini could carve such a convincing likeness of a man he had never met and who had died some fifteen years previously. Thanks, however, to recent archival discoveries, we now know that the Archbishop's death-mask was taken on 14 July 1607 by 'mastro Zanobi, formatore in Pisa', and paid for by Carlo Antonio's nephew, Amedeo dal Pozzo, Marchese di Voghera, who was the main beneficiary of his estate.[6] It seems likely that it, or a mould taken from it, may have been made available to Bernini when his bust of the Archbishop was commissioned, which would have served as a useful guide for the basic physiognomy and cranial structure of his subject. Many of the other busts carved by Bernini in his youth were posthumous portraits, and we know that a death-mask was used as the basis for the likeness on at least one other occasion – the very early portrait of Antonio Coppola in San Giovanni dei Fiorentini (1612).[7] It hardly needs stating, however, that Bernini's portrait of Carlo Antonio dal Pozzo is far from cadaverous in appearance, and we must assume that the sculptor also referred either to painted portraits, or to his imagination (or both), when creating his vivacious likeness.[8]

Of great interest in this connection are three painted portraits of the 'Arcivescovo Puteo' which feature, without attributions, in a list of items from Carlo Antonio's estate dated 25 September 1607, which were to be sent to his nephew Don Amedeo. What are presumably the same three portraits reappear in an inventory of Don Amadeo's own collection dated 20 July 1634, where one is identified as by Santi di Tito (1536–1602), and another by Ventura Salimbeni (1568–1613); the third is unattributed.[9] The sitter in the latter is described as seated and life size, and what is possibly an old copy of it is now in the Museo Nazionale di San Matteo at Pisa (fig.50).[10] Three further painted portraits of the Archbishop (conceivably the same ones) appear together in a post-mortem inventory of Signor Antonio dal Pozzo, drawn up in Florence in 1620, and known through a copy by Pier Leone Ghezzi.[11]

Carlo Antonio's appearance is described as follows in an account presumably written shortly after he died: 'fu di statura grande e grosso di pelo Biondo di Bella et veneranda faza et aspetto sanissimo nella sua vitta Expertissimo nel Bever [e] nel Magnare.' ('He was of big build, and fat, with fair hair, and a handsome and

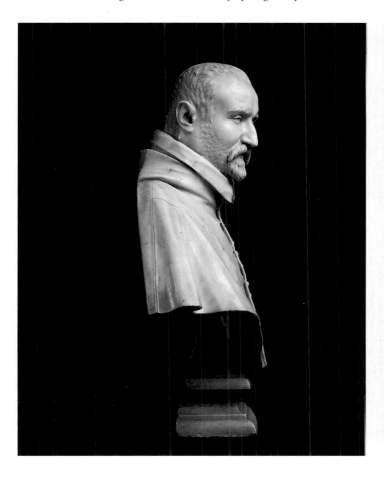

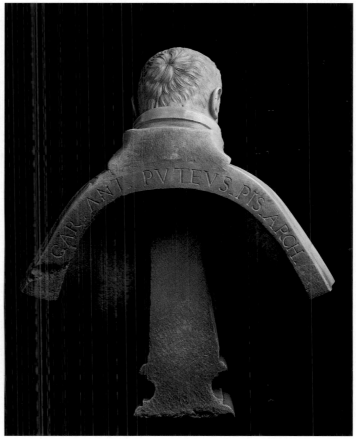

venerable face and a very healthy appearance; throughout his life, he was extremely knowledgeable about drinking and eating.').[12] Bernini has no doubt captured something of the spirit of this *buongustaio*, but although the brow is broad and the cheeks full, the features in the bust could hardly be described as fat, especially when compared, for example, to Bernini's *Bust of Cardinal Scipione Borghese* of 1632. With the sitter long dead, one must assume either that the models with which Bernini was supplied were deliberately flattering, or that Bernini was retrospectively idealising his subject in accordance with the wishes of the patron.

Sadly, there is no documentary evidence which sheds light on the circumstances of this commission, but the order was almost certainly placed by Carlo Antonio's *nipote* and protégé Cassiano dal Pozzo, as a tribute to the Archbishop's role in his own education.[13] Stylistic features of the bust nevertheless allow us to date it with some assurance to the first half of the 1620s, and probably more precisely still to the years 1622–4. The compelling naturalism of the carving of such details as the close-cropped stubble, the sense of movement generated by gentle turn of the head away from the vertical axis, and the bow-shaped truncation of the bust, affiliate this portrait closely with those of Pedro de Foix Montoya (probably late 1622; see cat.no.21), of Antonio Cepparelli (1622–3; fig.51) and of Cardinal Roberto Bellarmino (1623–4; fig.11).[14] The Edinburgh bust arguably finds its closest parallel in the bust of Cardinal Alessandro Damasceni-Peretti Montalto (1571–1623), great-nephew of Pope Sixtus V, which is in the Kunsthalle in Hamburg (fig.52).[15] Datable to about 1623, with its dark veining it could virtually have been carved from the same block of marble as Carlo Antonio.

There is no way of knowing how or where the bust was initially displayed in the Palazzo Dal Pozzo, which Cassiano shared with his younger brother Carlo Antonio. The prominence of the finely cut inscription around the truncation at the back, which is unique among Bernini's portraits, might suggest that it was intended to be visible rather than set against a wall (although is should be noted that many of Cassiano's pictures were later inscribed on their backs in similar fashion). There is in any case no reason to suppose that the display of the collection changed substantially after Cassiano's death in 1657, when Carlo Antonio inherited the property and its contents, and continued to make it accessible to international *savants*. We know from documentary sources that in 1689 there was 'un piedistallo scanellato di pero con sopra il ritratto in marmo di Monsignor Carl' Antonio Arcivescovo di Pisa', in the 'stanza overo studio delle Medaglie' ('a fluted pearwood pedestal supporting the marble portrait of Monsignor Carlo Antonio, Archbishop of Pisa', in 'the room, or rather study, for coins and medals'); while in a post-mortem inventory of Gabriele, Carlo Antonio's son, of 5–7 March 1695, we learn that the bust was still in the Stanza delle Medaglie, but its pedestal is described simply as 'nero di legno' ('black and made of wood').[16] The bust's subsequent history remains obscure, but it was probably acquired by Henry Howard, 4th Earl of Carlisle, during his visit to Rome in 1717, when he was purchasing classical sculptures (including some from the Dal Pozzo collection) to furnish Castle Howard, his palatial country house in Yorkshire. Its importance was evidently soon forgotten, and it remained unrecognised at Castle Howard until the 1960s, and was acquired from there by the Gallery in 1986.

[TC & AWL]

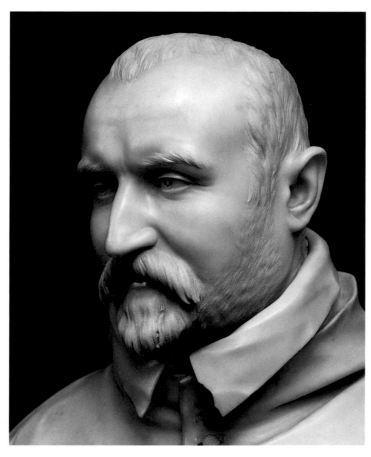

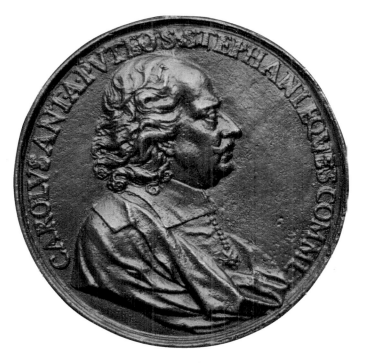

cat.no.23 *obverse*

cat.no.23 *reverse*

23

ATTRIBUTED TO GIOACCHINO FRANCESCO TRAVANI
*fl.*1634–1675

Carlo Antonio dal Pozzo (1606–89)

OBVERSE: Carlo Antonio, in profile to right, with flowing hair and
moustache, wearing a tunic, buttoned up the front, a broad collar, the
Order of Santo Stefano, a cloak around his shoulders; around:
CAROLVS ANT.A.PVTEO.STEPHANI.EQVES.COMMEN
REVERSE: Piety, seated as a Roman matron teaching three ragged
children before her; above and around: *PIETAS*
Bronze (cast); 8.9cm
Edinburgh, National Gallery of Scotland
(NG2576)

This rare medal portrays the younger brother of Cassiano dal
Pozzo, and sometime owner of Bernini's *Bust of Monsignor Carlo
Antonio dal Pozzo, Archbishop of Pisa* (see previous entry).[1] The
medal is unsigned, but must date from after 21 February 1657,
when Carlo Antonio was appointed a Knight of the Order of Santo
Stefano; it may well have been issued to comemmorate this
appointment. Carlo Antonio was especially renowned for his
charitable activities, which would account the image on the re-
verse. In 1627, for example, he became a deputy of the congrega-
tion of San Girolamo della Carità in Rome, and later also of the
charitable Society of the Holy Rosary. An etching by Pietro Testa
of a scene of almsgiving is dedicated to Carlo Antonio, 'the ben-
efactor of the poor'.[2]

In the case of this medal, there may have been a specific refer-
ence to the Collegio Puteo in Pisa, founded by Carlo Antonio's un-
cle and namesake the Archbishop, to house and educate youths
from northern Italy. The Collegio was located in the piazza oppo-
site the headquarters of the Order of Santo Stefano. [TC]

24

CAST FROM A MODEL BY GIANLORENZO BERNINI

Bust of Maffeo Barberini,
Pope Urban VIII (1568–Pope 1623–44)

Bronze, 104.5cm high, including the integral socle
Blenheim Palace, His Grace the Duke of Marlborough

The identification and authorship of this bust, which had been
known at Blenheim as a 'Tsar of Russia', were noted by the present
writer in 1974, but published only recently.[1] It is probably to be
identified with one that was sold from the Roman church of Santa
Maria di Montesanto in the nineteenth century, and replaced with
a plaster cast which is apparently identical in form. It was evidently
cast from the same model (which, to judge by the apparent age of
the sitter, may have dated from the later 1630s) as that used for the
bronze bust of Urban now in the Louvre.[2] Its presence at Blenheim
is due to the fact that the 9th Duke of Marlborough was a convert
to Roman Catholicism and acquired this papal bust, as well as two
in marble depicting cardinals, in his enthusiasm for his new faith.

Bernini, who when young had been a protégé of this particular
Pope and became a great friend, kept a terracotta model of one of
his various portraits of Urban VIII in his house until his dying day.
This was probably the model for the two busts in marble (one still
in the Barberini Collection in Rome and the other in the National
Gallery of Canada, Ottawa, fig.53) that Bernini carved in 1623,
shortly after Urban's accession to the papal throne.[3] In these
Maffeo engages the viewer with a sympathetic and quizzical gaze.
His beard, of which he was most proud – he was sometimes re-
ferred to as '*Papa Urbano della bella barba*' ('Pope Urban of the
beautiful beard') – was skilfully rendered by Bernini by undercut-
ting and dry chiselling.

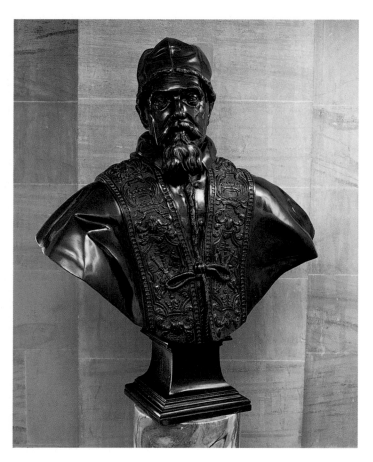

cat.no.24

In that image the sitter wears a fur-lined cape, whereas in the present one he is shown in a chasuble, its border richly embroidered with the papal insignia of crossed keys (representing the symbolic keys to the Church given metaphorically by Christ to St Peter in the New Testament). Later, Bernini produced a yet more splendid bust in bronze, with Urban – a few years older – arrayed in full pontifical regalia, including the papal triple-crowned tiara (Spoleto Cathedral).[4]

[CA]

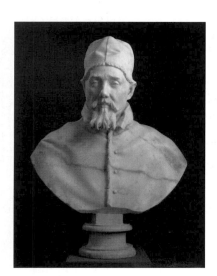

fig.53: Gianlorenzo Bernini, *Bust of Pope Urban VIII Barberini*, Ottawa, National Gallery of Canada

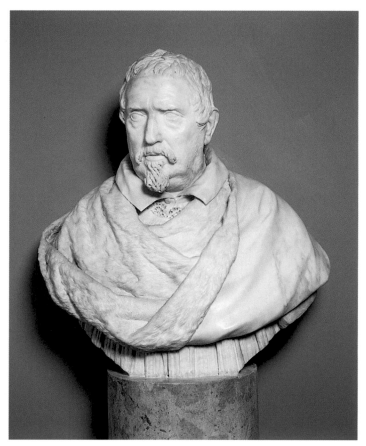

25
GIULIANO FINELLI 1601/2–1653
Portrait of Francesco Bracciolini dell'Api (1566–1645)

Marble, 66cm high, 61.5cm wide
London, Victoria and Albert Museum
(8883–1863)

This powerful portrait of the poet, playwright and courtier Francesco Bracciolini was for much of its history thought to be by either Bernini or Algardi, and only relatively recently, in a pioneering reconstruction of Giuliano Finelli's style and critical fortune, was it correctly ascribed to the sitter's fellow Tuscan, and dated to about 1630–33.[1] Subsequently documentary evidence was discovered, in the form of a poem, which confirms Finelli's authorship.[2] More recent specialist studies have clarified further the individuality of Finelli's sculptural style, and have illuminated various aspects of his artistic and professional relations with Bernini and Algardi.[3]

A native of Carrara and possessed of a prodigious natural talent, the young Finelli spent almost a decade in Naples, refining his technique in the workshop of the Florentine Mannerist sculptor Michelangelo Naccherino. From the time of his arrival in Rome from Naples around 1621, when he joined the workshop of Pietro Bernini, Finelli inevitably came under the sway of Gianlorenzo Bernini. He was highly praised for his virtuoso contribution to Bernini's *Apollo and Daphne* of 1622–4 (see cat.no.43), of which he carved many of the naturalistic details.

But he also remained receptive during the 1620s to the more sober and classical influences of Algardi and of the Fleming François Duquesnoy. By 1630 Finelli had become an independent master specialising in portraiture, and his services were soon sought by the most eminent Roman patrons, among them Cardinals Giulio Antonio Santoro, Giulio Sacchetti and Domenico Ginnasi.

The firm dating of the present bust to 1630–31 on the basis of newly discovered letters underscores Finelli's inventiveness in this genre.[4] The overall conception of this portrait, its intense realism in the description of surfaces and textures (down to the wart on Bracciolini's left cheek), and its truncation of the torso below (rather than at) the line of the mantle, is reminiscent of Algardi's portraiture, but it in fact predates by several years most of Algardi's comparable busts.[5] On the other hand, the extremely accomplished use of the drill to render details of the hair, beard and lace collar reflects Finelli's experience as Bernini's assistant. However, Finelli was here less interested than Bernini would have been in conveying an effect of potential movement, let alone the impression of interrupted action, and hence of drama, that characterises most of Bernini's mature portrait busts. On the other hand, Finelli does succeed in conveying a strong sense of psychological presence, as well as something of the indomitable personality and intellectual standing of the ageing poet and courtier. He gave Bracciolini an almost heroic pose, derived ultimately from ancient Roman (notably Augustan) models. Wrapped in a sumptuous fur-lined mantle, which Finelli was to use again in his bust of Monsignor Girolamo Manili (Rome, Santa Maria Maggiore), this well preserved sixty-five year old appears alert and vibrant, not unlike the slightly later portrait of Cardinal Giulio Sacchetti (Rome, Palazzo Sacchetti). The carving of the marble is particulary close in style to that of the bust of Michelangelo Buonarroti the Younger of 1630 (Florence, Casa Buonarroti), which seems to represent a major watershed in Finelli's career: together, these two portraits confirm his essential independence from Berninian models.[6]

Francesco Bracciolini was included by Ottavio Leoni in his series of etchings of famous men in 1626 (fig.54), and his reputation was at its height around 1630 when Finelli carved this bust. Already known for his epic poem *La Croce riacquistata* (Paris, 1605), and the mock-epic *Lo scherno degli dei* (1618), in 1628 he had published his panegyric *L'Elettione di Urbano Papa VIII, o La Divina Provvidenza* ('The Election of Pope Urban VIII, or Divine Providence') in honour of the Pope, with whom he had been on close terms earlier in his career, and whom he had served as secretary (1601–5).

Contrary to the image of Bracciolini projected by Finelli's bust, and notwithstanding his considerable literary talents, his was a far from heroic personality. With the death of Pope Clement VIII in 1605 he had assumed that Maffeo Barberini's career would be cut short, and had abandoned his patron to return to his native Pistoia, where he took holy orders. This, incidentally, explains why Finelli portrays him as a Monsignore, wearing the clerical alb beneath his fur-lined cloak. When in due course Maffeo was elected Pope, Bracciolini came crawling back to seek his pardon, which was magnanimously granted. In recognition of his subsequent devotion to Urban, he was even granted permission to append the Barberini bees ('api') to his name (see fig.54).

A painted portrait of Bracciolini (fig.55), probably by a member of Pietro da Cortona's studio and dating from around the same period (c.1630–35), survives in the collection of the heirs of Cassiano dal Pozzo, whose Roman house was famous for its collection of such portraits of illustrious contemporaries and friends.[7] It was Bracciolini who supplied the programme for Pietro da Cortona's great ceiling fresco in the *salone* of Palazzo Barberini (begun in 1632), which is closely related thematically to the eulogising *Elettione* of 1628. [FS]

left fig.54: Ottavio Leoni, *Portrait of Francesco Bracciolini*,
etching, London, British Museum

right fig.55: Studio of Pietro da Cortona, *Portrait of Francesco Bracciolini*,
Private Collection

26

AFTER GIANLORENZO BERNINI
(ENGLISH, SECOND HALF OF THE
SEVENTEENTH CENTURY)

King Charles I

Plaster cast, 31 × 35 × 20cm
The Trustees of the Berkeley Will Trust

By its inclusion of seraphic winglets around the face, this excerpt from Bernini's documented, but lost, bust of Charles I shows him as 'King and Martyr'.[1] The original was commissioned by Queen Henrietta Maria in 1635, and was carved on the basis of the celebrated triple portrait of the King painted specially by Sir Anthony van Dyck (fig.56).[2] Bernini's heroic though solemn bust of the king, with daringly undercut hair – including his splendid 'handle-bar' moustache – and drapery, arrived in 1637 and was very well received by the monarch. The sculptor was rewarded with a diamond of great worth, and was soon commissioned to produce a matching bust of the Queen, for which Van Dyck prepared separate studies of her wearing different clothes (see fig.18), but with the outbreak of Civil War the project lapsed.

The bust of King Charles seems to have been destroyed in a fire at Whitehall Palace in 1698, but there is quite a lot of evidence regarding its appearance: a variant in marble by an English sculptor,[3] an unfinished engraving, and drawings by Richardson and Vertue of plaster casts.[4] This plaster cast, and another in private hands, both only recently published, are significant additions, offering the most accurate record to date of the appearance of the face of Bernini's original. Even in this rather scratched and abraded cast, one can fully appreciate the virtuoso carving of the original, with its carefully contrasted textures of flesh and hair. The distinctive treatment of the eyes, with the iris drilled out in a crescent shape, leaving a projecting peninsula of marble at the top to catch the light and enliven the glance, is a hallmark of many of Bernini's portraits (see, for example, cat.no.22).

The newly discovered plaster casts indicate that the bust of Charles I at Windsor, which has long been thought to be a fairly faithful copy, was in fact quite liberal in its interpretation of details such as the wavy moustache and the exact play of hair around the forehead, perhaps simply owing to the sculptor's lack of Bernini's supreme ability and confidence in carving in details. [CA]

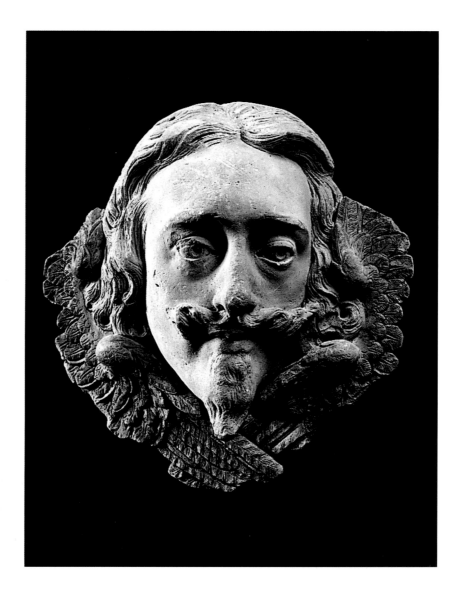

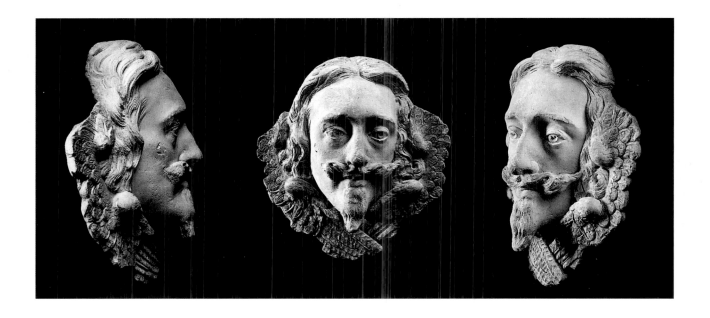

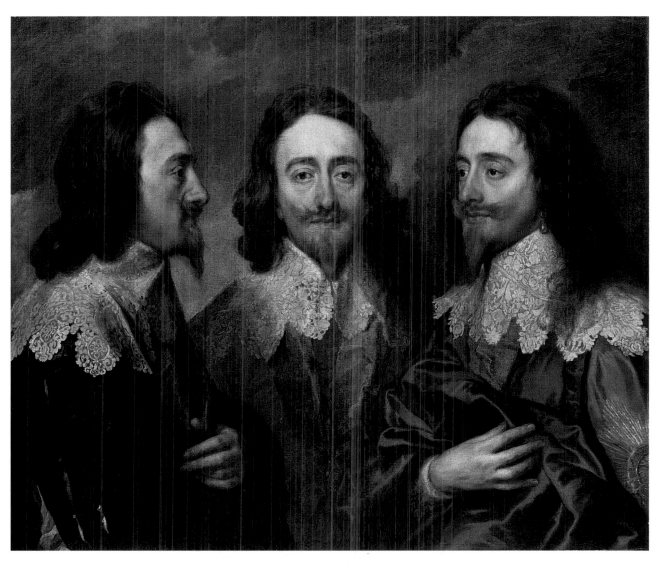

fig.56: Sir Anthony van Dyck, *Charles I in Three Positions*, Windsor Castle, The Royal Collection

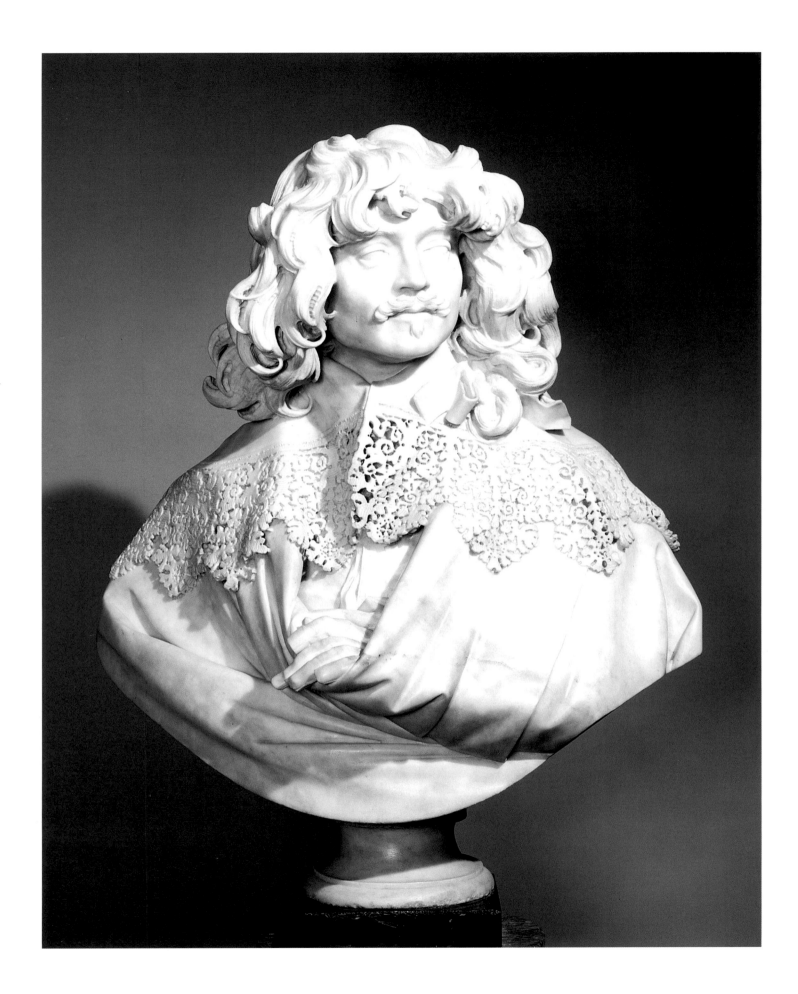

27

Bust of Thomas Baker (1606–58)

Marble, 81.6cm high, 72cm wide
London, Victoria and Albert Museum
(A63–1921)

By rights, the centrepiece of any British exhibition of Bernini's work should have been his bust of Charles I, carved in 1636 and destroyed in the fire at Whitehall Palace of 1698 (see previous entry). The Pope, Urban VIII, ordered his favourite sculptor to execute the bust as a favour which he hoped might draw the King nearer to the old faith. Exclusivity was a crucial part of the pontifical gift, so Urban was annoyed when he discovered that Bernini was carving a portrait of Thomas Baker, a minor English squire visiting Rome.[1] Bernini undertook the commission some time between 1637 and 1639, in order to show his English admirers what he could do from the life (rather than from a portrait) and because of a princely offer by way of payment. He was told to stop work immediately. The present bust must therefore be either unfinished, or finished openly by one of Bernini's assistants, or surreptitiously by the master himself. The most likely explanation is a mixture of the last two alternatives: the face is seemingly by Bernini's own hand, whereas the lace and drapery betray a mechanical studio procedure.[2] The blank eyes and the obtrusive strings of drill-holes in the hair are both highly effective devices in their own right and do not necessarily imply compulsory abandonment of the bust.

It may at first seem surprising that Bernini wished to demonstrate the advantages of working from the life through a model who appears to be such a mannequin. Bernini is known to have latched on to the slightest individuality or irregularity of feature in order to give character to his heads; he even boasted of his desire to record five-o'clock shadow in stone.[3] Such distinctive details are present in this bust, but one has to seek them out: there are faint dimples in Baker's cheeks; fine cartilages in his slender nose; hints of loose flesh under his chin. Otherwise Bernini here seemed content to groom a fashion icon, laying out the moustache into three precisely symmetrical skeins, leaving the eyes unmarked by any indication of pupil and polishing the skin to an Olympian smoothness. In part this is a record of a certain type of northerner's skin – fine, lightly-downed and luminous. High polish enables Bernini to give his marble the same translucent quality, seen especially in the aristocratically flared nostrils, which glow on the inside like frosted glass. There is also some guile in this oversimplification. Bernini has followed nature sufficiently to fix the likeness and satisfy his patron, while at the last moment veering towards caricature. His target is fashionable vacuity, so that the more bland the surface the more expressive the characterisation.

Bernini was famous for his caricatures, many of which have survived only in the form of copies (see cat.no.20), and there are accounts of three-dimensional equivalents, moulded in wax.[4] Caricature works by exaggeration, and in this case Bernini tactfully chose to exaggerate Thomas Baker's coiffure (it is too early in the century to be a wig). The weight of stone given over to hair is prodigious as is the gap between it and the face, so that the resulting shadows give it the necessary volume. There is no way of putting the matter to the test, but Baker simply *can't* have carried around a mop this profuse! The pattern of hair too is eye-catching. Bernini has here employed an unfinished effect, more like a painter than a sculptor, so that the strands are 'sketched in' and simplified, and the surface half-polished (especially in contrast to the skin). Yet there are no short-cuts in dealing with the complexity of the tangles: for every major rope of hair there is a stray lock which has swung round and lies against the flow. The meeting of the forehead curls and the eyebrows is an especially felicitous detail, the marble looking more like melted wax than chipped stone.

The effect is all the more striking when contrasted with the classical style of bust popular throughout this period. A Roman head has short curls clinging to the skull; it gains dignity by its single cannon-ball mass. The two parts here – massive hair with a dainty face almost lost in it – could not be less Roman.

As can be seen from his sketch of Innocent XI (fig.48), Bernini's caricatures also employ simplification, often taken to the point of omission. It is as if he types in the characteristic minimum of the sitter's features and attributes (a kind of essential 'pin-number'), and the viewer's recognition supplies the rest. Omission is difficult in a finished, fully carved block of marble: the blank eyes are all that Bernini could do in this department. Simplification, on the other hand, can come (as here) from repeated polishing, which lifts off individuality of detail from the surface of the marble. In this respect it is the exact opposite of a drawing, where the paper is simplest when left untouched. Bernini's bust is a succinct and witty caricature of a supercilious popinjay. [DST]

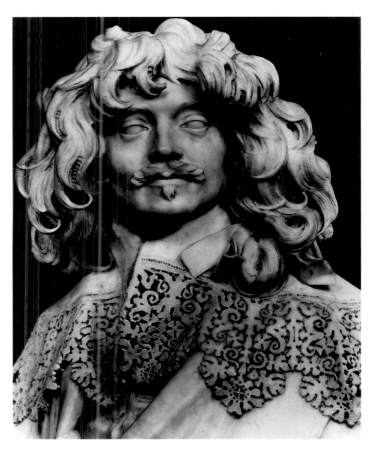

28

ALESSANDRO ALGARDI

Bust of Monsignor Antonio Cerri (1569–1642)

Marble, 85.5cm high
Manchester City Art Galleries
Purchased with the aid of the National Heritage Memorial Fund, the
National Art Collections Fund, the Pilgrim Trust, and private donors
(1981–305)

This bust is carved from a single block of white marble, and is in excellent condition. The elderly prelate is shown with closely-cropped receding hair, neatly-trimmed moustache with the tips pointing upwards, and a goatee beard. He is inclining his head forward and slightly to the left. Cerri is wearing a *mantella* with high collar attached at the neck, with vents for the sleeves, over a surplice trimmed at the neck with lace and with a tasselled draw-string hanging loosely to the lower left. The profile moulded pedestal with bow-shaped front is carved with the arms of Cerri – an uprooted oak tree – in a cartouche surmounted by a monsignore's hat.

This is an autograph bust by Algardi, of which there is a studio replica on the sitter's tomb in the Cappella Cerri in the Gesù in Rome (fig.57).[1] The early history of the bust, prior to its appearance at auction in 1917, remains to be firmly established, but it has been very plausibly suggested that it was brought to England by Henry Thomas Beresford Hope (1808–62), son of the famous collector and neoclassical designer Thomas Hope.[2]

This is a *tour de force* of carving by Algardi, in which the subtle characterisation and grave demeanour of the sitter reflect his profound study of classical portrait busts. The exquisite handling of the veins in the temples, the 'crow's feet' around the eyes, and the perfectly observed ears, display to perfection Algardi's sensitivity and technical virtuosity. The handling of the drapery is equally subtle, with the *mantella* being polished and the surplice left roughly textured. The overall calm *gravitas* of the portrait is relieved and animated by the dense, busy pleats of the surplice; the finely drilled lace-work; the gently swaying tassel and draw-string,

which emerge in an almost casual fashion from beneath the mantle; and the spirited cartouche, which seems to weld itself organically to the socle. A more severe version of this coat-of-arms forms part of the architecture of the Cerri Chapel (fig.58).

Cerri came from a distinguished Pavia family, and held various offices under Pope Urban VIII and Cardinal Francesco Barberini, including that of *Avvocato della camera Apostolica*. As early as the 1620s, Antonio Cerri had determined to purchase a chapel, in gratitude for the recovery from illness of one of his sons. At that stage it was to have been in the Theatine church of Sant'Andrea della Valle. Eventually, on 29 April 1640, he acquired the chapel in the Gesù which still bears his family's name. Cerri died two years later.

In the absence of documentary evidence, it is difficult to date the bust accurately, but on stylistic grounds it has been argued that it was carved at much the same time as that of *Cardinal Giovanni Garzia Mellini* in Santa Maria del Popolo of around 1637.[3] However, the style seems very close to the *Memorial of Odoardo Santarelli* in Santa Maria Maggiore, which probably dates from 1644 or after.[4] That being the case, there seems no persuasive reason why the Manchester bust does not date from a few years later than has hitherto been proposed, perhaps from 1640, when Cerri purchased the chapel in the Gesù. It also seems very close to the bust of *Cardinal Carlo Emanuele Pio da Carpi* at the Villa Mombello, Imbersago, which appears to date from 1641 or after.[5]

The chapel in the Gesù was designed by Pietro da Cortona, as we know from a contract dated 10 October 1645.[6] A Cortonesque drawing in the Kunstbibliothek in Berlin shows part of the right wall of the chapel much as executed, but with a large profile medallion in the niche in which the replica of the Antonio Cerri bust now stands.[7] The mediocre replica of the Manchester bust *in situ* in the chapel is plausibly attributed in one early source to Domenico Guidi (1625–1701), a competent and versatile sculptor who was one of Algardi's principal assistants (see also cat.nos.29 and 31).[8] It omits some of the finer details visible in the Manchester bust, such as the tassel, and, without a socle, it fits snugly into its circular niche. [TC]

left fig.57: Attributed to Domenico Guidi, *Bust of Monsignor Antonio Cerri*, Rome, Il Gesù, Cappella Cerri

right fig.58: Roman School, seventeenth century, *The Coat-of-Arms of Cardinal Carlo Cerri*,
Rome, Il Gesù, Cappella Cerri

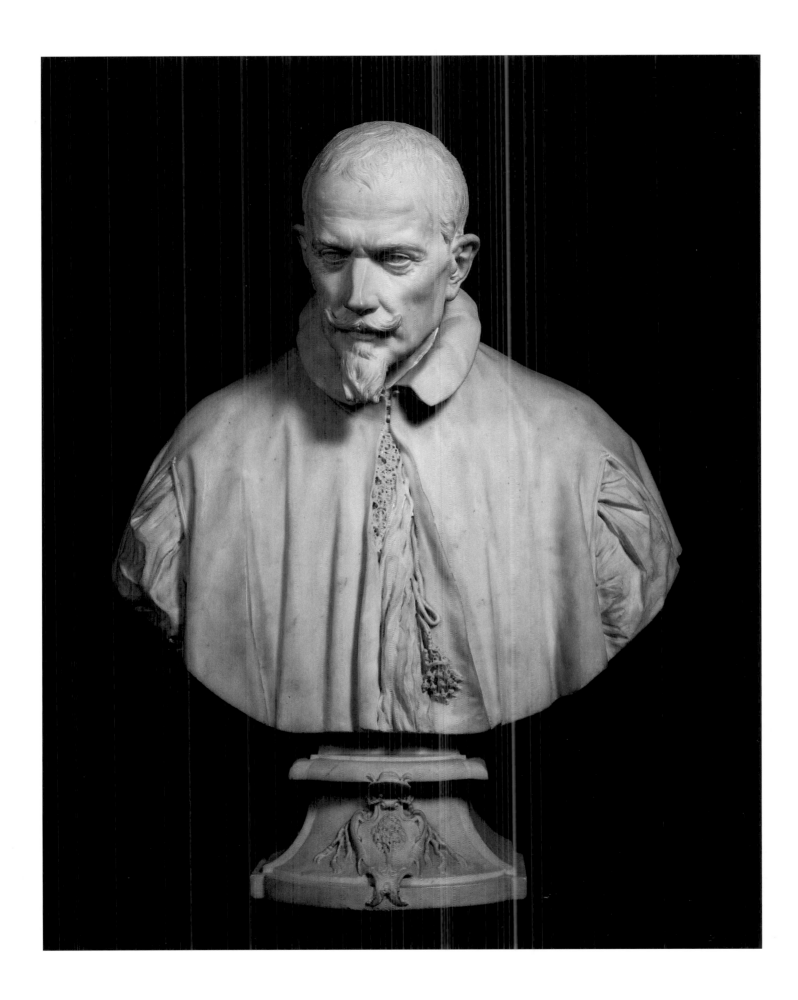

29

CAST BY DOMENICO GUIDI,
FROM A MODEL BY ALESSANDRO ALGARDI

Giovanni Battista Pamphili (1574–1655),
Pope Innocent X (from 1644)

Bronze, 97.5cm high, 87cm wide
London, Victoria and Albert Museum
(1088–1853)

This bust was purchased in London with a matching one showing Pope Alexander VIII. Such a pairing proves that they cannot have been cast before the latter's election in 1689 and that therefore the present image must be posthumous.[1] Traditionally the present bust has been regarded as by Algardi on account of its close similarity in all respects (save perhaps slightly more dramatically crumpled drapery) to Algardi's portraits of the Pope, notably a terracotta example in Palazzo Odescalchi, Rome.[2] However, its relationship with the bust of Alexander VIII furnishes a clue as to its actual maker, Domenico Guidi, for in an inventory of 1780 another bust of Alexander was listed as by Guidi, along with an Innocent X ascribed to Algardi.[3] It is highly probable therefore that Guidi was responsible for making the bust that accompanied his own creation, for he was one of the few sculptors of the seventeenth century to cast and finish his own bronzes. Using the standard model of his deceased master, Guidi strengthened the zig-zagging pattern of folds and altered some details in order to approximate his own style, as manifested in the bust of Alexander VIII that it was to pair.

Algardi's original bust of about 1650 'provides a deeply sensitive interpretation of the man and the pontiff, his tired and irascible eyes reflecting the bitterness of his many disappointments, together with an awareness of his power and the dignity of his rôle'.[4] It was carved in rivalry with Bernini, the more fiery sculptor of the two, who produced two portrait busts in marble of the same pope, both now in Palazzo Doria-Pamphili, Rome.[5] Algardi's calm and contemplative image is probably physiognomically the more accurate, as can be gauged by comparison with a third, masterly portrait of Innocent, this time in paint, by Diego Velázquez.[6]

Bernini, in an attempt perhaps to introduce the impression of actual colour and of drama into his head, grossly exaggerated certain features, notably the bulges over the brows and the sunken cheeks, in an almost caricatural way. There may even be a trace in their respective images of the sculptors' reciprocal attitudes to the Pope, for Innocent much preferred Algardi to Bernini, to whom he begrudged commissions, famously that for the *Four Rivers Fountain* in Piazza Navona, Rome. [CA]

30

ALESSANDRO ALGARDI

Profile Portrait of Pope Innocent X Pamphili

Black chalk, 12.3 × 9cm
London, Colnaghi Drawings

Given Algardi's distinction as a portrait sculptor, it is surprising that this newly discovered sheet is one of only two known portrait drawings by him.[1] The other, a pen and ink study in the Academia di San Fernando in Madrid, also represents Pope Innocent X in profile, and was evidently drawn rather earlier in his pontificate.[2]

It was during Innocent's papacy, when Bernini's fortunes suffered a temporary eclipse, that Algardi's career really blossomed.

The present drawing, small in scale and summary in handling, was most likely drawn from life. The rapid execution and slight adjustments to the contours of the cap and profile suggest that the sitter did not remain completely stationary, and these features give the portrait a less formal appearance than the more precise one in Madrid. The pentimenti around the lips and the creasing of the lower cheek convey the impression that the Pope was speaking – perhaps giving an audience – when the drawing was made. The separate patch of chalk at the right might be evidence of the draughtsman testing his material before commencing. Black chalk alone was a technique used relatively rarely by Algardi, although handling comparable to some passages here, such as the fairly broad parallel hatching, can be found in such drawings as the *Allegory of Bologna* in the Art Institue of Chicago,[3] and the *Venus in her Sea Chariot* in the J. Paul Getty Museum.[4]

It is tempting, given its profile view and diminutive scale, to associate this sketch with Algardi's activity as a designer of medals (see cat.nos.158–9).[5] The fact that it is considerably larger than the medals to which it might relate does not necessarily exclude this connection, for – unlike most of Bernini's designs for medals – this is also true of Algardi's recently identified sketch of *God the Father*, which unquestionably relates to the reverse of a medal (fig.156). On the other hand, the small size of the present drawing could equally well be explained by the demands of sketching a mobile subject from life. Indeed, this little drawing is the strongest evidence to emerge to date that Algardi may have adopted the practice, so often associated with Bernini, of making informal sketches to familiarise himself with a subject before embarking on a portrait bust. If so, it is questionable whether it is appropriate to connect the drawing directly with any one of Algardi's many sculpted portraits of Innocent X (see previous entry), but of these it perhaps bears the closest resemblance to the bronze bust in the Palazzo Doria Pamphili in Rome.[6] [AWL]

31

DOMENICO GUIDI 1628–1701

Bust of the Virgin Annunciate

Marble; an iron ring with two links at the back for fixing to wall,
89cm high × 76cm wide
Edinburgh, National Gallery of Scotland
(on loan from the Estate of the late Lord Kinnaird)

The Blessed Virgin Mary, as the 'most highly favoured lady', receives the news of the Incarnation from Gabriel, the angel messenger of God.[1] We can assume that there once was a companion bust of the Angel Gabriel, which is now missing. According to St Bernard, Mary was studying the book of the prophet Isaiah and had just recited the verse: 'Behold, a Virgin shall conceive and bear a son ...' when the Angel appeared.[2] The sculptor has shown her with her eyes lowered, appropriately full of meekness and grace.

Since at the least the early nineteenth century, the bust was believed to have been by Bernini, and was so described when in the library at Rossie Priory, Inchture, Perthshire.[3] It appears to have been purchased c.1822 'outside Rome' by Charles, 8th Lord

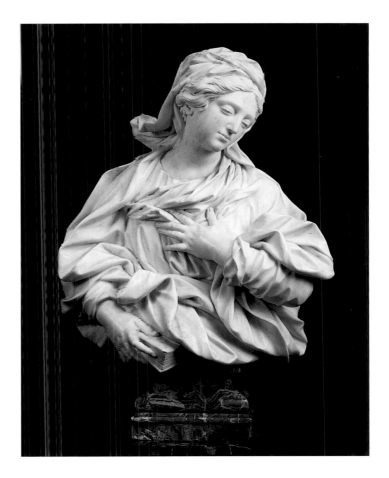

Kinnaird (1780–1826). However, although it is not by Bernini, recent critics appear to agree that it may be the missing bust that was described, c.1690, in the so-called '*Zibaldone baldinucciano*' as a work by Bernini's pupil and collaborator, Domenico Guidi.[4] Stylistically, it is certainly very close to Guidi's full-length statue of *St Apollonia* in the church of Santa Maria degli Abbondonati at Torano (Massa Marittima), a mature work dating from the 1670s.

For Bernini he carved *Angel with a Lance* for the Ponte Sant' Angelo, but he was more involved in collaborating with Algardi, in both marble and bronze. For example, it was probably he who carved the replica *Bust of Monsignor Antonio Cerri* for the Cerri Chapel in the Gesù (see fig.57). [TC]

III

Paintings

Bernini is so readily associated with the arts of sculpture and architecture that his role as a painter has been largely eclipsed. That he did paint is irrefutable, but the number, function, quality and scope – in terms of subject matter – of his easel paintings are matters of enduring debate. Painting was certainly a peripheral activity for Bernini, and he was never commissioned to execute an altarpiece; instead he nurtured the talent of other artists like Baciccio, when he required such work as part of his larger schemes. But he seems to have embraced painting on a smaller scale enthusiastically just as he was confirming his status in Rome. His biographers record that he started painting at the outset of the reign of Pope Urban VIII in 1623. Urban reportedly wanted his own Michelangelo, and saw the young Bernini, who already excelled as a sculptor, as fulfilling this role, and so asked him to train as a painter. According to Baldinucci, 'for the space of two continuous years Bernini devoted himself to the study of painting: that is, skill in the handling of colour. During this time he executed a large number of pictures which are splendidly exhibited today in the most celebrated galleries of Rome and other worthy places…'.[1] Baldinucci put the 'large number' at over 150, while Domenico Bernini in his biography of his father said there were 200 paintings. Modern attempts to track down these works have led to the identification of only a very small group of canvases that can be associated with the artist, most of which are figurative pictures dating from the early part of his career. The paintings included in this exhibition are the most important works in British collections which have in recent years been associated with Bernini. It is hoped that by bringing them together their associations – or the lack of them – will be clarified.

32

GIANLORENZO BERNINI
Saints Andrew and Thomas

Oil on canvas, 61.5 × 77.7cm (original canvas); 61.5 × 85.4cm (lining canvas)
Inscribed with an old inventory number at the lower left: *41*
London, The National Gallery
(NG6381)

Andrew and Thomas seem intent upon a theological debate, and create a compelling contrast between age and youth, and authority and questioning. The Apostle Andrew, who was a Galilean fisherman, has an appropriate, glistening attribute before him,

while Thomas clasps a carpenters' square, a symbol that refers to an apocryphal story about him being summoned to build a palace.[1] Thomas's presence, as the patron of builders and architects, seems particularly appropriate (albeit probably coincidental), as Bernini was involved with designing the new Palazzo Barberini in Rome just at the time this work was painted, and it is first recorded in the Barberini collection.

It is unlikely that the canvas was executed any earlier than 1623, because that was when Maffeo Barberini was elected Pope Urban VIII, and according to both of Bernini's early biographers it was Urban who encouraged the young sculptor to study painting.[2] Since it is documented in the Barberini collection on the 1 June 1627, it must therefore date from the mid-1620s.[3] As such it is among the earliest of Bernini's known works in oil that can be fairly confidently dated, and constitutes an important fixed point amid the uncertainty which bedevils analysis of his paintings. Because of this status, its characteristics – half-length figures in animated poses, apparently quite rapidly painted in a narrow, dark tonal range of browns and creams with touches of red – have come to be seen as the hallmarks of Bernini's painting style. These traits betray the influence of the work of painters such as Caravaggio, and create a painterly equivalent to the so-called 'trois crayons' combination of red, black and white chalk used in some of Bernini's drawn portraits.

The June 1627 entry in the Barberini inventory quite specifically describes 'a painting with the heads of two Apostles, Saint Andrew and Saint Thomas … by the hand of the Cavaliere Bernini'. However, another picture of the 'heads of two Apostles' by Bernini's contemporary Andrea Sacchi, which may have been intended as a pendant for Bernini's work, is recorded as having been paid for by the Barberini just two weeks later.[4] What complicates the situation is that a canvas by Sacchi (see following entry) has since at least the early eighteenth century been hung with the Bernini, but for persuasive reasons is probably not the work bought by the Barberini in 1627.[5] It is comparable in terms of format and date to the Bernini, but shows saints rather than Apostles, and is very likely to be a picture described as being in Sacchi's possession at his death in 1661.[6] In addition, although the two works are now of similar size, close examination of them suggests that they had to be altered at a later date in order to achieve this balance.[7] So it seems that Bernini's picture was painted as an independent work, probably made on his own initiative rather than as a formal commission

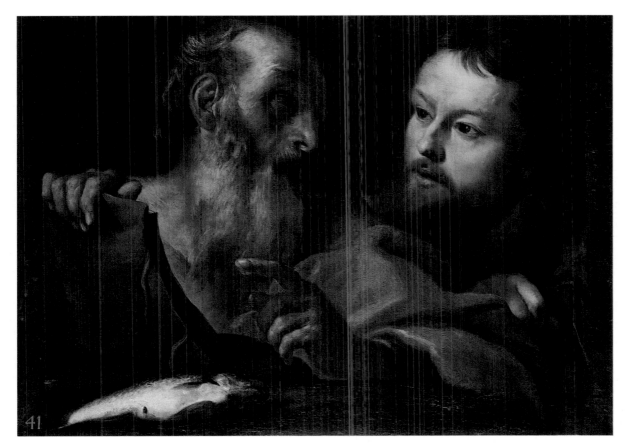

cat.no.32

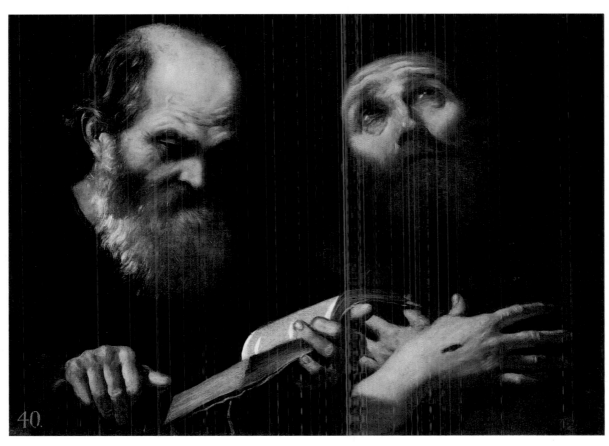

cat.no.33

from the Barberini, which was either given to or acquired by them when Bernini was working on other projects for the papal household, and later paired with Sacchi's painting.

There are three distinct ways in which it anticipates developments in Bernini's sculpted commissions, and shows how the artist could transfer visual ideas between media. The gesture of Saint Andrew seems not just to be pointing to the book, but implies a link with the space of the viewer beyond the realm of the picture, while the swirling drapery underscores his agitated state of mind – these are both devices repeatedly used by Bernini in his works in marble and bronze. Finally, the earnest conversational tenor of the picture anticipates later commissions by the artist, including the interaction between the portraits of members of the Cornaro family in Santa Maria della Vittoria. [CB]

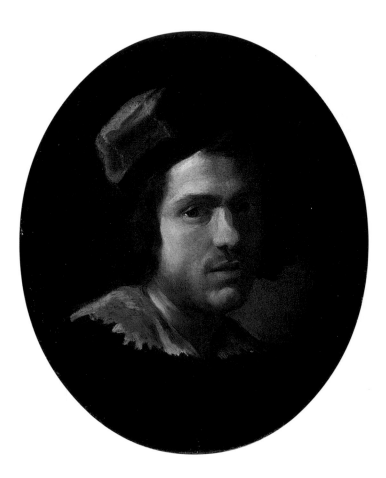

33

ANDREA SACCHI 1599/1600–1661
Saints Anthony Abbot and Francis of Assisi

Oil on canvas, 61.2 × 77.6cm (original canvas); 61.2 × 85.2cm (lining canvas)
Inscribed with old inventory numbers at lower left: *40*
and lower right: *18[?]9*
London, The National Gallery
(NG6382)

Sacchi was born in Nettuno, south of Rome, studied in Bologna under Albani, and settled in Rome in 1621, where he was a member of the Accademia di San Luca.[1] From 1629 he worked for Cardinal Antonio Barberini, and secured commissions for frescoes, altarpieces and portraits. The nature of his professional relations with Bernini has proved difficult to determine precisely, and has been somewhat confused by the purported links between this painting and cat.no.32.[2] As it seems likely that they were only associated from the early eighteenth century onwards (see discussion under previous entry), this does not help. However, the two artists certainly knew each other: Bernini's paintings seem to owe a stylistic debt to the work of Sacchi, and Sacchi specified in his will that he wanted Bernini to design his tomb – a fact that would suggest some intimacy, even though the sculptor did not carry out the work.

This accomplished picture shows Saint Anthony, the founder of monasticism, reading a book and holding a *tau*-shaped stick, while Francis gazes heavenwards in ecstatic contemplation, displaying the wounds of the stigmata on his crossed hands.[3] It is thought to date from a little after Sacchi's arrival in Rome, as its style is comparable to details from an altarpiece by the painter made for the church of San Francesco in Nettuno, which dates from 1623–4.[4] It has been suggested that the subject may have been determined by the fact that Sacchi was attempting to ingratiate himself with Antonio and Francesco Barberini, whose name saints are represented, and who were both made cardinals on the election of their uncle as Pope Urban VIII in 1623.[5] But the painting appears not to have been owned by either of them, since it seems to have remained in Sacchi's possession during his lifetime and is very probably a work recorded in the inventory, dated 21 June 1661, of the contents of his house at his death.[6] By 1692 it had entered the collection of Cardinal Carlo Barberini, and subsequently became paired with Bernini's picture.[7] [CB]

34

GIANLORENZO BERNINI
Portrait of a Man, traditionally identified as Nicolas Poussin

Oil on canvas, laid down on wood, 44 × 35cm (original rectangular canvas); made up to an oval measuring 54.8 × 45.7cm
Private Collection

In a manuscript inventory of about 1770 of the Worsley collection at Hovingham Hall, Yorkshire, this painting is described as a self-portrait by Nicolas Poussin. It was first published as such in 1947, with the suggestion that it might be an early work dating from about 1624 (that is, just after the artist's arrival in Rome) which had belonged to his patron, the great antiquarian Cassiano dal Pozzo.[1] Subsequent critics have for the most part agreed with the identification of the sitter, but have rightly argued that the robust manner of the painting is untypical of Poussin, and comparable instead to the style of Bernini's easel pictures.[2]

Comparison with the red chalk portrait of Poussin in the British Museum of about 1630 (fig.59), suggests that the traditional identification of the sitter is probably reliable, especially if allowance is made for a possible interval of several years between the two portrayals, and for the fact that, according to the inscription, Poussin was convalescing from a severe illness when the drawing was executed.[3] In both cases the artist is depicted informally, wearing a workman's hat, in stark contrast to Poussin's highly wrought and altogether more formal self-portraits from later in his career.[4]

The direct, 'no frills' manner in which the sitter is presented,

the muted palette, the robust brushwork and the lack of spatial definition in the background are all consistent with Bernini's manner of painting in the 1620s and 1630s, as represented, for example, by his three portraits in the Borghese Gallery (see figs.31 and 37).[5] If the portrait is by Bernini, it would provide additional evidence of early contact between two of the greatest artists active in seventeenth-century Rome, who later came to be polarised as representatives of private and public, and meditative and propagandist art. That the two artists did know each other, and were on good terms, by the later 1620s is confirmed by Bernini's statement that it was he who had secured for Poussin the commission for his altarpiece of the *Martyrdom of Saint Erasmus* for St Peter's (1628–9).[6]

But a firm attribution to Bernini is perhaps undermined by the fact that when he saw Poussin's two later self-portraits in Paris in 1665, he did not recognise the sitter, although he expressed a deep respect for his achievement. Nor does Chantelou record in his *Diary* any mention by Bernini that he had himself portrayed Poussin, and since Bernini was loquacious and Chantelou a meticulous recorder of his observations and opinions, this silence may have a bearing on the status of the present picture.[7] [CB]

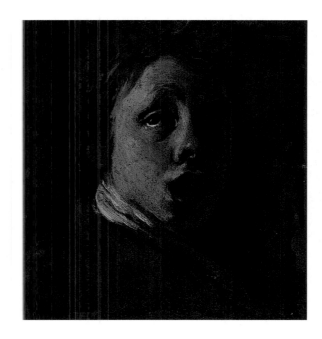

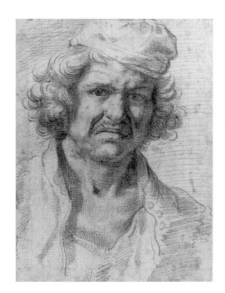

fig.59: Attributed to Nicolas Poussin, *Self-portrait*, London, British Museum

35
ATTRIBUTED TO GIANLORENZO BERNINI
A Boy Singing

Oil on paper, laid down on canvas, 25.5 × 23.8cm
Glasgow, University of Glasgow, Hunterian Art Gallery

This rapidly painted oil sketch shows a young boy apparently singing with gusto, although looking up in an apprehensive manner as though wary of our disapproval. It was in the collection of the Scottish engraver Robert Strange (1721–92),[1] who travelled extensively in Italy in the early 1760s, making copy drawings to be used as models for reproductive prints, and acquiring works of art. In Strange's catalogue for the sale of his collection in 1771 the picture was attributed to Andrea Sacchi,[2] and was described as 'one of the most animated studies I have seen; it has much of the character of nature, of knowledge of the principles of colouring, and a breadth of light and shadow'.[3] It was bought at the sale for eight guineas by the distinguished scientist William Hunter (1718–83) – whose collection included paintings by Rembrandt and Chardin, specimens of geology and pathology, a cabinet of coins and medals (a selection of which is included in this exhibition) and an impressive library – all of which he bequeathed to Glasgow University. As an anatomist, it is perhaps not surprising that Hunter should have been drawn to a such a lively physiognomic study.

The attribution to Sacchi was first questioned in the 1950s, and an association with Bernini proposed instead.[4] Since then there has been little scholarly consensus about the painting's authorship, or even the nationality of the artist. That it is Italian is nevertheless convincing, and it was probably executed in Rome quite early in the seventeenth century. However, a firm attribution to Bernini is hard to sustain in the absence of any similar pictures known to be from his hand. As an oil sketch on paper, it is also exceptional technically among the pictures usually attributed to Bernini.[5] The sketch does, though share some stylistic common ground with impromptu naturalistic works by less well known artists, such as the Veronese Marcantonio Bassetti (1586–1630).[6] [CB]

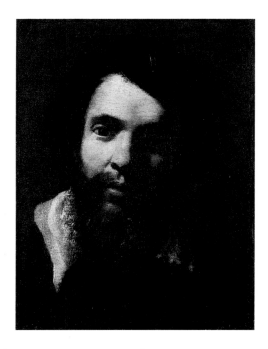

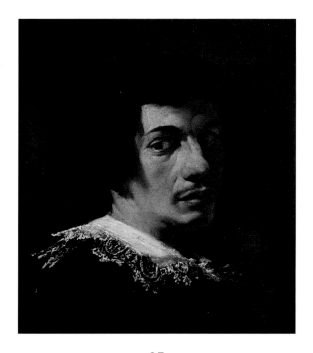




36

ATTRIBUTED TO GIANLORENZO BERNINI

Head of a Bearded Man

Oil on canvas, 43.8 × 33cm

The Cobbe Collection

Although no documentation links this intense and assured study with Bernini's work, the manner of execution and overall treatment suggest that it may well be by him.[1] The confrontational gaze of the subject is comparable with a number of Bernini's sculpted and drawn studies, and the careful, dappled modelling of the figure as his face turns into the light, with tiny dabs of white paint used to define the highlights, parallels effects visible in the three portraits by Bernini in the Villa Borghese, Rome (see figs. 31 and 37).[2] The way in which the face has been fully resolved but the surroundings left undefined is consistent with the appearance of these works, as are the warm hues.

If the *Bearded Man* is by Bernini, then it accords well with his belief that portraits should engage the viewer in a conversational manner. As he explained to Chantelou: 'To be successful in a portrait ... a movement must be chosen and then followed through. The best moment for the mouth is just before or just after speaking'.[3] This principle was adhered to from the very earliest of his sculpted portrayals.

The picture is in fairly good condition, although the paint surface has suffered some abrasion, and there is a pronounced horizontal craquelure which may suggest that the original canvas was at one point rolled up.[4] It was lined at an early date and the lining canvas is inscribed on the reverse in an eighteenth-century hand: 'Belonging to General Campbell [...] 1759'. Subsequently the work passed through the collection of Sir Luke Schaub and at his sale was described as 'The Head of Augustin [Agostino] Carracci' by Annibale Carracci.[5] There is certainly a similarity with some of Annibale's informal drawn and painted portrait studies (see fig.36), but the association with the *oeuvre* of Bernini seems at present more convincing.[6] [CB]




37

ASCRIBED TO GIANLORENZO BERNINI

Portrait of a Young Man

Oil on canvas, 43.8 × 38.7cm

Oxford, The Visitors of the Ashmolean Museum
(1950.10/A781)

This fine portrait was acquired by the Ashmolean in 1950,[1] and published in the following year as a work by Bernini dating from the period 1625–35.[2] Little is known of its provenance, and the attribution was based on a consideration of the pose of the sitter and the manner of execution, both of which were thought to be closely comparable with unchallenged works by the artist, such as the group of informal portraits by Bernini in the Villa Borghese, Rome (see figs. 31 and 37).[3] Some features of the painting – such as the alert, knowing gaze, the twist of the neck, and the slightly parted lips, which seem to imply that the sitter is about to speak – are indeed consistent with these works and other examples of Bernini's drawn and sculpted portraiture. But such traits, although pioneered by Bernini, became commonplace in seventeenth-century portraiture, and are not in themselves sufficient to sustain the attribution. Moreover, the modelling of the face seems far smoother and more fluid than that achieved by the broken, dabbed brushstrokes used to define the features of the subjects in the Borghese pictures. Taken together, these factors suggest that it is necessary to look elsewhere for an attribution.

It was first proposed in 1974 that the picture might be by a French artist active in Rome, such as Simon Vouet (1590–1649),[4] who, inspired in particular by Caravaggio, enjoyed a very successful career there between 1614 and 1627. The sitter is comparable to a generic facial type found in Vouet's informal portraits of this period, but the picture appears to be by an artist working in his circle rather than by Vouet himself. The apparently Berniniesque qualities of the canvas might reflect an awareness of the sculptor's output just at the time he was developing as a painter. [CB]




Academic Nudes

38

GIANLORENZO BERNINI

Seated Male Nude seen from Behind

Two shades of red chalk, heightened with white chalk,
on buff paper, 56.2 × 42.2cm
Inscribed in pencil at the lower left: *Cav.e Bernini*; and in pen on the
verso: *Academia del Sig.r Cavaliere Bernini / Comprata da Cesare Madona Adi
7 Aprile 1682 Scudi Sei — 6:/ da me Michele Maglia* [1]
Windsor Castle, Royal Library
(RL5537)

39

GIANLORENZO BERNINI

Seated Male Nude seen from the Right

Two shades of red chalk, heightened with white chalk,
on buff paper, 39 × 54cm
Inscribed in pen on an old label at the right of the recto: *Gio = / Cas ...*
Private Collection

These monumental and highly finished male nudes must, like
most of Bernini's portrait drawings, have been made as inde-
pendent works of art in their own right.[1] They have the character
of what might be called 'demonstration pieces', in which the
draughtsman seems to revel in his command of his materials and
of the human form.[2] The two drawings exhibited here, together
with another at Windsor (fig.60) and a fourth in the Uffizi, form a
stylistically homogeneous group, and all of them seem to represent
the same model, with his short beard and thick mop of hair.[3]

Only one of Bernini's studies from the life model – a sheet in the
Uffizi which is less densely worked and more dynamically posed
than the present examples – can be convincingly connected with a
sculptural work by him, the River Nile in the *Four Rivers Fountain*,
and is therefore datable to about 1650.[4] The exhibited drawings
(and the others in this group) may nevertheless be characterised as
'sculptural' in the sense that the models are viewed from a variety
of angles and are very much conceived in the round, with power-
ful musculature, projecting extremities and some difficult
foreshortenings.

The models seem fully integrated with their naturalistic props
and landscape setting, but these must surely be imaginary addi-
tions on Bernini's part, since such drawings from the nude can
hardly have been made outside in the open air.[5] The landscape

forms are suspiciously conveniently disposed so as to assist the
model in maintaining the pose, which supports the idea that
Bernini has simply transformed what were in reality geometric
benches, blocks and so forth. Furthermore, the branches and foli-
age are treated in a schematic and far from naturalistic manner,
using an insistent system of parallel hatching. If the settings were
indeed invented, Bernini must have decided at an early stage of the
drawing at what point, for example, the right leg of the model in
cat.no.39, or his buttocks and right thigh in cat.no.38, would be
truncated.

It is tempting to argue that Bernini is likely to have made draw-
ings of this type during the period when he was most closely in-
volved with the Accademia di San Luca (the Roman artists' acad-
emy), namely around 1630, and this would be consistent with their
style. At a meeting of the *Congregazione* of the Academy in Decem-
ber 1629, Cassiano dal Pozzo, who was present on behalf of the
Academy's chief patron and protector, Cardinal Francesco
Barberini, conveyed the latter's wish that Bernini be appointed its
Principe for the following year. Bernini accepted, but with reluc-
tance, and on condition that he would hold the post for one year

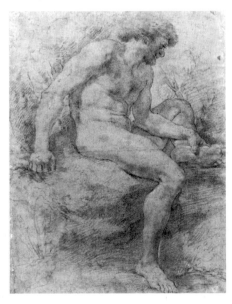

fig.60: Gianlorenzo Bernini, *Seated Male Nude*,
Windsor Castle, Royal Library

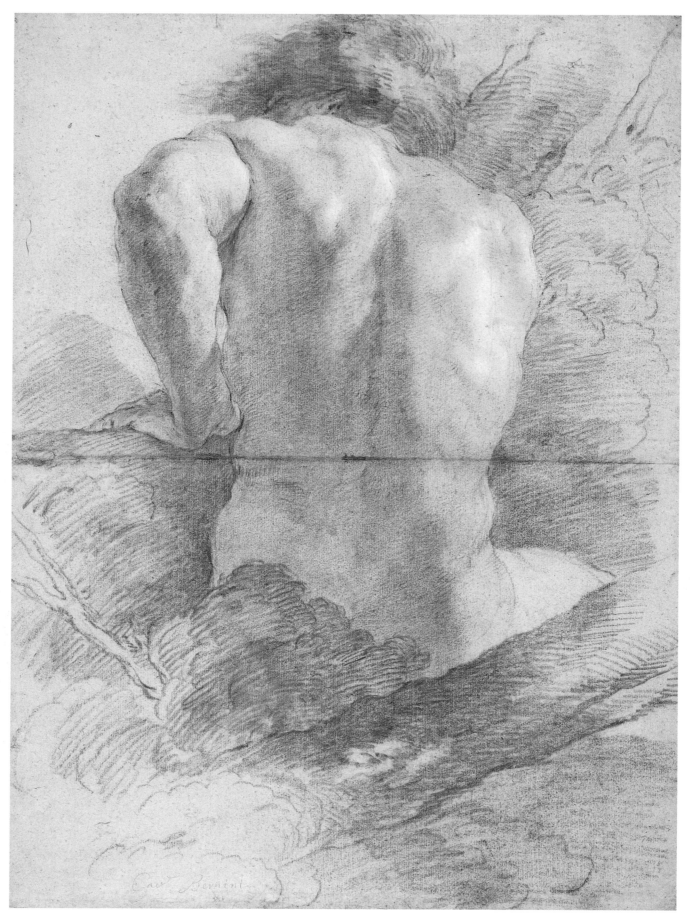

cat.no.38

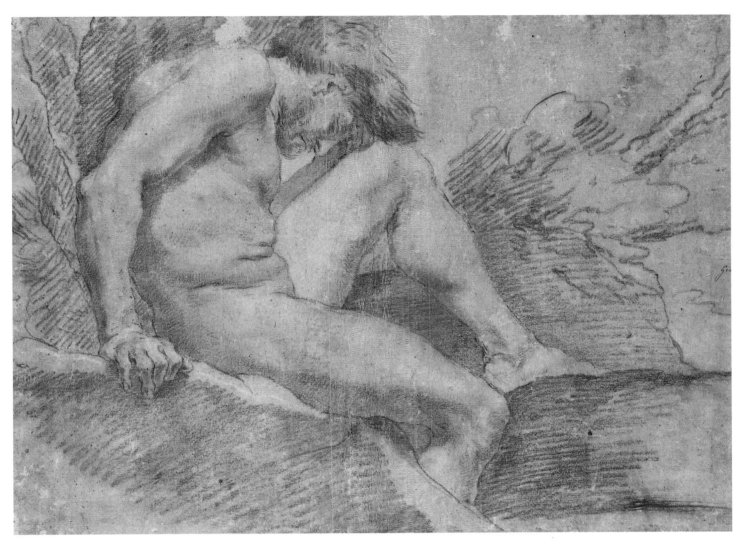

cat.no.39

only.[6] Nevertheless, and despite the subtitle 'academic nudes' used above, it is doubtful that these drawings were in fact made in the context of the official Academy. None of them shows the type of academic props one might have expected, nor any indication of other artists present drawing from the same model (as one sees, for example, in some of the drawings made in the Carracci's Bolognese academy). It seems probable that the true context for them was the life-drawing class that Bernini held from time to time in his own studio,[7] or possibly one of the other privately-run drawing academies to which occasional passing reference is made in the early sources.[8]

A fair amount of information regarding his views on life drawing can be gleaned from Chantelou's *Diary* of Bernini's visit to Paris in 1665, when he was asked to advise, among other things, on the teaching methods employed in the Académie Royale de Peinture et de Sculpture, founded in 1648. One of the anecdotes he related about his early youth (he could have been aged no more than ten) involved a chance meeting with Annibale Carracci on route to an unspecified drawing academy, and describes the manner in which the great painter went about posing the model.[9] His main preoccupation, however, seems to have been with the paucity of good life models. Another anecdote records him attempting to win the confidence of a particularly suitable but shy candidate, and elsewhere he was insistent that eastern Slavs, Greeks and Levantines made the best models for life drawing.[10] [AWL]

V

Small Bronzes, Reliefs and Reductions

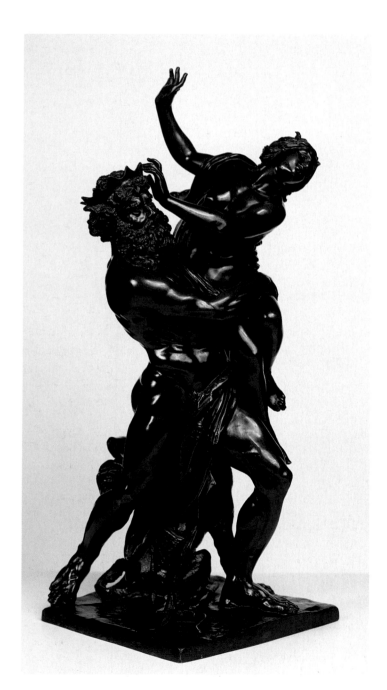

40

AFTER GIANLORENZO BERNINI

Pluto Abducting Proserpina

Bronze, with a deep brown patina. A heavy, lost-wax cast. Both of
Proserpina's arms, and Pluto's bident, were cast separately. The join in
Proserpina's right arm has come apart and is clearly visible. There is a
small plug repair in her left hand, 69.5cm high

Edinburgh, National Gallery of Scotland

(NG2561)

Bernini's early mythological groups in marble, with their wealth of
fine detail, subtly contrasted textures, and virtuoso technique in-
volving deep drilling and undercutting, are not obvious candidates
for successful reproduction on a small scale in the less tractable
medium of bronze. Such was their celebrity during Bernini's life-
time, however, that there was clearly a market for reductions of
this kind, although relatively few casts appear to survive today (see
also cat.nos.42–3), and none appears to have been made on the
sculptor's own initiative, or under his supervision.[1] In this
attractive rendition of Bernini's *Pluto Abducting Proserpina* (fig.61),
the energy and dynamism of the original are captured with
condiderable success, while relatively little attention was paid,
either in the wax or in the afterwork, to the exquisite details of
surface finish.

The group illustrates Ovid's account (*Metamorphoses*, V: 385–
424) of the abduction by Pluto, god of the underworld, of
Proserpina, daughter of the goddess Ceres, who was picking
flowers in a meadow. Pluto's horse-drawn chariot and Proserpina's
frightened companions are understandably omitted by Bernini,
and he introduces instead the god's most familiar attribute, the
three-headed Cerberus, guardian of the entrance to Hades, which
removes any possible ambiguity about the subject represented and
lends necessary structural support to the principal figures.

Pluto Abducting Proserpina was the second over life-size marble
group carved for Bernini's most important early patron, Cardinal
Scipione Borghese. It was commissioned in June 1621, when
Bernini received a payment on account, and was finished by the
following summer.[2] Within a year of its completion, however, it
was presented by Scipione, presumably as a politically-motivated
gift, to Cardinal Ludovico Ludovisi, nephew of Pope Gregory XV.
It remained in the possession of the Ludovisi descendants until

early this century, when it was purchased by the Italian state for the Villa Borghese.

Bernini was well aware that the works he carved for Scipione Borghese were destined to keep company with one of the greatest collections of antique statuary in Rome, and *Pluto Abducting Proserpina*, arguably more than any other group by Bernini, reflects his intense study and profound understanding of antique – particularly Hellenistic – sculpture. An early preparatory sketch for the group in Leipzig nevertheless shows Bernini drawing inspiration (fittingly enough in the present context) from bronze statuettes from the circle of Giambologna, specifically a *Hercules and Antaeus* attributed to Pietro Tacca.[3] During the metamorphosis of the composition, it seems probable that he also looked to pictorial sources, as he did in the case of the *Aeneas and Anchises* and the *David*, both in the Borghese Gallery.[4] For there are striking analogies between Bernini's group and a painting of the same subject by the Ferrarese artist Scarsellino (*c.*1551–1620; fig.62), which it is tempting to suggest he must have known.[5] Common to both painting and statue are the complex contrapposto of Proserpina's pose; the parallellism of her limbs, with one knee drawn up slightly above the other; the slender ropes of drapery which coil round the figures; the striding stance of Pluto, with his bident abandoned at his feet; and, above all, the dramatic counterpoise of the two protagonists as Proserpina struggles to free herself from the clutches of the lusting god of the underworld. It may not be too far-fetched to see in the grouping of the horses' heads in the middle-ground of Scarsellino's painting an amusing analogy to Bernini's triple-headed Cerberus.

Another bronze reduction of the same group, slightly larger and certainly based on a different model, is in Birmingham City Art Gallery.[6] [AWL]

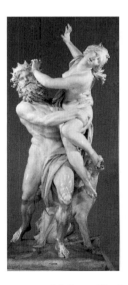

left fig.61: Gianlorenzo Bernini, *Pluto Abducting Proserpina*, Rome, Galleria Borghese

right fig.62: Ippolito Scarsella, called Lo Scarsellino, *The Rape of Proserpina*, Private Collection

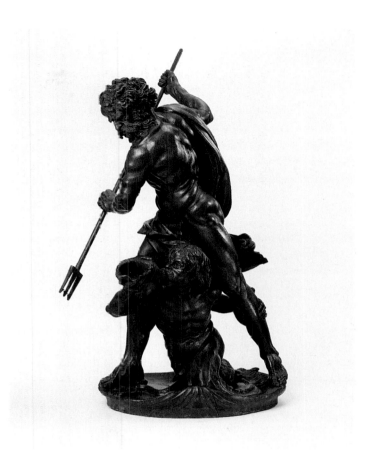

41

AFTER GIANLORENZO BERNINI

Neptune and Triton

Pine wood, 56.8cm high
London, Victoria and Albert Museum
(A.62–1925)

This statuette, carved from several pieces of wood joined together, is a much reduced copy of Bernini's marble group of *Neptune and Triton*, also now in the Victoria and Albert Museum (fig.14). It probably dates from the eighteenth century, and it may have been carved in England, where there was a cast of the statue by 1731, or in Rome before the sale of the original to Thomas Jenkins in 1786.[1] The wooden copy was selected for the exhibition as a surrogate for the original (which is too important and fragile to travel) in preference to one of the bronze reductions of the group, which invariably exclude the figure of Triton (see fig.64).[2]

The marble by Bernini was commissioned by Cardinal Alessandro Peretti Montalto (1571–1623), Pope Sixtus V's great-nephew, to embellish a large oval fish-pond known as the *peschiera* in his Villa alle Terme, which he had inherited from the Pope. From 1607 onwards, the villa and garden at Termini appear constantly in Cardinal Montalto's accounts: masons, stone-carvers (*scarpellini*), stucco-workers (*stuccatori*), sculptors (especially Alessandro Rondone the Elder) and painters (among them Giovanni Guerra and Baldassarre Croce), were continuously employed in its restoration and renovation. The gardens, including the fish-pond, were largely fashioned by Cardinal Montalto himself, not by his uncle as was widely believed until recently.[3]

The *Neptune* stood at the far side of the pool above a waterfall. From the main approach the spectator was confronted by a side view of the group, and had to walk around the broad basin to see it frontally. There has been some debate as to which – if any – precise episode from classical literature Bernini intended to represent. The scowling features and angry gesture of the god, thrusting downward with his trident, fit well with the description in Ovid's *Metamorphoses* (Book I, lines 274–91) of Neptune stirring up the waters to drown the world. The triton, on the other hand, once spouting a thin jet of water from its conch shell, seems to be linked with a slightly later passage in the same text (lines 329–39) describing the end of the deluge.[4]

Records of six payments totalling 400 scudi to Gianlorenzo Bernini (often mis-spelled Bonvino) in the *registri di mandati* (expenditure accounts) of Cardinal Montalto indicate that the *Neptune and Triton* was commissioned by March 1622 and completed before 23 February 1623, that is, slightly later than many scholars have hitherto thought.[5] Among Bernini's youthful sculptures the small *Saint Sebastian* at the Thyssen-Bornemisza Foundation in Madrid can also now be documented to later than previously believed, for Cardinal Maffeo Barberini paid the sculptor's father 50 scudi for it in December 1617: it has generally been dated in the past to around 1615.[6] Taken together, the new documentary evidence for these two sculptures suggests that the tales of Bernini's astonishing precocity, fuelled in later life by Bernini himself, may have been slightly exaggerated by his biographers.

At about the same time as he was carving the *Neptune and Triton*, Bernini also executed the fine portrait bust of Cardinal Montalto now in the Kunsthalle, Hamburg (see fig.52),[7] of which there appears to be no mention in the family archives. Were it not for his untimely death in June 1623, there are indications that Montalto may have gone on to become one of Bernini's most loyal patrons. For recent archival discoveries suggest that it may have been he, rather than Scipione Borghese, who placed the initial commission for the celebrated *David*, with the intention that it too should grace the garden of his villa (see following entry).[8] [PC]

42
AFTER GIANLORENZO BERNINI
David

Bronze, 55.5cm high
Inscribed with old inventory numbers:
No. 13 (at the base of the interior); 30 (on the base of the exterior).
Windsor Castle, Royal Collection

This is a thin-walled and expert lost-wax casting. The left arm, right forearm, ropes of the sling, and both legs were separately cast. There are running flaws on the back, repaired with screw plugs. The flesh surfaces are gently striated. The hair is vigorously and sensitively chased into curly locks, the cloak is stippled, and the rocky ground matt-punched. The straps of the kilt have an anthemion at their tops. The sword-grip and pommel are lightly incised with foliate motifs.

The statuette is a copy on a much reduced scale of the famous marble statue of *David* in the Borghese Gallery, Rome (fig.63).[1] Begun in July 1623, but finished before the *Apollo and Daphne* (on which Bernini was working concurrently; see following entry), this was the last of the statues that Bernini undertook to carve for his greatest early patron, Cardinal Scipione Borghese (recently discovered documents in fact suggest that Scipione took over the commission after the death of Cardinal Alessandro Peretti Montalto in June 1623; see previous entry). The *David* was greatly admired on account of the ferocious expression which, it was said, was based on the sculptor's own grimacing features viewed in a mirror. The open, aggressively masculine, pose was derived from

left fig.63: Gianlorenzo Bernini, *David*, Rome, Galleria Borghese
right fig.64: After Gianlorenzo Bernini, *Neptune with a Dolphin*, Los Angeles, J. Paul Getty Museum

an ancient source, the over life-size Hellenistic statue of a *Gladiator* (Paris, Louvre) that had been excavated not long before and acquired by Scipione in 1611. The carving in marble of the taut ropes of the sling was a *tour de force*, and even on the present small scale and in bronze the foundryman had recourse to casting them separately and joining them on afterwards to the rest of the figure.

Knowledge of casting techniques is as yet not very profound or exact and it is hard to establish the place and date of origin of most casts. In this case, while the original has always been in Rome, and the statuette may have been made there towards the end of the seventeenth century, it could equally well have been produced by one of the expert team of foundrymen and sculptors in bronze that worked for King Louis XIV at the Château of Versailles. A small wax model after Bernini's *David* (which could have served as a model for a bronze) is recorded, for example, in the collection of the sculptor François Girardon (1628–1715), and by 1673 Louis XIV owned a gilt-bronze version of the same figure.[2] The casting and after-working of this bronze are particularly close in style to those of a statuette after Bernini's *Neptune* now in the J. Paul Getty Museum (fig.64).[3] [CA]

43

AFTER GIANLORENZO BERNINI

Apollo and Daphne

Bronze, 92.7cm high
Newby Hall, Richard Compton

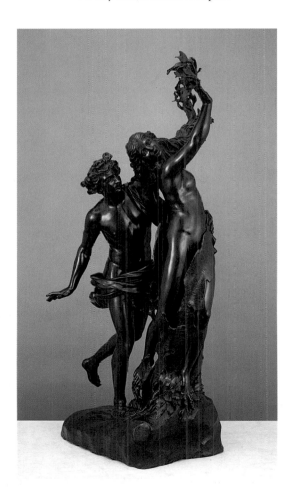

This is a copy on a much reduced scale of the famous marble group of *Apollo and Daphne* in the Borghese Gallery, Rome (fig 65).[1] This was carved between August 1622 and November 1625, when Bernini was in his mid twenties, for Cardinal Scipione Borghese, later the subject of Bernini's two marble portrait busts still in the Borghese Gallery (c.1632–3).[2] Following closely in date upon the *Pluto Abducting Proserpina* of 1621–2 and the *Neptune and Triton* of 1622–3 (see cat.nos.40–41), the *Apollo and Daphne* proved to be the last of Bernini's mythological sculptures, for thereafter he was commissioned by successive popes, notably Urban VIII, Innocent X and Alexander VII, to turn his talents to the service of the Roman Catholic church, principally, of course, in the Basilica of St Peter's.

The story is taken from Ovid's *Metamorphoses* (Book I, lines 453–568): Apollo, the Sun God, was so enamoured of a wood-nymph called Daphne that he pursued her as she fled from him. Inevitably he caught up with her, but in answer to a prayer that she uttered in desperation as he tried to embrace her, she was turned into a laurel tree (this tale was to explain how the laurel came to be called 'Daphne' in Greek).

To represent the rapid movement and intense, sexually-charged drama of this myth would have been hard enough in painting, but to execute it in fully three-dimensional actuality in marble, in such a way that the two figures would support their own weight and not topple over, was a challenge indeed, but one that the brilliant young sculptor welcomed. He studied earlier Italian garden statuary with similar groups of two closely-linked figures, and – so it seems – a northern engraving of the story, before composing his own suavely triumphant response to the technical and artistic challenge.

Bernini's Apollo – derived from that famous antiquity, the *Apollo Belvedere* – lays his hand on Daphne's stomach and as she looks back, her mouth wide open in alarm with her blonde hair swirling out behind, her fingertips and toes sprout leaves and rootlets, while a great shield of bark miraculously appears, protectively encasing her legs and private parts.

A valiant – if, inevitably, not entirely successful – attempt was made here to capture in the bronze the exquisite naturalistic details of Bernini's original, passages which are credited by one early writer to Bernini's assistant Giuliano Finelli.[3] [CA]

fig 65: Gianlorenzo Bernini, *Apollo and Daphne*, Rome, Galleria Borghese

44
WORKSHOP OF GIANLORENZO BERNINI
Grotesque Male Head

Bronze of light chocolate-brown colour, with traces of brown varnish,
13.5cm high (head only); 20.5cm high (including separately cast bronze
base); mounted on a wooden socle
Private Collection

This bronze corresponds very closely to one of the set of four gilt-bronze heads on marble socles that belonged, until recent times, to the heirs of Bernini.[1] They appeared in the heirs' inventory of 1706 as: 'quattro testine gettito in bronzo con li suoi piedi di pietra, quali erano li vasi della carrozza del Cavaliere' ('four little heads cast in bronze with stone plinths which were the vases [i.e. finials] of the Cavaliere's coach').[2]

According to one tradition handed down in Bernini's family, these grotesque heads originally decorated the carriage in which Pope Innocent X attended the inauguration of the *Four Rivers Fountain* in the Piazza Navona. Certainly, the grotesque head or *tête d'expression* motif is one that Bernini favoured, first appearing in the marble of the *Anima Dannata* (Condemned Soul) of 1619 (Rome, Palazzo di Spagna),[3] and later in two closely-related red chalk drawings of *Grotesque Heads* in the Kunstmuseum, Düsseldorf.[4] Rather similar grotesque shouting masks appear in a drawing by Nicodemus Tessin the Younger (in the National-museum, Stockholm) of the attic frieze of a coach, which is in-scribed: 'Pour le Roy d'Espagne / de l'ordinance du Cav. / Bernin.' ('For the King of Spain, to the design of the Cavaliere Bernini').[5]

Casts of these grotesque heads, distinct from the original four, are in the William Rockhill Nelson Gallery of Art, Kansas City and in the collection of Michael Hall, New York; another was formerly in the collection of John Gaines. [TC]

45
AFTER FRANÇOIS DUQUESNOY,
CALLED IL FIAMMINGO 1597–1643
Cupid

Bronze, 37.1cm high
Edinburgh, University of Edinburgh, The Torrie Collection

Formerly covered with green paint to simulate corrosion and give a fake antique patina, the *Cupid* seems to have been sold to Sir James Erskine of Torrie in Rome around 1800 as a classical bronze.[1] In fact, it was probably detached from a version of Duquesnoy's group of *Apollo and Cupid* (see fig.66). This he had created as a pair to another group, *Mercury and Cupid*, which in turn had been made for the Marchese Vincenzo Giustiniani to pair with a Hellenistic bronze *Hercules*.

That Duquesnoy modelled these compositions is proved by a mention in Bellori's biography of the sculptor.[2] Furthermore, the Giustiniani *Mercury and Cupid* is shown in an engraving by Claude Mellan, which is inscribed *Fran.us du Quesnoy Brix.is sculptor fecit* ('François Duquesnoy, sculptor from Brussels, made it').[3]

A pair of Duquesnoy's bronzes, consisting of the *Mercury* (lack-ing the Cupid and the caduceus shown in the engraving) and *Apollo and Cupid* (both missing their bows), has been in the Liechtenstein Collection since at least 1658, when they were described in an in-ventory as antique (fig.66).[4] It is clear that the Cupids and the ac-cessories were always cast separately and fixed on, which rendered them prone to removal later, as in the present case.

Apart from the Liechtenstein examples, only one other authen-tic pair is known, in the Palacio Real in Madrid.[5] It was presumably this that served as the model for the gilt-bronze *Apollo* group, com-plete with bow, which appears on the table in the *Allgeory of Repent-*

ance attributed to the Spanish painter Antonio de Pereda (and dating from the early 1640s) in the Stirling Maxwell Collection at Pollok House, Glasgow. Another pair now in the Thyssen-Bornemisza Collection in Madrid has recently been described as eighteenth-century.[6] A further so-called pair, formerly in the collection of J. Pierpont Morgan[7] and now in the Henry Huntington Art Gallery in San Marino (California), in fact have quite disparate bases. There are several additional examples of the *Mercury and Cupid* group alone, and it evidently continued to be reproduced later than the *Apollo and Cupid*.[8]

There are two other surviving examples of the *Cupid* from the Apollo group appearing alone as a separate statue, one in the Statens Museum for Kunst in Copenhagen,[9] and the other in the Nelson-Atkins Museum of Art in Kansas City, Missouri.[10] These both have a bow in the lowered left hand and an arrow in the raised right fist, which is clenched (unlike the Torrie version), but they have no quiver or sash. They stand on integrally cast, circular bases with a support for the left foot, and so were evidently manufactured as independent statuettes. The one in Copenhagen featured in an inventory of the Royal Art Cabinet of 1673–4.

There exists another similar model of Cupid balancing on his right foot on a globe, with his limbs arranged in reverse and with a sash for a quiver, trumpeting with a sinuous animal horn. This seems to have been conceived as a pair to the present statuette and accordingly has been attributed, convincingly, to Duquesnoy.[11]

Both these Cupids are related quite closely to a pair of flying cherubs on Duquesnoy's celebrated marble *Tomb of Ferdinand van den Eynde* in Santa Maria dell'Anima, Rome, carved between 1633 and 1640.[12] This corroborates the evidence supplied by Bellori suggesting a dating of the conception of the bronze statuettes in the second half of the 1630s. Duquesnoy excelled in modelling charming, chubby infants of this kind, both singly and in groups or reliefs, and they must have proved very successful commercially, judging from the number that survive, modelled in wax or clay, cast in bronze or stucco, and carved in marble or ivory. Such items feature in many inventories of sculptors' studios and collectors' cabinets of the late seventeenth and eighteenth centuries. [CA]

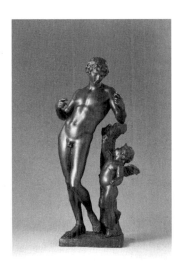

fig.66: François Duquesnoy, *Apollo and Cupid*, Schloss Vaduz, Collections of the Princes of Liechtenstein

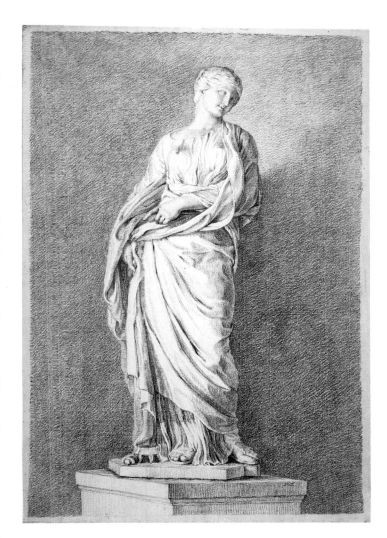

46
GIOVANNI DOMENICO CAMPIGLIA 1692–1775
Sta Susanna, after François Duquesnoy

Red chalk (two shades), 54 × 37.5cm
Edinburgh, National Gallery of Scotland
(D1991)

This drawing is an accurate record of François Duquesnoy's statue of *St Susanna*, carved in 1629–33 for the Roman church of Santa Maria di Loreto (fig.67). It is one of a series of drawings after sculpture by Campiglia in the Gallery's Print Room, and the only one which copies a modern, rather than an antique, piece. Campiglia was renowned in the mid-eighteenth century for his drawings after classical statues, many of which were engraved as book illustrations. The most lauded of these publications, in four volumes, is entitled *Museo Capitolino*, a project on which he collaborated with his friend and mentor Giovanni Bottari.[1] As the Pope's librarian, Bottari conceived and wrote the first great catalogue of ancient sculpture in accordance with the new scientific criteria.[2] Campiglia's lucid drawings after classical statuary were much sought after by British Grand Tourists, and later in his life the artist also acted as a drawing tutor for some of his most avid collectors, such as Sir Roger Newdigate.[3]

In 1629 the Roman Guild of Bakers commissioned Duquesnoy to produce a statue of the beautiful young Roman martyr Susanna. Duquesnoy, who was well known for his restorations of antique sculpture, based the *Sta Susanna* on an extensive and concentrated study of such classical statues as the Capitoline *Urania* and the Cesi *Juno*.[4] Although little known today, Duquesnoy's *Sta Susanna* was considered the canon for the modern draped female figure by Bellori, and during the seventeenth and eighteenth centuries it was arguably reproduced in plaster casts and bronze reductions more than any other modern work, including the most celebrated statues by Bernini.[5] Indeed, it seems likely that Campiglia may have made his copy from a cast rather than from the original sculpture, as its viewpoint does not correspond to the location of the statue in a niche set high on the apse wall of the church.[6] Nor is there any indication of this architectural setting in Campiglia's drawing, and the martyr's palm which the saint originally held in her right hand is missing.[7] The neutral background and high degree of finish would have made this drawing a highly suitable candidate for translation into a print.

The statue has itself been moved inside the church, from the right hand side of the high altar to the left: in the original context, Sta Susanna's pointing left hand would have made better sense, since it would have directed the viewer's attention towards the altar.

[EJS]

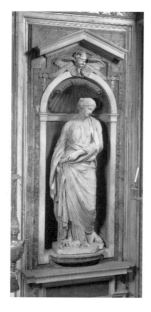

above fig.67: François Duquesnoy, *Sta Susanna*, Rome, Santa Maria di Loreto

below fig.68: Lewis Pingo, *Medal of Dr Richard Mead* (obv.) *with The Infant Hercules Strangling a Snake* (rev.), formerly London, Art Market

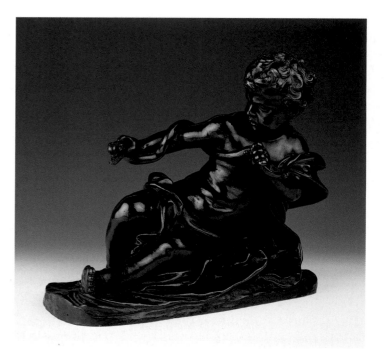

47

AFTER A MODEL BY ALESSANDRO ALGARDI

The Infant Hercules Strangling a Serpent

Bronze, black patina, 34.5 × 46 × 21.5cm

The Burghley House Collection

Surprisingly, this particular model is not mentioned by any of Algardi's early biographers, but several examples in terracotta or bronze were connected with his name in Italian seventeenth-century inventories, as well as in two English sale catalogues from the middle of the following century, and so there is no real doubt about its authorship.[1] Two of the terracotta models were among the studio effects of his follower, Ercole Ferrata, and so their attribution to Algardi is to be relied upon. In stylistic terms the composition, now known mainly from casts in bronze, is close to that of his *Putto on a Hippocamp* and so probably dates from late in Algardi's career, around 1650. Its subject is comparable to much of Duquesnoy's production for the open market (see cat.no.45), and Algardi may have determined to cash in on the popularity of this sort of vaguely classical image.

Such a subject appealed particularly to the English, most of whom were protestant and in an iconoclastic period could not be seen to be buying 'religious' (i.e. Roman Catholic) statuettes for fear of reprisals. The composition was well known and appreciated in England, for by 1724 Edward Harley, Earl of Oxford, of Wimpole Hall, Cambridgeshire, owned 'a fine boy in white Marble of Algardi (with the snake) frightned'. This subsequently appeared in Mr. Cock's sale of the collection on 11 March 1742 (lot 31): 'A Young Hercules big as life in marble by Algardi', and was bought for 17 guineas by Lord Ilchester. It has not been re-discovered, and there is some doubt as to whether Algardi in fact carved a version in marble at all.[2] None of the known marble versions appears authentic, and the outstretched arm and serpent are more appropriate for casting in bronze owing to the greater tensile strength of metal.

The second *Infant Hercules* documented in England is the

present example, which was bought by the Marquess of Exeter for £52.10s. at the sale in 1755 of the collection of that celebrated doctor and antiquary, Dr Richard Mead.[3] It was catalogued in Latin as the work of Algardi and illustrated – most unusual at the time – with a line engraving by G. van der Gucht. This had previously been used as a *cul-de-lamp* (end-decoration) on the last page of text in the third edition of Mead's treatise, *A Mechanical Account of Poisons in Several Essays*, published in London in 1745. To a casual observer the connection might seem obscure, but apparently Mead during his research had handled vipers, in order to collect their poison. A contemporary, Matthew Maty, wrote in 1755: 'This high pitch of heroism, to which he had wrought himself is finely represented by an antique statue, in his collection, engraved on a copper plate at the end of his Book; the figure is a Child in a bold and graceful attitude, holding out by the neck an enraged serpent, with this device, *Labor est Angues Superare*'.[4] Dr Mead had travelled in Italy, but he might also have purchased the treasured item from the sale of the effects of the art dealer Andrew Hay.[5] It has not previously been remarked that the significance of this image to Dr Mead and his friends is corroborated by its appearance (in reverse, perhaps having been derived from one or other published engraving) on the reverse of a handsome medal struck by Lewis Pingo in 1754 to commemorate Mead's death (fig.68).[6]

However this may be, the present bronze is expertly modelled and cast, needing little after-working: for example, the serpent is not incised with scales, as in some other casts. Another version in the Louvre, with Hercules seated on a cushion, is paired with a *Cupid* and they are probably French casts of about 1700. Similar themes of recumbent infants under various mythological guises were to become standard in the Versailles school of sculpture, as exemplified, for example, by L.S. Adam's *Boy with a lobster*, or Claude Bertin's *Infant Cupid*.[7] [CA]

48
CAST FROM A MODEL BY ALESSANDRO ALGARDI
Charity

Bronze, 44.2cm high
Edinburgh, The Trustees of the National Museums of Scotland
(A1867.44.1)

There is no direct evidence that this composition is by Algardi, but sufficient indirect evidence from diverse seventeenth-century documentary sources to place his authorship beyond reasonable doubt.[1] In March 1695 the Florentine sculptor Massimiliano Soldani wrote to the Prince of Liechtenstein offering to make him a cast of a figure of *Charity* by Algardi that was in Florence at the time, and measured five-sixths of a braccio in height (which is equivalent to 48.5cm).[2] The majority of the casts are 47.5cm high, but the present one is considerably smaller (partly because it lacks the oval base), making it likely to be the result of taking piece-moulds from an existing bronze and casting a new bronze from them (a 'surmoulage', or 'after-cast'), for this process entails a shrinkage of between 5 and 10%.[3]

Algardi's authorship as cited by Soldani is corroborated by the appearance a decade earlier, in 1686, of a clay model and a piece-mould of a 'Charity by Algardi' among the studio effects of the

Roman sculptor Ercole Ferrata, one of Algardi's former students. Ferrata was also one of Soldani's instructors in Rome at the Florentine Grand-ducal Academy, and so Soldani may have got hold of these valuable items himself, so that he would be in a position to offer to produce casts for his clients. A terracotta and a bronze cast of a *Charity* described as by Algardi were also listed in two separate seventeenth-century inventories in Bologna.

Amongst Algardi's sculptures this seems to be an early work, probably from the late 1620s, and may tentatively be associated with a statue in temporary materials that he supplied as part of the decoration of the catafalque erected for the funeral in 1630 of Carlo Barberini, brother of the reigning Pope, Urban VIII (see cat. no.123). The drapery ripples about the figure in a rather disorganised fashion and the child reaching up to her from below is closely related to ones by Duquesnoy.

The popularity of this statuette of *Charity* may reflect the widespread emphasis in seventeenth-century Rome on the efficacy of 'good works' in the salvation of the soul (see Christopher Black's essay p.16). [CA]

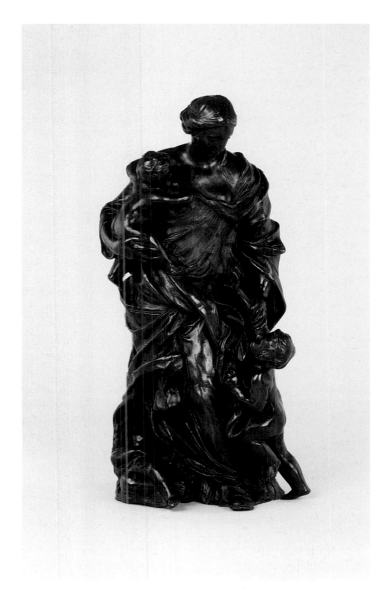

49
CAST FROM A MODEL BY ALESSANDRO ALGARDI
The Rest on the Flight into Egypt
Gilt-bronze, 28 × 34.2cm
Cambridge, The Syndics of the Fitzwilliam Museum
(M.1–1939)

Although there is no documentary evidence to support the attribution of the present composition to Algardi, or indeed to date it, his authorship is not in doubt and it may be compared in terms of style with his *Ecstasy of St Mary Magdalen* of 1635.[1] It was one of the sculptor's most popular productions, with no fewer than seventeen recorded variants in different media.[2] The present example is arguably the finest, in spite of the fact that the wing of the angel at the left has had to be cut to fit under the frame.[3]

The engraving of the details and the matt-punching on the hair and wings of the angel, the cloak of Joseph and the dress of the Virgin are highly accomplished. The leaves on the tree and the foreground plants are beautifully modelled in low relief. Details that are rendered in low relief stand out naturally, without needing to be emphasized by crude outlines drawn with a stylus, as in other less good casts.

Joseph's and Christ's heads are equidistant from the centre, which is marked by the projecting shoulder of Mary. Joseph has a pensive expression, induced perhaps by his having just read prophecies about the fate of Jesus in the book he supports with his left hand. Mary solicitously prepares to wrap the child in the fringed cloth that is held up, tent-like, by the angel and suspended from the far end from the tree. The baby is as chubby as one by Duquesnoy, with the folds in its fat divided by sharp creases, emphasised with strokes of the chasing tool.

The composition may have its origins in the drawing at Windsor, in which the Christ child is still more like a Duquesnoy sleeping putto and Joseph is shown standing (see following entry). The gesture of the angel, with arms outstretched and looking back over his shoulder, recalls that of Joseph holding the donkey in a drawing in Lisbon of a related but much rarer scene, the *Rest on the Return from Egypt*, and also in a sketch of a similar subject in the Uffizi.[4]

Significantly, an impoverished, though evidently fairly early, example of the *Rest on the Flight* relief in the Palazzo Pallavicini-Rospigliosi, Rome, is paired with a similar one showing the *Rest on the Return from Egypt*.[5] (A version of the latter recently on the art market in Florence is illustrated here, fig.69). It is worth noting that the figure of Joseph – and particularly the almost comic head of the donkey, which seems to react in a human way to the hushing gesture of the Child – are also derived from Algardi's initial drawing of the other scene, the *Rest on the Flight*. This second composition was just as surely designed by Algardi, even if – as has been suggested – the casts in the Roman palace were made in a Florentine workshop around 1700. [CA]

50
ALESSANDRO ALGARDI
The Rest on the Flight into Egypt
Pen and ink and wash over graphite, 18.6 × 25.3cm
Windsor Castle, Royal Library
(RL2348)

This elaborate drawing may reasonably be associated with Algardi's relief of this subject (see previous entry), although in view of the numerous differences it can hardly be described as strictly preparatory.[1] As a composition, complete with its landscape background, it has a strongly pictorial quality which recalls Algardi's early training in the Bolognese academy of Lodovico Carracci (it shares this characteristic with the following entry). The style of the landscape elements is typically Bolognese, and is especially reminiscent of the landscape drawings of Algardi's friend Giovanni Franceso Grimaldi. Only the frieze-like arrangement of the figures and donkey across the sheet hints at the fact that it is a sculptor's rather than a painter's drawing, and makes it suitable for translation into low relief. The range of graphic techniques, including stippled pen strokes on the faces of the Virgin and Child, and on the latter's shoulder, and a highly effective application of wash, is unusually broad for Algardi.

The combination of sleeping infant Jesus and the Virgin Mary's action of wrapping him in a light drapery – which is common to both drawing and relief – is a clear reference to Christ's future Passion and to the winding cloth in which he was entombed. Such allusions had since at least the Renaissance been very common in representations of the infant Christ. They can be seen in a more explicit, albeit iconographically puzzling, form in a related drawing by Algardi recently acquired by the Metropolitan Museum of Art in New York (fig.70), in which the Christ Child holds what appear to be three pyxes or lidded chalices.[2] The pose of the Virgin in the latter drawing is, incidentally, quite close to that of the equivalent figure in the Cambridge relief. [AWL]

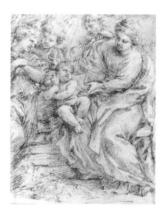

left fig.69: After Alessandro Algardi, *The Rest on the Return from Egypt*, formerly Florence, Art Market

right fig.70: Alessandro Algardi, *Holy Family with Angels*, New York, Metropolitan Museum of Art

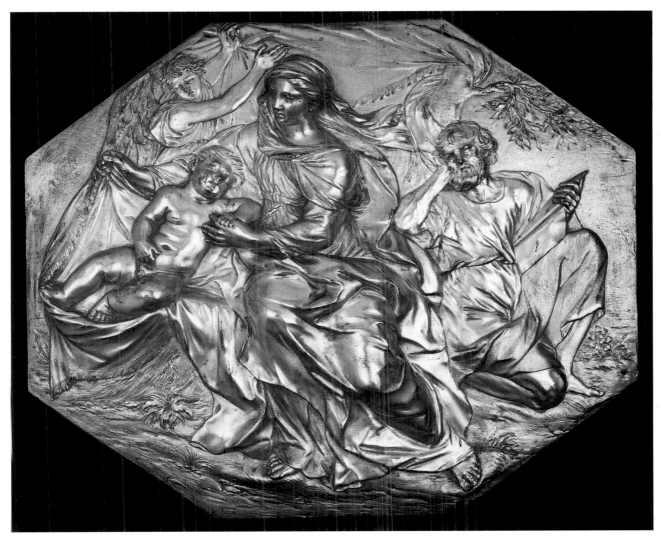

cat.no.49

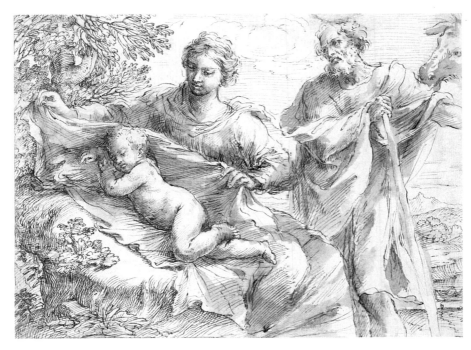

cat.no.50

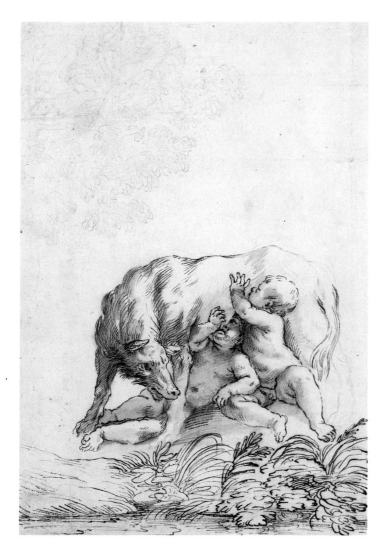

51

ALESSANDRO ALGARDI
The She-Wolf Nursing Romulus and Remus

Pen and brown ink and two shades of wash over graphite
and black chalk, 29.3 × 19.7cm
Windsor Castle, Royal Library
(RL5312)

Algardi studied at the Carracci academy under Lodovico, and
would have been well acquainted with the Carracci frieze of *The
Foundation of Rome* in the Palazzo Magnani, Bologna.[1] The present
drawing, with the wolf standing, curving around to look at her
charges, the river in the foreground, and a tree behind, appears to
be directly derived from the equivalent scene in this frieze (fig.71).
The long, shaggy fur and elongated muzzle of the wolf in the draw-
ing would seem to confirm that Algardi based his depiction on art
rather than life. Our knowledge of Algardi's early drawings is lim-
ited, but in view of their strong Bolognese character it is not alto-
gether impossible that this drawing and the stylistically closely re-
lated *Rest on the Flight into Egypt* (previous entry) may both date
from prior to Algardi's move to Rome in 1625.[2]

The drawing does not relate directly to any other work by
Algardi, although the subject recurs a few times elsewhere in his
oeuvre: there are two studies for an *Allegory of Rome*, in the
Rijksmuseum in Amsterdam, and the Louvre, which show the wolf
lying at the feet of a personification of Rome with Romulus and
Remus;[3] the *Fountain of the Acqua Vergine* also featured a similar
group (see cat.nos.105–6). The composition of the present drawing
compares more closely, though in reverse, with the stucco medal-
lion of Romulus and Remus in the Sala Rotonda of the Villa
Belrespiro, and it seems likely that Algardi recalled it, and the
fresco which inspired it, when designing this roundel.[4]

On the verso of the sheet is a black chalk study, possibly for two
shepherds in an Adoration, which must be by a different hand, and
a smaller pen and ink sketch of four men drilling (?). [EJS]

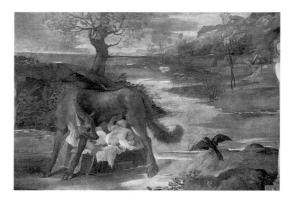

fig.71: Annibale and Lodovico Carracci, *Romulus and Remus
nursed by the She-wolf*, fresco, Bologna, Palazzo Magnani

cat.no.51 *verso*

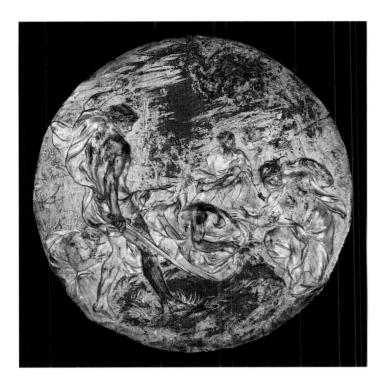

52

CAST FROM A MODEL BY ALESSANDRO ALGARDI
The Martyrdom of St Paul

Gilt-bronze. The gilding, which is extensively abraded, was coated with
what may be an original layer of lacquer or varnish, 50.2cm diameter
London, Victoria and Albert Museum
(111–1869)

This is a good example of a widely diffused relief designed by
Algardi for the altar frontal in the church of San Paolo, Bologna, to
supplement and identify the full-scale marble group of the *Execu-
tion of St Paul* above.[1] The latter stands above the high altar and was
commissioned under the will of Paolo Spada, who died in 1631.
Though a contract was drawn up and blocks of marble purchased
in 1634, Algardi was not paid for his work until 1641–3.[2] The prime
version of the bronze plaque in Bologna (fig.72) was cast by
the founder 'Maestro Cesare' (probably Cesare Sebastiani), and
cleaned and chased by one 'Monsu Pietro'.[3] The patron of the altar,
Virgilio Spada, retained Algardi's original model in terracotta as a
work of art to be framed in its own right, but the sculptor presum-

fig.72: Alessandro Algardi, *The Martyrdom of St Paul*, Bologna, San Paolo

ably had permission to reproduce this picture-like low relief from
his working mould(s). Indeed, another, less well finished, cast was
in the Collegiate Church in Rabat (Malta) by 1681–2, and several
other casts, including the present one, also probably date from the
seventeenth century.

The composition depicts the story that St Paul's head, after be-
ing cut off with a sword, bounced on the ground three times and
from each spot a fountain sprang, to the amazement of the execu-
tioner and witnesses. This explains why he raises his left hand, and
the young woman in the right foreground kneels and raises her
hands too, as she looks down at the gruesome head.

Modelling in this sort of very low relief on ductile moist clay is
a process akin to drawing, but light and shade are created not by
shading with the pen or chalk, but by adding small pieces of clay
and manipulating them into an approximation of the relevant
physical forms, without allowing them to project much above the
flat surface. In this way a spatial continuum can be preserved be-
tween background and foreground, as here. A weeping woman at
far left is indicated mostly by drawing her drapery with a stylus
over only minutely raised forms for her body, while the shoulders,
back, head and legs of the executioner project quite strongly and
are indented with the sculptor's thumbs and fingers, to leave his
rippling muscles standing out. The workmanship is comparable to
that of Algardi's other, earlier, reliefs such as the *Rest on the Flight
into Egypt* (cat.no.49). [CA]

53

ROMAN SCHOOL, ABOUT 1650–75
A Jesuit Baptising a Royal Family

Bronze relief, 36.5 × 44.4cm
Edinburgh, National Gallery of Scotland
(NG2556)

Identification of both the author and the subject of this relief have
proved elusive. The distinctive habits worn by the figures at the left
would appear to identify them as Jesuits, although even this is not
certain. If so, the most likely candidate for the foremost of this
group, who performs the baptism, is St Francis Xavier, whose mis-
sionary activities, particularly in India and the Far East, brought
him canonisation, along with the founder of his order Ignatius
Loyola, in 1622 (see cat.no.153). During the seventeenth century,
images of St Francis Xavier's successes served to inspire Jesuit nov-
ices travelling to dangerous missionary outposts throughout the
world. However, the details of the relief do not correspond to any
recorded conversion in Francis Xavier's life.[1] Indeed, it seems quite
possible that the relief represents a celebration of the missionary
activities of the Jesuit order as a whole, rather than an illustration
of a particular historical event. The members of the royal family
are presented in generalised, classicising costume, and they appear
to be of European rather than an Asiatic origin. If an episode in one
of the Jesuit missions to the East were being illustrated here, one
would have expected at least a few token oriental references, such
as a turban or two, a palm tree, or a camel – like those that appear
in Baciccio's *St Francis Xavier baptising an Eastern Queen* in
Sant'Andrea al Quirinale.[2]

The sculptor responsible for this relief was clearly greatly
influenced by Alessandro Algardi, and by bronzes cast to his de-

signs. The composition is very similar, though in reverse, to Algardi's *Pope Liberius baptising Neophytes* from the Fountain of St Damasus in the Vatican. In both, the figures in the foreground are gathered on either side of the baptismal basin, focusing the viewer's attention on the central protagonist leaning forward to baptise a kneeling figure.[3] The depiction of antique costume in the Edinburgh relief also relates very closely to that worn by Attila in Algardi's monumental marble relief of *The Encounter of Leo the Great and Attila* in St Peter's, for example in the acanthus ornamentation on the cuirass.[4] The generally slender proportions of the figures and the swaying movement of the chief cleric's vestments, also find close parallels in Algardi's work. Extensive chasing in the cold bronze was used to particular effect to differentiate textures, while distinctive indented contours help to distinguish the lowest relief figures from the background plane. Both of the latter features recur in a closely related relief now in the Metropolitan Museum of Art, which is based on the relief by Algardi on the Urn of St Ignatius Loyola (fig.73).[5] It has been suggested that the New York relief may have been cast by Giovanni Andrea Lorenzani,[6] who specialised in small religious reliefs in bronze, and it seems likely that the present relief is from the same workshop.　　[EJS]

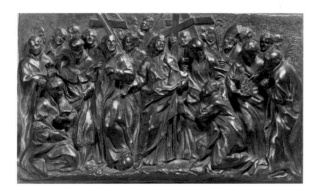

fig.73: After Alessandro Algardi, *St Ignatius Loyola with Saints and Martyrs of the Jesuit Order*, New York, Metropolitan Museum of Art (Rogers Fund, 1938)

54

CAST FROM MODELS BY ALESSANDRO ALGARDI

The Flagellation of Christ

Gilt-bronze, Christ, 21.8cm high; flagellators, 24.2cm high
(including plinth: 35.5 × 37.5 × 25cm)
Cambridge, The Syndics of the Fitzwilliam Museum
(M.1–1965)

The three gilt-bronze statuettes, the crumpled, abandoned robe, and the sash of Christ are set on a base laminated with mottled green marble. The column is turned out of a piece of agate. The base has salients at either end and a concave architectural moulding running round it, against which are mounted three blank baroque cartouches in gilt bronze, that on the front having palms of martyrdom sprouting from it.[1] The textures of the bronze components are differentiated by being alternately burnished or matt-punched, for instance on the inside and outside of Christ's robe, or on the nude bodies and on their loincloths. This after-working leaves the drapery looking rather hard and metallic.

This is an excellent example, with an Italian provenance,[2] of a widely diffused composition by Algardi, which probably dates from the mid- to late 1630s. The flagellators conform to Algardi's style as manifested in the marble *Beheading of St Paul* in the church of San Paolo, Bologna (*c*.1634), or in the *Hercules and Hydra* in relief on the gorget of his bust of Urbano Mellini in Santa Maria del Popolo, Rome.[3] Indeed, a preliminary terracotta model for the executioner of St Paul (now in the Hermitage, St. Petersburg), which is lither and more elongated in its proportions than the figure as finally carved in marble, is quite similar to the flagellator on the left.[4]

Historically-speaking, the best-known (though not the best) cast of the group is a gilt bronze one in the Kunsthistorisches Museum, Vienna,[5] but a superior group, also gilded, has recently emerged from the Corsini Collection in Florence, and is now in an American private collection.[6] The present, carefully finished figures, with traces of wire-brushing following the forms of their bodies, are like the figures in the latter group, the chasing of which has been claimed as being the best out of all the different casts of these models. The arrangement of the figures on the base in a diagonal line (from rear left to front right) is unusual, while the accoutrements lying on the ground appear to be unique. These factors suggest that the bronzes forming the group may have been cast at a later date from the same models or moulds as had been used by the foundrymen who worked for Algardi – for in his day major sculptors were not usually involved in the laborious technical processes of casting and finishing bronzes from their designs.

A previously unknown example of the *Flagellation* appeared recently on the London art market.[7] Examples of the group (or individual figures from it) cast in silver also exist, such as those in the National Gallery of Victoria, Melbourne;[8] in the Sacristy of Notre-Dame-des-Doms in Avignon; and in the National Gallery of Art, Washington DC.[9]　　[CA]

100

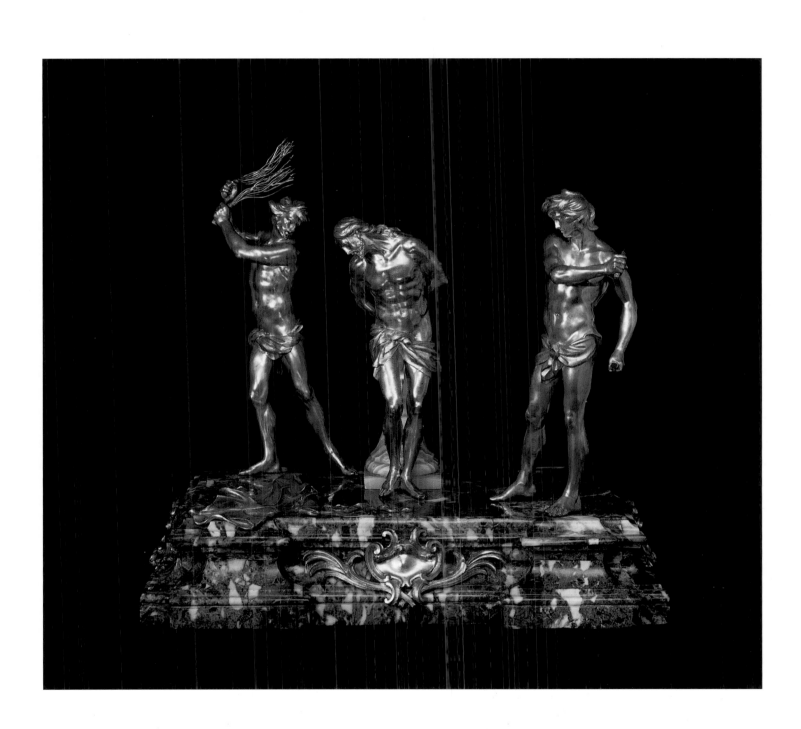

55

AFTER ALESSANDRO ALGARDI
St Nicholas of Tolentino

Bronze with a black patina, 38.6cm high
London, Sir Brinsley Ford, CBE, FSA

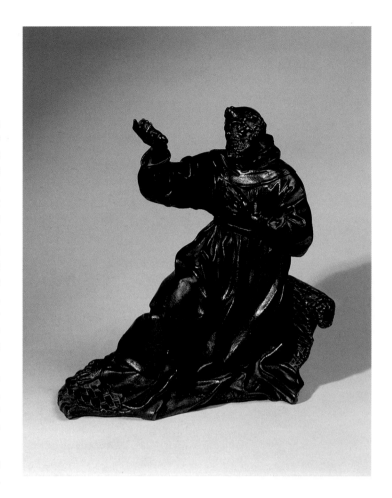

This bronze, which has a distinctive hammered finish, seems to be cast from a wax which in its turn was modelled on the terracotta by Algardi now in the Palazzo Venezia, Rome.[1] The latter was made in preparation for the marble group of *The Virgin and Child with Sts Augustine and Monica Appearing to St Nicholas of Tolentino* (fig.74), which was commissioned in 1651 by Prince Camillo Pamphili for the high altar of San Nicola da Tolentino in Rome. The group was probably completed by the time of Algardi's death in 1654, although it was not installed in the church until the end of 1656 at the earliest. Early sources indicate that Algardi's assistant Ercole Ferrata was largely responsible for the execution of the marble figure of St Nicholas, while another pupil, Domenico Guidi, carved the group of the *Virgin and Child with Saints* above. According to Bellori, Algardi supplied only the final touches to the marbles.[2] The ailing saint holds bread in his hand in allusion to the bread which the Virgin urged him to request from an old lady.

The wax model for the exhibited bronze may have been supplied by Ercole Ferrata, since two items fitting this description, and attributed to Algardi, were listed in his post-mortem inventory.[3] Another version of the bronze is in the Museum of Fine Arts, Budapest.

[This entry is adapted from Nicholas Penny's description of the bronzes in the Brinsley Ford Collection to appear in the forthcoming *Walpole Society*, 60, 1998].

fig.74: Alessandro Algardi and workshop,
The Virgin and Child with Saints Appearing to St Nicholas of Tolentino,
Rome, San Nicola da Tolentino

VI

Projects for St Peter's and its Piazza

56

PAOLO SANQUIRICO 1556–1630

The Façade of St Peter's, 1607

OBVERSE: Camillo Borghese, Pope Paul V (1550–Pope 1605–21), bearded and tonsured, in profile to right, wearing cope embroidered with a figure of St Peter(?) within a niche; around:
.PAVLVS.V.BVRGHESIVS.ROM.PONT.MAX.A.S.MDCVII.PONT.III.;
signed below truncation: *P SANQVIRIS*
REVERSE: Façade of the Basilica of St Peter's, Rome; around:
TEM.D.PETRI.IN VATICANO; in exergue: *ET.PORTAE.INFERI.NON /
PRAEVALEBVNT*
Bronze (cast); 5 6cm diameter
Edinburgh, National Gallery of Scotland
Purchased by the Patrons of the National Galleries of Scotland, 1988
(NG2473)

57

GIOVANNI HAMERANI 1646–1705

The Announcement of the Jubilee 1674

OBVERSE: Emilio Altieri, Pope Clement X (1590–Pope 1670–76), bearded in profile to right, wearing tiara and cope around:
CLEMENS.X.PONT.MAX.AN.V; signed below truncation:
IO.HAMERANVS.F.
REVERSE: Oblique view of St Peter's, with part of the Vatican Palace, trumpeting angel above; below, Romulus and Remus suckled by the She-Wolf; above: *FLVENT.A DEVM.OMNES.GENTES.*; dated in exergue: *1674*.
Silver; 4.1cm diameter. Traces of suspension loop broken off; a die crack visible across tiara.
London, British Museum
(M.1563)

Paolo Sanquirico's foundation medal heralds the start of the building history of St Peter's during the baroque period. Its instigator, Pope Paul V Borghese, is portrayed iconographically as successor to St Peter on the obverse of the medal. The medal was cast in 1607 for the ceremony which took place on 10 February 1608 to commemorate the foundation of the new façade of St Peter's under the direction of Carlo Maderno.[1] Exactly a year before, Maderno had begun work on a project for a barrel-vaulted nave flanked by side chapels, replacing what was left of the original Constantinian basilica.[2]

Until their demolition in 1606–7 by Maderno, the nave and portico of the old basilica had been in continuous use, although a gigantic new church had been begun in the crossing over the tomb of the Apostle Peter, on which many of the major architects of the Renaissance had been engaged.[3] This new centralised structure was designed by Bramante, and was based on ancient precepts regarding the suitability of centralised plans for tombs and memorials. When Michelangelo took over as designer, he modified Bramante's project. He was succeeded by Giacomo della Porta, who completed the work.[4]

Derived from Michelangelo's earlier dynamic design for a temple-front, the Paul V medal (cat.no.56) shows Maderno's first project for the façade of St Peter's, which is likewise dominated by a pedimented temple motif. Maderno's compact design, reduced to seven bays, left an uninterrupted view of the cupola and transept arms. In fact, the frontal viewpoint of the foundation medal makes it appear as though St Peter's were a Greek cross design, a centralised structure as planned by Bramante and Michelangelo, rather than a conventional Latin cross plan, with an extended

cat.no.56 obverse *left* reverse *right*　　　　cat.no.57 obverse *left* reverse *right*

nave. Like Cristoforo Caradosso's 1506 medal commemorating the re-building of St Peter's under Pope Julius II,[5] Sanquirico's design is extremely plastic in its execution, with the columns and ribs of the cupolas modelled in high relief, and the church fully occupying the medallic field.

Maderno's design for a façade derived formally and conceptually from the centralised Renaissance model was destined to be modified during construction, and these changes are clearly visible in Giovanni Hamerani's Jubilee medal (cat.no.57).[6] Maderno's compact façade has been expanded by two bays and now extends beyond the confines of the basilica itself. It is linked visually to the Vatican Palace, as well as forming part of the overall architectural scheme of the Piazza. The portico of the façade was furnished with precious antique columns, and decorated with gilt stuccoes and reliefs.[7] Its central portion houses the Benediction Loggia, from which the pope blesses the crowds gathered in the Piazza, and ceremonial processions from the Vatican Palace to the basilica passed through it. Moreover, Jubilee Years were announced from the Benediction Loggia, and officially inaugurated by the opening of the Porta Santa ('Holy Door'), located inside the portico.

Hamerani's medal is dated 1674 because the Porta Santa was opened on Christmas Eve of the year before the Jubilee. The symbol of Rome, the she-wolf with Romulus and Remus, appears in the foreground to identify the city as the locus of the celebration, while over the Piazza flies a triumphant figure of Fame (based on the figure in Bonacina's engraving; see cat.no.67), announcing the worldwide benefits of the Jubilee. Throughout that year, pilgrims flocked to Rome: the Arch-confraternity of the Trinità dei Pellegrini accommodated no fewer than 280,476 visitors during the course of the Jubilee (see also cat.no.116).

Although executed in very low-relief, Hamerani skilfully conveys the deep perspective of the Piazza and basilica, while at the same time managing to retain a sense of monumentality in the figures.[8] Indeed, this medal has aptly been described as 'a minor masterpiece that heralded a renewal of both the Roman school of medals and his own attainment of artistic maturity'.[9] In his use of perspective and illusionistic effects Hamerani was inspired by some of the medals produced by Gaspare Morone to Bernini's designs, such as that of the Quirinal Palace (cat.no.83) and the Colonnade of St Peter's (cat.no.64). The reverse was deemed so successful that the die was re-used for the Holy Years of 1725 and 1750. [ES]

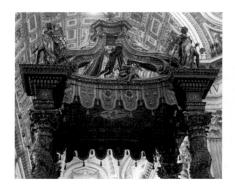

fig.75: Gianlorenzo Bernini and workshop, *The Baldacchino* (upper section), Rome, St Peter's

fig.76: *Antique Salomonic Column from the Constantinian Basilica of St Peter's,* Rome, St Peter's

ATTRIBUTED TO FRANCESCO BORROMINI 1599–1667
Three Designs for the Baldacchino:

58

Design for an Upper Column and Capital

Pen and brown ink and wash over graphite on discoloured white paper; the paper damaged at the upper and lower edges, 49.6 × 21.5cm
Windsor Castle, Royal Library
(RL5635)

59

Design for the Entablature over the Columns

Pen and brown wash over graphite on discoloured white paper, 39.2 × 34.1cm (overall dimensions of inlay sheet); 36.8 × 33cm (dimensions of original, irregularly shaped, paper). The Barberini sun is drawn on a separate piece of paper stuck down onto the original sheet.
Windsor Castle, Royal Library
(RL5636)

60

Design for the Canopy

Pen and brown ink and wash over traces of graphite on discoloured white paper, 33.9 × 45.2cm
Windsor Castle, Royal Library
(RL5637)

A *baldacchino* – or baldachin in English – is a ceremonial canopy held like a sun-shield over a Pope or monarch; the *Baldacchino* is a vast bronze replica of this form marking the high altar of St Peter's and the precise point where St Peter himself is buried (figs.3 and 75).[1] Bernini's was not the first *baldacchino* on this site: in 1606, even before the façade of the church had been completed, one was erected following the classic and expected design, with four angels holding the canopy on four staves. Bernini's version departed from precedent (and logic) by incorporating columns. He chose to imitate in a magnified form the eleven antique twisted columns which survived from the old Constantinian Basilica, and which were believed to have been brought from the Temple of Solomon in Jerusalem (for which reason twisted columns are called 'Salomonic') (see fig.76).

These three studies are detailed presentation-type drawings, almost identical to the *Baldacchino* as built.[2] Very minor variations confirm that the drawings are not copied after the final bronze.[3] Although they may have been made for presentation to the Pope, to secure approval of the design, they have a technical aspect to them (especially cat.no.60) which would have made them useful reference material for the numerous founders and artisans engaged on the project. They were probably drawn by the greatest architect of the period, Francesco Borromini, who worked briefly and unhappily as Bernini's assistant, during which time he made some important contributions of his own to the design of the *Baldacchino*, particularly to the crowning element.

The most interesting problem which Bernini posed for himself in the *Baldacchino* lay in the junction between two unrelated forms and structural systems – the canopy and the column. Strictly speaking the columns support the crowning angels, and the angels in turn hold up the canopy with decorative ropes. In all the earlier designs Bernini clarified this arrangement by having the canopy

apparently swinging freely *above* the level of the cornice.[4] Finally he decided to confuse the issue by dropping the canopy so that it aligns with the main entablature and shares the two uppermost mouldings of the cornice. This is the junction which Borromini resolved in detail in his study for the canopy (cat.no.60). The solution, which could well have been Borromini's own idea, is at once a visual pun and a heresy. Without thinking, the viewer interprets the flaps of the canopy as the triglyph and metope blocks of a Doric frieze, and yet they are imposters, temporary flummery insolently impersonating the noble solidity of an entablature.

The other drawings (cat.nos.58 and 59) allow us to concentrate on the peculiar character and meaning which Bernini gave to the columns. By choosing to replicate Salomonic columns, Bernini clearly identified his *Baldacchino* as a Judaeo-Christian, rather than Graeco-Roman, monument. This was a contrast which architectural theorists were just beginning to appreciate during the period of the Counter-Reformation. The Temple of Solomon in Jerusalem was the only sacred equivalent to the many pagan monuments in Rome. It was known through extravagant and 'scholarly' reconstructions, such as that by the Spanish Jesuits Girolamo Prado and Giovanni Villalpando published in Rome between 1596 and 1604 (see bibliography). The use of angels' heads and wings in the customised 'metopes' (visible in cat.no.60) is possibly of Salomonic origin: Prado and Villalpando illustrate the architectural order of Solomon's Temple as a combination of a Corinthian-style capital with a Doric-style frieze, but with human and animal heads in place of the Doric *bucrania* or bull's skulls.[5] According to Prado and Villalpando, the Dorian Greeks here copied the Jews, substituting reminders of their superstitious sacrifices for the 'living' heads. The authors conclude triumphantly by pointing out that a frieze is called a *zophoros*, from the Greek 'life-carrying'; if it had been intended to carry skulls, it would have been called a *thanataphoros*.[6]

This idea of a 'living' architectural form was carried over to the columns. Fortunately, classical architectural theory maintains that columns derive from trees.[7] The original Salomonic columns in St Peter's, and Bernini's replicas, make explicit this ancestry: a ring of leaves around the base of each of the sections of the column suggests a trunk's organic growth, as do the branches and foliage wrapped around the shaft (which in Bernini's case were cast directly from living specimens). Prado and Villalpando imagined further examples of playfully organic architectural detail at the Temple of Solomon: dates, for instance, are said to take the place of Doric *guttae*.[8] In the same spirit, Bernini quickened every part of the decoration, however intricate – the shaft has playing cherubs and wandering bees; the capital is foliated in every cranny, with a sun-face in the abacus; the entablature has lively mask and dolphin mouldings, as well as the irregular and 'natural' laurel leaves in the uppermost cyma. There are further comic details suggesting that the life surrounding the monument was cast into the bronze: lizards and flies crawl over the bases, and rosaries and papal medals are left hanging over ledges.

Bernini's is a 'living' column dedicated to the living God. In point of fact, it is also dedicated in the most permanent and irreversible manner to the living Pope, Urban VIII, as the majority of symbols employed – the bees, the sun-face and the laurels – derive from his coat-of-arms. [DST]

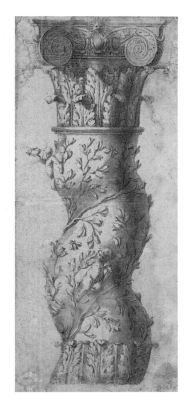

cat.no.58

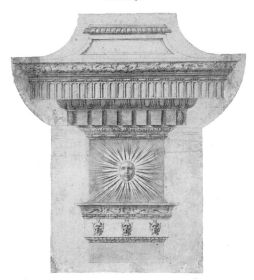

cat.no.59

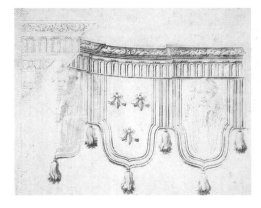

cat.no.60

cat.no.61 obverse *left* reverse *right*

cat.no.62 obverse *left* reverse *right*

61

GASPARE MOLA *c*.1580–1640
The Baldacchino of St Peter's, 1626

OBVERSE: Maffeo Barberini, Pope Urban VIII (1568–Pope 1623–44), bearded, in profile to right, bareheaded, wearing cope embroidered with busts of St Peter and St Paul; around: *VRBANVS VIII.PONT.MAX.A.IIII*; signed on truncation: *GASP* and on field below: *MOLO*
REVERSE: Elevation of Baldacchino, the cresting surmounted by a figure of the Risen Christ; around: *ORNATO.SS.PETRI ET PAVLI SEPVLCHRO*; in exergue: *M.D.C.XXVI.*
Bronze; 4.1cm diameter
Glasgow, University of Glasgow, Hunterian Museum

62

GASPARE MOLA *c*.1580–1640
The Baldacchino of St Peter's, 1633

OBVERSE: Maffeo Barberini, Pope Urban VIII (1568–Pope 1623–44), bearded, in profile to right, bareheaded, wearing cope embroidered with busts of St Peter and St Paul; around: *VRBAN. VIII.PONT.MAX.*; dated on truncation: *MDCXXXIII* and signed on field below: *GASP.MOL*
REVERSE: Elevation of the Baldacchino, the attic with ogee arches supporting a globe and cross; around: *ORNATO SS PETRI ET PAVLI SEPVLCHRO*; dated in exergue: *MDCXXXIII*
Silver; 3.9cm diameter
Glasgow, University of Glasgow, Hunterian Museum

The *Baldacchino* was commissioned quite soon after Urban's accession, and the columns were installed late in 1626 – which provided the occasion for issuing the earlier of the two medals under discussion here – but not officially unveiled until 1627. Bernini's revised form of the crowning canopy was not unveiled until the Feast of St Peter (29 June) 1633, an event commemorated by the striking of the later medal.[1] For the history and interpretation of the *Baldacchino*, see the previous entry.

[TC]

63

AFTER ALESSANDRO ALGARDI
Design for the Tomb of Leo XI

Pen and brown ink and wash over black chalk, 38.8 × 25.1cm
Inscribed at the lower left: *A. Algardi ft.*
Edinburgh, National Gallery of Scotland
(D909)

This drawing has usually been described as a copy after an early design by Algardi for his *Tomb of Leo XI* in St Peter's (1634–44) (fig.77).[1] The sculptural elements for the most part conform fairly closely to the tomb as executed, with the exception of the composition of the relief on the urn, and the identity of the allegorical figure to the left, who in the drawing is clearly identified by her accompanying column as Fortitude, whereas in the final tomb she represents Magnanimity (as specified in the 1634 contract). On the other hand, the architecture and ornamental features in the Edinburgh drawing differ significantly from those of the final tomb, and variant proposals for the framing pilasters are included.

One peculiarity of this commission was that the specific site for the tomb in St Peter's was evidently not finalised until after the sculptural elements, and even the cladding for the niche, had been

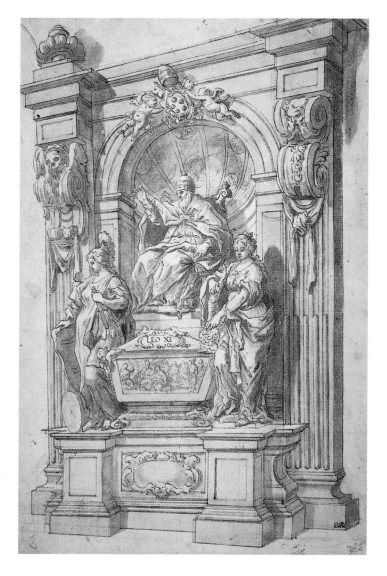

realised in marble. One must assume, however, that the go-ahead was given on the understanding that the tomb would occupy a niche in one of the piers in the side aisles of the basilica. A puzzling feature of the drawing is that is shows the monument viewed from an oblique angle, rather than frontally. Such a viewpoint would be extremely unusual in a preparatory drawing of this period, even allowing for the fact that the intended site for the tomb was a restricted one. Indeed, the drawing gives the impression that it (or rather the original from which it was copied) records a 'mock-up' of the monument actually installed in the church, with a view to settling on a suitable architectural surround and other decorative embellishments. So prestigious were major commissions in St Peter's, that such full-scale models were on a number of occasions in the seventeenth century erected in order for those involved to properly assess and approve the final effect: this was done, for example, with Algardi's own model for the relief of *The Encounter of Pope Leo and Attila*, and with Bernini's *Cathedra Petri* and *Tomb of Alexander VII*.

In the case of Algardi's *Tomb of Leo XI*, there is no mention in the extensive documentation of a model of this kind having been set up, and, even if this had taken place, it would be difficult to account for the differences in the sculptural elements between the drawing and the actual tomb. Algardi did, however, receive payments for what was evidently a relatively small-scale model made of wood and clay, which might conceivably have served as a basis for the projection represented by the present drawing.

Algardi was working on this tomb at the same time Bernini was undertaking the *Tomb of Urban VIII* (fig.7), and whilst *Leo XI* is dependent in some respects on the latter, these monuments are often used to illustrate the sculptors' respective classical and baroque inclinations. This conclusion is no doubt supported by the use of a single, light-coloured material in the Algardi, breaking with the tradition of casting the figure of the Pope in bronze.[2] However, this drawing suggests that Algardi may at one stage have been thinking in terms of a more flamboyant design, and that the omission of many of the decorative elements from the final monument may reflect the preferences of the patron (or his executors), or an attempt to control costs. [AWL]

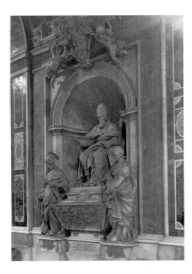

fig.77: Alessandro Algardi and workshop, *Tomb of Pope Leo XI de' Medici*, Rome, St Peter's

64A

GASPARE MORONE *fl*.1633–1669
The Piazza of St Peter's (version I), 1657

OBVERSE: Fabio Chigi, Pope Alexander VII (1599–Pope 1655–67), bearded, in profile to left, wearing cassock, cap, and stole; around: *VATICANI.TEMPLI.AREA.PORTICIBVS.ORNATA*; below on scroll: *ALEX.VII.P.M.*
REVERSE: Bird's-eye view of the basilica and Piazza, with obelisk and single fountain aligned on longitudinal axis; on scroll in exergue: *FVNDAMENTA.EIVS. / IN.MONTIBVS.SANCTIS*
Bronze (cast); 8.9cm diameter
Edinburgh, The Trustees of the National Museums of Scotland
(A1883-9.5)

64B

GASPARE MORONE *fl*.1633–1669
The Piazza of St Peter's (version II), 1657

OBVERSE: Fabio Chigi, Pope Alexander VII (1599–Pope 1655–67), bearded, in profile to left, wearing cassock, cap, and stole; around: *VATICANI.TEMPLI.AREA.PORT.CIBVS.ORNATA*; below on scroll: *ALEX.VII.P.M.*
REVERSE: Bird's-eye view of the basilica and Piazza, with obelisk flanked by two fountains; on scroll in exergue: *FVNDAMENTA.FIVS. / IN.MONTIEVS.SANCTIS*
Bronze (cast); 7.4cm diameter
Glasgow, University of Glasgow, Hunterian Museum

65

GASPARE MORONE *fl*.1633–1669
The Piazza of St Peter's, 1666

OBVERSE: Fabio Chigi, Pope Alexander VII (1599–Pope 1655–67), bearded, in profile to left, wearing Papal tiara and cope embroidered with Chigi devices; around: *ALEXAN.VII.PONT. MAX.A.XII*; signed below truncation: *GM*
REVERSE: Bird's-eye view of basilica, Piazza with central obelisk and two flanking fountains; around: *FVNDAMENTA EIVS IN MONTIBVS SANCTIS*; in exergue: *VATICANI TEMPLI / AREA PORTICIBVS / ORNATA*
Bronze; 4.1cm diameter
Edinburgh, National Gallery of Scotland
Purchased by the Patrons of the National Galleries of Scotland, 1994
(NG2607)

66

GASPARE MORONE *fl*.1633–1669
The Piazza of St Peter's, 1661

OBVERSE: Fabio Chigi, Pope Alexander VII (1599–Pope 1655–67), bearded, in profile to left, wearing tiara and cope embroidered with a figure of St Peter; around: *ALEXAN.VII.PONT. MAX.A.VII.*; signed below truncation: *GM*
REVERSE: Elevation of right arm of the Colonnade, in sky above a large scroll with the ground plan of the Piazza; in exergue: *FVNDAMENTA EIVS / IN MONTIBVS / SANCTIS*
Silver; 4.3cm diameter
Glasgow, University of Glasgow, Hunterian Museum

The complex genesis of the scheme for the Piazza in front of the basilica of St Peters can be traced through the numerous foundation medals which Bernini designed under the direct supervision of Pope Alexander VII, and which were executed by Gaspare Morone.[1]

On 31 July 1656 Bernini was commissioned by Alexander VII to regularise the area in front of St Peters,[2] and to enclose it with a free-standing, continous single-storey structure.[3] Alexander based his ideas on treatises on ancient architecture, in which porticoes and colonnades are not only indicative of imperial grandeur, but also served the practical function of shielding visitors from the elements – a sort of 'utilitarian' architecture.[4] The frenzied planning which immediately followed the Pope's decision can be reconstructed through surviving sketches, plans and written sources, which all indicate that the Piazza was originally planned as a trapezoid, and then, during 1656, as a rectilinear space.[5] A full-scale plan was laid out on the ground for perusal, and then partially erected along the empty, northern side of the square.[6]

It was only toward the end of 1656, in a second phase of planning, that the transverse oval form was adopted, apparently at the suggestion of the Pope himself.[7] This design was for a larger piazza than was actually built, and was composed of smaller single and then double porticoes encircling the oval area. An autograph drawing by Bernini shows that the design consisted of two half circles of arcaded porticoes flanking the Piazza, as seen in the two foundation medals of 1657 (cat.nos.64a and b).[8] A third phase of the project consisted of a revision of the oval design to reduce its breadth, and by May 1657 it had become almost circular ('*ovato tondo*').[9] At this time the arcades were replaced by colonnades consisting of four rows of columns, which were initially coupled (see cat.nos.64 a and b), but by September of 1657 were planned as separate columns (see cat.no.65). Two equal colonnades of over half-circle radius were planned to enclose the short sides of the oval (see cat.no.66), while a straight section of colonnade was to face the façade of the basilica from the east. This section, known as the 'third arm', was never built, although it features in prints (fig.78), as well as in these medals.

On 28 August 1657, Alexander VII personally officiated at the foundation ceremony, and directed that several special medals commemorating the event (cat.no.64a) be bricked into the foundations.[10] These medals had been commissioned from Bernini in June, along with a new portrait of the Pope for the obverse. Alexander VII also sent a sketch of the medal to the papal librarian and scholar Lucas Holstenius, asking him for suggestions for the motto to appear around the edge (fig.79).[11] On 3 August, the Pope chose the motto which related his family coat-of-arms of *monti* and stars with a passage from the Psalms, and settled its placement on the medal.[12] However, the axial arrangement of the fountain and obelisk on the first medal (cat.no.64a) was soon revised, and the twin fountains set on the transverse axis visible in the second version of this medal (cat.no.64b) were actually built by 1666.

Toward the end of 1657, a third medal was produced, although it is known only in a later edition dated 1666. Here the elevation consists of a continuous row of single columns, as in the executed design, although some further refinements were introduced. The design of this medal must date from after 2 September 1657, when Bernini showed the Pope the *disegno ultimo di colonne più grosse, e non doppie* ('latest design, with thicker columns, and not double').[13]

The fourth medal, issued in 1661 to mark the completion of the northern arm (cat.no.66), shows changes to the central axis, where wider entrances, coupled columns and temple-front pediments have been added.[14] The sophisticated design of this medal shows the perspective of the entire northern colonnade as seen from a central viewpoint. Although Alexander VII is portrayed in the first two medals with a cassock, cap and stole, in this one he is shown for the first time wearing the papal tiara, and with a cope decorated with the Chigi coat-of-arms, which lend an official celebratory tone to the design. The style of the reverse strongly suggests that Bernini may have been responsible for its design; indeed, it may also have been he who designed the new papal portrait. The com-

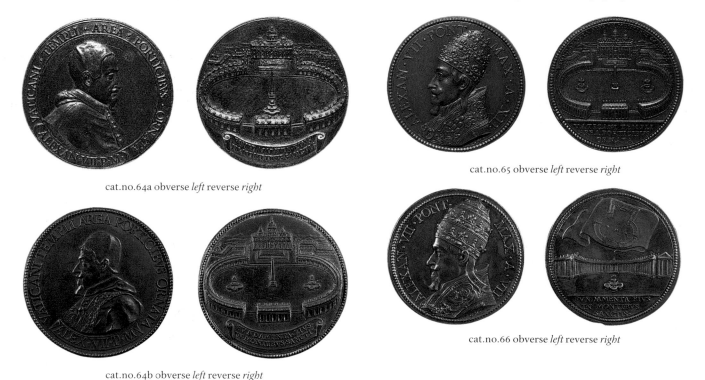

cat.no.64a obverse *left* reverse *right*

cat.no.65 obverse *left* reverse *right*

cat.no.64b obverse *left* reverse *right*

cat.no.66 obverse *left* reverse *right*

bination in one field of a plan and elevation of the colonnade is strongly reminiscent of Bernini's drawing in the British Museum (see following entry). [ES]

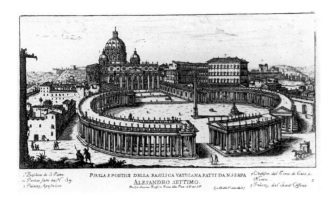

above fig.78: Giovanni Battista Falda, *The Piazza of St Peter's*, engraving, Rome, Bibliotheca Hertziana

below fig.79: Fabio Chigi, Pope Alexander VII, *Sketch for the Foundation Medal of the Piazza of St Peter's*, Rome, Biblioteca Apostolica Vaticana

67

GIANLORENZO BERNINI AND MATTIA DE' ROSSI
1637–1695

The Colonnade of the Piazza San Pietro, 1659

Pen and brown ink and wash over black chalk; the principal outlines indented, 52.2 × 84.2cm; a large loss along the central vertical fold made up by a later hand.
Inscribed in ink in the frieze over the central entrance in the bottom elevation: *ALEXAN VII FONT MAX A V*; there are long descriptive inscriptions at centre left and right, that at the left serving as a key, while that at the right is concerned with detailed measurements. There are two scales in Roman palmi at the bottom. At the lower left is inscribed the papal *incidatur*.[1]

London, British Museum
(Oo.3–5)

This splendid sheet was designed under Bernini's direction in his capacity as official Architect to the Fabbrica of St Peters, and was made in preparation for an engraving by Giovanni Battista Bonacina, which reproduces it in the same sense.[2] Its subject is the colonnade (*portici* in Italian) in front of St Peters, encircling the

oval piazza, which was intended to be realised in three segments. Spanning the drawing in an arc is the plan of one of the arms of the colonnade, while across the bottom appears its elevation and at the top right there is a vertical section. Together, these three elements of the drawing present the technical details of the architecture, carefully measured, but to different scales. The key-hole shaped plan of the whole Piazza at the upper left shows, in slightly idealised form, the carefully worked out symmetry of the design in relation to the plan of St Peter's.[3]

The bird's-eye view at the centre of the sheet, drawn in not entirely convincing, 'fish-eye' perspective, intimates in some measure the sensation experienced by visitors to the Piazza that the colonnade is circular rather than oval.[4] Perspective renderings of the obelisk and the two fountains on the cross-axis give a hint of their design. The progression in this view from the Piazza to the portico of the façade of the basilica, and on to its three cupolas, all of which incorporate columns, indicate that this is also a *pars pro toto*, showing the architectural integrity of the whole complex. An attempt has also been made to minimise the trapezoidal shape of the *Piazza retta* (as the area between the oval Piazza and the façade of the church is known), by diminishing the diagonal slant of its flanking corridors.

The sophisticated manipulation in this drawing, and the related engraving, of certain aspects of the real Piazza echoes the manner in which Bernini managed to overcome the difficulties of the site, so as to convey the impression of complete regularity and balance.[5] The visitor to the Piazza aware of such illusionistic tricks is irresistably drawn into what has been termed the *teatro de' Portici* ('the theatre of the Colonnades'). In a memorandum of about 1659, Bernini himself wrote that the colonnades 'reach out with open arms to embrace Catholics in order to reaffirm their belief, heretics to be reunited with the Church, and agnostics to be enlightened with the true faith'.[6] It may be significant in this context that additional inscriptions on the banderoles in the print (not present in the drawing), provide information, in two languages, about the history and aims of the design.[7]

Bonacina's engraving was intended for wide circulation, to serve as the officially sanctioned description of the new project for the Piazza of St Peter's. It was issued in response to the fact that other, unofficial engravings relating to the project were in circula-

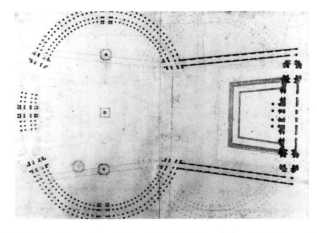

fig.80: Gianlorenzo Bernini and Mattia de' Rossi, *Plan of the Piazza of St Peter's*, Rome, Biblioteca Apostolica Vaticana

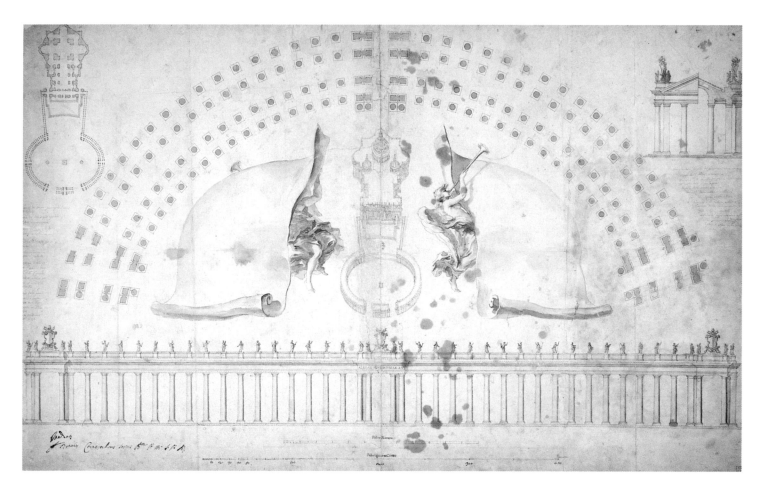

tion,[8] but also to counter criticism regarding its purpose, concept and architectural design. The text of the engraving explains the various reasons for which Alexander VII wished to see the project realised. First of all the practical considerations are examined, such as the concern for the *bene pubblico* – to provide shelter from rain and sun for pedestrians and carriages. Alexander VII is presented as the Pope who finally carries out what others before him only planned. And lastly the basilica itself is nominated as being symbolically at the centre of this new complex, which further elevates it aesthetically.

The official nature and high-mindedness of the plan indicate that it was developed by Bernini in close conjunction with the Pope and his advisers, and documents indeed record that the architect met with the Pope to discuss the plans. The execution of the drawing is here attributed to Mattia de' Rossi for both stylistic and documentary reasons, although the trumpeting angels, the handling of which is more spirited, may be by Bernini himself.[9] The drawing can be dated to the fifth year of Alexander VII's papacy (that is, within a year of 7 April 1659), as it is inscribed over the central entrance of the colonnade, *ALEXAN VII PONT MAX A V*.[10] In fact, we know that by July of that year Bonacina was already engraving the design onto a copper-plate.[11]

The project for the Piazza was well advanced by 1659: a fourth commemorative medal had been struck to reflect changes, and a cherry-wood and wax model of the whole project for the colonnades was being constructed.[12] Both of these, together with the present drawing, were based on the carefully executed plan of the

Piazza which was realised under the Pope's direct control as the official building project in the spring of 1659 (fig.80).[13]

When the engraving appeared, the building work was so far advanced that all of the columns facing into the square on the northern side were already standing, as well as some of those facing outwards. Later, however, Bernini himself introduced changes to the design engraved by Bonacina, such as the location and articulation of the third segment of the colonnade marking the entrance (which was never realised); the central passages leading through the porticoes were also altered, and finally, the attic was given a balustrade as a crowning feature. [ES]

68

AFTER GIANLORENZO BERNINI

St Agnes with the Palm of Martyrdom

Gilt-bronze. A heavy lost-wax cast on an integral rectangular base. There are some filing marks visible on the surface, and there is a minor casting flaw (unrepaired) to lower rear edge of plinth, 34.8cm high

Edinburgh, National Gallery of Scotland, 1995

(NG2632)

This gilt-bronze statuette is a reduction of the enormous travertine statue of *St Agnes* that stands above the entablature near the centre of the north Colonnade in the Piazza of St Peter's. A contemporary witness, Filippo Titi, claims that each of the ninety statues that grace the upper register of the Colonnade was prepared by Bernini.[1] In fact, a team of fourteen sculptors worked on these

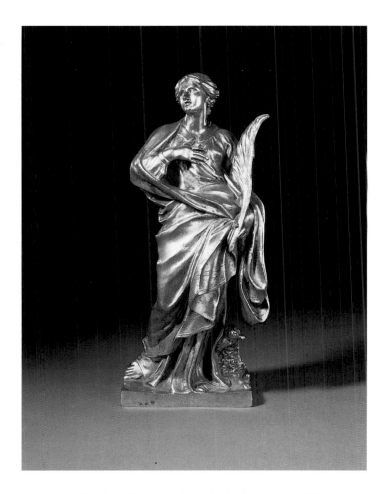

statues, and although Bernini no doubt kept a watchful eye on proceedings, it is unlikely that he even supplied drawings and terracotta *bozzetti* for every statue (all that survives from his hand relating to this project are a few slight sketches).[2] The existence of multiple examples of this statuette of *St Agnes*, which corresponds almost exactly to the statue on the Colonnade, suggests that it may derive from a lost *bozzetto* by Bernini himself.[3] A carved coat-of-arms of Alexander VII Chigi surmounted by the papal insignia was set on the Colonnade above each of the entrances to the straight

NE PORTICI DEL GRAN TEATRO DELLA PIAZZA DELLA BASILICA VATICANA
Architettura del Cavalier Bernini
2.

fig.81 After Gianlorenzo Bernini, *St Catherine and St Agnes Flanking the Arms of Pope Alexander VII*, Edinburgh, National Gallery of Scotland

corridors. Particular attention was understandably paid to the saints flanking them, which included, above the entrance leading to the Scala Regia, the *St Agnes* and *St Catherine of Alexandria*, the only two of all the saints on the Colonnade to be preserved in small-scale bronze statuettes (see fig.81).[4] *St Agnes* stands in an elegant *contrapposto* and gazes heavenward as she holds her palm of martyrdom in her left hand. The lamb, the saint's attribute due to the similarity of her name to the Latin *agnus* (meaning lamb), nestles against her left foot.

Several other versions of the statuette are known, one in the Metropolitan Museum of Art in New York, another in the chapel of Palazzo Doria-Pamphilj, and two in private collections in Rome and Los Angeles. The similarities between the various statuettes suggests that they all derive from the same prototype, and the minor differences were probably introduced at the stage of the wax models, a new one of which would have been required for each separate cast. The Edinburgh version shares with that in Los Angeles a slightly more pronounced tilt of the head and weightier folds in the mantle. It also shows especially fine attention to detail in the chasing and decorative edging on the mantle and in the lamb's fleece, and is the only version in which the palm of martyrdom is intact. [EJS]

69
GIANLORENZO BERNINI
Design for the Cathedra Petri Medal
Pen and brown ink and wash over graphite; quartered for transfer;
a compass hole at the centre, 5.9cm diameter
London, British Museum
(1946–7–13–689A)

70
GASPARE MORONE *fl*.1633–1669
The Cathedra Petri
Wax relief on a grey slate disc; incised with concentric circles around the
border and quartered; 4.3cm diameter
London, British Museum
(1932–8–6–35)

71
GASPARE MORONE *fl*.1633–1669
The Cathedra Petri, 1662
OBVERSE: Fabio Chigi, Pope Alexander VII (1599–Pope 1655–67),
bearded, in profile to left, wearing tiara and cope; around: ALEXANDER
VII PONT.MAX.AN VIII; signed on the truncation: GM
REVERSE: The Cathedra Petri (Chair of St Peter) in the apse of St Peter's;
around: PRIMA SEDES FIDEI REGVLA / ECCLESIAE FVNDAMENTVM
Bronze; 4cm diameter
Edinburgh, National Gallery of Scotland
Purchased by the Patrons of the National Gallery of Scotland
(NG2683)

These three exhibits document three stages in the production of a small medal of great artistic quality, a collaboration between Bernini as designer and Morone as modeller and die engraver.[1] The disc of paper on which Bernini's design is drawn is inscribed with concentric rings around its border using a compass; its dimensions

are slightly larger than those of the medal. Worked by Morone himself, the wax transformed the preparatory design into a three-dimensional object, so that the effect of the relief and the fall of light over its surface could be accurately gauged before the painstaking task of engraving the die began. The strongly pictorial quality of the final medal captures something of the vitality of Bernini's chiaroscuro design, with the rays of light appearing almost transparent, and countless reflections picking out the figures and the throne itself.

The exceptional care taken with the design and production of the Cathedra Petri medal reflects the exalted historical and religious value of its subject, a chair widely believed to have been used by St Peter himself. It was presented by the Emperor Charles the Bald to Pope John VIII in 875, and had actually been used since that time as a papal throne, kept in the basilica of St Peter's, or in the adjacent sacristy.[2] Urban VIII was the first to elevate the status of the throne from a symbolic to a cult object, by enclosing it in a golden casing in the form of a throne and placing it on the altar of the Baptistery Chapel in St Peter's.[3] The initiative taken by Alexander VII to transfer the throne permanently to the apse of the basilica, beyond the high altar, was motivated by Urban VIII's investment of the Cathedra with new found religious significance. The project for the apse decoration of St Peter's was commissioned from Bernini at the beginning of 1656, but was only completed towards the end of Alexander VII's papacy. The execution of the gilt-bronze and stucco sculptures was undertaken by the foremost specialist metal workers in Rome, and by Bernini's talented collaborators Ercole Ferrata, Antonio Raggi and Giovanni Paolo Schor.[4]

Contemporary studies commissioned by Alexander VII from scholarly members of his entourage, such as his Master of Ceremonies Francesco Maria Febei, fully describe and expound the political, as well as the religious, significance of the undertaking.[5] Reference was made to the writings of the great Catholic historian of the Counter-Reformation, Cesare Baronio, who identified the wooden throne with the actual seat which St Peter had used at Antioch and at Rome.[6] The Cathedra therefore took on the further status of a relic, as well as symbolising the legitimate temporal jurisdiction conferred on St Peter by Christ, which had long been one of the cornerstones of papal power.[7] With its new importance as a relic, the throne could be appropriately installed in the apse of the church dedicated to St Peter, where it was destined to be seen along the same main axis as the *Baldacchino* built over the Apostle's tomb.[8]

Bernini's first design for the Cathedra's new setting (fig.82) shows a kind of reliquary altar, in which the prominent display of the throne, carried aloft by the Four Doctors of the Church (Saints Augustin, Ambrosius, Gregory and John Chrysostom), was the main focus.[9] However, heated discussions and polemics regarding the authenticity of the Cathedra raised doubts regarding the propriety of elevating the throne to an object of veneration. The Frenchman Jean Caldin, for instance, claimed openly that the Cathedra was a fake. Research carried out by Fioravante Martinelli and Francesco Borromini led them to the conclusion that the throne was a secular object of much later date than the time of St Peter.[10] In fact, they worked out that it was a ruler's throne (*sedia gestatoria*) made of ebony, ornately decorated with ivory plaques carved with scenes showing an imperial coronation, the Labours of Hercules and the signs of the Zodiac. A decidedly profane iconography was thus revealed, which the Pope, moreover, had copied in detailed drawings by Carlo Fontana.[11]

It was evidently in response to such issues that Bernini transformed his earlier reliquary-altar design into a much more spectacular and mystical one covering the entire apse wall. This is project reflected in this annual medal of 1662 and which in most respects was carried out.

The Cathedra was set against a bank of clouds in a celestial zone, supported only symbolically and indirectly – by means of ribbons – by the Doctors of the Church. The main emphasis was shifted onto the apparition of the Holy Spirit, which was surrounded by angels and emanating rays of light (figs.20 and 83).[12] It

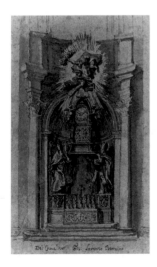 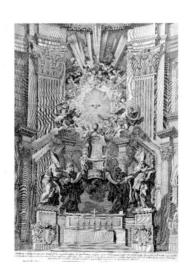

left fig.82: Studio of Gianlorenzo Bernini, *Design for the Cathedra Petri*, Windsor Castle, Royal Library

right fig.83: Jacques Blondeau, after Gianlorenzo Bernini, *The Cathedra Petri*, engraving, Private Collection

figs. 84 and 85 Gianlorenzo Bernini, *Studies for the Glory of the Cathedra Petri* (recto and verso), Windsor Castle, Royal Library

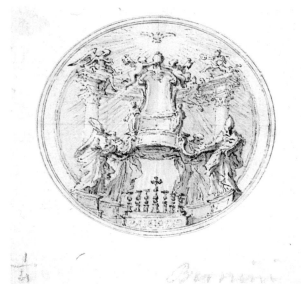

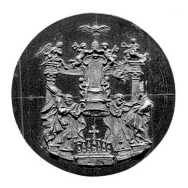

cat.no.70

cat.no.69

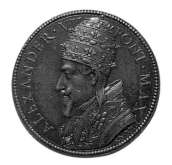

cat.no.71 obverse *left* reverse *right*

cat.no.72 obverse *left* reverse *right*

fig.86: Gianlorenzo Bernini or studio, *Design for the Scala Regia Medal*, Rome, Biblioteca Apostolica Vaticana

is the glory of the Holy Spirit manifested as light which is the subject of several autograph drawings by Bernini, including a double-sided sheet datable to 1663 in the Royal Library (figs.84–85). Its verso, revealed during conservation and published here for the first time, examines the relationship between the columns flanking the Cathedra (on the entablatures of which are perched the largest angels in the glory) to the window, giant pilasters and emanating gilt-bronze rays behind. [ES]

72
GASPARE MORONE *fl*.1633–1669
The Scala Regia, 1663

OBVERSE: Fabio Chigi, Pope Alexander VII (1599–Pope 1655–67), bearded, in profile to right, wearing tiara and cope embroidered with Chigi emblems; around: *ALEX.VII.PONT. MAX.A.IX*; signed in field below truncation: *.GM*.
REVERSE: Frontal view of the Scala Regia, seen through entrance arch surmounted by Chigi Papal arms supported by trumpeting angels; around, on a scroll: *.REGIA.AB AVLA AD DOMVM DEI*.
Bronze; 4cm diameter
Edinburgh, National Gallery of Scotland
Purchased by the Patrons of the National Galleries of Scotland, 1995
(NG2684)

This was the annual medal of 1663.[1] Bernini's outline drawing for the reverse is in the Vatican Library (fig.86).[2] The Scala Regia is the stairway that links the narthex and north Colonnade of St Peter's with the Vatican Palace.[3] The Pope showed interest in this project from 1657, but Bernini's finished design dates from January 1663. The space available was irregularly shaped, narrow and ill-lit, but Bernini rose to the occasion, cleverly disguising these infelicities and correcting them with converging walls and other skilful optical illusions. Bernini's great *Equestrian Statue of the Emperor Constantine* is situated just to the right of the view of the staircase shown in this medal, on the end wall of the narthex. [TC]

73

CIRCLE OF GIANLORENZO BERNINI

Design for the altar of the SS. Sacramento (recto);
Ground plan for an Oval Church (verso)

Graphite. The line above the base is marked off with evenly-spaced
incision marks; there are three ink marks at the level of the frieze above,
50.2 × 37.4cm
Windsor Castle, Royal Library
(RL5596)

74

GIANLORENZO BERNINI

Kneeling Angel for the Cappella del SS. Sacramento, with the
Head of a Second Angel Sketched in Behind

Brown wash over black chalk (and touches of graphite) on discoloured
white paper, 14.4 × 16.8cm
Windsor Castle, Royal Library
(RL5560)

75

GIANLORENZO BERNINI

Kneeling Angel for the Cappella del SS. Sacramento

Black chalk on white paper, 14.1 × 15.2cm (shaped to an oval, made up at
left, and inlaid)
Windsor Castle, Royal Library
(RL5561)

76

GIANLORENZO BERNINI

Kneeling Angel for the Cappella del SS. Sacramento

Pen and brown ink and wash over black chalk on discoloured white
paper, 15.3 × 13.6cm
Windsor Castle, Royal Library
(RL5562)

The Most Holy Sacrament is the wafer eaten at communion and
believed by Catholics to be, when consecrated, the living body of
Christ. It is at once a symbol of his sacrifice on the cross and the
means of spiritual survival for the faithful – literally, divine suste-
nance. Like most Roman churches, St Peter's houses its commun-
ion wafers on the high altar of a chapel specifically dedicated to the
Sacrament. Bernini was twice approached to provide designs for
this altar – by Urban VIII in 1629 (it was Urban who commissioned
Pietro da Cortona's altarpiece of the *Trinity* behind the tabernacle)
and by Alexander VII in 1665 – before finally executing the work for
Clement X in 1673–4 (fig.87).[1] Cat.no.73 shows what must be the
arms of the Pamphili Pope, Innocent X (*reg.* 1644–55) on the pedes-
tals, and thus testifies to another undocumented stage in the proc-
ess.[2] The latter is clearly an exploratory working drawing which
can be closely related to Bernini's ideas, but the draughtsmanship
is too limp and straggling to be by his own hand. It may have been
produced by a member of his studio working up one of his ideas, or
conceivably by a rival. Whether one wires it 'in series' or 'in paral-
lel', it slots in comfortably within Bernini's design sequence for the
altar.

The most important element in a sacrament altar is the cibor-
ium – a scaled-down temple designed to house the wafer itself, like
a shrine. In this design the ciborium, instead of resting on the altar
table, is held aloft by either Doctors of the Church (symbolically
'supporting' that institution, as in the *Cathedra Petri*), or angels
kneeling on pedestals (these are obviously intended as alternatives
presented to left and right respectively). Their arms are extended
without apparent strain, though supporting an entire church with
help only from the small cluster of winged angels' heads. In this
way the ciborium reads as a weightless and heavenly tabernacle.
Technically this would be achieved by running concealed girders
across the base of the temple and into the arms of the bearers, and
perhaps by making the temple itself from a light material such as
wood, clad in gold leaf. The most thrilling area of the design would
have been the void below the tabernacle, reached enigmatically by
the three steps above the altar table.

Bernini explored these same ideas in an autograph drawing
now in the Hermitage (fig.88); this, and the final arrangement ren-
dered in Francesco Aquila's measured elevation (fig.89) help us to
imagine how the various 'levitating' solutions might have fitted
their setting. All three images (cat.no.73 and figs.88–9) are pro-
vided with scales, so their dimensions can be exactly compared:
the two drawings would have been roughly the same height as the
executed design but somewhat narrower at the base. The pedestal
platform is of the same width in both drawings, and would have
fitted inside the arch for the high altar instead of extending beyond
it, as in the final version.

It is entirely typical of Bernini (and of his followers) that these
drawings show three-dimensional, free-standing monuments,
though the setting was a restricted one, with a single principal
viewpoint, which really required something relatively flat. The
figures at the rear of the tabernacle – hinted at in cat.no.73, and
fully realised in the Hermitage drawing – would have had to be ex-
ecuted in a form of semi-relief, a solution much favoured by
Bernini (he used it at just about this time for the *Tomb of Alexander
VII*). It is this illusionism – the suggestion of a much fuller and
deeper monument than could in fact be accomodated – which
distinguishes Bernini's tabernacle from its nearest precedent,

cat.no.73 *verso* (detail)

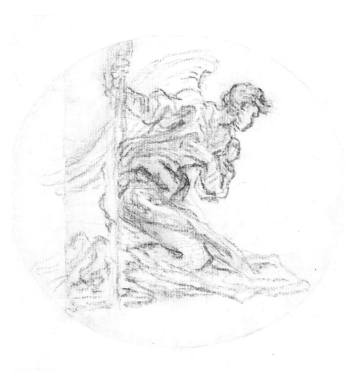

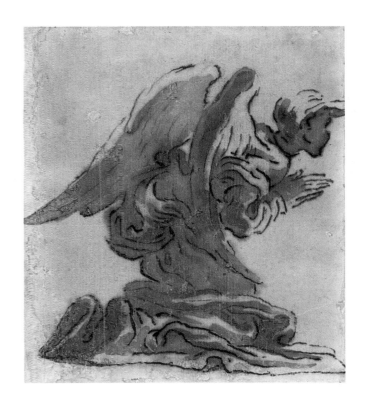

left cat.no.73a
above cat.no.74
below left cat.no.75
below cat.no.76

executed in 1598 by Bastiano Torrigiani for the Sistine Chapel in Santa Maria Maggiore, which is borne like a coffin on the shoulders of four angels (fig.90).[3]

By the time he made the other drawings exhibited here, Bernini had rejected the idea of the supported tabernacle in favour of the executed solution where the angels merely supplicate.[4] He had not, however, completely discarded the idea of an apparently three-dimensional monument: all three studies show angels turning *away* from the spectator, as if each formed part of an angelic ring encircling the tabernacle (this is confirmed by other drawings for the angels in Leipzig).[5] Only in the altar as executed did Bernini fully acknowledge the limitations of the site by restricting his angels to a single, enormous pair acting as intermediaries between the faithful and the consecrated Host in the tabernacle.

The three studies of individual angels (cat.nos.74–76) provide vivid insights into Bernini's thought process in creating this monument. In cat.no.75 the angel holds a staff – evidently a candle or a candle-holder (as seen in the Hermitage drawing, fig.88). In cat.no.74 Bernini seems to have been exploring the fierce contrasts of light and dark which are characteristic of gilt-bronze seen in candle-light. The wash, superimposed over black chalk, was here used to create patterns of light and dark rather than to render form: indeed Bernini deliberately exploited an evasive and ambiguous touch, which makes the individual substances of drapery, anatomy, hair and wings seem to melt together into one mysterious essence.

Both the final gilt-bronze angels and the preliminary drawings (especially cat.no.76) illustrate well Bernini's distinctive approach to drapery. As befits the sumptuousness of Heaven, the fabric is impossibly voluminous and weightlessly fine. In real life such material would sometimes cling to the body (being fine) and sometimes blow yards away from it (being voluminous): Bernini's, on the other hand, seems to flutter at an equal distance from the body all around, spreading only to make a base. The drapery allows us to intimate every part of the anatomy and yet never actually to 'grasp' it through the fabric. The angelic bodies were in this way made to seem impalpable essences.

In the process of conserving cat.no.73 for this exhibition, the ground plan for an oval church was discovered on its verso. Published here for the first time this, like its recto, is a working drawing dealing with ideas directly related to Bernini projects; 'by rights' it should be by Bernini himself, but again the execution falls short of his standard.

The absence of a scale makes it difficult to relate this plan to a particular site. The ruled lines providing a context for the church look like a network of streets, which cannot be identified. In more general terms, however, the church relates to two of Bernini's Roman projects: the destroyed chapel of the Re Magi at the College of the Propaganda Fide of the 1630s; and the church of Sant'Andrea al Quirinale (1658–70).[6] Like both of these, this plan shows a church built on a transverse oval plan, which generates a peculiar effect on the visitor of entering a space at once surprisingly wide and surprisingly shallow. Like the Re Magi Chapel, the cross-axis is marked by chapels, rather than by piers between chapels, as at Sant'Andrea. These four chapels, marking a cross shape, are separated by rectangular spaces with spiral stairways, presumably leading to balconies. The high altar chapel is surrounded by what look like choir stalls or *pries-dieu* for the officiating priests. The apparent size and elaborate plan of all the side chapels suggests a considerably larger church than Bernini's two executed examples mentioned above.

The drawing shows many *pentimenti* and alternative ideas: to the right of the entrance there are indications that a slightly larger interior space, with recessed columns, was being considered; on the altar side the pen suggests paired free-standing columns instead of the single ones most clearly visible on the entrance side.

The façade is dominated by a portico projecting into the road (or conceivably into a courtyard), with paired columns like those of Cortona's Santa Maria della Pace (see cat.no.86). This convex projection is 'answered' by a concave rear wall (again overdrawn in pen), generating an oval space under the canopy of the portico which is strictly neither an interior nor an exterior, a typically Berninian device of 'audience preparation'.

[DST]

 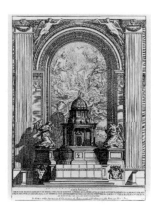 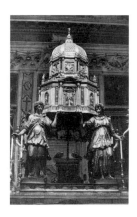

left to right

fig.87: Gianlorenzo Bernini and workshop, *The Altar of the Holy Sacrament*, Rome, St Peter's, Cappella del SS. Sacramento

fig.88: Gianlorenzo Bernini, *Design for the Altar of the Holy Sacrament*, St Petersburg, Hermitage Museum

fig.89: Francesco Aquila, after a drawing by Alessandro Specchi, after Gianlorenzo Bernini, *The Altar of the Holy Sacrament*, engraving, Private Collection

fig.90: Bastiano Torrigiani, *Tabernacle Supported by Angels*, Rome, Santa Maria Maggiore, Cappella Sistina

VII

Architectural and Decorative Designs and Architectural Medals

77

FRANCESCO BORROMINI 1599–1667

Design for the Façade of Sant'Andrea della Valle

Pen and grey ink and purplish-grey wash.
over stylus underdrawing, on off-white paper, 24.9 × 19.1cm

Oxford, The Visitors of the Ashmolean Museum

(Largest Talman X, F.19)

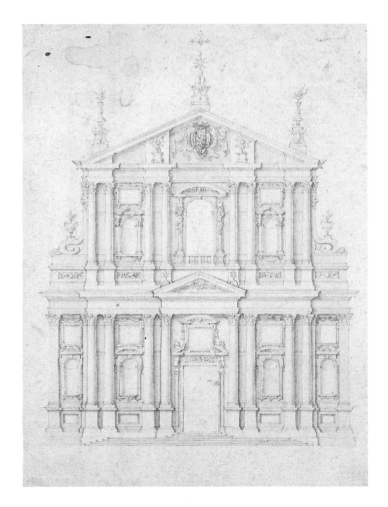

There are five drawings connected with the project for the façade of the Roman church of Sant'Andrea della Valle (fig.91) which are associated with the architects Carlo Maderno (1556/7–1629) and his nephew and assistant Francesco Borromini (1599–1667).[1] The present example is the finest of all – a small, jewel-like object which has been compared to a miniature.[2] In fact, the eighteenth-century collector John Talman so prized the drawing that he mounted it in the ornate gilt surround which still frames it today.

Borromini was just twenty when he came to Rome in 1619, and was employed in Maderno's *bottega* (workshop) as an architectural draughtsman and sculptor. Datable to 1623, the Ashmolean design is Borromini's first known presentation drawing.[3] The unusual pale grey-mauve colour of the wash emphasises the deep relief of the façade without obscuring the details. The refined execution of the meticulously ruled elevation demonstrates Borromini's enthu-

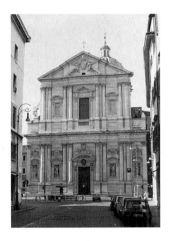 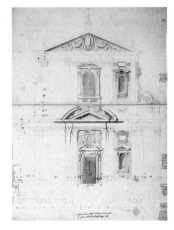

left fig.91: Carlo Rainaldi and Carlo Fontana,
Façade of Sant'Andrea della Valle, Rome

right fig.92: Francesco Borromini and Carlo Maderno, *Design for the Façade of Sant'Andrea della Valle*, Florence, Uffizi, Gabinetto Disegni e Stampe

siasm for the technical elements of his craft, while the fanciful and ornate details, such as the roaring lions' heads and paws which adorn the upper-storey volutes (a reference to the arms of the patron), as well as the term-figures supporting the central upper-storey window pediment, give an early indication of the vitality of Borromini's ideas for enlivening architecture.

The project for a new church for the Theatine Order (founded by San Gaetano di Thiene and confirmed in 1540) has a complicated history, involving a succession of architects.[4] The foundation stone was laid in 1591, but the façade was finally finished only in 1665. Carlo Maderno took charge from 1608 when Cardinal

Alessandro Peretti Montalto became patron of the church. Maderno must have been asked to design a grand façade along the lines of the recently completed Jesuit church, the Gesù, for in an annotation on one of the drawings for the Sant'Andrea façade he actually compares the measurements of the two (fig.92).[5] Borromini therefore came to an architectural project with which Maderno had already been involved for over ten years. Although we know that by 1623 Borromini had prepared his own designs for the lantern of the church, it has not been established whether he made original contributions to the architecture of the façade (aside from the decorative features mentioned above). However, the evidence of the present drawing suggests that he probably did.

The present design is much more compact and integrated than the Uffizi drawing (fig.92), and while this may be due to the fact that it was a presentation drawing complete with sculpture and ornament, it is nonetheless markedly different to the earlier working drawing. In the Ashmolean design, the decorative elements have become part and parcel of the architectural structure. For instance, the mezzanine relief-plaques on both storeys are the same width as the tabernacles upon which they rest, and they project into the frieze above to form part of a single vertical unit running parallel with their neighbouring columns. This is quite unlike the articulation of the same details on the Uffizi drawing, where the decoration is applied to the surface with little regard to the neighbouring structural elements.

Unhappily, with the death of Cardinal Peretti Montalto in 1623, the funds necessary to build a façade in travertine were no longer available to the Theatines, and the front of the church, at that time finished off in brick, was left unfaced until 1661, when the architects Carlo Rainaldi and Carlo Fontana completed it to a modified design of their own. Martinelli's wry comment that the Rainaldi façade 'differed in its beauty' to the earlier project of Maderno and Borromini, surely reflects Borromini's own view, since the latter supplied Martinelli with many details for the text of his *Roma ornata*.[6] [KW]

cat.no.78 obverse *left* reverse *right*

78
GASPARE MOLA *c.*1580–1640
The Church of Santa Bibiana Restored, 1634

OBVERSE: Maffeo Barberini, Pope Urban VIII (1568–Pope 1623–44), bearded, bareheaded, in profile to right, wearing cope; around: *VRBANVS.VIII.PONT.MAX.A.XI*; signed on truncation: *G MOLO* and dated below: *MDCXXXIIII*
REVERSE: Façade of Santa Bibiana; around: *AEDES.S.BIBIANAE.RESTITVTA.ET.ORN.*; in exergue: *ROMAE*
Silver; 4cm diameter
Glasgow, University of Glasgow, Hunterian Museum

This medal represents Bernini's rather austere new façade for the ancient little church in Rome dedicated to the early Christian martyr, Sta Bibiana (or Viviana).[1] Her remains were discovered during restoration work in 1624, which prompted the Pope to rebuild the church completely. The interior was decorated with a fresco cycle of the saint's life by Pietro da Cortona and Agostino Ciampelli (see following entry), while Bernini sculpted a marble image of the martyred virgin for the high altar (fig.13). Although the frescoes and the sculpture had been completed by November 1626, this medal was issued later as part of a series struck in the mid-1630s to commemorate Urban's interest in restoring buildings connected with the early Church. [TC]

79

PIETRO BERRETTINI, CALLED PIETRO DA CORTONA
1597–1669
Study of the Head of a Youth Wearing a Laurel Crown

Black chalk on partially faded blue paper, 25.5 × 20.7cm.
Drawn on a sheet composed of numerous irregular pieces of paper stuck
together; the principal outlines pricked for transfer.
Edinburgh, National Gallery of Scotland
(D1609)

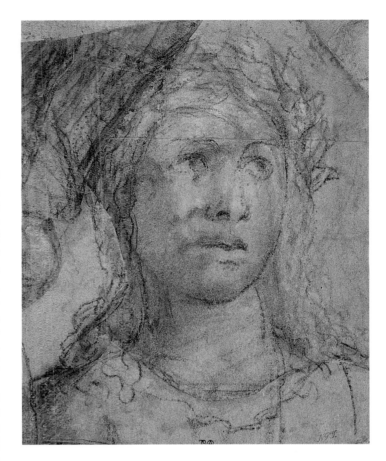

Much of the fascination of this patchwork of a drawing lies in its physical make-up.[1] Most of the head, down to the base of the neck, was evidently cut out in an irregular shape from an earlier drawing (itself composed of more than one sheet), and made up to a rectangle by gluing on numerous strips and patches of paper, some of which had themselves been drawn on previously (one can only imagine that Cortona was feeling exceptionally poor, or that there was a shortage of paper). The drawn head was then completed on this new compound sheet and its outlines pricked for transfer. After use, the final drawing itself appears to have been reduced in size. To complicate matters further, the original head was initially drawn in a different position, tilted to its right and gazing directly out at the viewer, and the ghosts of alternative eyes, nose, and mouth are faintly visible.

The revised, laurel-wreathed head in fact appears, to the same scale, in Cortona's fresco of *Sta Bibiana Refusing to Sacrifice to Idols* of 1624–6 (fig.93) in the seminal little church of Santa Bibiana, the renovation of which was Bernini's first significant architectural commission: he designed the austere tabernacle façade, and also carved the statue of the saint behind the high altar (see cat.no.78 and fig.13).[2] Cortona frescoed three scenes from the life of the titular saint on the upper nave wall of the church, opposite another three by his Florentine collaborator Agostino Ciampelli (1565–1630). Powdered charcoal would have been 'pounced' through the perforations in Cortona's drawing, and its outlines thus transferred to the wall surface to serve as a guide when he came to paint.

A very similar head also features in an oil painting by Cortona, *The Sacrifice of Polyxena*, which was painted for his important early patrons the Sacchetti brothers in 1624 or earlier, and is now in the Pinacoteca Capitolina in Rome (fig.94).[3] Puzzlingly, the earlier, alternative position of the head in the drawing is also visible as a *pentimento* (revision) in this painting (and even in photographs of it). The explanation must be that the original drawing was made as a study for the *Sacrifice of Polyxena*; the drawing was then reworked and, happier with this new solution, Cortona altered the painted figure accordingly; the modified drawing was then cannibalised for re-use in the fresco. The fact that an equivalent figure does not appear in Cortona's preliminary compositional study for the whole of the Santa Bibiana fresco (Rennes, Musée des Beaux-Arts) suggests that its inclusion was something of an afterthought, with the intention, presumably, of filling an awkward gap.[4] The drawing has been described as a cartoon fragment, implying that it was part of a larger full-scale drawing for the fresco. However, there is nothing to suggest that Cortona produced such a cartoon for the whole of this (or indeed any other) scene, and given its unique characteristics, it may be more accurate to regard it as an exceptional case rather than a rare survival. [AWL]

left fig.93: Pietro da Cortona, *Sta Bibiana Refusing to Sacrifice to Idols*, fresco, Rome, Santa Bibiana

right fig.94: Pietro da Cortona, *The Sacrifice of Polyxena* (detail), Rome, Pinacoteca Capitolina

80

FRANCESCO BORROMINI 1599–1667
The West Front of Palazzo Barberini

Pen and brown ink and wash with traces of graphite or black chalk,
47.2 × 76.1cm

Inscribed with a scale at the bottom; on the verso: *Faccia del Palazzo Barbarino* and a sum: (48 + 48 = 96 + 60 = 156, arranged vertically). Two roofed superstructures drawn very faintly in black chalk (evidently by a different hand) are just visible above the central block and the wing at the right; the former approximates the form of the belvedere later built at the rear of the palace.

Windsor Castle, Royal Library
(RL11591)

This drawing was originally published, with an attribution to Borromini's master Carlo Maderno, in the context of the first serious attempt to reconstruct the complex building history of the Palazzo Barberini.[1] Maderno was the architect initially commissioned to construct a grand palace for the family of the reigning Pope Urban VIII, but when he died in 1629, work had only just begun. Thereafter, the Barberini engaged Bernini as architect. As Maderno's nephew and assistant, Francesco Borromini had been involved with the project for Palazzo Barberini from the outset, and he continued to be employed as assistant to Bernini until 1633. The present elevation has been considered by most recent scholars to be an autograph drawing by Borromini based on a design by Maderno, but with some additions of his own.[2] However, a strong case could be made to argue that it in fact for the most part represents Borromini's own ideas.

Borromini was not only a brilliant draughtsman, but also had practical, structural building experience, and he is often therefore characterised as a 'true architect' in contrast to Bernini, whose approach was more that of a designer. After their initial collaboration at Palazzo Barberini and on the *Baldacchino* in St Peter's (see cat.nos.58–62), Borromini and Bernini went their separate ways; Borromini later claimed that Bernini had used him for his expertise and experience, without properly acknowledging him.[3] In fact, on almost all later engravings of the Barberini Palace, Bernini alone is named as architect. Borromini is credited in only one instance, on a view of the rear façade of the palace.[4]

A number of challenges presented themselves to the architects of the new Palazzo Barberini, not least of which was how to incorporate a previously existing villa, which had been purchased from the Sforza family and which was itself built on top of ancient ruins.[5] The site, moreover, was not level and proved difficult to build on. Maderno's earliest plan was for an enormous block-like building with four equal façades and a central courtyard, engulfing the earlier Sforza villa in one wing.[6] But the idea for a central courtyard was soon abandoned, and the west front of the palace was set back to form a main block flanked by two projecting wings, once of which incorporated the earlier villa (fig.95). Particular emphasis was now concentrated on the central part of this façade, which was redesigned as a three-storied loggia, open on the ground and first floors. This design was a completely novel solution for a palace in Rome: typologically, the open loggia was more characteristic of a suburban villa.[7]

In the present drawing, the windows on all three storeys of the recessed bays flanking the central block were given elaborate surrounds, with alternative proposals to left and right for the upper two storeys. These windows were designed quite differently to those on the wings, and it has been widely accepted that they were of Borromini's own invention. It is at this junction that he added a minor but highly personal detail: a narrow recess extending through all three storeys, and picked out in the drawing in darker wash.[8] He evidently wanted to emphasise the windows in order to enliven the awkward juncture of the central block and the protruding side wings. Borromini's dynamic, sculptural window surrounds were derived from Michelangelo's designs for windows at St Peter's (where Borromini worked with Maderno from 1619). The young architect clearly had no qualms about adapting for a secular context an innovative form developed for the most important church in Christendom, although the flattering parallel may have been intended to express the social ambitions of his patrons.[9] In similar vein, it has been suggested that the three-storey loggia of Palazzo Barberini may have been inspired by the Cortile of San Damaso in the Vatican Palace,[10] but even more striking is the comparison with Mascherino's double loggia of the cortile of the Quirinal Palace, where Borromini also worked under Maderno.

Although the lateral windows as built do not follow exactly either of the alternatives presented in the Windsor drawing, the design of that on the third storey on the right, with its curious ear-like profiles, was a model which Borromini was to repeat in countless variations, for instance in the window at the centre of the first storey of the façade of the Oratory of Filippo Neri (see following entry). Another peculiarity of the Windsor drawing is that it shows no proper cornice below the roof – giving the impression that the roof was destined to rest directly on the window pediments. In the actual building, a conventional tall entablature is punctured by oval windows at frieze level on the side wings, and subdivided by a row of corbels over the arch-topped windows of the loggia, changes probably made under Bernini's direction. Finally, it is interesting to note the addititon in chalk to the finished drawing, possibly also by Bernini, for a winged victory carrying an escutcheon for a coat-of-arms over the central window of the first-storey. The few small Barberini bees set into the lateral window frames alone are unlikely to have trumpeted the ownership of the palace sufficiently loudly for the Barberini.[11] The palace façade as built features Barberini bees prominently displayed in the spandrels of all the first-storey windows.

[KW]

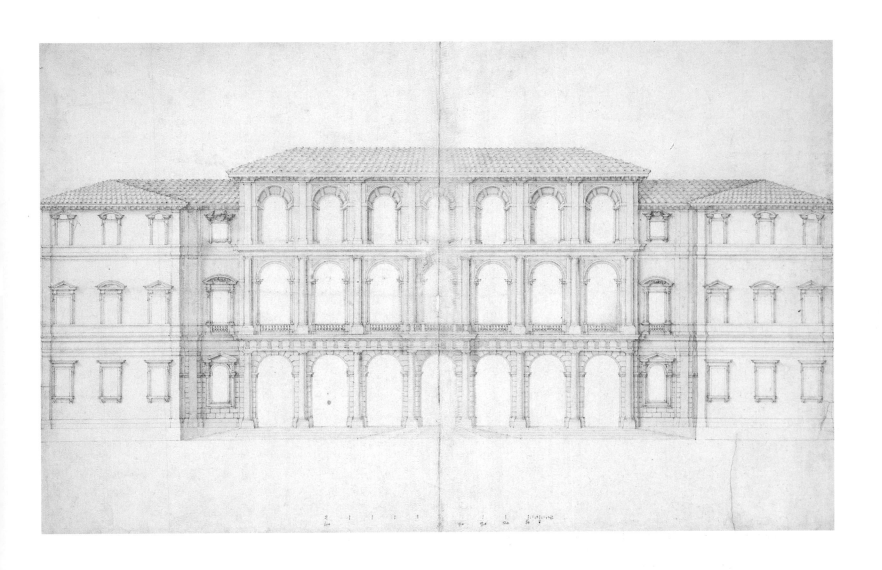

81

Design for the Façade of the Oratory of St Philip Neri

Graphite, 40.6 × 33.8cm
Windsor Castle, Royal Library
(RL5594)

This is an autograph Borromini drawing for the façade of the Ora-tory of St Philip Neri, probably dating from 1638.[1] It is an elevation with a plan and a scale (in Roman *palmi*) across the lower edge. This is one of the most important buildings and one of the most beautiful architectural drawings of the entire Roman Baroque.

The monastery of the Filippini (as the followers of St Philip Neri were called) lies next to the Chiesa Nuova, the mother church of the order, and was redesigned by Borromini from 1637 onwards. Unlike other monasteries, it includes an oratory, a public place of prayer and a concert venue for sacred music (hence the word *Ora-torio*). This public function had a profound impact on Borromini's thinking, as did the fact that the Filippini were not a closed order, but positively encouraged men of the world to join their number as 'part-timers'.

The Oratory itself is a large cuboid space lying sideways across the left half of this façade, accounting for the lower two floors of the five left hand bays. The right door visible here leads to a corri-dor running the entire depth of the monastery next to the church; the left door is a sham. The 'central' door leads to an ante-chamber, with a balcony above, both opening onto the Oratory itself. The half-bay at the left end marks a narrow staircase leading to the choir loft, situated over the Oratory's high altar. The façade is a trick: what reads as its main episode (the seven right-hand bays between the two rusticated strips) 'misses' the most important space immediately behind. It does, however, coincide with the courtyards within the heart of the monastery and with the main feature of the upper storey – the library, which runs across the five bays under the pediment. This lay-out is preserved in the executed building (fig.96), except that the library has been extended and the façade therefore continues at full height for its entire width. This detracts from the dynamic 'curling over' of the uppermost cornice, which, with the pediment, gives such a dramatic sky-line to the façade in this drawing.

To assess the novelty of Borromini's solution, we might reason-ably begin by enquiring how one might have expected such a mon-astery façade to look. This is best answered by imagining the first full bay on the left running without variation across the entire façade, with a door, and perhaps a small clock-tower, to mark the centre. It should be noted that the actual window apertures of the first floor *are* identical across the façade. The expected arrange-ment would be simple, deliberately repetitive, and decorated by window frames alone set off against smooth wall surfaces. Borromini made use of three elements which mark a dramatic de-parture from this norm: a pediment; an order of columns and pi-lasters; and curvature (seen clearly in the plan at the bottom of the sheet). The order in the present drawing consists of pilasters with four columns on the upper floor fronting the library; in the ex-ecuted façade pilasters were used throughout.

In seventeenth-century Rome, pilasters and pediments were generally reserved for public and religious buildings. A pediment derives from an antique temple-front. The form was borrowed for villas, but within the city its use was restricted to Christian tem-ples.[2] The order (perhaps in combination with piers and arches) was similarly used, in contrast to a simple wall surface, to distin-guish a church from a palace or monastery. This façade, with its dramatic pediment and tight network of pilasters, entablatures and arches (just visible over the ground floor niches), seems to be doing the wrong job. Instead of *contrasting* with the adjacent façade of the Chiesa Nuova, it *repeats* it: the main episode (between the two rusticated strips) is even of exactly the same width.

This public, church-like character was further expressed by the curvature of the façade, which Borromini himself described as imitating a man, with the convex centre forming his chest, and the two concave bays on either side representing his upper and fore-arms, opening to embrace the faithful.[3] The concavity is shown in the drawing in a slightly more pronounced fashion than in the final building. Even so, it is fairly notional: the plan shows the entire curvature of the façade to be contained within a meagre depth of 10 *palmi* (less than 2.5 metres), as if carved in low-relief out of a thin slab of stone. Ordinary, 'flat' church façades, like that of the Chiesa Nuova next door, are often this deep due to their advancing pilasters and free-standing columns. By contrast, the individual elements in this façade are of extreme shallowness, and the avail-able depth was reserved for the curvature of the whole, rather than squandered on the salience of the parts. The result is an illusion: a façade that from the side appears perfectly flat, while from the front it can almost suggest a semi-circular recess.

The central bay of the façade below the entablature is convex (visible in the plan), but above the entablature a huge niche makes it even more concave than the surrounding bays. This combination of convex and concave generates a shallow oval balcony, reached by a door from the library. The niche is the deepest part of the façade, made to appear deeper by a semi-dome with coffering, the lines of which meet at the base rather than the top, creating an effect of perspectival recession. This part of the façade looks like an apse – the back of an interior, rather than the front of a block. This apsidal climax to the façade's curvature gives to the space of the piazza in front of the Oratory the character of an interior, of an improvised place of worship. Rather than protecting the sanctity of the monastery behind, this façade lends sanctity to the space in front.

Clearly, a façade that can 'embrace' requires a novel system of joints. The articulating language here is as remarkable in its detail

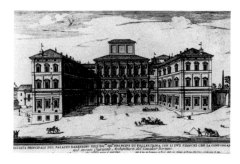
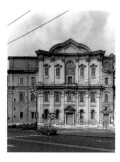

left fig.95: Alessandro Specchi, *The West Front of Palazzo Barberini*, engraving, Private Collection

right fig.96: Francesco Borromini, *Façade of the Oratory of St Philip Neri, Rome*

as is the impact of the façade as a whole. The most important element in the classical orders is the capital, which defines the character of the building as Doric, Ionic or Corinthian. The main order here is Corinthian, yet Borromini has entirely omitted the distinguishing acanthus leaves from the capitals, leaving only the small scrolls on the outer edges. Borromini did this, he explained, 'to indicate rather than to ornament or perfect the members and parts of architecture'.[4] It also has the effect of making the capital little more than a continuation of the shaft, so that the whole order becomes a simple band.

The classical orders operate on a system of post-and-lintel, yet here Borromini undermines the lintels of the main order by cutting out the architraves between the pilasters to make room for window hoods, which are tightly wedged in. This further accentuates the effect of a vertical band, passing through to the upper storey and even picked up by two bands within the pediment. These central accents, running up through the entire height of the building, are just like the bands marking the extreme corner of the block or the two rusticated strips. They work with the many horizontals – string-courses, main entablature and cornice – to create a lattice pattern, binding the façade together like a basket. This lattice system is a genuine and influential substitute for the post-and-lintel system of the conventional order.

The two sorts of classical pediments – triangular and segmental – were often combined at this date by overlapping or 'cross-cutting' (as seen, for example, in Pietro da Cortona's 1630s door into the theatre at the Barberini Palace), but never, as here, by welding the two together to make an altogether novel form. Borromini's pediment is also uniquely steep, with an apex of 110° rather than the customary 135°. This combines with its complex outline to give it more the character of a Gothic gable than a classical pediment.

The main difference between this drawing and the façade as built lies in the elimination of much of the fanciful and rich decoration, which was felt inappropriately ostentatious by the Filippini. The Salomonic columns of the main door with foliage bases, reminiscent of the *Baldacchino* (see cat.no.58), and the fanciful acroteria over the central section were the most obvious casualties of this corporate sobriety. In this drawing, as in the executed façade, Borromini rang the changes with a handful of decorative elements of clear religious significance – stars, torches and lilies. In the drawing the climactic dove rests in a blaze of light in the centre of the pediment, an effect possibly intended to be achieved using stained glass.

The extremely precise style of draughtsmanship used for this sheet served Borromini alike for working and presentation drawings. It contains an astonishing density of information (with variants, one drawn over the other) at the same time as conveying the power of the whole. In his drawings, as in his architecture, Borromini worked by accumulation, never allowing one effect – like the curvature – to trump the others. The graphite lines are relatively faint and are minutely descriptive; even the shading runs in neat horizontal lines, to suggest the brick courses of the executed building. Yet, viewed as a whole, one can already see in the drawing the broad massing of light and shade, and the distribution of tension and relaxation, which gives the façade itself such an anthropomorphic eloquence.

[DST]

82
GASPARE MORONE *fl.*1633–1669
The Quirinal Palace, 1640

OBVERSE: Maffeo Barberini, Pope Urban VIII (1568–Pope 1623–44), bearded, in profile to right, bareheaded, wearing cope; around: *VRBANVS.VIII.PONT.MAX.A.XVII*; signed on truncation: *G.M.F.*; dated on field below: *MDCXXXX*
REVERSE: The Quirinal Palace seen from the south corner; around: *AD AEDIVM PONTIFICVM SECVRITATEM*
Both faces inscribed within a border of Barberini bees arranged like a laurel crown.
Silver; 4.5cm diameter
Glasgow, University of Glasgow, Hunterian Museum

83
GASPARE MORONE *fl.*1633–1669
The Quirinal Palace, 1659

OBVERSE: Fabio Chigi, Pope Alexander VII (1599–Pope 1655–67), bearded, in profile to left, wearing cap, cassock, and stole embroidered with star; around: *ALEX.VII.PONT.MAX. A. IV*; signed on truncation: *GM*
REVERSE: Oblique view of the façade, with figures in front; on a banderole above: *ALEXAN.VII.PONT.MAX. / FAMIL.PONTIF.COMMOD. / ET.PALAT.QVIRIN.ORNAM. / AN.SAL.MDCLIX.*;
and in the exergue: *ROMAE*
Bronze; 3.9cm diameter
Glasgow, University of Glasgow, Hunterian Museum

cat.no.82 obverse *left* reverse *right*

cat.no.83 obverse *left* reverse *right*

Gaspare Morone's two signed medals, issued as annual medals nearly twenty years apart, both show on their reverses views of the Quirinal Palace.[1] While Urban VIII's medal depicts the main façade of the Quirinal seen from an angle, including the belvedere built over the Cappella Paolina and the Sala Regia, that of Alexander VII shows a view of the new wing, known – because of its exceptional length – as the Manica Lunga ('Long Wing' or 'Long Sleeve'), which was built to house the papal entourage and the Swiss Guards.

Pope Paul V Borghese (Pope 1605–21) had dramatically enlarged and re-fashioned what had been a papal villa located on the Quirinal Hill to create a proper palace, which then became the official summer residence of the popes. He built new sections around the original courtyard, and added important ceremonial chambers. Furthermore, he gave an architectural continuity to the exterior of a structure which was actually composed of many different buildings from different periods. But it was especially during the papacies of Urban VIII and Alexander VII that the Quirinal Palace evolved from a summer retreat to the full-time residence of the pontiff, a preference which was formalised under Alexander VII. This change was accompanied by an increased interest in the development of the area of the Quirinal by the popes and their extended families, for instance in the building of new churches and convents.[2]

During Urban VIII's papacy, the extensive gardens were further enlarged through the purchase of adjoining land from the Este family (fig.97).[3] The 1640 medal reverse shows a section of these gardens to the right, which were established in their definitive form by 1628.[4] The gardens were first secured by encircling walls and sentry towers, visible at the left of the medal, for which enormous substructures had to be built due to the sloping site of the Quirinal. In accordance with the motto of the medal, 'Ad Aedium pontificum Securitatem', not only was this second papal seat secured, but the piazza before it took on a new fortified character, which was further emphasised by the building of barracks for the Swiss Guards in the adjacent street, the Via Pia (today the Via del Quirinale). The two entrances to the palace visible on the medal were also added by Urban VIII around 1628: the main one from the piazza, which was further embellished with a Benediction Loggia in 1638[5] and the side entrance on Via Pia, designed to give access to meeting rooms, offices and judicial chambers. A second, earlier entrance into the gardens was suppressed for security reasons, but is still visible in an early seventeenth-century engraving by Giacomo Lauro.[6]

At the Quirinal, as at the Palazzo Barberini (see cat.no.80), Carlo Maderno was the architect in charge, assisted from 1625–9 by Francesco Borromini.[7] Borromini's ground plan for the entrance area of the Quirinal (fig.98), datable to c.1625–8, clearly demonstrates that he was actively involved in the restructuring of the Palace, and not just employed as a stonemason in the garden (as has been suggested).[8] Furthermore, it is his designs for portals which are shown on the medal.[9] Bernini, for his part, was responsible for the Benediction Loggia over the main entrance, and probably for the sentry tower flanking it, which it complements.[10]

By the time of Alexander VII's pontificate, however, Bernini alone was in charge of architectural modifications to the Quirinal. These consisted mostly of functional alterations such as the completion of the Manica Lunga along Via Pia, the event commemo-

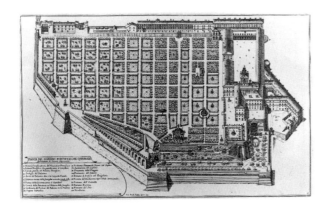

left fig.97: Giovanni Battista Falda, *Bird's-Eye View of the Quirinal Palace and Gardens*, engraving, Rome, Bibliotheca Hertziana

right fig.98: Francesco Borromini, *Plan of the Entrance Area of the Quirinal Palace*, Vienna, Graphische Sammlung Albertina

rated in the 1659 medal.[11] Here Bernini created a high point of decorous utilitarian architecture, managing harmoniously to enclose older sections of the building,[12] and doubling the wing's overall height and length, with only a single doorway framed by pilasters to break up the façade.[13]

Comparison of these two medals provides an interesting insight into the stylistic development of the medallist Gaspare Morone. The earlier medal, appropriately encircled with a strong frame composed of Barberini bees, shows a reduced bird's-eye view of the Palace, with certain architectural features picked out in relief. The more conventional composition and flat relief of the later medal is, however, enlivened by its assymetrical view, strong foreshortening, staffage of figures and the scroll unfolding in the breeze. Its style is closely related to a number of Bernini's own designs, such as his study for the Colonnade of St Peter's (cat.no.67). Indeed, Alexander VII refers to this medal in his diary for 8 September 1660, when Bernini appeared 'con disegno di medaglia per questa fabrica di Monte Cavallo'; a few months later, on 29 January 1661, another entry records the medal's completion.[14] No preparatory drawing for it is known, but the attribution to Bernini is further confirmed by evidence submitted in 1764 in support of a plea by the medallist Ferdinando Hamerani, where it is stated that this medal was 'taken from a drawing by Cavalier Bernini'.[15][ES & TC]

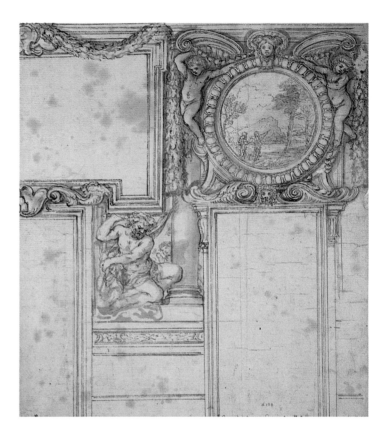

84

CIRCLE OF PIETRO DA CORTONA 1597–1669

Design for the Wall-decoration in the Gallery of Alexander VII in the Quirinal Palace in Rome

Pen and brown ink and wash over black chalk, 32 × 27.4cm
Inscribed at the lower right, in the hand of Padre Sebastiano Resta: *Pietro da Cortona Galleria di M.te Cavallo di Aless.ro VII.*
Oxford, Christ Church Picture Gallery
(JBS614)

Having decided to adopt the Quirinal Palace as his official papal residence, Alexander VII sought to enhance the urban setting of the palace and re-arrange its interior layout, in accordance with ideas contained in a theoretical text by Cardinal Sforza Pallavicini.[1] Alexander VII's projects included Bernini's 1657 scheme for a piazza in front of the palace with porticos, and an urban axis linking the garden entrance of the Quirinal to the Piazza del Popolo, but this was not realised.[2] However, a wing – the Manica Lunga – to house the papal entourage was built (see previous entry), and the rooms inside the main palace which faced out over the piazza were given particular prominence. A change in emphasis from the gardens at the rear to the façade looking over the piazza and city was called for, as the Quirinal Palace now took on a political significance it had not

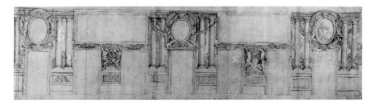

fig.99: Pietro da Cortona, *Design for the Gallery in the Quirinal Palace*, Berlin, Staatliche Museen, Kunstbibliothek

previously enjoyed. Soon after his election, Alexander VII commissioned the decoration of the long gallery which had remained unadorned since the papacy of Sixtus V (1585–90), and which offered thirteen large windows facing out over the square.[3] To be completed by 1657,[4] the iconographic programme for the decoration of this gallery signalled it as the Pope's most prestigious reception and audience chamber.[5] Furthermore, he installed his famous collection of architectural models in the gallery as a reference to actual projects he planned for the city of Rome.

The decorative programme for the gallery must be considered one of the most important of the second half of the seventeenth-century in Rome. Pietro da Cortona was given the commission to design the overall scheme and also the responsibility of procuring and supervising the best painters and stuccoists to carry out the work.[6] The framework of the gallery was conceived as a system of feigned architectural membering painted in chiaroscuro and linked to that of the ceiling (also designed by Cortona), with inserted *quadri riportati* (frescoed scenes painted so as to look like framed easel pictures) of biblical subjects.[7] His solution respects the actual confines of the architecture, and unlike other contemporary decorative schemes does not seek to open the space illusionistically. The genesis of his design can be followed in three surviving studies, of which the present sheet is the earliest.

The drawing spans one-and-a-half window bays, and consists of *quadri riportati* inserted above ornamental window pediments, while the intervening wall space is designed as a colonnade set on a high base. Further detailed studies exist for this scheme.[8] In this early design, putti frolic alongside the round frames over one window, while atlante figures shoulder the weight of the heavier rectangular picture surrounds over the next. They project in front of

the fictive space of the colonnade, while other incidental figures peep out behind them. In Cortona's later studies for this scheme in Düsseldorf and Berlin (fig.99) the figures were given a role as prominent as that of the architectural elements.[9] Refined through a series of drawings, Cortona's design is distinguished by its dynamic interpretation and classicising monumentality.[10]

Despite Padre Resta's attribution of this drawing to Cortona, it is more likely that it was executed by a member of his studio, conceivably Ciro Ferri, but the design it embodies must be Cortona's own. [ES]

85

ANDREA SACCHI c.1599/1600–1661

Design for the Decoration of the Vault of San Luigi dei Francesi

Red chalk heightened with white on grey paper, 39.1 × 25.7cm
Extensively annotated with measurements (in p[iedi] and di[giti])
Windsor Castle, Royal Library
(RL4941)

The artist's biographer Giovanni Pietro Bellori was the first to describe Sacchi's programme for the ceiling decorations in San Luigi dei Francesi, the French national church in Rome.[1] He recorded that Sacchi was commissioned by his loyal patron, Cardinal Antonio Barberini the Younger – at that time Protector of the French Crown at the Papal Court – to devise a decorative scheme

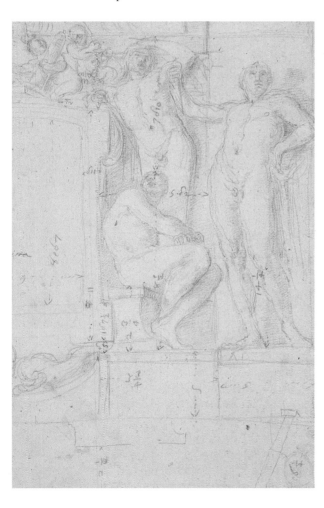

to embellish the whitewashed vault of the church. Sacchi's design, as documented by Bellori's description and by a group of thirty-one surviving studies, was based ultimately on Annibale Carracci's ceiling decorations in the Farnese Palace in Rome (fig.100).[2] Sacchi's admiration for Annibale is evident in the drawing exhibited here, featuring as it does a seated, chained *ignudo*, with a standing term figure behind, flanking a window frame.[3] The frame is surmounted by a (barely discernible) sphinx and frolicking putti bearing Roman fasces and swags. Below, occupying the curve of the cornice, a dolphin is indicated, a reference to the French royal heirs ('Dauphins'), while to the right is a heroic nude, one of a series intended to represent kings of France. He stands on a plinth in front of a broad pilaster, which Sacchi has sketched in to show that he was to occupy a space directly above the columns of the nave. As the barrel vault was originally devoid of architectural features, Sacchi intended to paint a system of *trompe l'oeil* strap-work as a backdrop to his scheme.

Sacchi's project for a series of monumental nudes to line the lower zone of the vault is clearly highly unusual as church decoration, although the French kings were presumably intended to be draped in the final frescoes. The artist had further intended to paint the *Glorification of St Louis*, patron saint of France, in the centre of the ceiling, flanked by ovals depicting one of the saint's victorious land battles, and a naval victory respectively. It is clear that this iconographic program, which was certainly devised by Cardinal Antonio on behalf of the French crown, was more secular than religious in character. In fact, the strong political content of the scheme may have prevented it from being carried out, for while we know from Bellori's account that scaffolding was erected and cartoons prepared, little of the project was ever executed.

The numerous drawings for this scheme now at Windsor once belonged to Sacchi's most talented pupil Carlo Maratta who, it was intended, was to have completed the frescoes. By this time, however, Cardinal Antonio had lost interest in a project which had dragged on for over ten years. Bellori, who was a keen supporter of Sacchi, notes that the artist lamented not having left a major fresco cycle to posterity, and observed that as Sacchi was already elderly when he took on the San Luigi project, he did so 'more in spirit, than in fact'. The vault of San Luigi was eventually frescoed in 1756 by Charles-Joseph Natoire, while a renovation of the interior architecture was carried out by Antoine Derizet (1756–64).[4] This redecoration altered the original aspect of the barrel vault, so that Sacchi's meticulously measured study no longer even fits the space.[5] [KW]

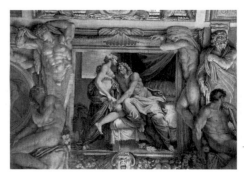

fig 100: Annibale Carracci, *The Ceiling of the Farnese Gallery* (detail), fresco, Rome, Palazzo Farnese

cat.no.86 obverse *left* reverse *right*

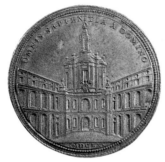

cat.no.87 obverse *left* reverse *right*

86

GASPARE MORONE *fl*.1633–1669
Santa Maria della Pace, 1658

OBVERSE: Fabio Chigi, Pope Alexander VII (1599–Pope 1655–67),
bearded, in profile to left,
wearing cap, cassock, and stole embroidered with stars; around:
ALEX.VII.PONT.MAX.A.IV; in the truncation: *GM*
REVERSE: Close-up frontal view of the two-storey church, with project-
ing semi-circular portico; above: *DA PACEM DOMINE / IN DIEBVS
NOSTRIS*
Silver; 3.9cm diameter
Glasgow, University of Glasgow, Hunterian Museum

This annual medal of 1658 records the completion of the façade of
the medieval church of Santa Maria della Pace, which was begun
by the architect and painter Pietro da Cortona in 1656 (fig.101).[1] It

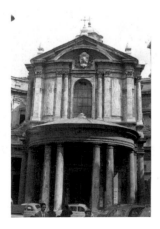
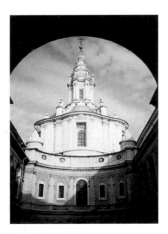

left fig.101: Pietro da Cortona, *Façade of Santa Maria della Pace, Rome*
right fig.102: Francesco Borromini, *Sant'Ivo della Sapienza, Rome*

is the first of a sequence of five medals that record the ecclesiasti-
cal building projects initiated or completed by Alexander VII. The
reverse is one of Morone's most successful compositions, with the
richly pulsating baroque façade narrowly confined within the cir-
cular medal format. [TC]

87

GASPARE MORONE *fl*.1633–1669
Sant'Ivo della Sapienza, 1660

OBVERSE: Fabio Chigi, Pope Alexander VII (1599–Pope 1655–67),
bearded, in profile to left, wearing cassock, cap, and stole embroidered
with star; around: *ALEX.VII.PONT.OPT.MAX*; signed on truncation
G.M; dated on field below: *AN VI*
REVERSE: Frontal view of the church, seen across the courtyard with the
wings of the Sapienza Palace to right and left; above: *OMNIS SAPIEN /
TIA A DOMINO*; dated in exergue: *MDCLX*
Silver; 4.1cm diameter
Glasgow, University of Glasgow, Hunterian Museum

This was the annual medal for 1660.[1] Alexander VII took a keen in-
terest in the completion of the Sapienza, or University of Rome,
begun by Giacomo della Porta in the 1570s. He employed
Francesco Borromini as architect of the project, who created a new
library, the Biblioteca Alessandrina, and the remarkable chapel of
Sant'Ivo, which was consecrated 16 November 1660 (fig.102).
Much use was made by the architect of the heraldic 'monti'
(monticules) and stars of the Pope, while the roof of the cupola
was made to resemble a highly schematised Parnassus.[2] The high
altarpiece by Pietro da Cortona (see following entry) is just visible
through the central door in the medal. [TC]

88

PIETRO BERRETINI DA CORTONA 1597–1669
St Ivo Intervening on Behalf of the Poor

Pen and grey ink and grey wash, heightened with white, over black
chalk; squared in black chalk; 43.3 × 30.7cm, including strips added at an
early date to left (3.8cm wide), right (3.6cm wide) and at the bottom
(1cm wide).
Edinburgh, National Gallery of Scotland
Purchased with the aid of the National Art Collections Fund
(D5327)

This is a highly-wrought preparatory study by Cortona for the high
altarpiece of the church of Sant' Ivo della Sapienza in Rome
(fig.103).[1] It was commissioned, as we know from the Diary of
Pope Alexander VII, by 11 April 1660, when the artist came to show
him a compositional drawing for approval.[2] The completed altar-
piece represents St Ivo (or Yves) of Brittany (died 1303), who had
read both theology and law at university, giving most liberally of
his money and legal advice to the poor. He is shown as if in a cloi-
ster, with a library behind him to left, and assisted by industrious
scholars and book-keepers. Before him, to the right, are a band of
supplicant men, women, and children. Above is a *gloria* with God
the Father surrounded by *putti* and saints; the celestial image ap-
pears as if painted on a cloth, which is raised and supported by a
group of flying *putti*. God points to the Vulgate proferred by a
kneeling St Jerome; behind him is St Luke with his Bull; at the cen-

tre, Pope Leo the Great; and to the right, St Alexander and St Fortunatus.[3]

Another drawing and an oil *bozzetto* by Cortona survive for this project. The Edinburgh sheet, in which the heavenly zone with putti is unresolved, appears to have been the first in the sequence.[4] This was followed by a more highly elaborated sheet in the Uffizi (fig.104), where the upper zone corresponds closely to the altarpiece as executed.[5] Cortona's spirited autograph *bozzetto* for the picture, which includes several pentimenti, is in the collection of the Confederazione Nazionale Coltivatori Diretti (fig.105).[6]

The history of the execution of the altarpiece itself is complex. The picture was laid in, but only the upper zone, and perhaps the group of supplicants at the right, was completed before Cortona died on 16 May 1669. Ciro Ferri, Cortona's most able assistant, was asked to complete the canvas, but he demanded 900 scudi for the task, which was deemed excessive.[7] It was next given to a much less distinguished Cortona pupil, Giovanni Ventura Borghesi (1640–1708). He was required to complete it in accordance with a model by Cortona furnished by Cardinal Girolamo Rospigliosi, sometime secretary to the Chigi Pope, which can be identified on provenance grounds as the *bozzetto* illustrated here (fig.105). The completed altarpiece was finally installed above the altar on 19 May 1683. [TC]

89

GASPARE MORONE *fl.*1633–1669

Elevation of the Papal Arsenal at Civitavecchia, 1660

OBVERSE: Fabio Chigi, Pope Alexander VII (1599–Pope 1655–67), bearded, in profile to left, wearing cap, cassock, and stole decorated with a star; around: *ALEX.VII.PONT.OPT.MAX.*; signed on truncation: *GM* and dated beneath: *AN.VI*

REVERSE: Façade of the Naval Arsenal, with boats in a choppy sea foreground; above: *NAVALE CENTVMCELL*; in exergue: *MDCLX.*

Silver; 4.2cm diameter

Glasgow, University of Glasgow, Hunterian Museum

This medal, which was ready by 1 May 1660, represents the final form of the papal arsenal, which was set at the rear of the harbour and consisted of a huge arcaded and column-covered structure that had much in common with the north colonnade of the piazza of St Peter's, that was being built in the early 1660s.[1] The fortification of this, the principal port of Rome, reflects a preoccupation with strengthening the city's defences which had been a hallmark of the latter part of Urban VIII's papacy, and was taken up again by Alexander VII. The remains of the arsenal were destroyed by bombing in 1944.[2]

The style of the reverse of this medal, with its precise detailing and low relief, is very close to that of Bernini himself, but was most probably taken from a pen drawing by Giulio Cerruti in the Vatican Library.[3] [TC]

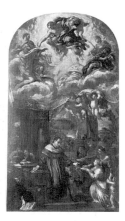

left fig.103: Pietro da Cortona (completed by Giovanni Ventura Borghesi), *St Ivo Intervening on Behalf of the Poor*, Rome, Sant' Ivo della Sapienza

centre fig.104: Pietro da Cortona, *Study for St Ivo Intervening on Behalf of the Poor*, Florence, Uffizi, Gabinetto Disegni e Stampe

right fig.105: Pietro da Cortona, *Bozzetto for St Ivo Intervening on Behalf of the Poor*, Rome, Confederazione Nazionale Coltivatori Diretti

90

GIOACCHINO FRANCESCO TRAVANI *fl*.1634–1675
Foundation Medal for Santa Maria dell' Assunzione at Ariccia, 1662

OBVERSE: Fabio Chigi, Pope Alexander VII (1599–Pope 1655–67); bearded, in profile to left, wearing tiara with ribbons, cope embroidered with Christ on His way to Calvary; around: *ALEX.VII.PONT.MAX.A.VII*; dated below truncation: *1662*
REVERSE: Façade of the drum-shaped church, surmounted by a dome; around: *BENE. FVNDATA.DOMVS.DOMINI.*; on a scroll: *B.VIRGINI ARICINORVM PATRONAE.*
Bronze (cast); 6.6cm diameter
London, British Museum
(G.III.PAP.M.AE.III.29)

This is the foundation medal of 28 January 1662 for Bernini's centrally-planned church at Ariccia, the design of which pays homage to the Pantheon, a building which Bernini greatly admired.[1] Ariccia is a small town outside Rome, between Lakes Albano and Nemi, which had been bought by the Chigi family in 1661. Bernini also built the nearby church of the Madonna del Galloro. His reponsibility for the foundation medals for both of these churches is attested by the entry in Pope Alexander VII's diary of 13 December 1661: 'Accomadiamo le lettere al Cavaliere Bernino per le medaglie alle chiese dell' Ariccia' ('We consigned to the Cavaliere Bernini the inscriptions for the medals for the churches at Ariccia').[2] The medal corresponds very closely to the central section of a drawing by Bernini formerly in the Palazzo Chigi at Ariccia (fig.106).[3] Although there is no documentary evidence to support it, the attribution of this medal and its companion to Travani is convincing. [TC]

91

GIOACCHINO FRANCESCO TRAVANI *fl*.1634–1675
Foundation Medal for Piazza del Popolo, 1662

OBVERSE: Fabio Chigi, Pope Alexander VII (1599–Pope 1655–67), bearded, in profile to left, wearing tiara with ribbons, cope embroidered with Risen Christ holding banner; around: *ALEX.VII.PONT.MAX.A.VII*; dated below truncation: *1662*
REVERSE: View of the Piazza del Popolo, with obelisk centre flanked by twin churches; around: *SAPIENTIA.IN.PLATEIS DAT VOCEM SVAM*; dated in exergue: *MDCLXII*
Bronze (cast); 6.5cm diameter
London, British Museum
(G.III.PAP.M.AE.III.31)

Pope Alexander VII, after commissioning Bernini to restore the Porta del Popolo for the entry of Queen Christina in 1655, decided to improve and adorn the lay-out of the piazza next to his family church, Santa Maria del Popolo.[1] The inscription on the reverse is taken from *Proverbs* I, 20: 'Wisdom gives voice in the squares of the city', and proclaims the Pope's purpose most eloquently. The task of replanning the piazza was first entrusted to Carlo Rainaldi, and later modified by Bernini and Carlo Fontana.

The medal shows the south side of the piazza, where three radiating streets – Via Larga (later del Corso), Via Leonina (del Ripetta), and Via Paolina (del Babuino) – lead into the heart of the city. The pair of apparently symmetrical churches that link these roads are, to the left, Santa Maria in Montesanto, and, to the right, Santa Maria dei Miracoli. The foundation stone of the new piazza was laid on 15 March 1662. [TC]

cat.no.90 obverse *left* reverse *right*

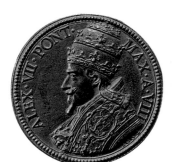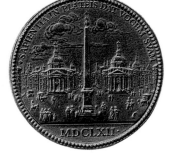

cat.no.91 obverse *left* reverse *right*

fig.106: Gianlorenzo Bernini, *Design for the Church of Santa Maria dell' Assunzione at Ariccia*, formerly Ariccia, Palazzo Chigi

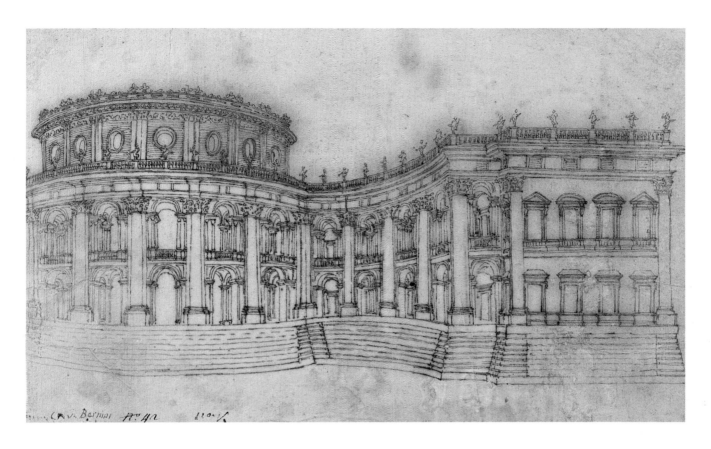

92
GIANLORENZO BERNINI
Design for the East Front of the Louvre
Pen and brown ink on discoloured off-white paper. There are ruled ink
lines round all four edges of the sheet, 16.5 × 21.7cm
Inscribed in pen and ink: *CAV. Bernini / No. 42 110.v.* (lower left);
G.L.Bernino (lower right of verso).
London, Courtauld Institute Galleries
(Blunt Bequest 51A)

This is Bernini's first project for the East façade of the Louvre, drawn in 1664 before he had any intention of visiting Paris.[1] The rusticated base is peculiar to a commission for a palace surrounded by a dry moat, but otherwise Bernini's design has little Parisian about it. Most obviously Roman is the idea of the blocks at either end of the façade (of which this drawing shows one), with their simple wall surfaces relieved by window frames of contrasting segmental and triangular pediments. These cubic blocks are four bays across and one identical bay deep; the only thing to distinguish them from a typical Roman palace is the use of a full pilaster (rather than a band or strip of rustication) to mark their corners.

Between these 'book ends', Bernini developed a façade of a very different character. The dramatic play of concavity and convexity in this central section is shown by Bernini's favoured device of the perspective drawing, as opposed to an elevation and plan (compare cat.nos.80–81). This records the general effect rather than the precise dimensions, but contemporary plans (in the Louvre, Paris) reveal that the façade would have curved back from the flanking wings on the line of a quarter circle, and advanced in the centre on a semi-oval.[2] This arrangement created a full oval space in the cen-

tre – on the ground floor an atrium reached by open arches; on the main floor above a hall rising through two storeys. Externally, this shape is to be seen most obviously in the free-standing oval of the attic storey. The uppermost cornice here, with its paired royal fleur-de-lys and scroll forms taking the place of a balustrade, was intended to suggest a giant crown.

The cladding of the curved section of the façade below this is typical of neither Roman nor Parisian architecture. The giant order (that is a pilaster or column running through two storeys) is continued from the end blocks. However, it changes from a single pilaster to a half column with two flanking pilasters, articulated in a regular sequence to separate the bays of a loggia. The nearest precedent is Michelangelo's Palazzo dei Conservatori on the Capitol in Rome, except that here Bernini opened the loggia on *both* floors, and arched its bays. The lower arches rest on piers and the upper ones on pairs of free-standing columns. This section is marked by a forest of columns and piers (with accompanying arches and entablatures) but no wall. Its effect of 'penetrable density' contrasts with the (aptly named) block at the corners, a device highlighted by Bernini's decision to begin the loggia one bay back from the front line of the façade.

Though sufficiently impressive to persuade Louis XIV to summon Bernini to Paris this design was never built, and nor was either of the two subsequent projects submitted by him (the present East façade of the Louvre was built to the designs of Charles Perrault in 1667–70). Its influence was none-the-less considerable: the play of curves lies behind Guarini's Palazzo Carignani in Turin, while the use of the giant order and double loggia with arched apertures may have inspired Alessandro Galilei's façade for the Lateran in Rome (see also cat.no.96). [DST]

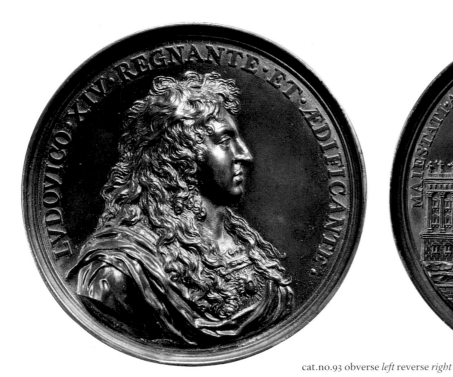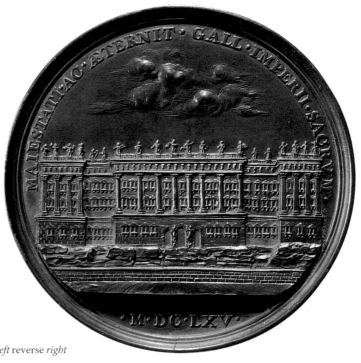

cat.no.93 obverse *left* reverse *right*

93

JEAN WARIN 1606–1672

Foundation Medal for Bernini's Louvre, 1665

OBVERSE: King Louis XIV (1638–*reg.* 1643–1715), in profile to right, with long flowing hair, wearing a sunburst on his cuirass, cloak arranged around shoulders; around: *LVDOVICO.XIV.REGNANTE.ET.ÆDIFICANTE.*
REVERSE: East façade of the new Louvre rising from a richly-rusticated podium; around: *MAIESTATI AC AETERNIT GALL IMPERII SACRVM*; dated in exergue: *M.D C.LXV.*; signed indistinctly above date: *IOAN VARIN FECIT*
Gun metal (two separate cast plates joined together); 10.8cm diameter
London, British Museum
(M.2154)

A *tour de force* of French medal casting, this was made in 1665 as the foundation medal for the new Louvre, which was to be built to Bernini's designs.[1] The reverse of the medal records Bernini's third and final design for the East front of the Louvre, which is shown in greater detail in an engraving by Marot. Warin was paid the huge sum of 1,199 livres for the medal on 10 December 1665. A very full and entertaining description of the ceremony of laying the foundation stone is given in Chantelou's *Diary*, which also usefully provides a rare record of Bernini's opinion of a medal: 'At the same moment the King sent to ask if all was ready, and was told it was. Warin was there, holding his medal. He had that morning shown it to the Cavaliere [Bernini], who told him it was in too high relief. He had replied that was how M. Colbert liked it, but was delighted to hear the Cavaliere say that it should be in lower relief as that was his own opinion'.[2] Warin evidently resented the high-handed intrusion of Bernini into Paris in 1665 and, clearly in competition with him, also carved in that year a marble bust of Louis XIV, now, like Bernini's bust, at Versailles. [TC]

94A

ALBERTO HAMERANI 1620–1677

Ponte Sant' Angelo, 1669

OBVERSE: Giulio Rospigliosi, Pope Clement IX (1600–Pope 1667–69), bearded, in profile to left, wearing tiara and cope; around: *CLEMENS.IX.PONT.MAX.AN.III*; signed below truncation: *ALB.HAMERAN*
REVERSE: Ponte Sant' Angelo viewed from above, Tiber crossing from left to right, round keep of Castel Sant'Angelo background left; inscribed above and around: *ÆLIO.PONTE. EXORNATO.*
Silver; 4cm diameter
Glasgow, University of Glasgow, Hunterian Museum

94B

CHARLES-JEAN-FRANÇOIS CHÉRON 1635–1698

Ponte Sant' Angelo Restored, 1669

OBVERSE: Giulio Rospigliosi, Pope Clement IX (1600–Pope 1667–69), bearded, in profile to right, wearing cap, cassock, and stole; around: *CLEMENS IX.PONT.MAX.AN.III*; signed on truncation: *F CHERON*
REVERSE: Ponte Sant'Angelo; across centre foreground, the River God Tiber reclines, holding a cornucopia and leaning against an amphora from which water flows; to his right the She-Wolf, suckling Romulus and Remus; above, an angel blowing the trumpet of Fame; around: *ÆLIO PONTE EXORNATO*; signed on rim: *F CHERON*
Bronze (cast); 9.8cm diameter
London, British Museum
(G.III.PAP.M.AE.I.8)

Pope Clement IX decided to Christianise the ancient Pons Aelius, the Hadrianic bridge crossing the Tiber at Castel Sant' Angelo, by erecting on its parapets ten marble angels carrying the instruments of the Passion (see fig.107).[1] Executed between 1667 and 1672, they

cat.no.94a obverse *left* reverse *right*

cat.no.95 obverse *left* reverse *right*

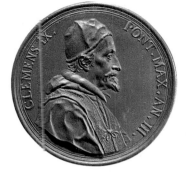
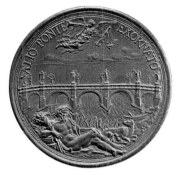

cat.no.94b obverse *left* reverse *right*

were probably all designed by Bernini, although the carving of eight of the sculptures was undertaken by assistants.[2] These two very different medals were issued in the same year to celebrate the restoration of the bridge. The larger of the two is the first documented work by the young Chéron, and it has been suggested that the portrait on the obverse may depend on a lost drawing supplied by Bernini, or even by Carlo Maratta. Compared to Hamerani's topographical design, Chéron's is distinguished by its allegorical character.

[TC]

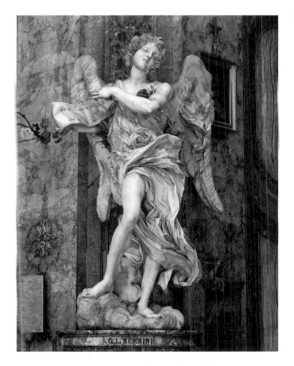

fig 107: Gianlorenzo Bernini, *The Angel with the Superscription*, Rome, Sant' Andrea delle Fratte

95
GIOACCHINO FRANCESCO TRAVANI *fl.*1634–1675
The Apse of Santa Maria Maggiore, 1672

OBVERSE: Emiliero Altieri, Pope Clement X (1590–Pope 1670–76), bearded, in profile to left, wearing tiara and stole; around: CLEMENS.X.PONT.MAX.AN.III; signed below truncation: TRAVANVS
REVERSE: The apse of Santa Maria Maggiore; around: IPSE FVMDAVIT.EAM ALTISSIMVS; dated below: AMD CLXXII
Silver; 3.5cm diameter
Glasgow, University of Glasgow, Hunterian Museum

The medal is a so-called 'mule', with the obverse signed by Travani and dated to the third year of Clement X's pontificate (i.e., 1672), while the reverse is dated the same year but is most commonly found with a different portrait on the obverse signed by Lucenti.[1] Girolamo Lucenti (1627–98) had by 1670 replaced Morone as Director of the Papal Mint and, in this instance, the reverse is clearly attributable to him.

The medieval apse of the great church of Santa Maria Maggiore was to have been rebuilt by Bernini for Pope Clement IX, on an ambitious scale. However, at that Pope's death in 1669 Bernini's scheme was abandoned, and a more modest one was commissioned in 1672 by the new Pope from Carlo Rainaldi. It had the advantage of being much cheaper than Bernini's project, and of preserving the precious medieval mosaics in the apse of the basilica.[2]

[TC]

96
ROMAN SCHOOL, 1680s
Design for a 'Pleasure Palace'

Pen and ink and grey wash over traces of black chalk or graphite, 18.4 × 27.6cm
There is a replacement piece of paper measuring 7.5 × 11.2cm carefully inserted by the draughtsman at the top centre of the sheet, on which is drawn the belvedere feature of the building (the bottom edge of the insert is shaped to follow the lines of the architecture).
Inscribed on the verso: *w* (indicating that it was once owned by William Talman)
Edinburgh National Gallery of Scotland
(RSA1322)

This free-hand drawing for an ideal 'pleasure palace' or country villa, drawn with a slightly tremulous hand and enlivened with grey wash, shows a two-storey structure derived ultimately from Bernini's first design for the East front of the Louvre (see cat.no.92). Its central block has as a convex façade, while the

flanking side wings are flat and square. The elevation is bound together by Corinthian pilasters running through both storeys, which appear at the corners of the wings and separate the bays of the central block.

The central ground storey is conceived as an open portico, the openings flanked by free-standing columns and the main entrance approached by curved steps. The inviting quality of the central block was clearly designed as a foil to the severity of the side wings, which have rows of windows but no doors. By means of an insert glued to the top of the sheet, the draughtsman has added an arcaded and richly ornamented circular belvedere above the central block, with a projecting loggia to either side. This is surmounted, like the remainder of the façade, with a balustrade topped with statuary. Another drawing by the same hand in Berlin shows the side elevation of this fanciful project with the belvedere fully integrated, and the Edinburgh drawing must, therefore, predate it (fig.108).[1]

The recent discovery in Vienna of a ground plan closely related to the 'Pleasure Palace' gives an idea of the intended dimensions of the building, since it has a scale (fig.109).[2] This drawing also indicates internal subdivision of the building into a series of rooms. As the wings were designed to be at the same level as the central block, the lateral doors indicated in the Berlin side elevation were superfluous, and were eliminated in the plan in favour of windows.

In terms of typology, the Edinburgh design belongs with a group of drawings made in connection with a competition for architectural design, devised by Domenico Martinelli and held in 1683 at the Roman Accademia di San Luca, the theme of which was the 'villa conceived as a noble palace'.[3] Despite the fact that the only architect cited in the archives of the Accademia as having taken part in this competition is Vincenzo della Greca the

Younger, others must have participated.[4] The relatively painterly style of draughtsmanship of the Edinburgh drawing reflects developments at the Accademia around 1680, while the references to celebrated architectural monuments, notably Bernini's Louvre design, demonstrates this to be an 'academic' exercise. Bernini's design may, in turn, have depended on Borromini's earlier project for San Paolo fuori le Mura, which shows a similar disposition of convex and straight elements along the façade.[5] The architectural membering of the central block of the Edinburgh drawing recalls Michelangelo's Capitoline Palace, while the crowning belvedere is inconceivable without the precedent of Borromini's design for a similar feature at Palazzo Pamphili in Piazza Navona.[6] It is precisely the synthesis of these various models in the Edinburgh drawing which allows us to date the project to the 1680s.

The Austrian architect Johann Bernhard Fischer von Erlach, who lived in Rome from 1670 to 1687, incorporated exactly this type of design for a 'pleasure palace' into his regular repertoire. He exported the design north of the Alps, and both designed and actually constructed buildings along these lines. Fischer von Erlach published an architectural treatise in Vienna in 1721 entitled *Entwurff einer Historischen Architektur*, which included a plate described as a 'Lust-Gartten-Gebäu', a 'Pleasure Palace'(fig.110), which he claims was 'von mir inventieret, gezeichnet und Grundriss davon gegeben' ('invented, drawn and planned by me'). He furthermore drew a variant of the pleasure palace for the Count Johann Adam Andreas von Liechtenstein, which he signed with the Italian version of his name.[7] We may therefore date this project to his Italian sojourn, between 1684 and 1687.[8] However, although the ideas presented in the Edinburgh drawing are certainly closely dependent on Fischer von Erlach, the style of the draughtsmanship is not entirely characteristic of him.[9] [ES]

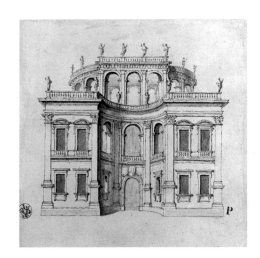

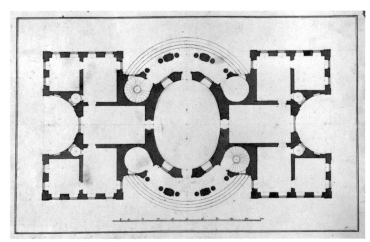

left fig.108: Roman School, 1680s, *Design for the Side Elevation of a 'Pleasure Palace'*,
Berlin, Staatliche Museen, Kunstbibliothek

right fig.109: Roman School, 1680s, *Ground Plan of a 'Pleasure Palace'*,
Vienna, Graphische Sammlung Albertina

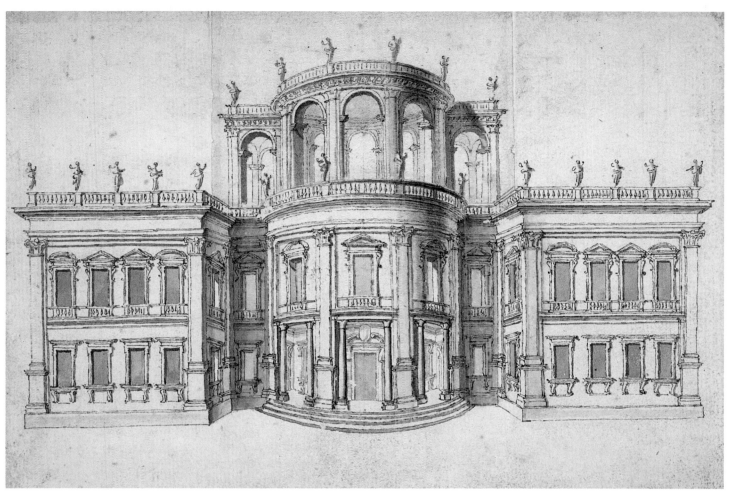

cat.no.96

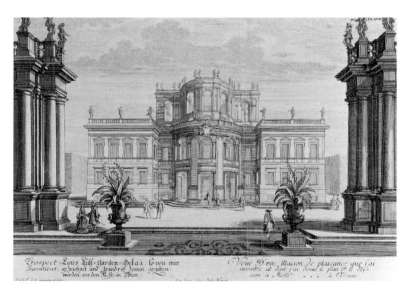

fig.110: After Johann Bernhard Fischer von Erlach, *Prospect of a 'Pleasure Palace'*,
engraving, Edinburgh, National Gallery of Scotland

VIII
Designs for Fountains and Outdoor Monuments

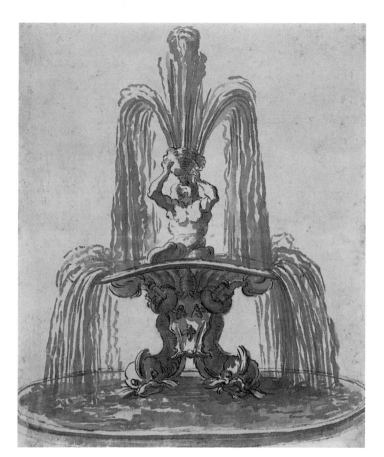

97
STUDIO OF GIANLORENZO BERNINI
Design for the Triton Fountain
Pen and brown ink and wash, over traces of black chalk or graphite, on
pale brown paper, 31.9 × 26.3cm
Windsor Castle, Royal Library
(RL5626)

This rather crude drawing, executed by one of Bernini's studio
hands, explores the pattern of water issuing from the *Triton Foun-
tain* in Piazza Barberini of 1642–3 (fig.111).[1] Without pumps of any
kind, the water pressure in Roman fountains at this time was en-
tirely dependent upon the height of the source; the *Triton Fountain*
was fortunate in having its water piped from the Acqua Felice high
up on the Viminal Hill. The dramatic narrative of the fountain is
built around the spectacular upward jet of water which this pres-
sure was capable of producing: a triton bursts out of the waves and
empties his conch shell of water (like a modern snorkel), in prepa-
ration for sounding a fanfare for Neptune. His chest and cheeks are
distended with the exertion.

In the final version the water rises in a single thin jet (of a paltry
height now that it depends on a mechanically pressured water sys-
tem). The interest lies in the water's return, as it cascades over the
triton's chest and shell-basin. In this drawing, Bernini's pupil
seems to have been envisaging three distinct jets, but it is difficult
to imagine that he ever took this solution very seriously, as it pre-
supposes such an enormous volume as well as pressure of water.

[DST]

98
GASPARE MORONE *fl.*1633–1669
The Fountain of the Four Rivers, Piazza Navona, 1650
OBVERSE: Giambattista Pamphili, Pope Innocent X (1574–Pope 1644–55),
bearded, in profile to right, crowned with tiara, wearing cope; around:
INNOCEN.X.PONT.MAX.A.VI; signed in field below truncation: *GM*
REVERSE: Piazza Navona, dominated at the centre by an obelisk, to right
the Pamphili Palace; around: *ABLVTO AQVA VIRGINE*; at bottom:
AGONALIVM CRVORE.
Silver; 3.7cm diameter
Glasgow, University of Glasgow, Hunterian Museum

This special medal of 1650 simultaneously commemorates Inno-
cent X's efforts to bring water to the heart of the old city and to

fig.111: Gianlorenzo Bernini, *The Triton Fountain*, Rome, Piazza Barberini

136

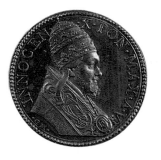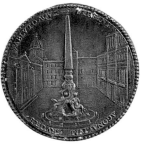

cat.no.98 obverse *left* reverse *right*

99
GIANLORENZO BERNINI
Design for the Fontana del Moro in Piazza Navona
Pen and brown ink and wash on brown paper, the water in blue wash,
39.6 × 24.5cm
Windsor Castle, Royal Library
(RL5625)

100
GIANLORENZO BERNINI
Design for the Fontana del Moro in Piazza Navona
Pen and brown ink and wash, over traces of graphite, on pale brown
paper, 24.6 × 20.6cm
Windsor Castle, Royal Library
(RL5623)

beautify the square which was overlooked by his family palace. In 1647 Borromini, and subsequently – once the Pope had viewed his more exciting model – Bernini, were commissioned to erect a fountain in the centre of the Piazza Navona with, at its own centre, an Egyptian granite obelisk recently excavated in the Circus of Maxentius. The obelisk was raised over the grotto-like foundation in 1649, but the sculptures representing the four continents then known through their most celebrated rivers (Danube, Nile, Ganges and Plate), carved by members of Bernini's workshop, were not completed until 1651. The image on the reverse, a re-issue of the 1649 foundation medal, follows the earlier models and differs from the fountain as executed.[1] [TC]

The Piazza Navona in Rome is a long space of cigar-tube shape, which preserves the form of the running arena of an ancient stadium (fig.4). In 1572 fountains were erected at either end of the piazza, with basins typical of the period, their complex outlines somewhat like a centralised church plan – a basic cross shape disguised by cut corners and four apses (fig.112; compare cat.no.73 verso).[1] The southern fountain, which was to become the *Fontana del Moro* ('Fountain of the Moor'), was also given an unusually rich sculptural decoration, executed by specialists working under the overseeing architect, Giacomo della Porta: four near-identical tritons squat in each of the arms, blowing water out of shells, while four masks, supported by dolphins and shells, spout drinking wa-

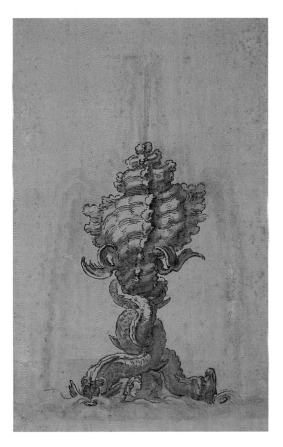

cat.no.99

cat.no.100

ter from the 'cut corners' (it should be emphasised that for the purposes of baroque fountain designers, 'dolphin' meant a comically monstrous fish, not a cuddly mammal). At the centre of the southern basin there was originally a nondescript rockery with a spout out of the top; in 1652 Innocent X commissioned Bernini to do something better.[2]

Cat.no.99 is Bernini's first idea, which developed into an executed fountain of similar form.[3] Deemed too small for the Piazza Navona, this *Lumaca* ('Snail') was taken in 1653 to Innocent's new suburban pleasure garden, the Villa di Belrespiro at San Pancrazio.[4] Bernini's basic idea in this drawing was to take a familiar architectural outline and re-cast it in organic form. The typical Roman fountain has a circular basin supported by a species of giant stone baluster, like a table lamp. In his design, Bernini re-created this baluster using natural forms: the tapering base is intimated by his dolphins, and the nearly spherical 'bulb' by his conch shell. His fountain was to have had one main jet of water, straight up from the top, the various ledges being designed to bounce the water outwards on its way down, as demonstrated here in the blue wash. It is difficult to determine whether the mouths of the fish were to have jets or drains for the water, or both.

Bernini had already used all these ideas for his *Triton Fountain* in Piazza Barberini (fig.111). However, this later design exhibits some interesting developments: there are three fish instead of four, resulting in an unexpected, triangular form within the otherwise completely quadrilateral basin; and here Bernini has created an organism of jagged, rustic and slightly asymmetrical contour.

Cat.no.100 was almost certainly planned as a replacement for the *Lumaca* at the centre of the southern basin fountain, preceding the present *Moro* of 1655 (fig.113).[5] There is no way of knowing why this design was never executed, as it is one of the most brilliant of

all Bernini's fountain ideas, expressed in his vividly evocative pen and wash drawing style. It was, however, developed further into a terracotta *bozzetto* (now in the Hermitage, St Petersburg), before being abandoned.[6]

As in the *Lumaca*, Bernini began by collecting separate elements from the 1572 fountain and amalgamating them into a dynamic ensemble. Instead of Della Porta's static, symmetrical tritons and pairs of (much smaller) dolphins, Bernini imagined two tritons writhing in mortal combat with four dolphins (of the same scale). The action is generic – perhaps the tritons are trying to hold the fish out of the water to suffocate them – but Bernini's chief aim was evidently to make a story out of previously static and dormant matter.

The 'baluster outline' is here even more evident than in the *Lumaca*. One can easily perceive how the tritons' tails make the tapering base and their backs the bulb of the baluster. The fish heads make a rim like a basin, and their tails assume the form of a smaller baluster for the second tier. It is easy to grasp how this design would work in three dimensions, with a dolphin's head spouting water at each of the four points of the compass. Its integration with the 'four-square' fountain of 1572 is consummate. Great care was also taken to entangle the separate creatures in their struggle, welding their bodies together and 'plugging-up' the centre of the sculpture, so that no eroding light could pass through.

Is this, then, a dynamic drama or an architectural mass? Its success lies in being both at once. Drama implies emotion. The triton's face expresses exaggerated fury (a bushy and frowning eyebrow catching the sunshine), yet it is turned inward and three-quarters buried. From most angles the tritons would read as impersonal lumps of inexplicable activity. The dynamism is also double-edged: the eye might be led around the group by the sloping backs and confused, cork-screw wrestling of the tritons, but from a distance it would reveal a clear vertical spine running up the whole, and regular horizontal spouts.

This conflict is resolved by metamorphosis. In Shakespeare's *The Tempest* (Act II, Scene 2), Trinculo creeps under Caliban's gaberdine to shelter from a storm; Stephano comes across what he takes to be a four-legged, two-voiced monster. In an analogous way, Bernini created forms which are in the first place strange and grotesque: the fish appear flaky, as if made of giant scales or torn sections of tree bark; the backs of the tritons are gnarled, rubbery and glistening. These substances become more bizarre by seeming to coalesce in a process of mutual metamorphosis. A constant theme in Ovid's *Metamorphoses* (and even in folklore) is that change is triggered by extremes of passion. Here insane fury turns these separate beings into a many-headed monster, an aberrant tangle of DNA. Once the viewer has come to accept metamorphosis, it is easier to imagine moving figures changing into frozen architecture. A final element of 'still motion' is provided by water, which, as Heraclitus teaches, is always the same in its pattern and always different in its actual matter. [DST]

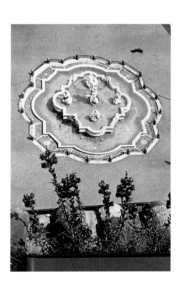
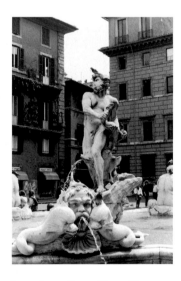

left fig.112: View of *The Fontana del Moro* from above, Rome, Piazza Navona
right fig.113: Gianlorenzo Bernini and others, *The Fontana del Moro*, Rome, Piazza Navona

cat.no.101 *recto* cat.no.101 *verso*

101

GIANLORENZO BERNINI

Designs for the Neptune Fountain, Sassuolo (recto and verso)

Graphite (recto); black chalk (verso), on rough off-white paper,
34.7 × 23.8cm
Windsor Castle, Royal Library
(RL5624)

102

GIANLORENZO BERNINI

Design for the Neptune Fountain, Sassuolo

Black chalk on rough off-white paper, 34 × 26.4cm
Windsor Castle, Royal Library
(RL5627)

103

STUDIO OF GIANLORENZO BERNINI

*Design for a Fountain at Sassuolo with a Marine God
and a Dolphin*

Pen and ink and wash with traces of black chalk, 40.6 × 27.3cm
London, Victoria and Albert Museum
(CA1.416)

In 1652–3, Bernini produced a series of fountain designs, of which these are three of the most informative, for the palace of Francesco I d'Este, Duke of Modena, at Sassuolo (he had recently delivered his magnificent portrait bust of the Duke, fig.150).[1] The idea outlined in cat.no.103, which seems to be a studio drawing (worked up, perhaps, from the autograph study now in the Getty Museum, fig.114), corresponds closely to the fountain as executed by Bernini's assistant Antonio Raggi (fig.115). As in the drawing, the finished fountain sits against a large arched niche with a semi-circular basin in front. In most other respects Raggi's work is such a pale rendering of Bernini's conception that it is more profitable to consider the drawing in isolation. The central figure group of a marine deity furiously struggling with a dolphin, which spews up its last watery breath, derives from the Fontana del Moro (fig.113). As in cat.no.100, Bernini plays with the grotesque patterns of the dolphin's scales and the deity's bulbous features and cauliflower hair. This comical likeness (or at least equivalence) of 'man' and fish is completely lost in Raggi's disappointingly human marine god. The way this figure perches upon a jagged, diagonally fissured rock-arch is reminiscent of the figure of Danube in Bernini's *Four Rivers Fountain* (see fig.22).

The remaining three images (cat.no.102, and the recto and verso of cat.no.101) probably reflect Bernini's early ideas for the Sassuolo project. All relate to a single fountain, which was never

executed in this form: the present *Neptune Fountain* at Sassuolo (fig.116) has little in common with these designs. It is likely that this fountain was to have been sited against a wall, as none of the figure groups offer very attractive rear views. There is a hint of a full oval basin in cat.no.102, but this may just be following the line of a niche or apse, as again the shell and figures here do not suggests a free-standing group. All three alternatives show water apparently issuing from within the shell basin. This is presumably because there was insufficient water pressure to sustain a higher jet. In cat.no.101 recto the water seems to gush up as if from the divine pressure of Neptune's feet. In the other two designs (cat.nos.101 verso and 102), the water appears to seep up from within the basins, producing an effect of a smooth, mirror-like surface. With a few gentle ripples this would have reflected beautifully waving strings of sunlight onto the undersides of the figures. The 'splash' of these two alternatives would have depended entirely on water spilling over the sides of the shell.

In all three images a basin is supported by a pair of hippocamps (marine centaurs). Bernini was careful to show their hooves just resting upon the surface of the pool, as if they were able magically to gallop on water. The way nature impersonates architectural forms here – the shells becoming basins, the Hippocamps volutes – is reminiscent of the *Triton Fountain* in Piazza Barberini (see cat.no.97).

For the crowning feature of this fountain Bernini tried out various alternatives. Cat.no.101 recto shows a grotesquely swaggering Neptune, reminiscent of Bernini's earlier *Neptune and Triton* in the Victoria and Albert Museum (fig.14), which makes the whole fountain read as a sea-chariot. On the other two images, the shell reads more as a marine bower of love: on the verso of this sheet Neptune, doubled up with eagerness, mounts the rocky couch of his wife Amphitrite. In cat.no.102, Amphitrite romps all over Neptune, who is so pitifully acquiescent that she is able to snatch his trident. This kind of horse-play is of course hardly Olympian, but Bernini treats fountain sculpture as a comic genre, quite distinct from the rest of his work. His fountains are peopled by a cast of strutting, excitable and over-sexed sea-monsters, more Caliban than Prospero. [DST]

104

GIANLORENZO BERNINI

A Nereid Reclining on a Dolphin: Design for a Fountain

Brush drawing in brown wash over black chalk. The sheet extensively damaged and faded, 33 × 24.3cm

London, British Museum

(1946–7–13–688)

This is an autograph Bernini drawing for an unknown fountain.[1] A number of features suggest a connection with the Sassuolo fountain projects of 1652. The sleeping nymph is broadly similar in pose to the figure of Amphitrite in cat.no.101, as well as to Bernini's roughly contemporary figure of *Truth Unveiled* (Rome, Galleria Borghese).[2] The vertical shading to the left of this drawing may be an indication of architecture or the edge of topiary, suggesting that this fountain was to have been set in front of an arched opening or niche, like the Victoria and Albert Museum's study for Sassuolo (cat.no.103). If this arch were to be open, the sheet would resemble the design, probably again connected with the Sassuolo project, in the Staatliche Kunstbibliothek in Berlin.[3] This would have been more effective than a closed niche, as the view through the arc of drapery and the architecture of the arch would have echoed one another. There are also clear signs of a circular pool, suggesting that the fountain was to stand some way in front of the arch. This is certainly, therefore, a design for a free-standing group – even if the rear views would be imperfect – and was probably intended for a garden.

Bernini's idea depends upon the group's isolation. He created an upright balancing act out of apparently unstable elements – a woman perched on a writhing fish. The Nereid appears to be asleep, as if perfectly at home on such a precarious bed. These effects depend upon the viewer enjoying the vertical poise of the stone, however complex its swirls. Bernini had also planned a dramatic arch of drapery to shade the Nereid's face (at certain times of day), an effect which would have been enhanced if the viewer could have seen light surfaces through the shadowed ring of stone. There is no indication of where water might have issued from, unless the intention was for a minimal volume to be seeping out of the fish's nose and draining through his mouth. [DST]

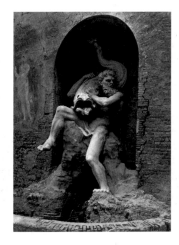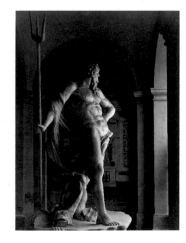

left fig.114: Gianlorenzo Bernini, *Design for a Fountain with a Marine Deity and a Dolphin*, Los Angeles, J. Paul Getty Museum

centre fig.115: Antonio Raggi, *Fountain with a Marine Deity and a Dolphin*, Sassuolo, Palazzo Estense

right fig.116: Antonio Raggi, *Neptune Fountain*, Sassuolo, Palazzo Estense

cat.no.103

cat.no.104

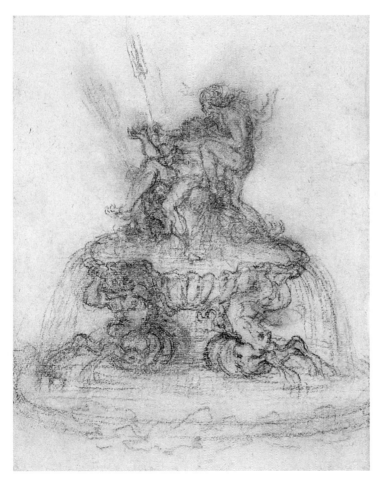

cat no.102

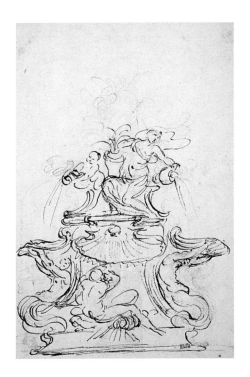

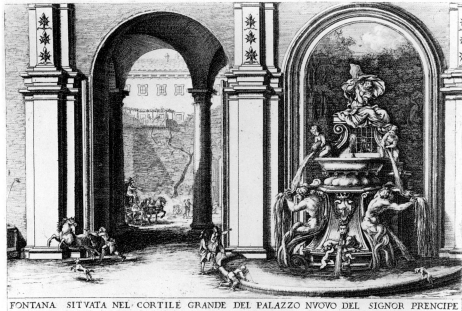

FONTANA SITVATA NEL CORTILE GRANDE DEL PALAZZO NVOVO DEL SIGNOR PRENCIPE
Panfilio nella Piazza del Colleggio Romano. Architettura del Caualiere Alessandro Algardi. 20

Francesco Venturini del'et inc. G.Iac.Rossi le stampa in Roma alla pace con Priu.del S. Pont.

105

ALESSANDRO ALGARDI

Design for the Fountain of the Acqua Vergine, Rome, 1653

Pen and black ink over graphite, 27.3 × 19cm
Edinburgh, National Gallery of Scotland
(D923)

106

GIOVANNI FRANCESCO VENTURINI 1650–1710

The Fountain of the Acqua Vergine, Rome
(after Alessandro Algardi)

Engraving, 20.8 × 29cm (plate size); 27 × 39cm (paper size)
Inscribed below: *FONTANA SITVATA NEL CORTILE GRANDE DEL
PALAZZO NVOVO DEL SIGNOR PRENCIPE / Panfilio nella Piazza del
Collegio Romano Architettura del Cavaliere Alessandro Algardi*; to the left: *Gio
Francesco Venturini del. et inc.*; to the right: *20/G. Iac. Rosso le stampa alla
Pace con Priv del. S. Pont.*
This engraving was plate 20 in Venturini's *Le Fontane ne' palazzi e ne'
giardini di Roma con il loro prospetti et ornamenti disegnate ed intagliate dal
Gio. Francesco Venturini (parte terza)*, dedicated to Livio Odescalchi,
nephew of Pope Innocent XI.
Edinburgh, National Gallery of Scotland
(P2914.46)

The dashing drawing is identified and published here for the first
time as an autograph sketch by Algardi for the fountain commis-
sioned by Prince Camillo Pamphili for the Cortile del Giardino of
the Palazzo Pamphili on the Corso (now Palazzo Doria Pamphili).[1]
The fountain was executed in stucco by Ercole Ferrata to Algardi's
designs.[2] It has not survived, but it was described by Algardi's bi-
ographer Giovanni Battista Passeri, and its appearance is known

through the engraving by Venturini exhibited here; through a
coarse study after it seen obliquely from the left, which is in the
Kunstbibliothek, Berlin; through a drawing in the Victoria and
Albert Museum; and through another at Düsseldorf, now divided
into two parts.

Apparently issuing from a wall of the palace, the fountain con-
sisted of three tiers with, at the top, the Virgin Trivia (or Trevi)
seated, holding aloft a pitcher, her cloak billowing around her like
Fortuna. She sat on the lintel of a window, flanked by rich volutes,
at the base of which knelt putti on a basin. The putti held
cornucopiae, from which jets of water gushed onto scallop shells.
Below, two tritons with twisted tails flanked a pedestal
ornamented with the shield and coronet of Prince Pamphili. From
a lion-mask spout below the sheild a further jet of water issued into
a wide, semi-circular basin. Beneath this jet gambolled the infant
Romulus and Remus suckled by the she-wolf. The wall of the
palace behind was frescoed by Gaspard Dughet with a forest scene,
as if 'the sylvan origin of the pure spring had been carried by the
water into the dusty heart of Rome'.[3]

Algardi's preparatory design, which has the appearance of an
elaborate, tiered salt-cellar, differs in several respects from the
fountain as executed. The female allegory of Trevi at the top is as-
sisted by a single putto in pouring water from three amphorae; be-
low is a river god, presumably representing the Tiber, with his legs
resting on an amphora gushing water. The substitution of the lat-
ter figure in the actual fountain with the group of Romulus and
Remus is hardly surprising, for the implication that the water had
been pumped directly out of the filthy Tiber – rather than deliv-
ered from springs outside Rome via a renovated system of ancient
acqueducts and pipes – would have given quite the wrong message.

[TC]

107

Design for the Elephant and Obelisk Monument

Pen and brown wash over graphite, 27.3 × 11.6cm
Windsor Castle, Royal Library
(RL5628)

In 1630 an elephant was seen in Rome for the first time in a hundred years.[1] This occurrence inspired Bernini two years later to propose the idea of an obelisk-bearing elephant for the gardens of the Palazzo Barberini. This drawing can be connected to this unrealised project on account of the Barberini bees which crawl up the apex of the obelisk; the only other record is a terracotta *bozzetto* in the Corsini Collection, Florence.[2] These designs can be regarded as a trial run for Bernini's much-loved elephant of the 1660s, which still stands in the small square in front of Santa Maria sopra Minerva (fig.117).[3]

The obelisk for the Barberini project was unearthed in 1570 and brought in 1632 to the Palazzo Barberini. Bernini's plan was to erect it just across his mock ruined bridge to the south of the palace.[4] In the event, the obelisk lay in two fragments in the palace grounds for more than a century before it was finally erected in the Pincian Gardens in 1822, where it still stands today.

Unlike the later monument at Santa Maria sopra Minerva, in this design Bernini did not shore up the area under the elephant's stomach, allowing the weight to be borne over a void (a conceit he was later to use for the *Four Rivers Fountain*, fig.22). Faint graphite lines drawn down the elephant's legs may indicate that Bernini was thinking about centres of gravity and weight-distribution. The enormous hump would also have helped to create a secure arch structure under the obelisk. With its slightly heraldic and symmetrical outline, Bernini was clearly thinking of his elephant as much in terms of a pedestal as an animal.

Obelisks first reached Europe through the Roman conquest of Egypt, and for this reason they became emblems of military triumph. In Papal Rome they were consecrated and surmounted by a cross, as a symbol of the triumph of Christianity over paganism. This obelisk bears a cross and the same symbolic idea, reinforced by the Barbernini bees of the patron. The principal characteristic of the elephant was considered to be its prodigious strength, which enabled it to bear war-towers in battle and trophies in the subse-

quent triumphal processions.[5] It is this association with triumphs which links elephant and obelisk. The other elephantine characteristic was believed to be wisdom, derived from longevity.[6] Like all his brute creations, Bernini's elephant is wonderfully full of character: gnarled, wrinkled, and with an expression of trumpeting rage. It is difficult to determine whether these were intended as attributes of wise old age or, more likely, of reluctant servitude.[DST]

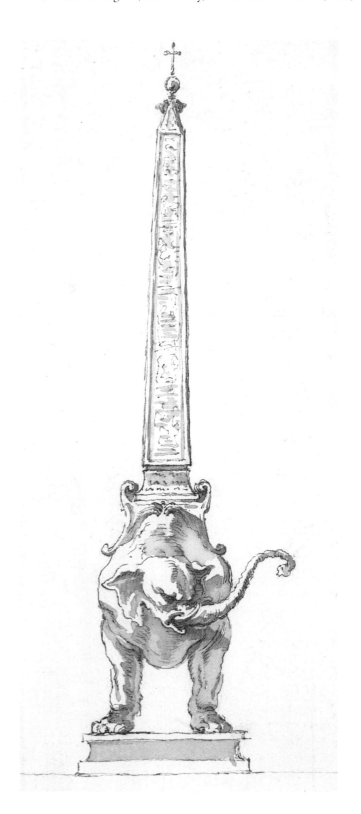

fig.117: Gianlorenzo Bernini and workshop, *Elephant and Obelisk Monument* (detail), Rome, Piazza Santa Maria sopra Minerva

108

AFTER GIANLORENZO BERNINI

Frontal View of the Equestrian Statue of Louis XIV

Pen and brown ink and wash, heightened with white, over touches of
black chalk. There are numerous areas of damage and repair. The horse's
hoofs, the rocks around them and the King's right hand have been
reworked by a later hand, 49 × 37.1cm
Inscribed *Palmi Romani* and *Piedi di Francia* above the scales at the top of
the sheet.
Edinburgh, National Gallery of Scotland
(D3208)

109

AFTER GIANLORENZO BERNINI

Back View of the Equestrian Statue of Louis XIV

Pen, brown ink and wash, heightened with white. Extensively damaged
and repaired, 48.8 × 37.1cm
Edinburgh, National Gallery of Scotland
(D3207)

When in November 1685 the French King Louis XIV finally saw the
equestrian statue that Bernini had made of him, he was so shocked
that he initially wanted to have it destroyed. On reflection he had
it modified (by François Girardon) into a statue of the classical
hero Marcus Curtius (fig.118) and it was then set up in the gardens
at Versailles, where it remains.[1] In 1678, two years before his death,
the artist had confirmed in a letter to his Parisian friend Chantelou
that the statue had been finished for some time, and confided his
fear that the French would find little to admire in it.[2] It is difficult
to judge whether Bernini was genuinely dissatisfied with the piece,
or whether he was rather acknowledging the difference in taste
between Rome, where the exuberant baroque flourished, and
Paris, where a less extravagant, classicist style had become fashion-
able. The original statue having been altered and heavily weath-
ered, the two drawings under discussion, although badly damaged,
are valuable documents for the reconstruction of its original ap-
pearance.

It seems that the project for an equestrian statue of Louis XIV

was first mooted in 1665, when Bernini was in Paris working on his
designs for the Louvre and on a portrait bust of the King.[3] It was
not until 1669, however, that the French Minister Colbert formally
commissioned the work.[4] He specified that it should be similar to
the statue of *Constantine the Great*, which Bernini had just finished
for the landing at the foot of the Scala Regia in the Vatican (figs.16
and 119), but sufficiently different from it not to be a copy. Colbert
and Bernini agreed that the master would carve the head himself,
and use students of the newly opened French Academy in Rome
for the rest, supervising their work and executing the final touches
himself.

An elaborate terracotta model in the Galleria Borghese in Rome
and a highly finished drawing in Bassano (fig.120) document suc-
cessive stages in the design process. The basic composition was
adapted from the *Constantine* with relatively little change, apart
from the pose of the rider, but the high rock touching the horse's
belly in the model (introduced as a means to disguise the necessary
support for the statue) was partly masked in the Bassano sheet and
the two Edinburgh drawings by the unfurled standards of the
King's conquered foes (not easy to make out in the photographs).
A medal by Travani (see following entry), probably issued when
the statue was finished, suggests that the unfurled standards were
indeed executed.[5]

The Edinburgh drawings seem to record accurately what the
finished statue must have looked like, since the mane and drapery
correspond exactly to the statue of Marcus Curtius. This suggests
both that these parts of the statue were unaffected by the later al-
terations, and that the drawings were copied either after the
finished statue, or after a highly finished (and possibly full-size)
model for it.[6] The measurement scales inscribed at the top of the
frontal view indicate a width of about 4.5 metres, which is the ap-
proximate size of the finished statue. It may be these very drawings
that were produced in response to Colbert's somewhat exasper-
ated request in 1682 for a 'small drawing as exact and similar to the
original as possible', which he wanted because the accounts given
in Paris of the statue were 'so different' from one another.[7]

According to his son, in this exceptional case Bernini, fired by a
criticism that the King's face seemed too joyous, explained the

left fig.118: Louis Desplaces, after Gianlorenzo Bernini and François Girardon, *Equestrian Statue of Louis XIV Transformed into Marcus Curtius*,
engraving, Edinburgh, National Gallery of Scotland

centre fig.119: Francesco Aquila, after Gianlorenzo Bernini, *Equestrian Monument to Constantine the Great*, engraving, Edinburgh, National Gallery of Scotland

right fig.120: Gianlorenzo Bernini, *Study for the Equestrian Statue of Louis XIV*, Bassano del Grappa, Museo-Biblioteca-Archivio

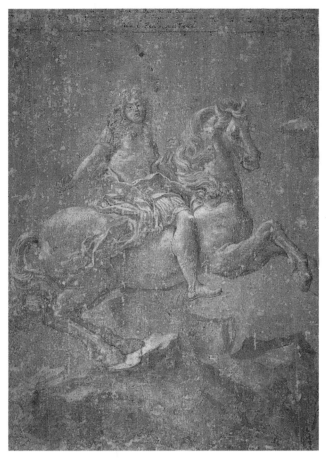

cat.no.108

cat.no.109

meaning or *concetto* of the statue in the following terms. The statue showed the King at the top of the steep and rocky mountain of Virtue – which, according to mythology, Hercules (from whom Louis XIV claimed descent) had preferred to the easy path of Vice. He is smiling because only those who reach the summit 'breathe the air of sweetest Glory'.[8] To judge from the Edinburgh drawing, Bernini's depiction of the King's smile must thankfully have been reasonably subtle and restrained.

The statue also yielded one of the master's most illuminating comments on his sculpture. When a visitor claimed that the drapery and mane were too agitated and dissimilar to antique precedents, Bernini is said to have replied:

'This which you claim as a fault is in fact the highest achievement of my art. It is here that I have overcome the difficulty of taming marble as though it were wax, and have thereby in some measure united painting and sculpture. The reason why the Ancients did not achieve this may have been that they lacked the courage thus to subdue the stone to their will.'[9] [AT]

110

ANTONIO TRAVANI 1661–after 1712

King Louis XIV on a Rearing Horse, after Bernini's Statue, c.1688

OBVERSE: Louis XIV (1638–*reg.* 1643–1715), wearing Roman armour, mounted on a rearing horse to right; around: *LVD.MAGN.REX.CHRISTIANISSIMVS*; on the scroll below horse's belly: *ET MAIOR TITVLIS / VIRTVS*; signed centre above rim: *ATF*
REVERSE: The True Religion holding a cross, left, crowned by Victory, right, with a figure of Heresy with a bundle of books (? Protestantism) prostrated; around: *VICTORE REGE VICTRIX RELIGIO*; signed on bottom edge: *A TRAVANVS F*
Bronze (cast); 6cm diameter
London, British Museum
(G.III.FR.M.36)

This is a fine early cast, with the etched guidelines for the raised lettering from the original wax (which do not quite tally) still visible.[1] The obverse is adapted from Bernini's great equestrian marble portrait of the King, which so displeased him that it was modified into a figure of Marcus Curtius (see previous entry) and erected in the gardens at Versailles. The medal corresponds quite closely to the spirited autograph pen and wash drawing in Bassano (fig.20). For its immediate source, however, Travani may have had recourse to a rare and larger uniface medal, an example of which is in the Vatican, and the style of which is close to that of François Chéron (compare cat.no.94B).[2] [TC]

cat.no.110 obverse *left* reverse *right*

Designs for Tombs and Church Monuments

111

PIETRO DA CORTONA 1597–1669

Design for the High Altar of San Giovanni dei Fiorentini

Pen and brown ink and brown and grey wash over black chalk,
89.3 × 37.8cm
A superimposed strip of paper was added by the artist
between the main drawing and the plan below, upon which the upper
5mm or so of the latter is drawn.
Inscribed in ink at the bottom: *Disegno fatto da Ciro Ferri per l'Altar Mag /
giore di S. Gio. de Fiorentini fatto poi dal / Borromini come presentemente si
vede / quale ã della Casa Falconieri* ('Drawing done by Ciro Ferri for the
high altar of San Giovanni dei Fiorentini, which was later made by
Borromini as can now be seen, [and] which belongs to the Falconieri
family'); and in the background behind the Baptism group:
verde ('green').
There is a scale in black chalk at the left side.
Windsor Castle, Royal Library
(RL01115)

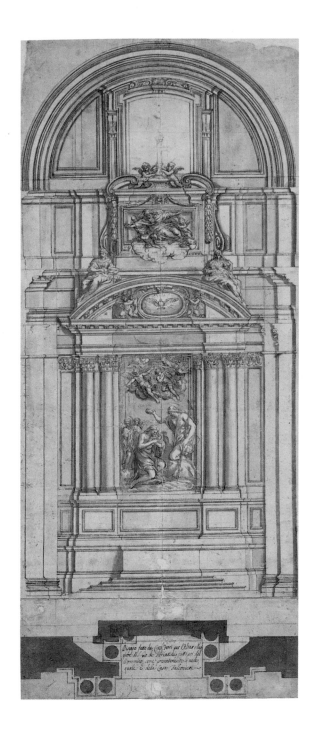

The impact of Cortona's project for the high altar of the Florentine
church in Rome, San Giovanni dei Fiorentini, is traditionally said
to depend on the artist's previous designs for stage-sets and
Quarantore decorations, particularly because of the theatrical ma-
nipulation of light sources.[1] The sculptural decoration of the altar
is dedicated to the Baptism of Christ and, following the biblical
account, all three parts of the Trinity are present. In the main re-
cess, a sculpted group shows *St John Baptising Christ*. Above, the
dove of the Holy Spirit hovers in the tympanum and God the
Father soars in from on high. Lightly sketched in at the apex of the
design, in front of the large tribune window, is a huge cross. The
overall impression of Cortona's project is of a gigantic tabernacle.

The plan at the bottom of the drawing makes clear that the altar
recess was quite deep, and the intention must have been that a
marble group completely or nearly in the round should occupy it,
set against a green marble revetment (hence the inscription). This
is confirmed by the fact that the kneeling figure of Christ casts a
shadow on the wall behind, while various parts of the design
appear to project in front of the framing architectural elements,
including, significantly, the column to the immediate right of the
Baptist. The angels accompanying the two principal figures would
no doubt have been in lower relief. This was essentially the form
adopted for the altarpiece as executed later by Antonio Raggi (see
fig.121).

The plan also gives an idea of how the artist intended to manipulate light sources. The back wall of the structure is separated from the columnar screen in front supporting the entablature in such a way as to allow light from windows in the back of the apse to filter in from both sides. This indirect light would have played softly across the principal sculpture. Higher up in the tympanum, the Holy Spirit was to be painted directly onto an oval glass oculus, and would have shone out brightly like an apparition in the middle of the apse wall. Finally, brilliant light from the upper tribune window would have silhouetted the cross sharply and bathed the projecting figure of God the Father with glancing light from above. This complex system of illumination approximated the effects achieved in Quarantore decorations, where candles and oil lamps were hidden behind stage flats to evoke an impression of mystical radiance emanating from the exposed Eucharist.

Sadly, although a full-scale wooden model was installed in the church for the approval of the patron, Orazio Falconieri, and expensive coloured marbles had been quarried, the altar as designed by Cortona was never constructed. The model, erected in 1634, remained *in situ* until 1656 at which point Borromini, who had supplanted Cortona as architect of the altar the previous year, had it taken down in order to replace it with an altar of his design.[2] It was probably on the strength of the much-esteemed palace that Borromini had recently designed for Falconieri that he managed to poach this commission. Nevertheless, Cortona's bold conception of the apparition of the Holy Spirit as an oculus surely inspired Borromini's novel innovation of completely liberating the tympanum space to form a window.

Borromini improved on Cortona's model by raising the entablature of the main tabernacle so as to equal that of the rest of the church. Furthermore, he had the capitals on the altar carved from the same red-veined *cottanello* marble as the columns, thus producing an overall effect of an integrated and unbroken architectural sweep at frieze and cornice level. As the *cottanello* columns had already been quarried and worked to fit Cortona's 1634 project, Borromini adapted them by skilful additions to fit his grander scheme.[3] Nonetheless, the limits imposed by the incorporation of some elements from the earlier design may account for one unusual feature – the disproportionately tall base of Borromini's altar.

The project continued to be dogged with problems, however, as Borromini died in 1667, before his design was fully realised, and the commission reverted once again to Cortona. He provided the scheme for the stucco decorations above the level of the tympanum, a project that was finally carried out after Cortona's death in 1669 by his pupil Ciro Ferri. The latter was also responsible for completing the architectural elements of the Falconieri wall tombs which occupy the side walls of the tribune (see following entry).

[KW]

112

ERCOLE FERRATA 1610–1686
Faith: Sketch-model for the Monument to Cardinal Lelio Falconieri

Terracotta, 36.3 × 32 × 17cm
Cambridge, The Syndics of the Fitzwilliam Museum
Purchased with the aid of the National Art Collections Fund,
Mrs Beatrice N. Stuart Bequest
(M.6–1988)

This lively sketch-model (*bozzetto* in Italian) shows a personification of Faith, with a winged putto supporting a portrait medallion of Cardinal Lelio Falconieri. It represents a preliminary stage in the design of Ferrata's tomb of Falconieri (who had died in 1648) in the tribune of San Giovanni dei Fiorentini in Rome (fig.122). The marble figure of Faith gazes towards the chalice held aloft in her right hand (broken off in the terracotta), from which rises the Host, symbol of the Eucharist and therefore of Christ's Passion. The putto, who struggles to support the weight of the large medal-

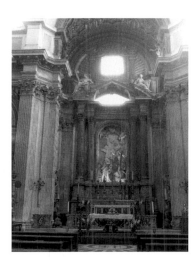

fig.121: Francesco Borromini, Antonio Raggi and others,
High Altar of the Church of San Giovanni dei Fiorentini, Rome

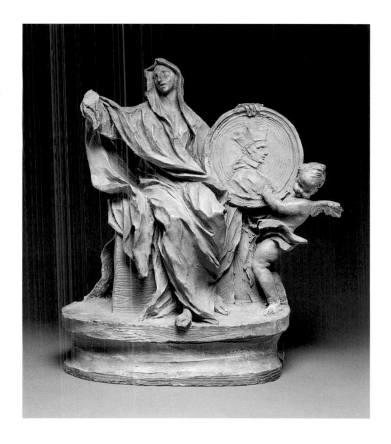

lion, nevertheless manages to gesture with one arm towards the portrait of the deceased. The putto's pose in the terracotta was followed closely in the final monument, athough his drapery is more substantial and more agitated. The pose of Faith, however, and the arrangement of her drapery (now much more voluminous) were reworked in the final marble, transforming the relatively slight and fragile terracotta figure into a ponderous, stoic matron. The portrait relief of Lelio Falconieri was also enlarged, and his cassock extended over the edge of the medallion frame to accentuate his presence.

No less than six terracotta models for the *Faith* survive, three of which may be identical with items listed in the inventory of Ferrata's studio.[1] The Fitzwilliam example, however, is the most spirited and least finished. The rough quality of the modelling, with blobs of clay added to represent the putto's drapery, suggests that it may be the only truly preparatory model. The other examples all correspond closely to the finished monument, and some if not all of them may have been produced as *ricordi* after it was completed. Ferrata's post-mortem inventory specifies that one of the terracottas was a copy made by his pupil Melchiorre Cafà.

Ferrata worked as assistant to both Bernini and Algardi on many projects, ranging from the decorations of the nave of St Peter's planned by Bernini for Innocent X, to the high altar of San Nicola da Tolentino designed by Algardi for Camillo Pamphili (see cat.no.55). He became a member of the Accademia di San Luca in 1654, and was steadily employed on major projects until his death in 1686. Later in his career he ran an important studio through which passed most of the best sculptors of the following generation.[2]

Ferrata had received the commission for the Falconieri monument by 1669, and the marble group was in place by 1674. It was his most celebrated work to date, and the biographer Pascoli records that it was highly praised by Bernini.[3] The monument was erected to the left of the high altar in San Giovanni dei Fiorentini, opposite a matching monument by Domenico Guidi to Lelio's brother, Orazio Falconieri. It was Orazio who commissioned first Pietro da Cortona, and later Borromini, to design the high altar of the church (see previous entry). [KW]

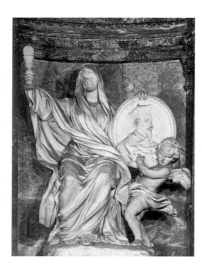

fig.122: Ercole Ferrata, *Tomb of Cardinal Lelio Falconieri*,
Rome, San Giovanni dei Fiorentini

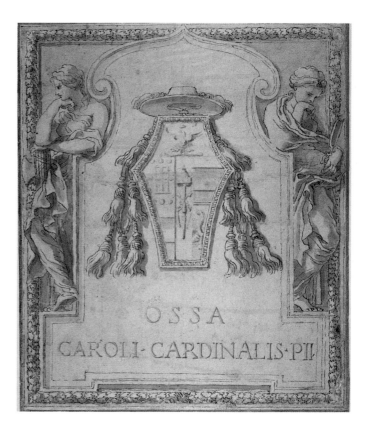

113

GIANLORENZO BERNINI
Design for the Tomb Slab of
Cardinal Carlo Emanuele Pio da Carpi (1568–1641)

Pen and brown ink and wash over black chalk, 29.2 × 24.2cm; the lower
right corner made up.
Inscribed below the coat-of-arms: *OSSA / CAROLI.CARDINALIS.PII*
('The bones of Cardinal Carlo Pio')
Edinburgh, National Gallery of Scotland
Purchased with the aid of the National Art Collections Fund and the
Foundation for Sport and the Arts, 1992
(D5329)

Until recently in the collection of the Earls of Leicester at Holkham Hall, this is Bernini's carefully executed design for the tomb-slab of Cardinal Pio da Carpi in the Gesù.[1] Despite covering an area of approximately four by three metres, the tomb is not easy to locate as it is normally covered by seating (there are apparently no commercially available photographs of it). It is situated in the right-hand side of the tribune, between the crossing and the steps leading to the high altar. The shaped tablet, enclosing a *testa di cavallo* ('horse's head') shield with the Pio da Carpi arms surmounted by a cardinal's hat, is flanked by figures of Justice and Prudence. With its slightly tremulous line and deftly applied wash, the drawing is characteristic of Bernini's more highly finished studies, and may have served as the basis for a contract. The figures are reminiscent of those on the *Tomb of Urban VIII* (fig.7), while the shaped tablet is similar to the one Bernini designed later for the chair-back of the Cathedra Petri (fig.20).

The tomb-slab was executed in grey and orange-yellow marbles, with the coat-of-arms, the lettering, the figures and the fram-

ing garland in engraved brass (the workmanship of which is rather crude). It corresponds in most respects to the drawing, but the inscription on the finished slab reads: *OSSA.CAROLI.CARD.PII / SAC. COLLEG.DECANI.* ('The bones of Cardinal Carlo Pio, Deacon of the Sacro Collegio').[2] A few other details were altered, such as the position of the right hand of Prudence (see fig.123). The original bill of 26 July 1650 from the mason, Filippo Renzi and countersigned by Bernini, survives.[3] It has been suggested that the design may originally have been intended for a wall monument rather than a horizontal slab.[4] However, the design does not really belong within the tradition of wall memorials, whereas, executed as it was in inlaid stone and metal, it fits into a recognisable and typical format for heraldic floor slabs.

Commissioned by Cardinal Emanuele Pio da Carpi the Younger, this slab covered the coffin of his uncle, who was buried in the Gesù nine years previously, on 3 June 1641. Carlo Emanuele Pio da Carpi the Elder had a distinguished career in the Church, having been appointed Bishop of Albano in 1627 by Urban VIII, and was subsequently Bishop of Porto (1630), Ostia, and Velletri (1639), and Deacon of the Sacred College. A fine marble bust of the Cardinal by Alessandro Algardi still belongs to the sitter's descendants.[5] [TC]

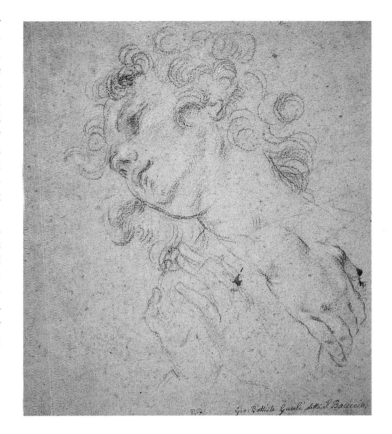

114

GIOVANNI BATTISTA GAULLI,
CALLED BACICCIO 1639–1709
Study of the Head and Hands of an Angel (recto);
Studies of Hands (verso)

Red chalk, highlighted with white, on buff paper. 26.7 × 23.6cm
Inscribed at the bottom: *Gio: Battista Gaulli detto il Baciccio.*
Edinburgh, National Gallery of Scotland
(RSA144)

The acute foreshortening, tilted angle of the head and ideal features of the principal study suggest that this drawing may have been made in connection with one of the music-making angels in the fresco of the *Vision of Heaven* decorating the dome of the Gesù. The fresco is in poor condition (currently under restoration), and it has not been possible from published photographs to link the drawing with a specific angel in the dome. However, the head does correspond very closely to an angel holding sheet music in

Baciccio's *bozzetto* for part of the dome in the Pinacoteca Vaticana (fig.124), although the latter was not followed exactly in the final fresco.[1] The connection with that particular figure is also weakened by the pair of hands in the drawing, which seem to belong to the same figure as the head. The position of these, gently pressed together, suggests a pose of adoration, which might plausibly connect it with one of the other angels in the fresco.

When Baciccio was awarded the Gesù commission in 1672 it would occupy him for the next decade and would ultimately be recognised as one of the most ambitious decorative programmes of the Roman Baroque. Such a vast scheme naturally involved extensive and diligent preparation, and Baciccio presumably made many preparatory drawings and *bozzetti*. [EJS]

left fig.123: Filippo Renzi and others, after Gianlorenzo Bernini, *Tomb Slab of Cardinal Carlo Emanuele Pio da Carpi* (detail), Rome, Il Gesù *centre* cat.no.114 verso
right fig.124: Giovanni Battista Gaulli, called Baciccio, *A Concert of Angels: Bozzetto for part of the Dome Fresco in the Gesù* (detail), Rome, Pinacoteca Vaticana

115

GIANLORENZO BERNINI

Design for a Monument to Doge Giovanni Cornaro

Pen and brown wash over graphite, 41.6 × 29.5cm

London, Courtauld Institute Galleries

(Blunt Bequest 52)

Bernini created his *Ecstasy of Saint Teresa* for the celebrated Venetian family, the Cornaro (fig.00). This is an unexecuted project for a monument to Doge Giovanni Cornaro in the church of San Nicolò da Tolentino in Venice.[1] In spite of the Venetian setting, Bernini was here mulling over familiar Roman ideas. He clearly wanted the tomb to be read as a free-standing burial chamber; the faint plan across the bottom of the sheet shows it to be a wall-tomb of minimal depth. It is rare at this date, but entirely characteristic of Bernini, to employ perspective (of a rather exaggerated kind) on a measured drawing. Presumably built around an existing door, the tomb, like that of Alexander VII, makes a virtue of necessity by suggesting a symbolic door into the burial chamber, guarded above by a low-relief carving of Death, brandishing scythe and hour-glass in a double reminder of mortality.

The Doge kneels in prayer on his own sarcophagus, flanked by Justice, with a baby carrying her *fasces*, and Charity, suckling one baby while another buries his face in his hands, sobbing inconsolably at the Doge's death. Charity bows her head, as befits a humble

'domestic' virtue, while Justice, an 'educated' virtue, looks upward to contemplate the nobility of the departed Doge. It is typical of Bernini that these figures were given some apparent freedom of movement: perching on a ledge, rather than being contained within a niche. There is also a deliberate absence of symmetry: both figures even look in the same direction. In the same way, the two trumpeting figures of Fame, holding the Cornaro arms, have postures which are 'rhyming' rather than strictly symmetrical.

Bernini was obviously already thinking at this stage about the use of coloured marbles, since there is a suggestion of their pattern in the area immediately above the door. On the evidence of similar executed projects, like the *Tomb of Cardinal Pimentel* in Santa Maria sopra Minerva, Rome (1653),[2] the marbles would have been 'atmospheric' rather than gaudy in colouring, with a preponderance of grey.

Bernini's design for Doge Cornaro's tomb is an assemblage of familiar elements just tweaked in order to give them variety and drama. [DST]

116

ALESSANDRO ALGARDI

Design for a Memorial Monument to Pope Innocent X Pamphili (recto); *Sketch of an Architectural Recess* (verso)

Pen and brown ink over graphite, 21.4 × 15cm

Windsor Castle, Royal Library

(RL1584)

This preliminary study for a memorial erected to Pope Innocent X Pamphili to commemorate his beneficence toward the pilgrims' hospice in the Roman church of SS. Trinità dei Pellegrini is among Algardi's few surviving drawings for an architectural project.[1] Although little known today, in the seventeenth century this monument would have been one of the most highly visible papal memorials in Rome, since it was erected in the refectory hall of the busiest pilgrims' hospice in the city (fig.125). The memorial forms part of a larger programme of papal patronage related to the Holy Year celebrations of 1650, which fell in the middle of Innocent X's papacy (1644–55) and which included the restoration of the ancient basilica of San Giovanni in Laterano and the cladding in sumptuous marbles of the interior of St Peter's.[2]

The Confraternity of the Trinità, who ran SS. Trinità dei Pellegrini, had been formally established in 1560 in response to the needs of the hundreds of poor pilgrims who converged on Rome to gain plenary indulgences during Holy Years, and found themselves without food, lodging or medical care.[3] San Filippo Neri (for whom see also cat.no.81) was among the confraternity's original supporters, who distinguished themselves by their acts of charity toward these visiting pilgrims.[4] The lay members of the confraternity all dressed alike in deep-red cassocks, to symbolise the ardour of their devotion to Christ burning in their hearts. Inspired by Christ's example in caring for the poor, they performed the humblest of tasks to serve the pilgrims, such as kneeling before them and washing their feet. The series of papal monuments erected at the hospice of SS. Trinità dei Pellegrini, beginning with that for Clement VIII Aldobrandini (*reg.* 1592–1605), commemorates the popes who had personally attended the pilgrims during

Holy Years, washing their feet and serving them meals.[5] Not only were the pilgrims thus reminded of the Christian duties of charity and humility, but they were also cared for spiritually by constant preaching (especially at communal mealtimes), the singing of hymns and vespers, and religious instruction. Catechism was taught regularly, and with justification, for it is recorded that many of the newly arrived pilgrims were ignorant even of how to make the sign of the cross properly.[6]

The architectural complex containing the hospice, refectories, dormitories and all other service buildings contiguous to the church of the Trinità dei Pellegrini was destroyed in 1940.[7] The memorial designed by Algardi survives, in somewhat compromised form, in a refectory wing adjoining the church.[8] Most significantly, the bronze busts and other ornamentation which once graced all the papal memorials were removed during the French occupation. Replacement plaster casts of the portrait busts were eventually set into the niches. Of the alternative proposals presented in Algardi's sketch, the monument as executed was clearly based on the solution at the left side, with the broken pediment in the form of a volute. The design chosen is more severely architectural than sculptural. The marble parts of the monument were executed by Algardi's assistants, but he himself made the terracotta models for the bust of the Pope, the putti and the tiara, and cast and cleaned the wax moulds used for the final bronzes.[9] The distinctive tapering pilasters flanking the niche are strongly reminiscent of Borromini's columns flanking the main entrance at the Propaganda Fide. The cherubim with wings spread like brackets at the base are also very Borrominesque (fig.126), and contemporary with Borromini's bracket cherubs of enormous wingspan at San Giovanni in Laterano. Furthermore, the detail of the acanthus foliage propping up the niche, which is given the shape of the heraldic Pamphili lily, is characteristic of the punning humour which Borromini regularly displays in his architectural decoration.[10] In view of such influences from Borromini, it may be noted that Algardi was also probably involved in the programme for new sculptural decorations for the re-vamped Lateran basilica, a project for which Borromini had overall responsibility.[11] [KW]

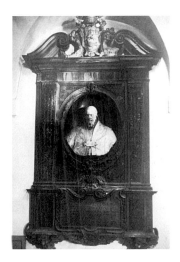

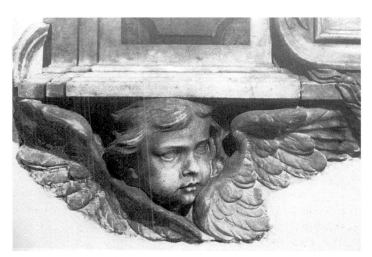

left cat.no.116 *verso*

centre fig.125: Alessandro Algardi and others, *Monument to Pope Innocent X*. Rome, SS. Trinità dei Pellegrini

right fig.126: Daniele Guidotti, after Alessandro Algardi, *Head of a Cherub* (detail of fig.125)

cat.no.117 obverse *left* reverse *right*

117

GASPARE MORONE *fl*.1633–1669

The Church of Sant'Agnese in Agone (Sant'Agnese in Piazza Navona), 1654

OBVERSE: Giambattista Pamphili, Pope Innocent X (1574–Pope 1644–55); bearded, in profile to left, wearing cassock and cap; around: *INNOCENTIVS.X.PONT.MAX.*; signed *GM* and dated below the truncation: *AN.X.*
REVERSE: Façade of Sant'Agnese in Agone; around: *D.AGNETI VIRGINI ET MART. SACRVM*
Bronze; 3.9cm diameter
Glasgow, University of Glasgow, Hunterian Museum

According to tradition, Sant'Agnese was martyred in a room that was part of the undercroft of the Stadium of Domitian.[1] Over the old church and martyrium, Girolamo Rainaldi and his son Carlo built a new church, strongly influenced by Maderno's St Peter's, although on a significantly smaller scale. Inaugurated in August 1652, work proceeded until March 1653, when Innocent X suspended building, and in August gave the commission instead to Borromini, who then tore down parts of the façade and erected new towers and the dome.[2] Borromini's recently published autograph study for the reverse of this medal is in the Albertina in Vienna (fig.127).[3]

[TC]

fig.127: Francesco Borromini, *Design for the Medal of Sant'Agnese in Piazza Navona*, Vienna, Graphische Sammlung Albertina

118

GIANLORENZO BERNINI

Study for a Monument to Pope Innocent X

Pen and brown ink and wash over traces of black chalk; a few drops of oily liquid have 'bleached' the washes in three spots to right of centre, 46.8 × 33.1cm. Inscribed *Losconi*(?) in ink at lower left.
Edinburgh, National Gallery of Scotland
Purchased with the aid of the National Art Collections Fund, 1997
(D5429)

This impressive drawing first appeared at auction in London in 1996 with an attribution to the studio of Bernini, but in reality it is an important new addition to Bernini's oeuvre.[1] The central figure is clearly a pope, for he wears the papal cap (*camaura*), cloak and stole, and the acolyte to his right bears the papal tiara as an attribute. The suggestion that he may be identified as Pope Innocent X Pamphili, with his hooded eyebrows and distinctive wispy beard (here apparently shaved or parted at the centre of the chin) is entirely convincing (compare cat.nos.29–30).

Whether the design was intended, as has been proposed, for Innocent's projected tomb in the church of Sant'Agnese in Piazza Navona is more problematic, for the iconography would be unusual for a papal tomb. There is no funerary imagery, no sarcophagus, and the flattering allegorical figures which adorn Bernini's other papal tombs are absent (although the virtues of the deceased would no doubt have been spelled out in the inscription below). Instead, the frail Pope, his right hand raised in benediction, leans for support on the forearm of the bearded acolyte to his left. It seems likely that Bernini intended to represent a specific moment in the papal celebration of the Mass when, having knelt during the confession of sins, the Pope rises to give absolution to the faithful by blessing them. It would thus be more accurate to characterise the drawing as a design for a memorial monument to Innocent X, rather than an actual tomb (it was not until 1677 that Innocent's remains were transferred to Sant'Agnese and, after further delays, all record of the location of his funerary casket appears to have been lost). That Bernini's design was indeed intended for this church would explain why neither of Innocent X's principal family insignia, the dove with an olive branch in its beak, or *fleurs-de-lys*, makes an appearance,[2] for these would have been superfluous given that the entire church was under the private patronage of the Pamphili.

Much of Innocent X's patronage was lavished on the Piazza Navona, and included the commissioning of Bernini's *Four Rivers Fountain* (see cat.no.98 and fig.21), the extension and refurbishment of the family palace, which overlooks the piazza, and the expansion and rebuilding by a succession of architects (notably Borromini) of the adjacent church of Sant'Agnese (see previous entry). It seems that it was the Pope's intention to transform the church into a veritable 'Cappella Papalis' (papal chapel), to which he would have had direct access from his palace next door. Alessandro Algardi was initially commissioned to design and execute the Pope's tomb for the right arm of the church, but his death in 1654, followed in January 1655 by that of Innocent himself, interrupted work. Some modest progress on the project took place over the next decade under the stewardship of Prince Camillo Pamphili (including the installation, in the left arm of the church, of the two marble pilasters visible in fig.128). Responsibility for the figures

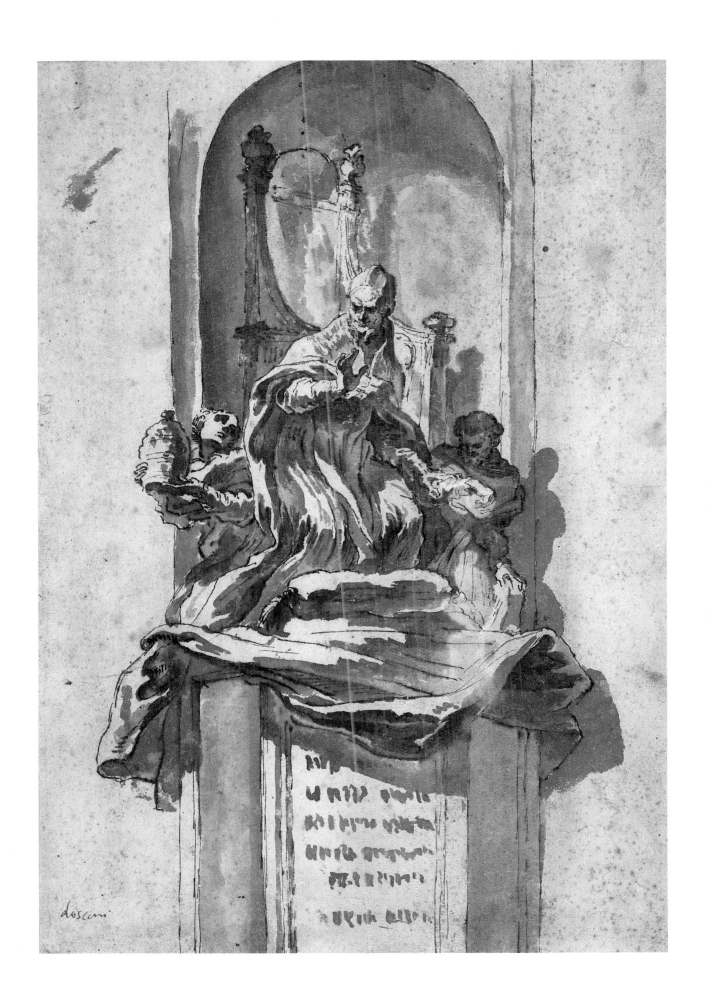

destined for the tomb had evidently devolved onto Algardi's pupils Ercole Ferrata and Domenico Guidi, but it was not until 1666, after Camillo's death, that they were formally commissioned to carve statues representing the Pope and two allegorical figures, *Prudence* and *Justice*. When in 1667 Bernini was appointed to oversee the completion of the church, there was evidently still scope to revise the plans for the tomb, for two drawings from Bernini's workshop at Windsor relate to the project.[3] One is a design for the whole tomb (fig.128), the other a variant idea for the pose of the Pope alone, but these too remained on paper. In the event, it was not until well into the eighteenth century that a monument to Innocent X was erected in Sant'Agnese, above the front entrance (fig.129).

The Edinburgh design is clearly very different in conception from the Windsor scheme (fig.128), and strong arguments can be put forward to suggest that it dates from considerably earlier, probably from the last year or so of Innocent X's pontificate.[4] It is thus likely to have been designed and submitted by Bernini as an alternative to the project proposed by his rival Algardi. The possibility of locating the monument in the left rather than the right arm of the church must at least have been contemplated by this date, since Bernini indicates two doorways flanking the inscription at the bottom which would have given access to the Palazzo Pamphili next door. A location in the left arm would also accord with the cast shadows in the drawing, and with the Pope's gaze and benediction, which would have been directed at those entering Sant'Agnese through the main door.

Although the drawing itself is vibrant, with its mix of forceful and more tremulous contours, and its boldly applied wash producing strong chiaroscuro contrasts, it is hardly surprising on balance that the project was not executed in this form. Particularly awkward is the conjunction of the angled papal throne and the concave niche. The conception as a whole would also seem altogether too transitory for a funerary monument. That a design of this nature was contemplated at all must be due to the Pope's rather exceptional project to transform his family church into a papal chapel where he would attend and celebrate Mass. That Bernini's unex-

ecuted design nevertheless enjoyed a modicum of celebrity is suggested by the existence of a copy of it, probably dating from the eighteenth century, which appeared recently on the London art market and has also been acquired by the National Gallery of Scotland.[5] One novel idea contained in the drawing – the dramatic swathe of marble drapery overhanging the inscribed tablet below – was taken up and adapted by Bernini for his tomb of Alexander VII Chigi in St Peter's (1671–8). [AG & AWL]

119
ERCOLE FERRATA 1610–1686
The Martyrdom of Sta Emerenziana
Terracotta, 69.5 × 47.8 × 15.9cm
Birmingham Museums and Art Gallery
(1968.P23)

This terracotta *bozzetto* for the *Martyrdom of Sta Emerenziana* was realised as a marble relief altarpiece in the church of Sant'Agnese in Agone in Piazza Navona (fig.130).[1] Like the final relief, the terracotta has a concave form. Little is known about the life of this obscure Roman virgin martyr saint. She is supposed to have been present at the burial of St Agnes, the titular saint of the church. When pagan fanatics arrived to diperse the Christian mourners, Emerenziana courageously continued to keep vigil at the tomb, whereupon she was stoned to death.[2] According to her hagiography, Emerenziana was baptised in her own blood as she died defending her faith and confessing to God. Tradition further relates that Emerenziana was buried close to St Agnes, and she was thus a highly appropriate subject within the iconographic programme of the church as a whole. By emphasising the early Christian roots of the church, her presence would by extension have underscored the ancient lineage of its patrons, the Pamphili.[3]

In Ferrata's composition the delicate figure of Emerenziana is shown kneeling piously before St Agnes's sarcophagus; behind her are the pagan fanatics, modelled as muscular young Romans in the act of stoning her. Emerenziana looks poignantly toward her fleeing companions, while above an angel is descending to sanctify

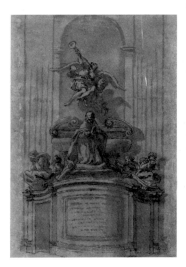
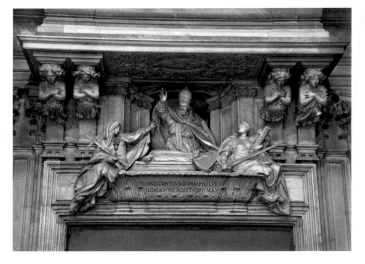
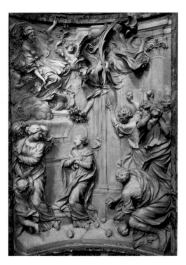

left fig.128: Studio of Gianlorenzo Bernini, *Design for a Tomb for Pope Innocent X*, Windsor Castle, Royal Library
centre fig.130: Ercole Ferrata and Leonardo Retti, *The Martyrdom of Sta Emerenziana*, Rome, Sant' Agnese in Piazza Navona
right fig.129: Giovanni Battista Maini, *Monument to Pope Innocent X*, Rome, Sant' Agnese in Piazza Navona

her with a floral crown and present her martyr's palm. The majestic figure of St Agnes appears over the sarcophagus to welcome Emerenziana. She is accompanied by putti, one of whom has a lamb, symbol both of St Agnes herself and of Christ's sacrifice. The ground below is scattered with the material remains of Emerenziana's lapidation.

Ferrata's commission for a relief to be installed behind the altar in the north-west pier of Sant'Agnese (coincidentally, directly below Baciccio's *Justice* pendentive; see following entry) also suffered an unhappy fate.[4] The sculpture was originally ordered from Ferrata by Camillo Pamphili in 1660. The present *bozzetto*, which has a provenance from the Doria-Pamphilj collection, is almost certainly identical with the one submitted by Ferrata in that year to Don Camillo for approval. A standard contract was drawn up between patron and sculptor, which stipulated that Ferrata would be paid part of the 1,000 *scudi* fee as a down-payment, and the rest upon satisfactory completion of the work. But when the lower two-thirds of the relief had been finished, Ferrata realised that he had underestimated the work involved, and wrote to Don Camillo asking for extra money to purchase the necessary marble to complete the upper part of the relief. This was refused, and so the work was installed in the church with the upper section – including the figures of St Agnes, the angel and the putti – finished in the much cheaper material of stucco. In fact, it emerges clearly from archival

documents that the Pamphili were exploiting Ferrata – he was overworked and underpaid.

He died leaving the St Emerenziana altarpiece unfinished, and one of his pupils, Leonardo Retti (documented 1666–1714), was then commissioned to complete it. Retti was also executor of Ferrata's estate, in which capacity he attempted to cheat Ferrata's heirs of the payment due for Ferrata's part of the relief, when in fact he was paid much more to complete it. This led to a long legal dispute which was only finally resolved in 1715. Retti did eventually carve the upper portion of the relief, keeping closely to Ferrata's model (completed by 1709). However, as a part of the legal case, various sculptors were called in to give their official opinions of Retti's contribution, which were generally unfavourable. The difference in style between the two sculptors can be seen in the final work: the draperies, for instance, in Retti's upper section are fussier than Ferrata's, which fall in a heavy, classicising manner.

[KW]

120

GIOVANNI BATTISTA GAULLI, CALLED BACICCIO 1639–1709

An Allegory of Justice: Design for a Pendentive in Sant'Agnese in Piazza Navona

Pen and brown ink and wash over black chalk, 22.9 × 19.6cm

Windsor Castle, Royal Library

(RL5550)

This drawing is one of four surviving preliminary studies (two drawings and two painted *bozzetti*) for one of the four frescoed pendentives representing allegories of *Prudence, Temperance, Faith and Charity* (together), and *Justice, Peace and Truth* (together) in the Pamphili church of Sant'Agnese in Piazza Navona (fig.131). Baciccio received this commission – his most important one to date – in 1666 on Bernini's recommendation, and the frescoes were completed in 1672.[1]

The present study corresponds fairly closely in its composition to the final fresco, and must belong to an advanced stage of the preparatory process. The definitive shape of the fresco field, with two awkwardly narrow arms flanking an encroaching arch at the bottom, had by this stage been settled. The Windsor study was clearly preceded by a spirited drawing formerly at Holkham Hall, in which the figure group is drawn within a lightly inscribed circle (fig.132).[2] This suggests that Baciccio was initially contemplating an arrangement similar to that adopted by Domenichino at San Silvestro al Quirinale, with circular fresco fields isolated within the irregular shape of the pendentives.[3] A recently discovered oil *bozzetto*, published here for the first time, is identical in its composition to the ex-Holkham Hall study, although all suggestion of a circular format has been eliminated (fig.133). A second painted *modello* (Zeri Collection, Mentana) corresponds in all but the most minor details to the pendentive as executed, and must have postdated the Windsor drawing.[4]

Despite the changes in format and composition, the basic ingredients of the design remained consistent from the outset. The most important figure is clearly Justice, with her scales resting on her thigh, and the sword with which to enforce her verdict. She is embraced by Peace, holding an olive-branch, and together they crush

cerning the relative prominence to be accorded to the latter two allegories. In the ex-Holkham Hall drawing and related *bozzetto* (figs.132–3), Law is given pride of place, with Truth sketched in below and behind. These roles were reversed in the exhibited drawing from Windsor, only to be modified once again in the final fresco, where the sensuous, scantily-clad figure of Law – the nearest figure to the viewer – is daringly shown from behind. In fact, upon their unveiling in January 1672, the pendentives were criticised in some quarters for their lasciviousness and there is evidence that the nudity of some figures may have been masked by drapery.[5] While the specific references in Baciccio's pendentive may be complex, the overall message is clear: under the guidance of the Pamphili patrons of the church, Justice, fostered by Peace and supported by Truth and sacred Law, will prevail.

Shortly after receiving the Sant'Agnese commission, and encouraged by Bernini, Baciccio had planned to visit Parma specifically to study Correggio's frescoes in the Duomo and San Giovanni Evangelista, although he did not actually make the trip until the spring of 1669. The experience had a noticeable influence on the style he adopted for the Sant'Agnese pendentives, with their predominantly pale palette and blonde tonalities.[6] Indeed, Baciccio's visit bears out in the most literal way the art-historical cliché that Correggio's fresco cycles in Parma, dating from the 1520s, remained the touchstone against which all similar decorations were measured over a century later. [KW]

121

CIRCLE OF PIETRO DA CORTONA 1597–1669
Design for a Tomb with a Portrait Bust

Pen and brown wash and black chalk, 34.5 × 16.9cm
Inscribed along the bottom: *Pietro di Cortona ...* (only partially legible)
Windsor Castle, Royal Library
(RL4449)

Scholars have identified the features of the bust as those of Pietro da Cortona, in a tomb of his own design or that of his pupil, Ciro Ferri.[1] Recognising self-portraits is a notoriously unreliable enterprise, and the fact that the faint indications on the shield at the top

below them a demonic monster. In the final fresco (but not yet in the Windsor drawing), Justice is crowned by two hovering putti, to signify her sovereign power to establish the rule of law. The remaining two allegorical figures represent Truth, supporting a blazing sun with her right hand (in the fresco she also has a globe, as she does in Bernini's celebrated statue of *Truth* in the Borghese Gallery), and Law, with the Mosaic tablets inscribed with the Commandments. There seems to have been some indecision con-

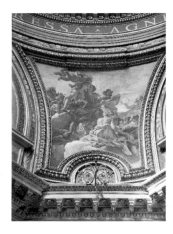 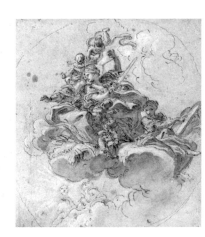 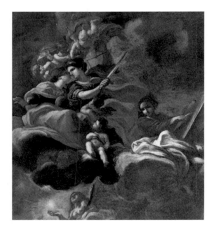

left fig.131: Giovanni Battista Gaulli, called Baciccio, *Allegory of Justice*, fresco, Rome, Sant' Agnese in Piazza Navona
right fig.132: Giovanni Battista Gaulli, called Baciccio, *Study for the Allegory of Justice*, Private Collection
centre fig.133: Giovanni Battista Gaulli, called Baciccio, *Bozzetto for the Allegory of Justice*, Private Collection

of the tomb in the present drawing are totally unlike Cortona's arms casts further doubt on the traditional identification. The style of the drawing and the architectural invention are consistent with Pietro da Cortona, but it would seem safer to leave open the issue of the identity of the tomb's intended occupant.

The basic elements of a modest Roman wall tomb are present in this design – inscription, sarcophagus, bust, coat-of-arms, all set within an architectural frame. Cortona clearly wished to explore alternatives, rather than slavishly repeating decorative features: in the giant foliated scrolls over the lid of the sarcophagus; in the swags; and in the consoles made to read as capitals for the 'pilasters'. The most striking detail is the utterly undecorated slab of the inscription resting upon the floor in an almost 'primitive' manner worthy of Michelangelo. [DST]

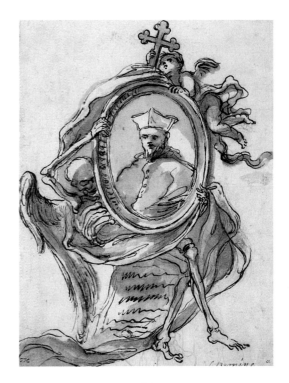

122

STUDIO OF GIANLORENZO BERNINI

Design for the Tomb of a Cardinal

Pen and brown ink and wash over graphite, 22.9 × 16.8cm
Inscribed in brown ink over black chalk at the lower right: *L. Bernine*
London, British Museum
(1913-3-31-177)

Though not by Bernini himself, this drawing could be an elaboration by a member of his studio of an autograph idea, and is similar in its conception to Bernini's *Memorial to Alessandro Valtrini* in San Lorenzo in Damaso (fig. 34).[1] It is a typical example of Bernini taking the essential ingredients of a Roman wall-tomb – portrait, inscription, angel and skeleton (used here instead of a sarcophagus or other indication of mortality) – and making a story out of them.

left fig. 34: Gianolorenzo Bernini and workshop,
Memorial to Alessandro Valtrini, Rome, San Lorenzo in Damaso

right fig. 35: Studio of Bernini, *Angels Supporting a Globe*,
Vienna, Graphische Sammlung Albertina

The idea is that Death is carrying off the Cardinal, but he is also carrying him upward. Death is the gateway to Heaven, so its personification can paradoxically be seen to serve immortality – exactly the beneficent role awarded to Time in the *bozzetto* of *Time and Death* (see following entry). The face of Death is in shadow, and he looks down towards mortality; an angel however looks up, holding a cross and guiding the medallion portrait on its way to Heaven. The unifying element is the drapery – at once symbolic of the shroud and a useful surface upon which to inscribe eulogies. Probably to be executed in black marble, like those of Bernini's monuments to Maria Raggi (Santa Maria sopra Minerva) and Alessandro Valtrini (fig.134), it swirls in an imaginary wind sent to winnow the grain from the chaff.

Another Bernini studio drawing of *Angels Supporting a Globe* in the Albertina in Vienna, is drawn with the same distinctive, wiry pen lines and generously applied wash, and appears to be by the same hand (fig.135).[2] [DST]

123

ASCRIBED TO GIANLORENZO BERNINI
Time and Death

Terracotta, with traces of gilding, 36.8cm high
London, Victoria and Albert Museum
(A29–1984)

Although very close to Bernini's own modelling style, there is insufficient evidence to attribute this terracotta to the master himself, as opposed to one of the legion of excellent sculptors working in his idiom in Rome in the seventeenth and early eighteenth centuries.[1] The model is in generally good condition, though most of the extremities have been damaged. The back was left as a rough accumulation of clay. Obvious traces of gilding in the hollows over the front suggest that the entire group was gilded, presumably at some later date when such *bozzetti* became collectors' items.[2]

The subject and the unfinished back of this group suggest that it may be a design for part of a wall tomb. If so, it would have been combined with at least some of the elements seen in any number of such tombs in Rome – an architectural framework; an effigy or

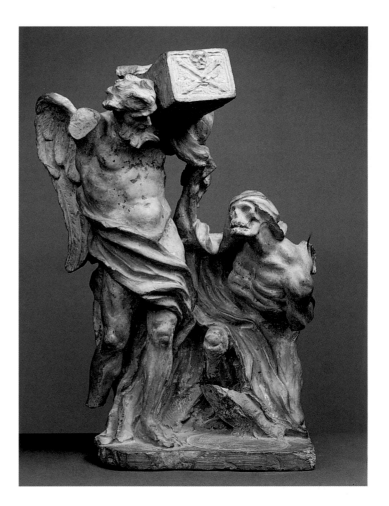

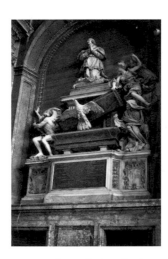

fig.136: Domenico Guidi, *Tomb of Cardinal Lorenzo Imperiali*, Rome, Sant' Agostino

bust of the deceased; inscriptions and coats-of-arms. A pertinent example is Domenico Guidi's *Tomb of Cardinal Lorenzo Imperiali* in Sant'Agostino (1673), which incorporates separate allegorical figures of Time and Death (fig.136). The outline of the terracotta group, listing slightly towards the left, suggests that it may have been intended to sit to the right (as we look at it) of a central feature such as a pyramid, with another allegory balancing on the other side.

The meaning of this group depends upon the simultaneous likeness and contrast between Time and Death. Both appear as interchangeable reminders of mortality in countless tombs. Here, on the other hand, they are contrasted rivals, staring at each other with a species of hostile recognition, with Time, unusually, acting on behalf of the deceased. It is fairly common to find Fame snatching a portrait away from the reach of Death, but in this group it is Time who lifts the coffin out of harm's way. His elegant gesture would have been more effective before the break at the shoulder, when both arms would have met on the coffin over his head, like a caryatid weighed down by the building it supports. Like Christ in a *Noli me Tangere*, Time treats Death to a body swerve.

In sharp contrast, Death crouches, snatching enviously at the shroud. At his knees there is what appears to be an oval man-hole, with a raised cover (once held up, presumably, by Death's missing left arm). This must be a symbolic vault or catacomb (or even the mouth of Hell), which Death is opening for the deceased. Death's head is shrouded and he has a stringy, semi-decomposed anatomy.

The meaning of the ensemble is clear: the passage of Time confirms the immortality of a man's reputation through fame (or of their soul, through redemption), thus cheating an angry Death of its prize. [DST]

124
GIANLORENZO BERNINI
The Blessed Ludovica Albertoni

Terracotta. The losses to the face and to the pillow evidently occurred during firing, 19.5 × 45 × 20cm
London, Victoria and Albert Museum
(A93–1980)

The Blessed Ludovica Albertoni was a fifteenth-century Roman noblewoman who took the veil and became revered for her piety and charitable works. Cardinal Paluzzo degli Albertoni, whose nephew married the niece of the Altieri Pope Clement IX (1670–76), commissioned this monument to his recently (1671) beatified forbear (see fig.2).[1] Ludovica experiences the ecstatic release of a virtuous death. In the Altieri Chapel of the Franciscan church of San Francesco a Ripa, the setting of the executed work, the visitor seems almost to interrupt her death-throes, looking past the high altar, over a short passage covered in a multi-coloured marble carpet, and into a cell, with its own gilded decoration and concealed window. Though created by Bernini, this architectural arrangement reads like one of those saints' private rooms preserved as shrines, which are so common throughout Italy.

The model exhibited here represents an advanced stage of the preparatory process and corresponds as closely to the final marble as Bernini's models ever do. He was already exploring the idea of the nun's habit splitting down the seam of the chest, almost as if a shell were bursting open to release her spirit. The peculiar arch of the neck expresses the spasm of death, but also allows Ludovica's head to be tilted into the stream of light coming from the concealed window to her left. Her veil projects around her head in thin flutes of terracotta, which in the marble version are highly polished in order that the cross-light exposes as far as possible the translucency of the stone. The Blessed Ludovica appears transfigured in death.

Scholarly opinion is divided about the status of three other terracotta models of this figure, one each in the Hermitage and the Louvre and another in a private collection, and the precise relationship of these to the present sketch-model and to the finished marble remains to be clarified.[2] [DST]

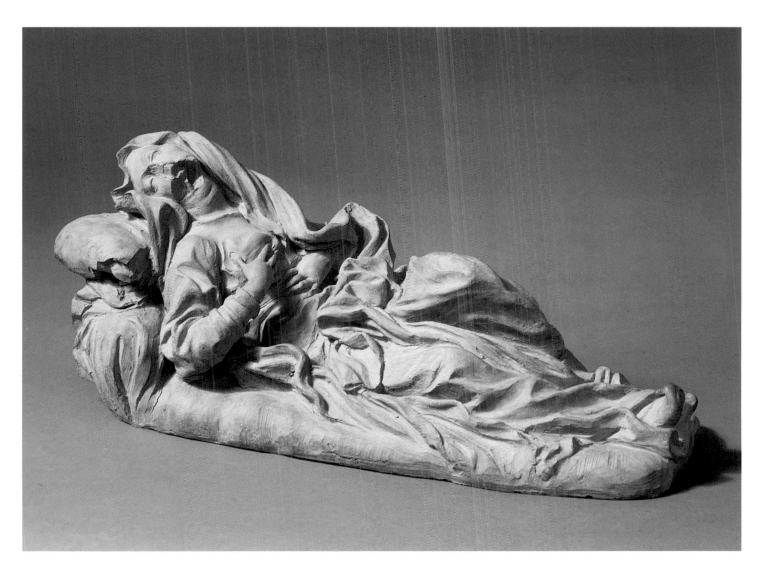

125

GIOVANNI BATTISTA GAULLI,
CALLED BACICCIO 1639–1709

The Three Maries at the Sepulchre

Oil on canvas, 84 × 111.5cm
Cambridge, The Syndics of the Fitzwilliam Museum
Purchased with the aid of the National Art Collections Fund
and the Regional Fund
(PD7–1987)

Baciccio was born in Genoa, arrived in Rome at the age of eighteen, and pursued a meteoric career there as a protégé of Bernini.[1] His bravura style was deeply inspired by the sculptor's works, and his most spectacular and ambitious commission – the fresco decoration of the apse, dome, pendentives, and nave vault of the Gesù (1672–85) – was secured and developed with Bernini's collaboration.[2] Baciccio also painted smaller collectors' pictures such as this and engaging portraits, including the fine depiction of Bernini in old age exhibited here (cat.no.7). *The Three Maries at the Sepulchre*, a splendid and excellently preserved example of the artist's mature manner, dates from the period of the Gesù frescoes, and reflects Baciccio's intense study of Bernini's creations.[3] The angels with their flowing draperies and elegant poses are relatives of those Bernini designed for the Ponte Sant'Angelo in the late 1660s (fig.107),[4] and the swooning Mary in blue at the right recalls the sculptor's *Blessed Ludovica Albertoni* in San Francesco a Ripa (see previous entry).[5] But Baciccio was far from being a slavish follower of his mentor, for while the linear ebbs and flows of the composition which heighten the emotional intensity of the encounter are entirely Berninesque, the rich saturated colours seem akin to a quite different tradition, and perhaps reflect a knowledge of the late narratives of Poussin. Baciccio's careful planning of his composition is illustrated by the elegant and precise preparatory drawings for it at Düsseldorf and in the Ashmolean Museum (fig.137).[6]

The story of the Maries or Holy Women discovering the empty tomb of Christ after his Resurrection is recounted in all four gospels.[7] They brought aromatic oils with which to anoint his body and are usually shown, as here, led by the Magdalen, who holds a jar of myrrh. As the early morning light breaks over Golgotha and Jerusalem in the background, the angels announce to her that Christ has risen. The news has not yet reached two disciples who ascend the path at the right.

The Magdalen, who became a penitential archetype in innumerable Counter-Reformation paintings, provides the thematic link between this picture and its pendant, *Christ in the House of Simon the Pharisee* at Burghley (fig.138), in which she washes Christ's feet.[8] Both works seem to have been acquired in Rome in 1684–5 by John, 5th Earl of Exeter.[9] *The Three Maries* is recorded in the Burghley inventory of 1738, where it is described, slightly inaccurately, as '3 angels coming to the Sepulchre, two Angels sit upon it, the Apostles at a great distance'.[10] The pendants remained together until the sale of William, 3rd Marquess of Exeter at Christie's in June 1887, when the *Three Maries* was sold as a work by Eustache Le Sueur.[11] [CB]

 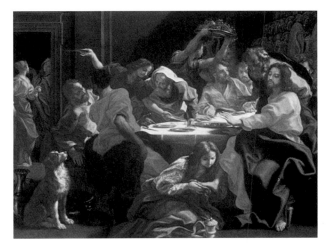

left fig.137: Giovanni Battista Gaulli, called Baciccio, *A Standing Angel*, Oxford, Ashmolean Museum
right fig.138: Giovanni Battista Gaulli, called Baciccio, *Christ in the House of Simon the Pharisee*, The Burghley House Collection

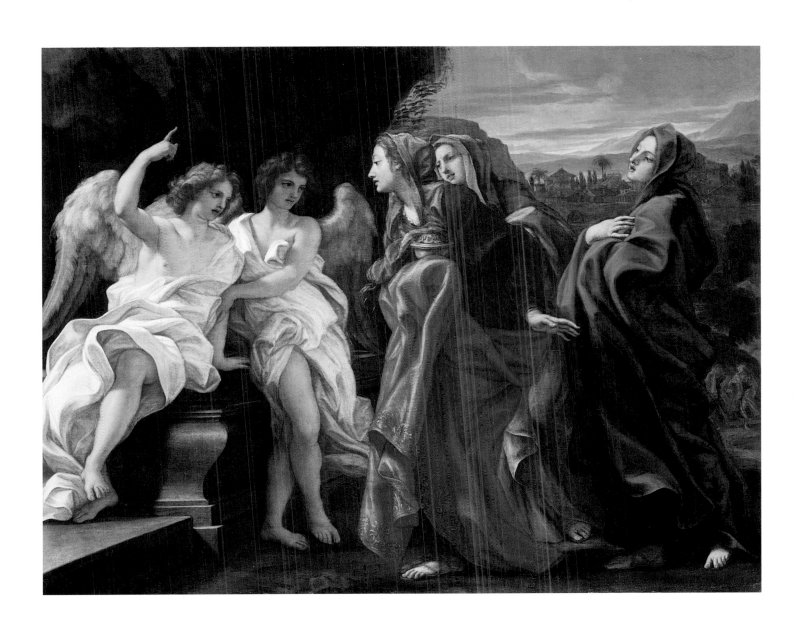

Designs for Ephemera

126

PIETRO DA CORTONA 1597–1669
*Design for the Quarantore Decorations in
San Lorenzo in Damaso, 1633*

Pen and brown ink and wash over black chalk, 39.8 × 56.8cm
Windsor Castle, Royal Library
(RL4448)

Cortona's unfinished drawing shows a project for a Quarantore celebration which took place in February 1633 in the Roman church of San Lorenzo in Damaso, located within the palace of the Cancelleria, the residence of the papal vice-chancellors.[1] The design, which was probably destined to be engraved, was commis-sioned from Cortona in 1632 by Cardinal Francesco Barberini, who had been appointed vice-chancellor of Rome the previous year by his uncle Pope Urban VIII.

Although Quarantore celebrations had formed part of the religious calendar of San Lorenzo in Damaso since 1551, the particular splendour of Cortona's project was intended to commemorate the Cardinal's recent nomination to a post second only to that of the Pope himself, while also emphasising the magnificence of Barberini patronage generally. Intended for both laymen and the clergy, Quarantore celebrations consisted of a continuous exhibition of the Eucharist (the consecrated host) over the high altar for forty hours (see also Christopher Black's essay, p.17).[2] This spectacle to glorify the sacrament was realised by means of a temporary

architectural stage-set (an *apparato*) built in the apse of the church, and accompanied by music, sermons and prayers. Quarantore *apparati* were based on contemporary designs for the theatre, and it has often been noted that the popularity of these *apparati* in turn influenced permanent architectural design.[3]

Cortona's design involved a re-cladding of the interior of San Lorenzo, transforming it into a stage-set which completely obscured the real church architecture. The side walls were lined with tall pedestals supporting massive detached Corinthian columns at the midway point of the nave, with pilasters at each terminal bay enclosing niches for statuary. Above, a heavy entablature with an acanthus-leaf frieze supported an attic storey on which rested vases of flowers and candelabra. At clerestory level in Cortona's design, lightly sketched in lines indicate an upper order of pilaster decoration. Cortona's classicising architecture was based on secular models, deriving ultimately from Andrea Palladio's Teatro Olimpico in Vicenza.[4]

The *tour de force* of this *theatrum sacrum* lies at its central focus – the apparition of the consecrated host, housed in a tabernacle held above the altar by hovering angels, with no visible supports. Cortona's design marks the first time in baroque art that flying angels are used in this way to draw special attention to the real presence of Christ in the Eucharist.[5] Clouds and cherubim fill the apse, which is further accentuated by the pairs of detached columns clustered at the juncture with the tribune. More clouds drift out over the proscenium arch, symbolically representing the divinity of Christ emanating outwards like the radiance from the Host. With the air pungently perfumed with incense, this ingenious touch must have given spectators the impression that they were participating in the sacred mystery of transubstantiation.

The practice of Quarantore celebrations stems from at least the medieval liturgy, when the forty-hour period between Christ's Crucifixion and Resurrection was observed by continuous vigil.[6] Subsequently the custom was encouraged by the Church as a spiritual antidote to the traditional festivities and entertainments celebrated before Lent, during Carnival.[7] Quarantore became tremendously popular spectacles, so much so that in 1537 in Milan it was decided to celebrate the Quarantore perpetually, moving the event from one church to the next. In 1592 Clement VIII established rules governing the staging of Quarantore to introduce a greater sense of decorum to the festivities by emphasising their religious rather than their theatrical aspect.[8] But this had little effect on the inventiveness and sumptuousness of the celebrations, and by the time of Cortona's design, Quarantore were huge, costly *apparati* that took weeks to construct. They were realised in wood, canvas, stucco, papier-mâché and terracotta, painted with marbling and gilded to look like permanent architecture.[9] A contemporary report of the 1633 San Lorenzo in Damaso celebration records that throughout the forty-hour period devotional sermons were read, with musical accompaniment by the most celebrated composer of the time, Stefano Landi.[10] Most important for the success of the Quarantore, however, was the lighting of the Eucharist from behind and from below so as to create the illusion that the Host itself was the light source from which divine rays emanated. This was accomplished by the use of hundreds of candles and oil lamps which were hidden behind the stage flats. Cortona's design proved so popular that it was in continuous use for fifteen years.[11] [KW]

127

ALESSANDRO ALGARDI
Design for a Processional Float
Pen and brown ink and wash, 26.2 × 19.7cm
Inscribed at the upper right: *Lalgarde*
Oxford, Christ Church Picture Gallery
(JBS613)

Despite its light, otherworldly quality, this design for a float was intended to be realised in wood, papier-mâché and canvas, and to display a holy icon carried in procession.[1] It is precisely this ephemeral character of the design which the artist accentuated: the holy image was to 'float' along, seemingly carried on angels' wings, under a baldachin supported by flying putti who busily endeavour to balance the four corners. It is easy to imagine the bumpy, jolting progress this apparatus would have made along the crowded, cobbled streets of seventeenth-century Rome.[2] A miraculous or devotional image, painted or perhaps in embossed silver, would have been inserted in the frame, which is surrounded by cherubim. Below, representing the earthly realm, was a terrestrial globe, to which the angels would seem to be attached by their fluttering drapery. Tall candles can be glimpsed sprouting from the decorative flower-vase finials over the lower canopy. The whole structure would have been carried on wooden poles.

Whether or not the project was ever realised, Algardi's design gives a clear indication of the elaborate and inventive nature of baroque ephemeral decorations, as well as a sense of the super-

imposed religious symbolism. For the drawing further shows holy light emanating from the icon: the rays are sketched radiating in all directions, so that when the image was borne in procession, everyone within range could have benefitted from its sanctity. Religious processions of this kind were akin to pilgrimages, since a holy image was generally carried along a specific route, with predetermined stops along the way where prayers were offered, imitating a re-enactment of the original pilgrimage, the Via Crucis. The city at large participated in religious processions, since the routes along which they passed were decorated with rich tapestries and hangings suspended from windows, or simply draped across the façades, giving the streets something of the character of church interiors decked out for special celebrations. Processions often had musical accompaniment, sometimes composed specially for the occasion.

It has been suggested that this design may have been made for the Holy Year of 1650, when Algardi was employed by the Pamphili Pope Innocent X for various sculptural and architectural decorations marking the occasion (see, for example, cat.no.116).[3] Although there are guide-books describing the festivities provided for the host of pilgrims who came to Rome that year to gain plenary indulgences, there is nothing specific enough in Algardi's design to link it to a particular church or confraternity.[4] Nonetheless, the essential concept of such a decoration is typical of post-Tridentine Rome, which presented itself ever more sumptuously as a spiritual locus for redemption through pilgimage to its seven basilicas. It was precisely the doctrine relating to papal indulgences granted to pilgrims which Martin Luther had so passionately attacked, on the grounds that it induced a false sense of security regarding individual salvation. The Catholic Church responded with a proliferation of processions, feast-days, Quarantore devotions and various other festivities, which were immensely popular not only for their spiritual content, but also because they were so beautifully designed and executed. [KW]

128
STUDIO OF GIANLORENZO BERNINI
Design for the Catafalque of Don Carlo Barberini
Pen and brown ink and wash on discoloured white paper, 48.5 × 26.1cm
A scale at the bottom of the sheet
Windsor Castle, Royal Library
(RL5613)

Don Carlo Barberini (1562–1630), elder brother of Pope Urban VIII, died on 25 February 1630 in Bologna.[1] As is vividly described in contemporary accounts, a sumptuous funerary service was immediately arranged for 29 February at the Bolognese church of San Petronio.[2] The cost of the service was almost 5000 *scudi*, of which 800 was spent on the construction of a funerary catafalque – an ephemeral architectural structure built of wood, canvas and plaster, designed to serve as a temporary tomb housing a symbolic sarcophagus for the deceased. Carlo's body was provisionally interred in Bologna, but was eventually buried in the Barberini family chapel in Sant'Andrea della Valle in Rome.

On 6 March, at a special convocation of the Roman Senate, it was decided to erect a commemorative statue to Don Carlo, who had been nominated Governor of the Borgo and General of the

Church by Urban VIII in 1623.[3] Still *in situ* at the Capitoline, both Bernini and Algardi contributed to this curious composite statue, which incorporated an antique torso.[4] This was only the beginning of the official honours dedicated to the memory of Don Carlo. Throughout 1630 Bernini was employed in the design of various funerary decorations, including the present project for a monumental temple-style catafalque, which was erected inside the civic church of Santa Maria in Aracoeli on the Capitoline Hill for the requiem mass for Don Carlo celebrated on 3 August.[5]

The drawing (which despite its high quality cannot be by Bernini himself on account of the strangely mannered figures) communicates clearly the intended magnificence of the Aracoeli catafalque, which reached the ceiling of the church.[6] Bernini was given a gold chain worth over 300 *scudi* in gratitude for his diligent role in the design and execution of the structure.[7] Including the

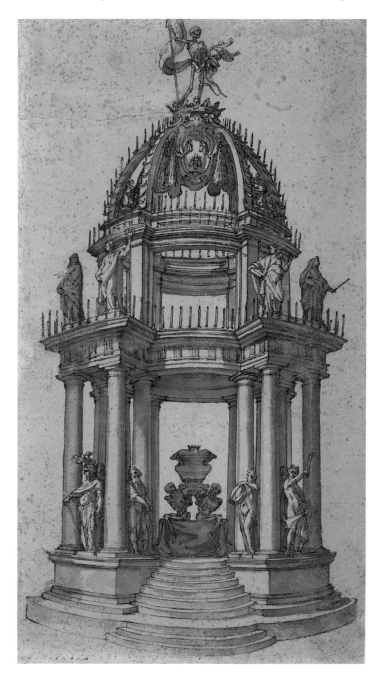

temporary decoration of the main portal of the church, the extravagant sum of over 12,000 *scudi* was spent on the event – roughly the cost of building a modest new church from scratch![8]

Contemporary descriptions of Don Carlo's catafalque do not match the Windsor design exactly. It is specified, for instance, that the columns, which are shown in the drawing as Tuscan Doric, were in reality fluted and painted to simulate bronze; and the sarcophagus, which is supported in the design by two skeletons, was reported to have been held up by four statues of military figures. The triumphant figure of Death which surmounts the crown of the catafalque holding a banner forcefully heralds the way to salvation. This macabre figure parallels Bernini's slightly earlier design for the *Baldacchino* in St Peter's, which in the original plan, recorded in an engraving and a medal (cat.no.61), featured a similarly posed crowning figure of Christ triumphant.

The architectural typology of this catafalque follows late sixteenth-century Roman models, which were designed as circular temple-mausoleums covered by a cupola. The originality of Bernini's design lies in the fact that he opened up the structure to allow a view of the sarcophagus inside, stripping the architecture back to its bare bones of columns, essential entablatures and the ribs of the cupola. With skeletons figuring prominently, the funerary note was assured. The statues on the entablature and inside the colonnade represent military figures and allegories, but the precise iconographic programme cannot be deduced from the drawing.[9] It was obviously intended to honour the character and achievements of Don Carlo, and the military trophies – just visible between the ribs of the cupola – refer to his most important role as General of the Church. The Barberini bees feature prominently on the escutcheon suspended in the cupola, flanked by hanging garlands. The crown was justified by the fact that Carlo Barberini, shortly before his death, purchased the Principality of Palestrina from the Colonna family, and thus gained for himself and his heirs the hereditary title of Prince.

Don Carlo's memorial service was a sumptuous occasion. The interior of the church of the Aracoeli was decorated with military trophies and weapons, and elaborately framed eulogising inscriptions in gold lettering on a black background, all illuminated by hundreds of torches and candles. Three orations were read, mass was celebrated, and the pontifical choir sang, before an audience which included the entire College of Cardinals, all the Senators of Rome, and a host of other prelates and gentlemen.[10] As if to compensate for this excessive spectacle, during the service alms were distributed to the poor throughout Rome. [KW]

129

ALESSANDRO ALGARDI
AND GIOVANNI FRANCESCO GRIMALDI 1606–1680
*Side Elevation of the Catafalque for the
Marchese Ludovico Fachinetti*

Pen and grey black and brown ink and grey and brown wash over
black chalk; the outlines indented, 52.1 × 24.3cm
Inscribed at the lower left with the papal censor's permission for the
design to be printed: ...*socius R[everendissi]mi P[atris] M[agistri] S[acrii]
P[alatii] A[postolici]*
London, British Museum
(AT–10–70)

130

GIOVANNI FRANCESCO GRIMALDI 1606–1680
*Project for the Front Elevation of the Catafalque for the
Marchese Ludovico Fachinetti* (recto); *Design for the
Decoration of an Apse* (verso)

Pen and brown ink and grey wash over black chalk, 46.6 × 22.8cm
Numbered at the lower right: 6; on the verso: *i.25*
London, British Museum
(AT–10–69)

131

ALESSANDRO ALGARDI
*Two Studies for the Figure of Immortality on the Catafalque
for the Marchese Ludovico Fachinetti*

Pen and brown ink and wash over traces of black chalk; the background
washed by a later hand in pale blue watercolour, 12 × 20.8cm; drawn on
two separate sheets joined together.
Oxford, The Visitors of the Ashmolean Museum
(M782–1)

These three drawings all relate to a catafalque erected in 1644 in the church of the Bolognese community in Rome, SS. Giovanni e Petronio dei Bolognesi, for the funeral service for the Marchese Ludovico Fachinetti, Bolognese ambassador to the Papacy.[1] The funerary decorations were commissioned and paid for by the Bolognese Senate, and the artist chosen to design the project, Alessandro Algardi, was also Bolognese, as was his collaborator Giovanni Francesco Grimaldi. A successful display was clearly important in maintaining the artistic reputation of the Bolognese school in Rome, and to this end a booklet commemorating the event was published, with a complete set of etchings by Grimaldi showing the lavish temporary decorations (see fig.139).[2]

Although SS. Giovanni e Petronio was founded in 1582, it was not completed until the end of the seventeenth century; in 1644 it still had a rough masonry façade and even the dome may not yet have been constructed.[3] Algardi's decorative programme for the façade was thus unhindered by existing architectural membering; he designed huge reclining river gods to flank the central portal, with an enormous winged Fame trumpeting above.[4] These figures were painted in chiaroscuro, rather than modelled in papier-mâché like those on the catafalque itself.[5]

The prints of the funeral show the interior of the church hung with sombre decorations, incorporating reliefs of skeletons, hourglasses, and inscribed escutcheons with portrait busts above. The niches were draped with black fabric, and housed smoking vases on classicising plinths, while the upper order was decorated with paintings of the Fachinetti arms (trees encircled by banners). The cupola was also draped with black cloth, and in the pendentives were skeletons holding winged hourglasses and scythes.[6] Candles lined the cornice of the church. The monochrome prints capture little of the colouristic richness of the ensemble, but we know from contemporary accounts that all the decorations were in gold, silver, gilt-bronze and various coloured marbles. Algardi also installed over the high altar of the church a huge bronze *Crucifix*, which he had made for another Bolognese patron, thus covering an altarpiece of *The Virgin and Child Enthroned with Sts John and*

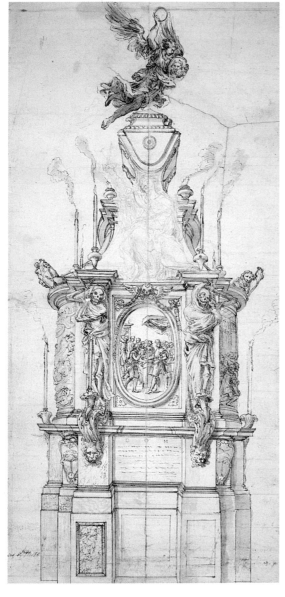

cat.no.129

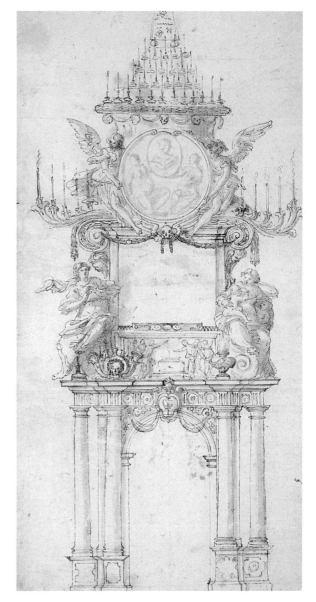

cat.no.130 *recto*

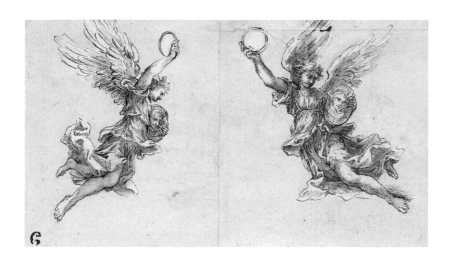

cat.no.130 *verso*

Petronio, of which Algardi is known to have disapproved.[7]

Only the plan of Fachinetti's catafalque is indicated on the nave floor in the printed view of the interior (fig.139), in order, no doubt, that the other decorations, notably Algardi's own *Crucifix*, could be seen without obstruction. Two prints were devoted to the catafalque itself, one of which reproduces exactly the collaborative drawing by Algardi and Grimaldi exhibited here. The catafalque as realised followed Algardi's design closely, and was surmounted by a silver-coloured flying figure of *Immortality*, carrying a metal ring and a portrait of the deceased, which the artist presented from two different directions in the drawing from Oxford exhibited here.

The design of the catafalque seems rather cumbersome, for it was projected as a sepulchral tomb rather than a temple-like structure (compare cat.no.128). It consisted of a tall base with inscriptions, above which was a richly decorated zone with narrative reliefs flanked by skeleton-herms in place of columns, while huge figures of Faith and Prudence crowned the cornice. Above, placed on tall supports, rose a sarcophagus of feigned porphyry. In the collaborative drawing (cat.no.129), the lightly sketched-in allegorical figures, as well as a few corrections and the angel above, are by Algardi, while Grimaldi appears to have been responsible for executing the rest of the drawing. The design of this structure, especially the elevated sarcophagus, appears to have been influenced by Andrea Sacchi's catafalque for the Jesuit benefactors erected in the Gesù in 1639.[8]

It is interesting to compare Algardi's design with the second drawing, evidently by Grimaldi alone, for the same project, which shows variant designs to left and right (cat.no.130). With its base composed of a Doric colonnade, its elaborate central section with allegorical figures and inscribed tablets, its circular medallion supported by angels enclosing more allegories holding up a portrait of the deceased, and its crowning element of an obelisk rising above rows of candles, Grimaldi's design is an amalgam of several established catafalque types. In many respects it looks back to earlier structures, such as those erected in 1572 in San Lorenzo in Damaso for Augustus II of Poland, and in 1621 for Philip III of Spain in San

Giacomo degli Spagnuoli.[9] It is perhaps not surprising that Algardi's proposal for the Fachinetti catafalque, which is more solidly and sculpturally conceived, was preferred to Grimaldi's, which confuses the eye with too many opposing elements. [KW]

132

GIANLORENZO BERNINI OR STUDIO
Design for the Catafalque of Muzio Mattei

Pen and brown ink and wash over black chalk; a vertical ruled line in black chalk at the center of the sheet, and a scale drawn in black chalk across the bottom, 26.2 × 19.5cm
London, British Museum
Purchased with the aid of the National Art Collections Fund
(1952-1-21-26)

This project for a catafalque for Muzio Mattei, the General of the Roman Church who died fighting the Turks in Crete in May 1668, is one of Bernini's last designs for funerary ephemera.[1] During the decades since Bernini's skeletal, temple-like catafalque for Carlo Barberini (cat.no.128) fashions had changed, and either an obelisk or a pyramid type catafalque design was now generally favoured (see also the following entry).[2] This preliminary study for Muzio Mattei's catafalque is a curious combination of the two traditions. Its cylindrical central element is set on a monumental base with corner projections, and supports a pyramidal cone reminiscent of Borromini's spire at Sant Ivo (see fig.102). With its proliferation of candles spiralling up to the flaming torch at its apex, this latter element is not unlike an antique funeral pyre – an appropriate reference for a military hero of ancient lineage.[3] Yet the base is broad and securely anchored by the military figures at the corners, who stand resolutely on heaps of armour bearing furled banners. The sweep of candles down the volute buttresses links the two lower elements of the design.

The catafalque was intended for a *Missa Post Acceptum Mortis Nunciam*, a requiem mass offered immediately for someone who has died in a distant land.[4] Pope Clement IX was greatly saddened

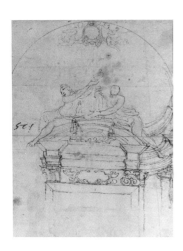
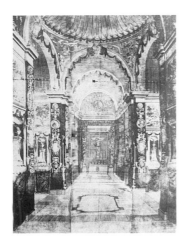
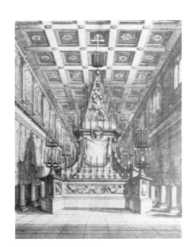
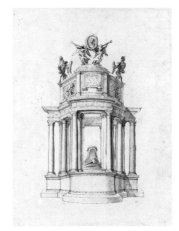

left to right: cat.no.130 *verso*

fig.139: Giovanni Francesco Grimaldi, *The Decorations of the Church of SS. Giovanni e Petronio in Rome, for the Funeral of the Marchese Ludovico Fachinetti*, etching
fig.140: After Gianlorenzo Bernini, *The Catafalque for Muzio Mattei*, engraving, Rome, Biblioteca Apostolica Vaticana
fig.141: Studio of Gianlorenzo Bernini, *Design for the Catafalque for Muzio Mattei*, Windsor Castle, Royal Library

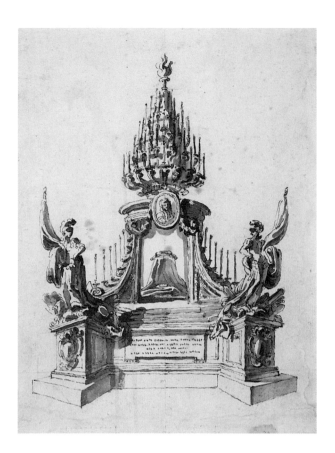

GIANLORENZO BERNINI

Design for the Catafalque of the Duc de Beaufort

Pen and brown ink and brown and grey wash over traces of black chalk
and graphite, 25.2 × 17.9cm

Inscribed at the upper right in ink by the papal censor: *Incidat[ur] / P.
Monardus m[agiste]r s[ocius] / R[everendissi]mi P[atris] M[agistri] S[acri]
P[alatii] A[postolici]*

London, British Museum
(1874–8–8–11)

This is a design for the magnificent catafalque erected in September 1669 in the church of the Aracoeli to honour François de Vendôme, Duc de Beaufort, commander of the papal fleet under Clement IX.[1] It provides a perfect illustration of one of the central aims of Bernini's art, namely that of creating a '*bel composto*', or harmonious union of the arts of painting, sculpture and architecture (see Christopher Baker's essay, p.23).[2] Although Bernini's idea seems somewhat slight when compared, for example, to his earlier monumental catafalque design for Carlo Barberini (cat.no.128), it nevertheless represents a consummation of all Bernini's earlier experiences in this field.

The towering pyramid was, when constructed, painted a deep lapis-lazuli blue and adorned with heroic battle scenes and eulogistic inscriptions in gold (fig.142). The pyramid is borne by dancing

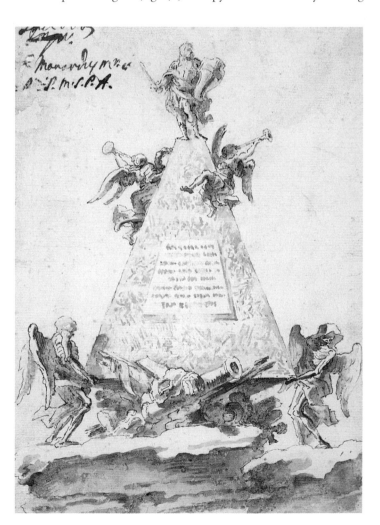

at the death of Mattei, but he was also worried about the continuing threat of the Turks, and the function of the mass was as much intercessionary as it was commemorative.

As erected in Santa Maria in Aracoeli for the service held on 8 June 1668, the design of the catafalque had evolved into a definite pyramid, placed on a tall pedestal base with towers of candelabra instead of soldiers at the outer corners (fig.140). The untidy piles of trophies visible in the drawing in the end neatly decorated the basement frieze and the pyramid in the form of reliefs; the opening to the sarcophagus was draped; and the buttresses were all but obscured by a profusion of candles. The overall impression derived from the engraved record is of a less spontaneous and more geometric design, but the suppression of the figurative elements may have been due more than anything to sheer pressure of time: only a week elapsed between the news of the General's death reaching Rome and his memorial mass.

A stylistically very similar drawing at Windsor (fig.141) has also been convincingly associated with this project. It must predate the British Museum drawing, and provides confirmation of Bernini's progressive shift from a temple-like catafalque to a pyramidal structure. It too includes a medallion portrait of the deceased as a complement to the symbolic draped sarcophagus in the central void. Both drawings are somewhat dry and precise in their execution when compared to Bernini's autograph study for the Beaufort catafalque, and are seemingly the work of a skilled studio assistant.[5]
[KW]

skeletons, which were painted to simulate gilt-bronze statues. Here there is no fictive sarcophagus within an architectural shell, as the pyramid itself has become the tomb.[3] Whereas the skeletons supporting the sarcophagus of Don Carlo were almost overwhelmed by the weight of their task, their enormous and energetic brethren here bear the weight of Beaufort's immortal fame with ease.

The brilliance of Bernini's idea of using grinning skeletons to support the pyramid lies in the conceit that the same Death that had cut short Beaufort's illustrious career is here actively involved in perpetuating the glorious memory of his heroic deeds and nobility of spirit. His eternal fame rests on the heaped trophies of his military triumphs, which serve as a foundation for the pyramid. At its apex, two winged victories, trumpeting his fame, flank the serenely classicising full-length statue of Beaufort himself, with his sword and shield emblazoned with a cross. In the actual catafalque he was completely gilt, like an antique cult statue, yet he represents an apotheosis of Christian virtue and valor, having died fighting Turkish infidels for the Papacy.

With more time at his disposal than he had in the case of the Mattei catafalque (see previous entry), Bernini was able here to design a completely novel ephemeral structure in which all the sculptural elements were superbly executed. The degree of his personal involvement in this catafalque is reflected in a recently discovered autograph study for one of the dancing skeletons, which is inscribed in his own hand with instructions to the sculptor who was to execute the figure (fig.143) – a macabre sketch which encapsulates the grim humour of Bernini's conceit.[4]

Bernini's programme for the requiem mass included fifty silver torchères set around the catafalque, as well as the customary draping of the interior of the church and the lighting of the clerestory level. Contemporary witnesses marvelled at the cost of the structure – estimated at between 8,000 and 10,000 *scudi*. It is recorded that Clement IX sent an impression of the engraving of the event to Louis XIV as soon as it was published, in recognition of his subject's services to the Church.[5] [KW]

134

ATTRIBUTED TO GIANLORENZO BERNINI
The Triumph of Faith:
the Papacy Flanked by Figures Bearing Crowns
Pen and brown ink and wash, on paper washed brown,
28.9 × 21.5cm; shaped to an oval
Windsor Castle, Royal Library
(RL5585)

One of Bernini's very few surviving designs for a firework display, this drawing shows Bernini's preliminary idea for the celebratory spectacle which was held in the Piazza Farnese, site of the French Embassy in Rome, on 27 June 1668.[1] The display was devised by Bernini for the French Ambassador, the Duc de Chaulnes, to commemorate the Peace of Aix-la-Chapelle, concluded on 2 May of the same year between Louis XIV and the Spanish Regent, Queen Maria Anna.[2] Bernini's conception centres on the theme of the elements: the flames indicated in the drawing ignited spontaneously from a bank of clouds out of which rose a terrestrial globe (representing fire, air and earth respectively; water was present in the form of the two fountains in Piazza Farnese, as shown in fig.144). The extravagance of this idea was balanced by the overall symmetry of the design, the primary message of the display being the absolute sovereignty of the Papacy over all temporal powers on earth.[3] The rigidly frontal allegorical figure of the Papacy, the broker of peace, holds the papal keys and a laurel branch and is

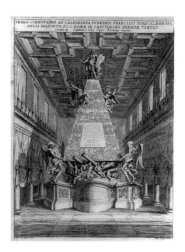
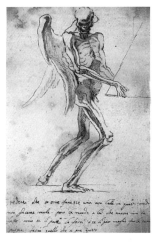

fig.142: Pietro Santi Bartoli, after a drawing by Mattia de' Rossi, after Gianlorenzo Bernini, *The Catafalque for the Duc de Beaufort*, engraving, London, Courtauld Gallery, Witt Print Collection

fig.143: Gianlorenzo Bernini, *A Winged Skeleton Supporting the Corner of a Pyramid*, Rome, Istituto Nazionale per la Grafica

crowned with an enormous papal tiara. The two subservient fe-male figures, kneeling in fealty and presenting the royal crowns of France and Spain, are symetrically arranged on either side.

During the actual firework display, the huge globe (over sixty feet high) caught fire and burned for quarter of an hour.[4] However, as a surprise for the spectators, and to emphasise the message that through peace the papacy will redeem the world from the threat of war, the display was designed so that as the flames died down, the figure of the Papacy re-appeared unscathed above.[5]

In a drawing made after the event (fig.144), the Piazza is shown brightly lit by branched candelabra in the form of *fleurs-de-lys*; the flames below the globe are contiguous with the bright streaks of the exploding fireworks; while to either side the paired fountains of the square, with their *fleur-de-lys* finials, spout refreshing jets of water into the fiery night sky.[6] Sevin's drawing shows one significant change from Bernini's Windsor design: the two figures representing France and Spain have been replaced by personifi-cations of War and Victory, who present a sword and a palm respectively to the Papacy. The Duc de Chaulnes might under-standably have found Bernini's first design unsuitable, since by surrendering her crown, the personification of France would in effect have been surrendering her sovereignty to the papacy – a notion which would not have amused Louis XIV. Pope Clement IX in fact only figured as a pawn in the peace negotiations between the warring sovereigns – Louis XIV had invaded Spanish Flan-ders, and was ready to proceed against Franche-Comté. It was only the threat posed by the alliance formed between Holland, England and Sweden which put a halt to his war-mongering.

Although the Windsor design has frequently been published as a studio drawing, there is a fluency in the line and a crispness in the application of the washes which seems to betray Bernini's own hand.[7] Stylistically it compares well with cat.no.118, which has also in the past been considered to be a product of Bernini's studio. [KW]

fig.144: Paul-Pierre Sevin, *Fireworks in the Piazza Farnese, 27 June 1668*, Stockholm, Nationalmuseum

The 'Arti Minori' and Designs for Applied Art Objects and Engravings

135

PIETRO DA CORTONA 1597–1669

Design for a Mace for Cardinal Antonio Barberini

Pen and brown ink and wash over black chalk, 41.2 × 18.3cm
London, Victoria and Albert Museum
(D1708–1885)

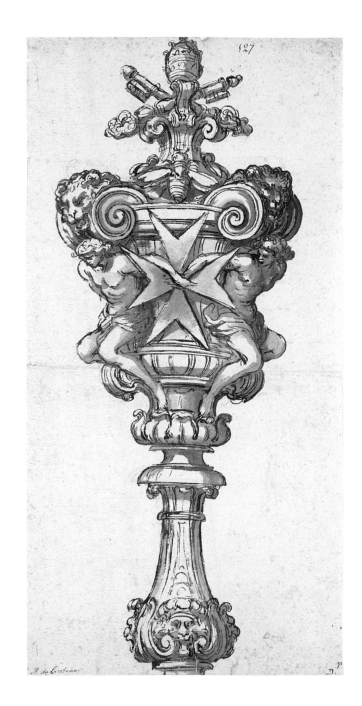

This splendid presentation drawing for a ceremonial mace bears the distinctive coat-of-arms of Barberini bees and a Maltese cross of Antonio Barberini the Younger (1607–71), nephew of Pope Urban VIII (*reg.* 1623–44). Antonio was created cardinal in 1628 at the surprisingly youthful age of twenty, a move which was highly criticised within the College of Cardinals; the Pope was, in fact, openly challenged as to why he had bestowed the title upon a 'boy of no merit'.[1] Moreover, Antonio was the third member of the Barberini family to be raised to the cardinalature, an unprecedented record of papal nepotism, and an early indication of the Pope's indulgence of his demanding family.

Cortona's design prominently displays the insignia relating to Antonio's honorary appointment by the Pope in 1625 as Grand Prior of the Order of the Knights of Malta – the Maltese cross with its split points. This, too, had been a controversial instatement: when news of it was reported in Malta, the General of the Order was set upon by armed Knights angered by the humiliation of the gesture. Antonio seems to have been especially favoured by Urban VIII on account of his vivacious and ambitious nature, and despite his famously arrogant behaviour – colourfully chronicled in contemporary accounts – he rose to prominence as a political figure and as an astute patron of the arts. A rare engraving of Cardinal Antonio, inscribed with a eulogistic poem, was made in connection with the Cardinal's project to commemorate his cultural achievements by means of a book extolling the Barberini Palace and its rich collections of art and antiquities (fig.145).[2]

The exhibited drawing is one of three closely related designs for Cardinal Antonio's mace by Pietro da Cortona.[3] Although it has been loosely dated to the 1630s on stylistic grounds, it must in fact have been designed in 1628 for Antonio's ordination as cardinal. Cardinals' maces were heavy silver or silver-gilt objects which were carried ceremonially, by special attendants called *mazzieri*, during the procession to the Quirinal Palace to receive the Pope's blessing which followed the rites of ordination.[4] During the

ceremony called the *possessio*, in which a newly-elected Pope processed from the Vatican to San Giovanni in Laterano (his titular church as Bishop of Rome), they were held aloft ('*mazzi alzati*') by all the *mazzieri* of the College of Cardinals, denoting the dignity of the office and its attendant judicial authority. Sadly, few examples of these ceremonial maces survive, probably because they served no liturgical function and were kept at the cardinals' residences, unlike church silver, which was generally safe-guarded in sacristies or treasuries.[5] A large silver mace can, however, be seen in one of Cortona's own paintings, where a young attendant casually props it on his shoulder during a papal audience.[6] And an elaborately tooled leather case for a mace is preserved in the Doria-Pamphilj collection in Rome; during the cardinal's procession such cases were carried by special attendants on horseback.[7]

The exhibited drawing is a fully finished presentation study, of the type that would have been submitted to the patron for final approval of the design. It was preceded by at least two other preparatory studies: a black chalk sketch in Würzburg;[8] and a more elaborate but still exploratory drawing in the Uffizi.[9] The present design is particularly successful in its integration of decorative and architectural elements, such as the interweaving of the *ignudi* perched under the volutes with the Maltese cross, and the bees with their spread wings which act as a base for the finial of papal arms.

A design for a different mace by Cortona, also in the Victoria and Albert Museum, may have been made for the ordination of Cardinal Antonio's older brother Francesco Barberini in 1623, and is notable for its mix of naturalistic details and classicising elements derived from antique decoration (fig.146).[10] A further example in the Uffizi bears the arms of the Sacchetti, who were Cortona's first important patrons after his arrival in Rome from Tuscany, and was probably made on the occasion of Giulio Sacchetti's elevation to the purple in 1626.[11]

Cortona's Roman workshop, which was part of his own house, was not simply a painters' studio; he set up a foundry there as well, which enabled him to supervise the production of sculpture and decorative objects from his own designs.[12] [KW]

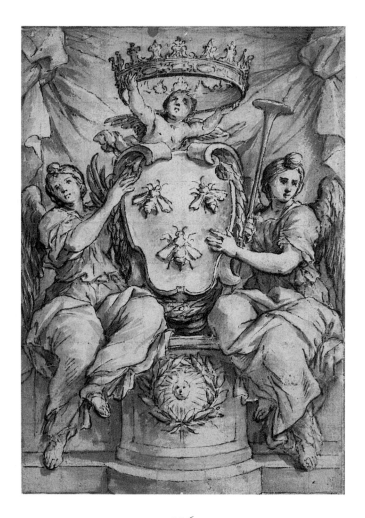

136

GIOVANNI FRANCESCO ROMANELLI 1610–1662
Design for a Tapestry Door Hanging

Pen and brown ink and wash, lightly squared in black chalk,
25.2 × 16.9cm

London, Courtauld Institute Galleries
(Witt Collection 4520)

When this drawing was first published in 1958, it was suggested convincingly that it might be a design by Romanelli for a tapestry *portiera* (door-hanging), although no corresponding tapestry appears to survive.[1] It shows two female allegorical figures, Fame with her trumpet on the right and Virtue Immortalised with her palm on the left, presenting to the viewer an escutcheon with the three bees of the Barberini family coat-of-arms. A putto hovers above, balancing a large crown over the coat-of-arms. This indicates that the arms are those of Prince Taddeo Barberini, Prefect of Rome and nephew of Pope Urban VIII.[2] On the plinth below is a laurel crown encircling a radiant sun, two of the principal Barberini symbols, alluding to virtue and wisdom, which are 'joined to reinforce the idea that the family loves and possesses Divine Wisdom'.[3] Taddeo Barberini was the patron of Andrea Sacchi's pioneering ceiling representing *Divine Wisdom* in the Palazzo Barberini (fig.144), and the idea that the family was divinely preordained to rule was promoted widely in the iconography of works they commissioned.[4]

left fig.145: Cornelis Bloemaert, after Andrea Sacchi and Filippo Gagliardi, *Cardinal Antonio Barberini*, engraving, Edinburgh, National Gallery of Scotland

right fig.146: Pietro da Cortona, *Design for a Mace with the Barberini Emblems*, London, Victoria and Albert Museum

The Barberini came to power in Rome upon the ascension of Maffeo Barberini to the papacy in 1623 as Urban VIII, and they immediately sought to enrich themselves through church revenues and socially advance themselves by means of strategic marriages and political appointments. The brother of the Pope and father of Taddeo, Carlo Barberini, was installed as General of the Church in 1623; in 1629 he bought the Principality of Palestrina from the ancient, baronial Colonna family. When he died soon thereafter, the title and property devolved to Taddeo, who, moreover, had married a Colonna. Taddeo initially resided at the Barberini Palace with his wife, Anna Colonna, but they moved after only two years in 1634 when she became superstitious regarding giving birth to healthy male children at the Palace. However, as door-hangings were highly portable the family's move to another palace in Rome does not necessarily affect the dating of this drawing.

While most of the tapestries produced for Palazzo Barberini were elaborately framed with designs incorporating explicit allusions to Barberini symbols, the border designs were usually produced separately from the main fields. Romanelli may here have been required to devise a central panel only with Taddeo's coat-of-arms. The swathe of drapery knotted at the upper corners which serves as a backdrop may have been an intentional pun on the function of the *portiera* as a draped cloth to cover a door aperture. *Portiere* were not only hung individually over doors to keep out draughts, but also as an integral part of a tapestry series in a room.

Tapestries, much more so than paintings, were considered objects of extreme luxury and prestige and were displayed for important visitors or ceremonies.[5] Taddeo's brother, Cardinal Francesco Barberini, established a tapestry workshop in the Barberini Palace in 1626 to rival that of the French King Louis XIII, who had presented him with a magnificent series of tapestries designed by Rubens as a diplomatic gift in 1625.[6] Pietro da Cortona and Romanelli were the main artists employed by Cardinal Francesco to supply designs for tapestry production.[7]

Romanelli's drawing is squared-up in black chalk, a method which would have allowed full-scale cartoons to be executed easily from the artist's small original designs. The coloured cartoons would then have been used directly by the weavers in the production of the tapestries, the design of which would have been reversed in the process.

[KW]

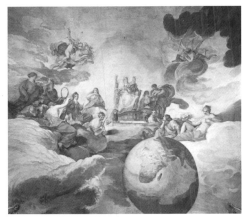

fig.147: Andrea Sacchi, *Allegory of Divine Wisdom*, ceiling fresco, Rome, Palazzo Barberini

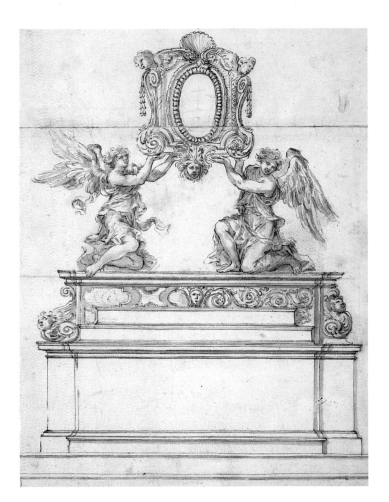

137

ALESSANDRO ALGARDI

Two Kneeling Angels Supporting a Reliquary above an Altar

Pen and two shades of brown ink, with brown and grey wash, over black chalk; some traces of underdrawing with the stylus, 33.9 × 25.2cm
London, British Museum
(AT.10-101)

138

ALESSANDRO ALGARDI

A Reliquary Casket Supported by a Kneeling Angel

Black chalk, 16.6 × 9.4cm
London, British Museum
(AT.10-100)

The base of the more elaborate drawing (cat.no.137) is formed as an altar, and as the decorative motifs are reminiscent of small-scale goldsmiths' work, it is likely that the frame was intended for a relic.[1] What may be a container for a relic surmounted by a cross is lightly sketched in black chalk in the central oval. Alternative designs are presented to left and right for both the altar and the elaborate reliquary frame. It has been suggested that at least some of the architectural elements of the drawing may be by Giovanni Francesco Grimaldi, with whom Algardi collaborated on some comparable projects (see, for example, cat.no.129).[2] The greyer wash and somewhat drier line of the reliquary frame (excepting

173

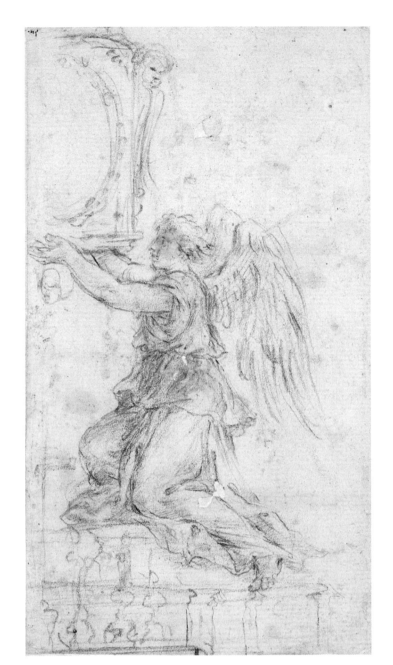

the head at the bottom) may indeed indicate Grimaldi's involvement.

The second, slighter sketch of one angel alone (cat.no.138) seems to be related to the same project. If so, its intended location above an altar is confirmed by the row of candlesticks lightly indicated below the angel. No corresponding object appears to survive, although a reliquary which depends heavily on Algardi's designs of this kind has been identified in the Treasury of San Lorenzo in Florence.[3] [TC]

139
ALESSANDRO ALGARDI
Hercules Shooting the Stymphalian Birds
Pen and brown ink, with light-brown wash, over black chalk,
25.2 × 18.5cm
Inscribed at the lower centre: *Bernini*; numbered at the lower right: N.36.
London, British Museum
(1946–7–13–1383)

140
ALESSANDRO ALGARDI
Hercules Rising from the Pyre
Pen and brown ink, with pale brown wash, 13.3 × 22.1cm
London, British Museum
(1982–7–24–4)

141
ALESSANDRO ALGARDI
*Two Putti Supporting a Cardinal's Hat and an Escutcheon
with the Arms of Camillo Pamphili*
Pen and brown ink and wash over black chalk
17.8 × 12.2cm
London, British Museum
(1991–10–5–80)

These three drawings from the British Museum all relate to the stucco decorations in the Galleria di Ercole (the Hercules Gallery) at the Villa di Belrespiro, now the Villa Doria-Pamphilj, outside the Porta San Pancrazio in Rome.[1] The villa was built in 1645 by Cardinal Camillo Pamphili, nephew of Pope Innocent X. Although

figs.148, 149 & 150: After Alessandro Algardi, *Hercules and the Stymphalian Birds* (left), *Hercules Rising from the Pyre* (centre),
Putti Supporting the Arms of Camillo Pamphili (right), stucco, Rome, Villa Doria-Pamphilj

cat.no.139

cat.no.141

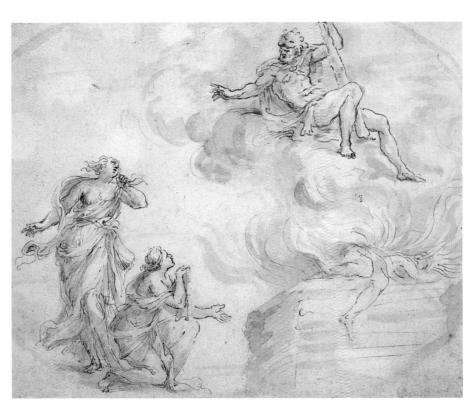

cat.no.140

Algardi was given overall control of the project, he had no experience of designing and constructing a building, and must have relied heavily on advice from others over these matters. His principal assistant, however, was the painter Giovanni Francesco Grimaldi, and their respective roles in the design of the building has been much debated.

The decoration of the Villa as a whole was intended to celebrate the great antiquity of the Pamphili dynasty; the stucco reliefs in the Galleria di Ercole allude to the family's claim to descent from Hercules himself. The Pamphili accounts record payments for this work to the *stuccatori* Rocca Bolla and Giovanni Maria Sorisi dating from April and May 1646. The three drawings exhibited here represent original designs by Algardi, but most of the other reliefs were in fact adapted from other sources, notably the engraved crystal Hercules scenes from a casket made by Annibale Fontana, which Algardi had evidently studied carefully in Mantua.

The extremely elongated figure in Algardi's drawing of *Hercules Shooting the Stymphalian Birds* was tempered by the stuccoist, and although the design is followed closely in other respects, the great hero's archery skills appear less impressive in the final version (fig.148).[2] In the study for *Hercules Rising from the Pyre*, lines applied in wash cut off the corners, suggesting the final oval format of the field (fig.149).[3] The indication in the drawing that Hercules should feature twice in this scene, being consumed by the flames and rising above them, was abandoned in the relief as executed. One of the female witnesses has also been transformed into a soldier holding three arrows, and the other woman now has a large jug. The study of *Putti Supporting the Arms of Camillo Pamphili* relates to the relief in the centre of the vault in the Galleria di Ercole (fig.150).[4] The final stucco differs in some minor but significant respects from the preparatory drawing: a cross was inserted below the hat; the putto at the left hold's a baton in his right hand; and the double points of a large cross of the Order of Malta now project from behind the escutcheon. The appearance of a cardinal's hat and a cross in the midst of the emphatically secular room seems somewhat incongruous.

[TC]

142

FRANCESCO PERONE
AFTER A DESIGN BY ALESSANDRO ALGARDI

*A Picture Frame with Symbols of the Pamphili Family,
Enclosing a Painting of the Annunciation by Luigi Gentile*

Repoussé silver; the painting in oil on copper,
52 × 40.5cm (frame); 31 × 26.1cm (painting)
Backed with a sheet of gilt copper engraved with the arms of
Pope Innocent X Pamphili
London, Museum of the Order of St John

This ensemble once belonged to Sir Paul Methuen of Corsham Court, Wiltshire, according to a catalogue of his collection written in 1760, where the painting was said to be by Francesco Albani and the frame 'by the famous statuary Alessandro Algardi'.[1] However, the picture corresponds to one of four paintings by Luigi Gentile (*c.*1604/6–1667) passed by Algardi for payment late in 1648, while the frame corresponds with four that were ornamented with doves, lilies and putti, for which Francesco Perone was paid earlier in the same year.[2]

As Algardi vetted the paintings and his name was firmly attached to the piece in the eighteenth-century inventory, it is likely that he was largely responsible for the design of the frame, notably the putto above and the Pamphili doves, which resemble other renderings for ornaments and frames in his work. Owing to the tendency to melt down such frames for the value of their metal,

is a putto supporting a laurel and *fleur-de-lys* wreath and a blank banderole.

The arms are those of Giovanni Battista Pamphili (1574–Pope 1644–55) as Pope Innocent X, and the relief must therefore date from the period of his papacy. When acquired, it was thought to have been carved by the Fleming François Duquesnoy (1597–1643). Although the style is generically similar to Duquesnoy's, he died a year before Innocent became Pope, which excludes his involvement in its design. However, the composition also recalls works by Algardi, such as his designs for the stucco decoration in the Villa Doria Pamphili (for example, fig.150) and his drawing for the *Memorial to Innocent X* (cat.no.116). The actual execution of the relief is likely to have been the work of a specialist ivory carver. Depending on whether the cloth of honour is being laid over or drawn off the papal insignia, the ivory might date from either 1644 or 1655, that is either when Giambattista Pamphili was elected to the papacy, or when he died. [TC]

very few have survived, which makes this one especially precious for our knowledge of baroque decorative art.

Unlike the bronze statuettes and reliefs in this exhibition, all of which were cast, this frame was fashioned by beating sheets of silver over a form to give the approximate shape, and then burnishing some parts and matt-punching others to produce the details in relief and a contrast of textures.

The whole may have been delivered in one of the red leather cases with gilt stamping made in the same year and designed for presentation by the Pope. The recipient is not known, nor how the item came into the possession of the avid collector Sir Paul Methuen. [CA]

143
UNKNOWN NORTHERN ARTIST
POSSIBLY AFTER A DESIGN BY ALESSANDRO ALGARDI
Relief with Putti Supporting the Insignia of Pope Innocent X

Ivory, 18 × 10.3 × 2.3cm
Edinburgh, The Trustees of the National Museums of Scotland
(A1877-20-63)

This carved ivory relief shows two putti standing on a narrow shelf, holding up the papal tiara and keys, which are partly veiled by a fringed cloth of honour. The composition is framed by a wreath which consists of two crossed olive-branches, while higher up flies a dove with a smaller olive-branch in its beak. Above there

144

ALESSANDRO ALGARDI
Designs for a Finial on a Chair for Pope Innocent X
(recto and verso)

Pen and brown ink over graphite, 23.2 × 15cm
Windsor Castle, Royal Library
(RL1561)

In the drawing on the recto, two naked putti sit on the voluted shoulders of a vase, holding Pamphili doves on their left shoulders, while from of the neck of the vase rise three stems of the Pamphili *fleur-de-lys*.[1] The sketch on the verso, revealed during recent conservation, presents a variant of this design, with larger doves and no putti (the putti visible in the illustration are showing through from the recto).

The drawings are studies for the brass finials on the Pope's chair, which were designed by Algardi, and for which he received payments on 27 April 1647 and 6 May 1648. The accounts clearly describe the armorial details, and state that they were cast by Pier Francesco Fiocchini, who charged 120 scudi for them. [TC]

145

ALESSANDRO ALGARDI
Design for a Table Ornament: a Vase Flanked by Two Satyrs

Graphite, 28.8 × 19.6cm
Windsor Castle, Royal Library
(RL1550)

The male satyr at the left embraces a goat, while the satyress at the right holds a human baby. It is unclear for what purpose this drawing was made, although the suggestion that it may have been intended for an ornamental vase to grace a table is plausible.[1] It may have been intended to consist of a hardstone vase with metal mounts, like some of the grand ornamental vases dating from a little later and issuing from the Florentine Grand-ducal workshops. The drawing betrays Algardi's stylistic indebtedness to Cortona. The slight sketch on the verso of this sheet may represent a plan of the base of this object. [TC]

146

ALESSANDRO ALGARDI
Design for a Salt-cellar or a Cradle

Pen and brown ink and wash over black chalk; a seemingly unrelated red chalk sketch underneath, 21.4 × 16.3cm
Inscribed in pen at the lower centre: *Bernino*
Edinburgh, National Gallery of Scotland
(D900)

The drawing shows three putti riding on the backs of dolphins, whose entwined tails support a scallop shell.[1] Its former identification as a design for a table-fountain poses a problem in that the 'dolphins below have open mouths that look as if they should have spouted water, yet this could not have reached the shell raised on their twisted tails'.[2] It may be that the dolphins were here intended to refer neither to water nor to salt, but to the French Dauphin (meaning 'dolphin'). We know that Algardi designed a frontispiece, engraved by Camillo Cungi, to Guglielmo Dondini's poem in praise of the birth of the Dauphin, later Louis XIV, in 1638.[3] The present design may also have been associated with the festivities celebrating this event. It is even possible that it was intended as a cradle, for it is not unlike cradles such as the 'Culla Rospigliosi'.[4] On the other hand, very similar dolphins appear supporting dishes of sweetmeats in Pierre-Paul Sevin's drawing for a banquet held in 1667 (Stockholm, Nationalmuseum).[5]

A chalk copy of the Edinburgh drawing, in reverse, is in the Louvre (inv.no.6856), and is presumably an offset made from a direct copy. [TC]

147

GASPARE MORONE *fl.*1633–1669
The Entrance of Queen Christina of Sweden, 1656

OBVERSE: Fabio Chigi, Pope Alexander VII (1599–Pope 1655–67), bearded, in profile to right, wearing cap and cassock; around: *ALEXAN.VII.PONT.MAX.A.II*; dated below truncation: MDCLVI and signed: GM
REVERSE: Ceremonial cavalcade of Queen Christina entering the Porta del Popolo from Via Flaminia; around: *FEL.FAVS.Q.INGRES.*
Silver (pierced); 3.5cm diameter
Glasgow, University of Glasgow, Hunterian Museum

Queen Christina of Sweden, daughter of the militant Protestant King Gustavus Adolphus, converted to Catholicism, abdicated her throne and made her way via Flanders to Rome.[1] Her joyous entry, a great papal propaganda coup, took place on 23 December 1655. The gateway of the Porta del Popolo was restored and decorated by Bernini at the Pope's behest, in honour of the event. [TC]

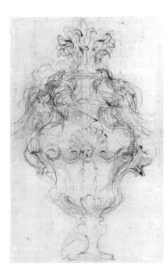

cat.no.144 *verso* cat.no.145 *verso*

cat.no.147 obverse *left* reverse *right*

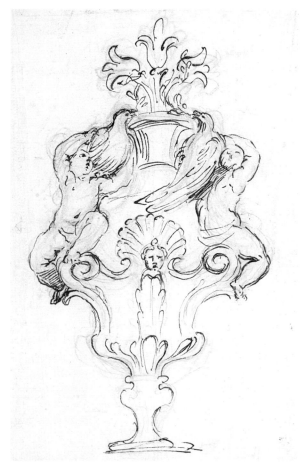

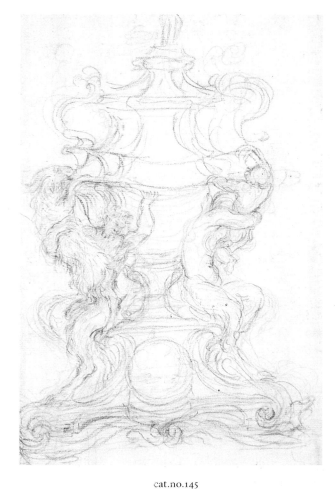

cat.no.144

cat.no.145

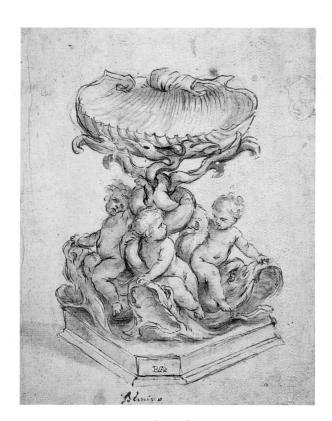

cat.no.146

148
GIANLORENZO BERNINI
Design for the Back of a State Carriage,
with Two Fighting Tritons

Pen and brown ink and wash over black chalk, 22.5 × 24.5cm
London, Victoria and Albert Museum
(88.14.A)

This vigorous drawing shows two muscular tritons tearing at each other's forelocks and howling in anguish. Although hitherto catalogued as a product of Bernini's studio, it is clearly an autograph drawing of high quality, a view supported, for example, by the fact that there are significant discrepancies between the black chalk underdrawing and the superimposed pen and wash clarifications.[1]

It is known that Bernini provided designs for coaches, among them, according to his son and biographer Domenico, the blue and silver carriage in which Queen Christina of Sweden made her state entry into Rome in December 1655.[2] Although the possibility that this design might relate to Queen Christina's carriage has been considered,[3] but rejected on the grounds that fighting tritons would not have been a fitting embellishment for the coach of the newly-converted Queen, it in fact has much to recommend it. Tritons certainly appear to have been amongst her favoured *imprese* (personal emblems), and featured, for example, on a silver and blue banner hanging prominently from a castle tower in the opera, *La Vita Umana* (1658), performed in Queen Christina's honour; in the centre, below the proscenium arch, in the same opera; and as supports for the looking-glass designed by Bernini (see cat.no.150).

Despite the existence of several etchings of the Queen's *ingresso* of 1655, and contemporary descriptions and even payments for the coach, there is no reliable image of it, and no description of the sculptural elements. Christina evidently liked coaches, for she had no fewer than twenty-one of various kinds when she died. Five different drawings by Ciro Ferri for the carved figurative back of one of these are in Leipzig.[4]

The choice of these mythical marine creatures was entirely appropriate for the Queen's coach. Not only do tritons usually sport beside the car, or chariot, of Amphitrite (with whom she would have identified, being herself the ex-Queen of a great sea power), but also because Queen Christina cast herself as Pallas Athene, who often in antiquity boasted the epithet 'Tritogeneia', referring to her birth beside the stream Triton, near Knossos. It therefore seems quite plausible that Bernini intended this drawing for one of Queen Christina's large collection of coaches, if not specifically the one used for her entry into Rome. The drawing would appear to date from the 1650s, and comparable figures appear in Bernini's designs for the *Neptune Fountain* for the Duke of Modena at Sassuolo and the *Fontana del Moro* in the Piazza Navona (see cat.nos.99–102).

On the verso of this sheet there is a sketch of a fragment of a rusticated column or quoin. [TC]

149
GIOVANNI BATTISTA LENARDI 1656–1704
Study for the Back of a Papal Coach

Pen and brown ink and wash, 20.4 × 23cm
Edinburgh, National Gallery of Scotland
(D5433)

Bernini was probably the originator of this type of full-bodied sculptural design for coaches. With the exception of rare autograph designs (see previous entry), the best drawings of coaches from his workshop were made by Giovanni Paolo Schor from Innsbruck (1615–74), but others – neat, competent, but lacking in verve – seem to have come from the hand of Lenardi (or Leinardi), a pupil of Lazzaro Baldi (1624–1703), who provided finished drawings for engravers and craftsmen to copy. He was involved in the

series of coach designs provided for Lord Castlemaine's embassy of 1687, as is clear from the inscriptions on the printed plates (see figs.29–30). Characteristic examples of his drawings are in the Kunstmuseum, Düsseldorf and the Gabinetto dei Disegni e delle Stampe in Rome.[1]

Very few actual coaches from the seventeenth century survive, but there is one dating from 1638, made in Rome for the Prince of Eggenberg, in the Castle of Ceský Krumlov in Bohemia.[2] Of a very similar type, but dating from later, are the three sumptuous coaches made for the embassy of the 3rd Marquis of Fontes to Pope Clement XI in 1716, which are preserved in the National Museum of Coaches in Lisbon (see fig.151).[3] [TC]

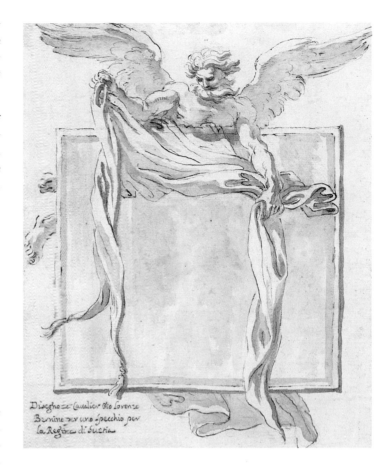

150

GIANLORENZO BERNINI

Design for a Looking-Glass for Queen Christina of Sweden

Pen and brown ink and wash over black chalk, 23 × 18.8cm
Inscribed in ink at the lower left: *Disegno del Cavalier Gio Lorenzo / Bernino per un Specchio per / la Regina di Suetia* ('Design by the Cavaliere Gian Lorenzo Bernini for a mirror for the Queen of Sweden')
Windsor Castle, Royal Library
(RL5586)

In this design, Time flies behind a large, simply-framed, rectangular looking-glass, and draws back tasselled curtains to reveal the mirrored image of Truth.[1] During his visit to Rome, Nicodemus Tessin the Younger recorded seeing the mirror for which this drawing was preparatory in a room on the *piano nobile* of Queen Christina's Palace, the Palazzo Riario. He wrote that it was of an extraordinarily large size and consisted of several pieces of glass, with their joints hidden by draperies. The figure of Time was carved almost in the round, and gilded. Tessin made a drawn copy of the looking-glass (now in the Nationalmuseum, Stockholm), which is inscribed in bottom left corner: '*Specchio nella Camera / della Regina Christina / invenzione del Bernini*'.

Although Tessin undoubtedly saw the looking-glass *in situ*, his own copy may in fact have been based on a variant design (now lost) by Bernini, from which the inscription would have also been copied.[2] The subject is further complicated by the existence of another design from Bernini's studio, also in Stockholm, which shows the looking-glass supported on an elaborate stand formed by two tritons, with Time swinging a large scythe and holding a clock while unveiling the mirror. What is evidently an accurate record of the looking-glass supported on its triton base appears in a drawing in the Victoria and Albert Museum, wrongly ascribed to the Genoese artist Domenico Piola (fig.152).[3] If the latter does represent the final form of the looking-glass made for Queen Christina, Bernini's original scheme seems to have been much elaborated by another hand, perhaps that of his collaborator, Giovanni Paolo Schor (1615–1674).

The subject of Time, or Death, unmasking Truth was a motif much favoured by Bernini, most dramatically in the great marble figure of *Truth Unveiled* of 1646–52, now in the Villa Borghese, which we know was intended to be accompanied by a flying figure of Time.[4] The ingenious suggestion has been put forward that Bernini's looking-glass was not intended to reflect the Queen's face, which was processed daily by Time, but to reflect the sun, the Queen's favoured *impresa*, and also an emblem of Truth. The conceit would have been that Queen Christina, in the guise of the sun, was to be reflected in her mirror as the radiant personification of Truth.[5] [TC]

fig.151: Roman School, early eighteenth century, *Rear of one of the Coaches from the Embassy of the Marquis de Fontes to Pope Clement XI*, Lisbon, National Coach Museum

fig.152: Ascribed to Domenico Piola, *Queen Christina's Looking-glass*, London, Victoria and Albert Museum

cat.no.147 obverse *left* reverse *right*

151

GIOACCHINO FRANCESCO TRAVANI *fl.*1634–1675
Queen Christina of Sweden, 1665

OBVERSE: Head of Queen Christina (1626–89), in profile to right,
wearing laureated helmet of Pallas Athene; around:
.REGINA.CHRISTINA.; signed below truncation: *TRAVANVS*
REVERSE: Phoenix on a flaming pyre, wings outstretched, looking
towards the sun; around: *MAKE ΛΩΣ*; dated in exergue: *1665*
Bronze (cast); 6.2cm
Edinburgh, National Gallery of Scotland
Purchased by the Patrons of the National Galleries of Scotland, 1990
(NG2533)

This medal represents Christina, Queen of Sweden, who became
Queen as a child in 1632. The daughter of the great Protestant pala-
din, King Gustavus Adolphus, Queen Christina abdicated in 1654
having converted to Catholicism.[1] She arrived in Rome in triumph
in 1655, where she remained for the rest of her life. The motto on
the reverse of this medal is a play on words ('Makalös', meaning
'peerless' or 'without its pair' in Swedish), reflecting not only her
matchless personal qualities but also that she was unmarried. By
writing the latter part of the word in Greek lettering, she excited
the cultural circles of Rome to distraction. She became a close
friend and confidante of Bernini, who had redecorated the Porta
del Popolo for her triumphal entry into Rome, and who went on to
design a looking-glass (see previous entry), a coach, and a throne
for her, as well as annually presenting her with one of his drawings.
It was Queen Christina who commissioned Baldinucci's *Life* of
Bernini, which was in turn dedicated to her.

Queen Christina was clearly a great supporter of the medallist's
craft, for no fewer than thirty-seven different medals representing
her have been identified.[2] [TC]

152

PIETRO BERRETTINI,
CALLED PIETRO DA CORTONA 1596–1669
Design for a Title-Page

Black chalk on white paper, 49.3 × 37.5cm
The drawing was cut into three pieces, probably by the engraver, and
subsequently reassembled. The putto in the cartouche above is drawn
(by a different hand) on a separate piece of paper and stuck down. The
principal outlines are incised for transfer.
Inscribed in ink within the blank frame with the papal *incidatur*, giving
official authorisation for the image to be published as a print.
Edinburgh, National Gallery of Scotland
(D920)

This drawing was probably made as a design for a title-page, but
the absence of any reference in its central field to the author or ti-
tle of the publication it was intended to preface has frustrated at-
tempts to fathom its symbolism.[1] Its high degree of resolution
guaranteed that the engraver to whom it was handed would be in
no doubt as to what was required of him.

Some of the leading artists of the seventeenth century, among
them Bernini himself and Peter Paul Rubens, devoted their ingenu-
ity to the invention of sophisticated title-pages of this kind, in
which allegorical means are used to intimate the content of the
book. Indeed, these designs were sometimes used subtly to declare
the scientific or theological views of the author.[2] Some of the sym-
bols featured in the present drawing – dividers, scales, a hammer
and wedge rending a block, pulleys, and a winch – have led to the
understandable suggestion that it may have been intended as the
title-page for a book on mechanics, although this would not wholly
explain other elements of the design, such as the antique triremes
in the lower central panel, or the cherub apparently spearing a
globe with his staff in the upper cartouche.

The identification of a print corresponding in most respects to
this design and attributed to Cornelis Bloemaert (fig.153) has, if
anything, complicated matters further.[3] For the print represents a
reworking of the original engraving designed by Cortona for use in
another context. In the process the copper plate was cut down, re-
moving the base with symbolic reliefs visible in Cortona's draw-

fig.153:Cornelis Bloemaert, after Pietro da Cortona, *A Title-Page*,
engraving, Paris, Bibliothèque Nationale

ing. The fact that the present design had been officially approved for publication, and that the drawing was then indented and cut up for use by the engraver (with only a minor alteration to the flying cherub) suggests strongly that a print of it in this form must have been produced.

A significant difference between the drawing and the print is that the central space in the latter, which would usually have been reserved for the title, has a seascape with shipping, a large star (possibly the pole star), an unidentified coat-of-arms, and a banderole with the inscription *OCCULTA VIRTUTE*. The cartouche above now contains only one terrestrial globe, and a star similar to that which appears in the central panel has been introduced, to which the cherub is linked by a chain. The cherub pulls on a second chain, also attached to the star, which partially encircles the globe. The scroll bears the inscription *ARCANIS NODIS*, from Claudianus's poem *Magnes* ('The Magnet'), which has led to the suggestion that

this second version of the design may have been used as the title-page for a book on magnetism. The presence of shipping in both the drawing and the engraving might suggest more specifically that the two publications may have been concerned with astronavigation.

Although the drawing has in the past been dated to around 1650, its forms are very similar to another title page designed by Cortona for Tarquinio Galuzzi's commentary on Aristotle, published in 1632.[4] Some of the typically Cortonesque architectural features, such as the broken triangular pediment motif and the framing open scrolls of the cartouche, also find their closest parallels in Cortona's built architecture of the 1630s, such as his doorway to the theatre at Palazzo Barberini.[5] The precision black chalk technique is comparable to other drawings dating from this earlier period, such as the *The Head of an Angel* formerly in the Ferretti collection, datable to 1633.[6] [EJS]

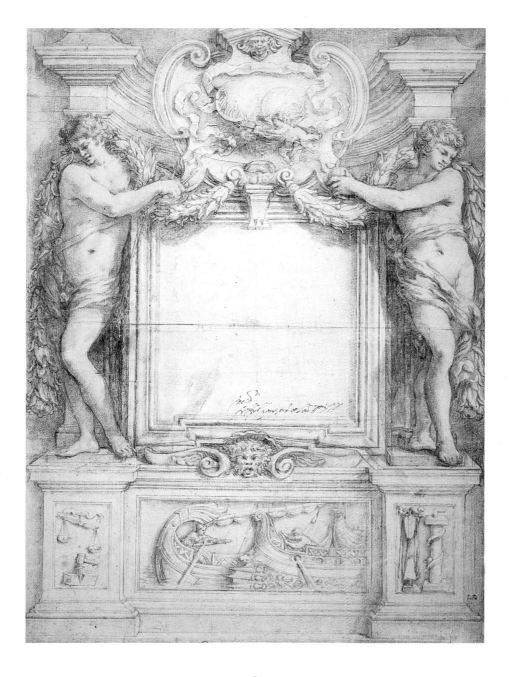

183

XII

Medals and Designs and Models for Them

cat.no.153 obverse left *reverse* right

153

GIACOMO ANTONIO MORO *fl*.1610–1624/5

The Canonisation of Five Saints, 1622

OBVERSE: Alessandro Ludovisi, Pope Gregory XV (1554–Pope 1621–23), bearded, in profile to right, bareheaded, wears cope; around: *GREGORIVS.XV.PONT.MAX.*; signed: *AN M*; dated on truncation: *AN II*

REVERSE: Pope enthroned at left, surrounded by clerics and cardinals, reading from a book; around: *CINQVE.BEATIS.COELESTES.HONORES*; in exergue: *DECERNIT.1622.*

Silver; 3.3cm diameter

Glasgow, University of Glasgow, Hunterian Museum

At sessions of the Council of Trent there had been concern with the purification and strengthening of the cult of saints. In a gorgeous ceremony on 22 March 1622, Gregory XV recognised the celestial honours bestowed upon God's faithful servants: Ignatius Loyola, founder of the Jesuit Order; Francis Xavier, Jesuit missionary in the Far East; Filippo Neri, founder of the Oratorians; Theresa of Avila, reformer of the Carmelites and mystical visionary; and the more obscure Isidore of Madrid, a peasant farmer of great piety, who was to become the patron saint of the Spanish

capital. These multiple canonisations gave a great boost to the popular new religious orders, who responded by commissioning new buildings and art works to reflect their official status. Although this medal was not designed by Bernini, the first four of these saints were crucial figures in baroque Rome, providing subject matter for much sacred painting, sculpture, and architecture.[1]

[TC]

154

GASPARE MORONE *fl*.1633–1669

Canonisation of St Francis of Sales, 1665

Uniface: for description see reverse of previous entry.

White wax low-relief on a disc of slate, 3.9cm diameter

London, British Museum

(1932–8–6–11)

155

GASPARE MORONE *fl*.1633–1669

Canonisation of St Francis of Sales, 1665

OBVERSE: Fabio Chigi, Pope Alexander VII (1599–Pope 1655–67), in profile to left, wearing tiara and cope embroidered with monticules; around: *ALEXAN.VII.PONT.MAX.AN.XI.*; signed below truncation: *GM* and dated: *MDCLXV*

REVERSE: View towards apse of St Peter's, looking through the Baldacchino and over the high altar; Pope is seated on an elevated temporary throne, with tiers of cardinals seated flanking him on either side; above and around:

BEATO FRANCISCO EPISCOPO INTER SANTOS RELATO

Silver; 4.3cm diameter

Glasgow, University of Glasgow, Hunterian Museum

cat.no.154

cat.no.155 obverse left *reverse* right

184

This was the annual medal of 1665, and Morone's wax model for it.[1] On 19 April 1665, Pope Alexander canonised Francis of Sales (1567–1662), a native of Chablais and later Bishop of Geneva. St Francis is celebrated for being a co-founder of the Order of the Visitation and author of two books of mystical theology, *An Introduction to the Devout Life* (1609) and *A Treatise on the Love of God* (1616). Alexander VII was particulary devoted to Francis of Sales, having also beatified him in 1662, and long before that as cardinal he campaigned for his canonisation. A recently discovered painting on copper by Carlo Maratta (1625–1713) of *Francis of Sales in Prayer* was commissioned by Alexander VII in 1662 and is known to have hung in his bedroom (fig.154).[2] [TC]

156

GASPARE MORONE *fl.*1633–1669

Canonisation of Sts Peter of Alcantara and Maria Maddalena dei Pazzi, 1669

OBVERSE: Giulio Rospigliosi, Pope Clement IX (1600–Pope 1667–69), bearded, in profile to left, wearing cassock, cap, and stole; around: *CLEM.IX.PONT.MAX.A.III*

REVERSE: St Peter of Alcantara, left, and Sta Maria Maddalena dei Pazzi, right, kneel upon a cloud bathed in the divine rays issuing from the Holy Spirit, above centre; around: *ADDITVM ECCLESIAE MVNIMEN ET DECVS*; below on scrolls: *S.PETRVS DE ALCANTARA* and *S.M.MAGDALENA DE PAZZIS*. Silver; 3.4cm diameter

Glasgow, University of Glasgow, Hunterian Museum

The annual medal of 1669.[1] On 28 April 1669 Pope Clement IX performed the rites of canonisation on Peter of Alcantara (1499–1562), a Spanish Franciscan, and Maria Maddalena dei Pazzi (1566–1607), a Florentine Carmelite, both fervent ecstatic mystics who were

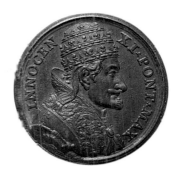

cat.no.157 obverse *left* reverse *right*

greatly venerated in the Baroque period. Two variant designs by Bernini for the reverse of Morone's medal are in Amsterdam (fig.155).[2] Morone's image is much flatter and more mundane than Bernini's drawing: the three-quarter views were sacrificed, and the saints' heads rendered instead in strict profile, with conventional haloes added above. [TC]

157

GIOVANNI HAMERANI 1646–1705

Defeat of the Turks, 1683

OBVERSE: Benedetto Odescalchi, Pope Innocent XI (1611–Pope 1676–89), bearded, in profile to right, wearing tiara and cope embroidered with scrolling foliage; around: *INNOCENT XI PONT MAX*

REVERSE: Wreath formed of two palm fronds, tied at their stems; within: *DEXTERA / TVA DOMINE / PERCVSSIT / INIMICVM*; dated below: *1683* Bronze (cast); 4.7cm diameter

Edinburgh, National Gallery of Scotland

Purchased by the Patrons of the National Galleries of Scotland, 1998

(NG2678)

This example of the medal is unsigned, because a casting flaw masks the field below the truncation, which is usually signed *IO.HAMERANVS*.[1] The Pope was abstemious, and not only balanced the papal budget but actually achieved a surplus. With it he made a substantial contribution to the Catholic army. In 1683, under Jan III Sobieski (1629–96), the Polish warrior and patriot, Catholic forces relieved the city of Vienna, which was then besieged by the Turks led by their Grand Vizier, Kara Mustafa, and expelled the Turkish host from Austria. It is this event that was commemorated by the issue of this medal. [TC]

cat.no.156 obverse *left* reverse *right*

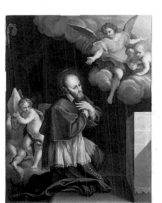

left fig.154: Carlo Maratta, *St Francis of Sales in Prayer*, Private Collection

right fig.155: Gianlorenzo Bernini, *Designs for the Medal Commemorating the Canonisation of Sts Peter of Alcantara & Maria Maddalena dei Pazzi*, Amsterdam, Rijksmuseum

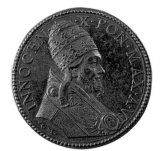

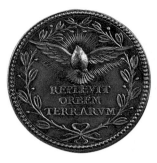 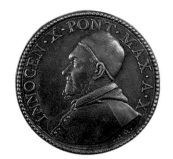

cat.no.158 obverse *left* reverse *right* cat.no.160 obverse *left* reverse *right*

158

GASPARE MORONE *fl*.1633–1669

St Peter in Glory, 1651

OBVERSE: Giambattista Pamphili, Pope Innocent X (1574–Pope 1644–55), bearded, in profile to right, crowned with tiara, wearing cope; around: *INNOCEN.X.PON.MAX.A.VI*; signed on truncation: *G.M*
REVERSE: St Peter enthroned in clouds looking three-quarters left, holding up in his right hand the Keys of Heaven, in his left the Gospels; around: *APERIAM.VT THESAVROS.ANNI. SANCTORIS TECVM*
Silver; 3.8cm diameter
Glasgow, University of Glasgow, Hunterian Museum

This is a re-issue of the annual medal of 1649. Alessandro Algardi temporarily supplanted Bernini as the principal recipient of papal commissions for sculpture on the accession of the Pamphili Pope. Algardi, who has not traditionally been associated with medal production, has convincingly been put forward on stylistic grounds as the designer of this medal, a suggestion which has been given added weight by the recent emergence of a preparatory drawing by Algardi for the reverse of a very similar medal (see following entry).[1] [TC]

159

GASPARE MORONE *fl*.1633–1669

God the Father, 1651

OBVERSE: Giambattista Pamphili, Pope Innocent X (1574–Pope 1644–55), bearded, in profile to right, crowned with tiara, wearing cope embroidered with the Virgin of the Immaculate Conception; around: *INNOCEN.X.PON.MAX.A.VII*; signed below truncation: *GM*
REVERSE: God the Father; around: *FIAT PAX IN VIRTVTE TVA.*
Bronze; 3.9cm diameter
Glasgow, University of Glasgow, Hunterian Museum

The style of the reverse is very close to that of the previous medal, and the perceptive hypothesis, made on stylistic grounds alone, that both were designed by Algardi has been confirmed by the recent appearance at auction of Algardi's lively pen and ink sketch of God the Father with putti for the reverse of the present medal (fig.156).[1] The arrangement is indeed similar to the marble of *God the Father with two Putti* over the high altarpiece of San Nicola da Tolentino, which was executed to Algardi's design (see cat.no.55). Algardi was a very close associate of the die-engraver Morone, while the President of the Mint, Giacomo Franzone, was one of Algardi's patrons.[2] [TC]

160

GASPARE MORONE *fl*.1633–1669

The Dove of the Holy Spirit, 1653

OBVERSE: Giambattista Pamphili, Pope Innocent X (1574–Pope 1644–55), bearded, in profile to left, wearing cap and cassock; around: *INNOCEN.X.PONT.MAX.A.XI*; signed below bust: *GM*
REVERSE: Radiant dove with outstretched wings, enclosed by two entwined olive branches; below the dove: *PLEVIT ORBEM TERRARVM.*
Silver; 3.8cm diameter
Glasgow, University of Glasgow, Hunterian Museum

The medal shows the Holy Spirit placed within a wreath composed of two olive branches. As the Holy Spirit is the source of Divine Wisdom (*Sapienza*), the reverse of this medal represents the triumph of Truth throughout the world.[1] The dove and olive are also the emblems of the Pamphili Pope. The medal may have a specific, topical meaning, as the Pope suppressed the French cult of Jansenism by a bull in the Spring of 1653, when he asserted the triumph of truth and wisdom over error and false logic. [TC]

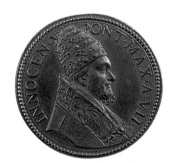 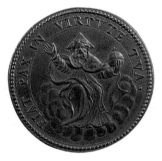

cat.no.159 obverse *left* reverse *right*

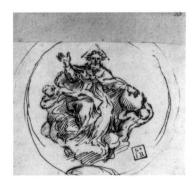

fig.156: Alessandro Algardi, *God the Father with Putti*, formerly New York, Art Market

186

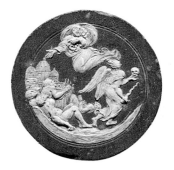

cat.no.161 fig.157: Gianlorenzo Bernini, cat.no.162 obverse *left* reverse *right*
Design for the Reverse of the Cessation of the Plague Medal
present whereabouts unknown



161

GASPARE MORONE *fl.*1633–1669

The Cessation of the Plague, 1657

Uniface: description same as reverse of following entry.
White wax low relief on a disc of grey slate; 4cm diameter (image: 3.2cm)
London, British Museum
(1932-8-6-24)

162

GASPARE MORONE *fl.*1633–1669

The Cessation of the Plague, 1657



OBVERSE: Fabio Chigi, Pope Alexander VII (1599–Pope 1655–67); bearded, in profile to right, bareheaded, wearing cope with embroidered panel of an angel carrying a cross and chalice; around: *ALEXAN.VII.PONT.MAX.A.III*; signed in field below truncation: GM
REVERSE: St Peter, clutching keys, floats upper centre, gesturing towards the basilica of St Peter's left, below him the bodies of supplicant plague-stricken, an Angel of Death with sword and skull exiting right; around and below: *VT VMBRA ILLIVS LIBERARENTVR*


Gilt-bronze; 3.5cm diameter
London, British Museum
(G.III.PAP.M.AE.VI.233)



This annual medal, issued on 29 June 1657, was commissioned by Pope Alexander VII to mark the end of the pestilence in Rome, which within one year had accounted for 15,000 people, or about an eighth of the entire population.[1] The Pope did much to ameliorate the situation by instituting swift and sensible measures to help isolate the problem and safeguard the city. This is the first medal

that is known to have been designed by Bernini, and his vigorous pen and wash study for it was formerly at the Royal Institution of Cornwall, Truro, but is now apparently lost (fig.157).

Morone's preparatory wax model for this medal is a valiant, although ultimately somewhat pedestrian, attempt to translate faithfully into miniature relief the very bold and free *chiaroscuro* drawing. Wax models of this kind served as accurate guides to be followed by the die-engraver, a craft which required great precision.[2] [TC]



163

GIANLORENZO BERNINI

Designs for the obverse and reverse of a Scudo: (a) *St Peter Blessing the Arms of Pope Alexander VII;* (b) *A Christian Knight(?) Offering Alms to a lame Beggar*

Pen and brown ink with grey and brown wash over graphite or black chalk, (a) 7.4cm diameter; (b) 7.6cm diameter
London, British Museum
(1945-47-13-689B)

164

GASPARE MORONE *fl.*1633–1669

St Thomas of Villanova Offers Alms to a Lame Beggar

Uniface: Description same as reverse of the scudo, minus inscription
(see below)
White wax low relief on a disc of slate; inscribed with concentric circles round the borders using a compass; 3.9cm diameter
London, British Museum
(1932-8-6-10)



cat.no.163

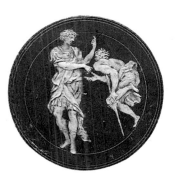

cat.no 164

165A AND B
GASPARE MORONZE *fl.1633–1669*
Scudo, with St Peter Blessing the Arms of Pope Alexander VII, 1658

OBVERSE: St Peter in billowing draperies floats upper left, his right arm raised in benediction, looking down at the papal arms consisting of Chigi monticules quartering Della Rovere oaks, the shield supported by crossed papal keys and surmounted by the papal tiara; around:
ALEX.VII.PONT.MAX.ROMAE
REVERSE: A Christian Knight, wearing a cloak over his armour, turns to right, offering alms to a lame beggar; around: *DISPERSIT DEDIT PAVPERIBVS .I.E.M.I.S.S.*
Silver; 4.1cm diameter
Edinburgh, National Gallery of Scotland
Purchased by the Patrons of the National Galleries of Scotland, 1994
(NG2625)

Another example of the same medal:
Silver; 4.3cm diameter
London, British Museum
(BANK, M.1039)

Within neat, concentric border lines drawn with the compass, Bernini's drawings – miniature miracles of design – were created as detailed guides for the wax models executed by Gaspare Morone (only that for the reverse survives). The models were in turn followed closely in the engraved die from which the scudo was struck. Although Morone's wax is a careful rendition of Bernini's drawing, in the translation from one medium to another much of the energy and fluency of the design was inevitably lost: compare the swaying *contrapposto* and forward thrust of the saint in the drawing to the stiff, vertical pose in the model; or the back of the beggar's head, which was transformed by the modeller into a crude profile.[1]

These silver scudi or piastres were apparently coined in 1658, and have traditionally been associated with the canonisation of the Spanish bishop, St Thomas of Villanova (or Villanueva, 1488–1555). However, it has been pointed out that this scudo may be identical with one first tested in February 1656, two years before the saint was canonised. Furthermore, Thomas was an Augustinian friar who became Archbishop of Valencia in 1544, whereas the principal figure on the reverse of this coin is shown in Roman armour. It seems likely that the image actually represents the *miles christianus* (Christian knight) providing charity. As the scudo was struck shortly before St Thomas of Villanova's canonisation it evidently became erroneously associated with that event.

There is another version of this coin with the addition of an interior border line on the obverse.[2] [TC]

166A AND B
ATTRIBUTED TO GIOACCHINO FRANCESCO TRAVANI *fl.1634–1675*
Androcles and the Lion, 1659

OBVERSE: Fabio Chigi, Pope Alexander VII (1599–Pope 1655–67), bearded, in profile to left, wearing cassock, cap, and stole; around:
.ALEXANDER.VII.PM.PIVS.IVST.OPI.SENEN. PATR.GENTE.CHISIVS.MDCLIX
REVERSE: Androcles, in Roman armour, stands and raises his sword towards a lion who crouches before him in submission, the composition enclosed by an arena filled with spectators; around:
MVNIFICIO.PRINCIPI.DOMINICVS.IACOBATIVS.; and, on a scroll: *ET.FERA.MEMOR.BENEFICII.*
Bronze (cast); 9.5cm diameter
Edinburgh, National Gallery of Scotland
(NG2676)

Another example of the same medal:
Bronze (cast); 9.8cm diameter
Glasgow, University of Glasgow, Hunterian Museum

The history of this medal, arguably the finest and most ambitious example of Italian medallic art of the seventeenth century, is particularly well documented.[1] It was believed that the swift intercession of Pope Alexander VII had helped to bring to an early end the plague of 1656–8 and, as a result, the Roman people wished to express their gratitude by erecting a monument to him on the Capitoline Hill. The Pope tactfully declined this honour, remarking that he would be sufficiently rewarded if his image was merely engraved on the hearts of the Roman people. Prompted to offer another kind of tribute, Domenico Jacobacci, a Roman nobleman and papal agent, commissioned this medal to be cast for the same purpose.

The reverse, with *Androcles and the Lion*, illustrates the Roman legend first recorded by Apion and Seneca, and popularised in the second-century *Noctes Atticae* of Aulus Gellius. The story involves a gladiatorial combat, in which a lion spares the life of a condemned slave who once pulled a thorn from his foot. The lion was thus a symbol of thankful remembrance for past favours, and also, significantly, the symbol of the Roman commune.

Two contemporary prints with dedicatory inscriptions portray this medal. One was designed by Bernini, engraved by G. B. Bonacina, and dated 1659 (fig.158);[2] the other was designed by Pietro da Cortona, also engraved by Bonacina, but dated to the following year (fig.159).[3] The print after Cortona does not identify the originator of the medal's design, while the earlier one bears the inscription: *Numisma opus Bernini*. Bernini's authorship is further confirmed by an entry in Alexander VII's appointments diary for 25

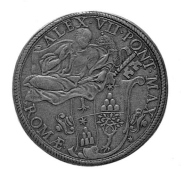 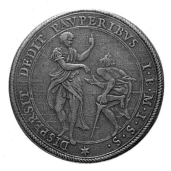 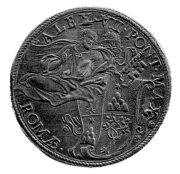

cat.no.165a obverse *left* reverse *right* cat.no.165b obverse *left* reverse *right*

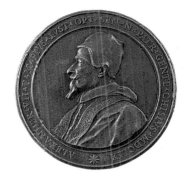

cat.no 166a obverse *left* reverse *right*

cat.no 166b obverse *left* reverse *right*

March 1659: *Il Cav. Bernino col gettito d'argento della medaglia de Jacovacci*. ('The Cavaliere Bernini, with the silver cast of the Jacobacci medal').[4] In October of the same year, Leonardo Agostini, a Florentine gentleman, mentioned the medal in a letter to a friend, Carlo Strozzi, in the most explicit terms: *Al Procaccio ... consegnato una medaglia di N S fatta del Signor Cavaliere Bernini al instanza del Signor Jacovacci* ('A medal of our Holy Father made by the Cavaliere Bernini at the bidding of Signor Jacobacci, delivered to Procacci').[5]

Clearly, Bernini was deeply involved with the overall design of the medal, but it does have some curious features. Firstly, it is in high relief, and as such is just not the sort of medal favoured by the sculptor (see Bernini's comments on Warin's foundation medal for the Louvre, cat.no.93). It also may be significant that Bernini's drawing in the Pushkin Museum, Moscow, for the dedicatory print, shows the actual medal as two blank circles. It is also curious to find Pietro da Cortona making a magnificent drawing for a print which included the same medal. The style of *Androcles and the Lion* is not markedly like Bernini's, and is indeed much more reminiscent stylistically of Cortona.[6] Both artists, it may be noted, were favoured by Alexander VII. A possible explanation may be that the commission for the medal was given to Bernini, who was responsible for the design for the portrait obverse and its overall appearance, but that Cortona supplied the design for the composition of *Androcles and the Lion*. Bernini and Cortona were rivals, so the explanation for the publication of the second print may have been for Cortona to draw attention to his own involvement in the medal's design. [TC]

167
ATTRIBUTED TO GIOACCHINO FRANCESCO TRAVANI
fl.1634–1675

Pope Alexander VII, 1661

Un face: Fabio Chigi, Pope Alexander VII (1599–Pope 1655–67), bearded, in profile to left, wearing tiara with ribbons and cope embroidered with a demi-figure of St Paul; around: *ALEX.VII.PONT.MAX.A.VIII*; dated below truncation: *1661*

Brass (cast, with incuse reverse); 10.3cm diameter

London, British Museum

(M.1180)

This handsome portrait of Alexander VII is unsigned, but it is usually ascribed to Gaspare Morone.[1] It is, however, very close stylistically to smaller signed medals of the same Pope by Travani, with reverses of Santa Maria dell' Assunzione (see cat.no.90) and Santa Maria di Galloro, both foundation medals dating from 1662 for churches designed by Bernini.[2]

Although there are no designs known for the portrait, it seems likely to have followed a drawing Bernini. Not only was Alexander VII responsible for commissioning many medal designs from Bernini, but he also directly concerned himself with the details of their appearance and inscriptions, as is documented in his *Diary*.[3]

[TC]

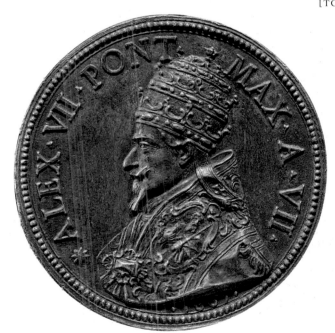

fig.158: Giovanni Battista Bonacina, after Gianlorenzo Bernini, *Dedicatory Print to Alexander VII*, engraving

fig.159: Giovanni Battista Bonacina, after Pietro da Cortona, *Allegory of the Liberation of Rome from the Plague*, engraving, Rome, Archivio di Stato

168

ATTRIBUTED TO GIROLAMO LUCENTI 1627–1698

Benedetto Odescalchi, Pope Innocent XI (1611–Pope 1676–89)

Uniface: Pope, in profile to right, wearing cassock, stole, and cap
Bronze (cast and richly chased); 25.5cm diameter
Edinburgh, National Gallery of Scotland
Purchased by the Patrons of the National Galleries of Scotland, 1988
(NG2472)

Lucenti became an engraver at the Papal Mint under the director-ship of the then elderly Gaspare Morone, whom he succeeded two years later. Also a trained sculptor in marble, he assisted Algardi and collaborated with Bernini as his chief bronze caster on various projects, including the papal tombs in St Peter's, the tabernacle of the Altar of the Sacrament, and sugar-paste *trionfi* (modelled by Ferrata) for a banquet given for Queen Christina of Sweden.

This very finely chased cast belongs to a sequence of large uniface profile portraits of popes, all of similar measurements, all lacking inscriptions, and all probably depending on drawings or wax models executed by Bernini.[1] They portray Alexander VII (*reg.* 1665–67), Clement IX (*reg.* 1667–69), Clement X (*reg.* 1670–76), and Innocent XI (*reg.* 1676–89).[2] The image of Clement IX corresponds closely, but in reverse, to Bernini's drawing in Leipzig (fig.44), and to a damaged terracotta relief in a Roman private collection, which has also been associated with Bernini's name.[3] It seems likely that Bernini provided 'official' portraits to serve within the Papal Mint as prototype likenesses for the coinage and medals to be struck or cast on a smaller scale. The wide variations in the quality of chas-ing and patina among these medallions suggests that they were cast and finished by several different artists, and no doubt at different dates, under Lucenti's supervision. Innocent XI became Pope only in 1676, and Bernini died four years later, so this may represent one of the sculptor's last designs. [TC]

cat.no.169 obverse *left* reverse *right*

169

ATTRIBUTED TO ELIA TESEO *fl.*1650s–1660s

OBVERSE: Francesco I d'Este, Duke of Modena, in profile to left, with long curling hair, lace collar, and armour, a sash tied over his right shoulder; around: *.FRA.I.MVT.REG.EC.DUX. VIII*
REVERSE: A three-decker first-rate galleon in full sail, an Este eagle emblazoned on her stern; around: *.NON.ALIO.SIDERE.*
Silver (cast and chased); 8.7cm diameter
Cambridge, The Syndics of the Fitzwilliam Museum
(CM30–1967)

An apparently unique example of this chunky silver medal, it has been suggested has been suggested that it is the work of Elia Teseo, a goldsmith who worked in the Modenese mint, of which he be-came director after the death of his uncle Gioseffo in April 1665. He signed many coins issued by Francesco I's successor, Duke Alfonso IV.[1] In 1647 Duke Francesco wrote to his brother Cardinal Rinaldo d'Este in Rome, requesting a drawing by Bernini to serve as a model for his coinage (which evidently was not forthcoming, for he repeated this request in 1650). However, rather than follow an actual design by Bernini, the splendid obverse of this medal seems rather to have been inspired by Bernini's magnificent marble por-trait bust of the Duke (fig.160), which was carved on the basis of three painted portraits and arrived in Modena in November 1651.[2]
[TC]

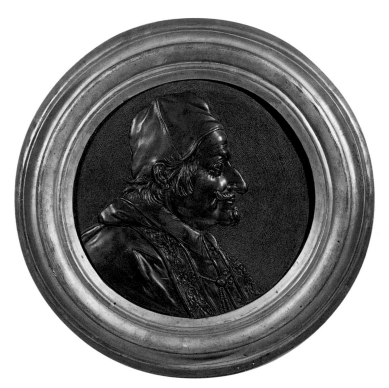

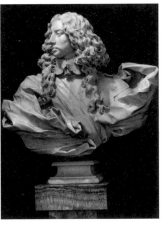
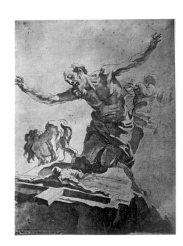

left fig.160: Gianlorenzo Bernini, *Bust of Francesco I d'Este, Duke of Modena,* Modena, Galleria Estense

right fig.161: Gianlorenzo Bernini, *St Jerome in Penitence,* Paris, Musée du Louvre

Miscellaneous Religious Compositions

170

GIANLORENZO BERNINI

St Jerome in Penitence

Brush and brown wash over black chalk, 15.7 × 22.3cm
London, Courtauld Institute Galleries
(Witt Fund 4752)

It is not known for what purpose this intensely spiritual image was made.[1] We do know that drawings of similar subjects were presented by the artist as gifts to friends and patrons. A celebrated example, also representing the *Penitent St Jerome* and now in the Louvre (fig.161), was drawn during Bernini's visit to Paris and was given to Jean-Baptiste Colbert on 4 October 1665; a copy by Bernini's son Paolo of another, showing *St Mary of Egypt*, was presented to the Abbé Buti.[2] However, the modest dimensions of the present drawing suggest that it may have been a spontaneous expression of devotion on Bernini's part. St Ignatius Loyola's *Spiritual Exercises*, which Bernini practiced regularly, recommend the use of images of this kind during prayer as a stimulus to devotion, with the aim of inspiring the worshipper to a state of remorse and penance. One can well imagine that the artist, who was much pre-

occupied with matters spiritual in his later life, may also have viewed the very act of creating such an image as a cathartic and redemptive one.[3]

Bernini shows St Jerome, the archetypal male penitent, at the extreme point of his self-chastisement, collapsed before the cross and beating his chest with a rock. The artist has captured with great feeling the profound spirituality of the saint's surrender to devotion through meditation on Christ's Passion. By denying the viewer sight of the saint's face, Bernini emphasised the deeply private nature of the saint's communion with God. The importance of drapery in supporting the emotional state of the figure is a hallmark of Bernini's work, and in this drawing the swathe of cloth around the midriff certainly accentuates the expressive distortions of the body, and enhances the poignancy of the conception.

The use of wash alone over the chalk underdrawing reflects the confidence and sophistication of Bernini's late drawing technique. The *Kneeling Angel* from Windsor (cat.no.74) offers the closest comparison in terms of style, which suggests that this drawing too may date from the first half of the 1670s.[4] Created entirely from the imagination, Bernini's drawing of the *Penitent St Jerome* indeed reveals 'one whose perception and grasp of form was phenomenal'.

[EJS]

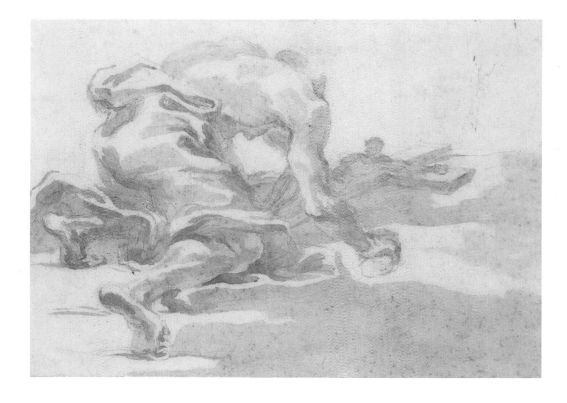

171

GIOVANNI BATTISTA GAULLI,
CALLED BACICCIO 1639–1709

The Sacrifice of Isaac

Pen and brown ink and wash, heightened with white (slightly oxidised in
places), over black chalk, on blue paper, 31.9 × 23.3cm

Edinburgh, National Gallery of Scotland

Purchased with the aid of the National Art Collections Fund and the
Foundation for Sport and the Arts, 1992

(D5328)

An angel stays the blade-weilding arm of Abraham, who was in-
structed by God to sacrifice his son Isaac as a test of his faith (*Gen-
esis*, 21: 1–19). This bold, somewhat sculptural drawing is usually
considered to be a preparatory study for Baciccio's painting of this
subject (*c*.1685–95) in the High Museum of Art, Atlanta (fig.162), al-
though it differs from that composition in significant respects.[1] A
second compositional drawing of this subject, in a private collec-
tion in London, is more loosely handled and exploratory than the
Edinburgh sheet.[2] It includes the figure of God the Father sur-
rounded by cherubim at the top, but in other respects, notably the
pose of Isaac, it is closer than the Edinburgh drawing to the Atlanta
painting. It would not be exceptional, however, for Baciccio to
have made several quite different studies for a composition before
settling on a preferred option (see cat.no.120).

A '*Sacrifice of Abraham*' is recorded as one of a series of four
paintings of sacred history in the post-mortem inventory of
Baciccio's son Giulio Gaulli.[3] While this may well be the picture
now in Atlanta, the possibility remains that it was differently
composed, and corresponded more closely to one or other of the
compositional drawings. The only surviving drawing by Baciccio
that can be connected to the Atlanta painting without reservation
is the separate, squared study for the figure of Abraham in
Düsseldorf.[4] [AWL]

fig.162: Giovanni Battista Gaulli, called Baciccio, *The Sacrifice of Isaac*,
Atlanta, High Museum of Art (Gift of the Kress Foundation, 1958)

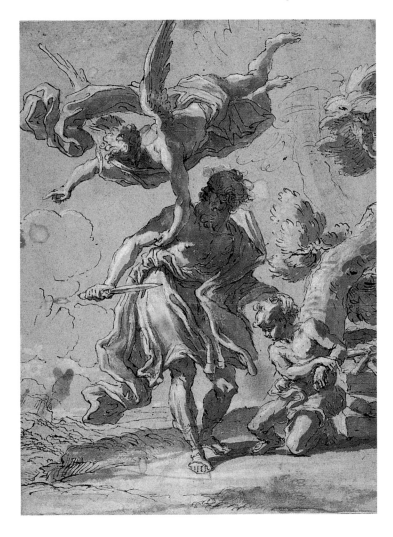

Bibliography and Notes

Bibliography

ALBERTI, 1955
Alberto Alberti, *De Re Aedificatoria*, translated by James Leoni, 9 vols., London, 1955 (reprint)

ANDREWS, 1968
Keith Andrews, *Catalogue of Italian Drawings in the National Gallery of Scotland*, 2 vols., Cambridge, 1968

AVERY, 1997
Charles Avery, *Bernini: Genius of the Baroque*, London, 1997

BACCHI, 1996
Andrea Bacchi, *Scultura del '600 a Roma*, Milan, 1996

BALDINUCCI, 1682
Filippo Baldinucci, *Vita del Cavalier Gio Lorenzo Bernino, scultore, architetto e pittore*, Florence, 1682

BALDINUCCI, 1847
Filippo Baldinucci, *Notizie dei professori del disegno da Cimabue in qua*, edited by Ferdinando Ranalli, 5 vols., Florence, 1847

BALDINUCCI, 1966
The Life of Bernini by Filippo Baldinucci, translated by Catherine Enggass, with an introduction by Robert Enggass, University Park (Pa.), 1966

BAUER, 1976
George C. Bauer (ed.), *Bernini in Perspective*, Englewood Cliffs, 1976

BELLORI, 1942
Giovanni Pietro Bellori, *Vite di Guido Reni, Andrea Sacchi e Carlo Maratti* (transcribed from the manuscript MS2506 in the Bibliothèque Municipale, Rouen) edited by M. Piacentini, Rome, 1942

BELLORI, 1976
Giovanni Pietro Bellori, *Le Vite de' pittori, scultori ed architetti moderni*, edited by Evelina Borea, Rome, 1976

BENOCCI, 1989
Carla Benocci, 'Documenti inediti sul *Nettuno e Tritone* di Gian Lorenzo Bernini per la peschiera della villa Peretti Montalto a Roma'. *Storia della città*, XIV, 1989, pp.83–6

BERENDSEN, 1961
Olga Berendsen, *Italian Sixteenth and Seventeenth Century Catafalques*, Ph.D. dissertation, New York University, 1961

BERNINI, 1713
Domenico Bernini, *Vita del Cavalier Gio. Lorenzo Bernino*, Rome, 1713

BLACK, 1989
Christopher F. Black, *Italian Confraternities in the Sixteenth Century*, Cambridge, 1989

BLUNT, 1958
Anthony Blunt, 'The Palazzo Barberini: The Contributions of Maderno, Bernini and Pietro da Cortona', *Journal of the Warburg and Courtauld Institutes*, XXI, 1958, pp.256–87

BLUNT, 1973
Anthony Blunt, *Art and Architecture in France, 1500–1700*, Harmondsworth 1973

BLUNT, 1978
Anthony Blunt, 'Gianlorenzo Bernini: illusionism and mysticism', *Art History*, 1, 1978, pp.67–89

BLUNT, 1979
Anthony Blunt, *Borromini*, London, 1979

BLUNT, 1982
Anthony Blunt, *Guide to Baroque Rome*, London, 1982

BLUNT AND COOKE, 1960
Anthony Blunt and Hereward Lester Cooke, *The Roman Drawings of the XVII & XVIII centuries in the collection of Her Majesty the Queen at Windsor Castle*, London, 1960

BORROMINI, 1725
Francesco Borromini, *Opus Architectonicum*, Rome, 1725 (Republished with an introduction and notes by Paolo Portoghesi, Rome, 1964)

BORSI, 1991
Franco Borsi (ed.), *Il Palazzo del Quirinale*, Milan, 1991

BOUCHER, 1998
Bruce Boucher, *Italian Baroque Sculpture*, London, 1998

BRAUER AND WITTKOWER, 1931
Heinrich Brauer and Rudolf Wittkower, *Die Zeichnungen des Gianlorenzo Bernini*, 2 vols., Berlin, 1931

BUSIRI VICI, 1967
Andrea Busiri Vici, 'L'Ultima posa' di Gian Lorenzo Bernini', *Palatino*, 1967, pp.282–7 (reprinted in Andrea Busiri Vici, *Scritti d'Arte*, Rome, 1990, pp.228–32)

BYAM SHAW, 1976
James Byam Shaw, *Drawings by Old Masters at Christ Church Oxford*, 2 vols., London, 1976

CARERI, 1991
Giovanni Careri, *Bernini: Flights of Love – The Art of Devotion*, translated by Linda Lappin, Chicago and London, 1991

CHANTELOU, 1885
Paul Fréart de Chantelou, 'Journal du Voyage du Cavalier Bernin en France', edited by Louis Lalanne, in *Gazette des Beaux-Arts*, 1883–5

CHANTELOU, 1985
Paul Fréart de Chantelou, *Diary of the Cavaliere Bernini's Visit to France*, translated by Margery Corbett, edited with an introduction by Anthony Blunt and annotated by George C. Bauer, Princeton, 1985

CONNORS, 1980
Joseph Connors, *Borromini and the Roman Oratory: Style and Society*, New York, Cambridge (Mass.) and London, 1980

CORTONA, 1956
Cortona, *Mostra di Pietro da Cortona*, exhibition catalogue by Alessandro Marabottini and Luciano Berti, Rome, 1956

DELUMEAU, 1957
Jean Delumeau, *Vie économique et sociale de Rome dans le seconde moitié du XVIᵉ siècle*, 2 vols., Paris, 1957–9

DICTIONARY OF ART, 1996
The Macmillan Dictionary of Art, edited by Jane Turner, 34 vols., London and New York, 1996

D'ONOFRIO, 1957
Cesare D'Onofrio, *Le Fontane di Roma*, Rome, 1957

D'ONOFRIO, 1967
Cesare D'Onofrio, *Roma Vista da Roma*, Rome, 1967

D'ONOFRIO, 1977
Cesare D'Onofrio, *Acque e Fontane di Roma*, Rome, 1977

ENGGASS, 1964
Robert Enggass, *The Paintings of Baciccio: Giovanni Battista Gaulli 1639–1709*, University Park and London, 1964

FALDI, 1954
Italo Faldi, *Galleria Borghese. La scultura dal secolo XVI al XIX*, Rome, 1954

FAGIOLO DELL'ARCO, 1967
Maurizio and Marcello Fagiolo dell'Arco, *Bernini: una introduzione al gran teatro del barocco*, Rome, 1967

FAGIOLO DELL'ARCO AND CARANDINI, 1977
Maurizio Fagiolo dell'Arco and Silvia Carandini, *L'Effimero barocco: strutture della festa nella Roma del'600*, 2 vols., Rome, 1977

FAGIOLO AND MADONNA, 1985 (1)
Marcello Fagiolo and Maria Luisa Madonna (eds.), *Barocco Romano e Barocco Italiano*, Rome, 1985

FAGIOLO AND MADONNA, 1985 (2)
Marcello Fagiolo and Maria Luisa Madonna, *Roma 1300–1875: La città degli Anni Santi. Atlante*, Milan, 1985

FAGIOLO AND MADONNA, 1985 (3)
Marcello Fagiolo and Maria Luisa Madonna (eds.), *Roma Sancta: La città delle basiliche*, Rome, 1985

FAGIOLO DELL'ARCO AND PANTANELLA, 1996
Maurizio Fagiolo dell'Arco and Rossella Pantanella, *Museo Baciccio: in margine a quattro inventari inediti*, Rome, 1996

FAGIOLO, 1997
Marcello Fagiolo (ed.), *La Festa a Roma*, 2 vols., Rome, 1997

FLORENCE, 1997
Florence, Uffizi, *Disegni del Seicento Romano*, exhibition catalogue by Ursula Verena Fischer Pace, 1997

FORT WORTH, 1982
Fort Worth, Kimbell Art Museum, *The Art of Gianlorenzo Bernini: Selected Sculpture*, exhibition catalogue by Michael P Mezzatesta, Fort Worth, 1982

FRASCHETTI, 1900
Stanislao Fraschetti, *Il Bernini: La sua vita, la sua opera, il suo tempo*, Milan, 1900

FUSCO, 1997
Peter Fusco, *Summary Catalogue of European Sculpture in The J. Paul Getty Museum*, Los Angeles, 1997

GARMS, 1972
Jörg Garms (ed.), *Quellen aus dem Archiv Doria-Pamphilj zur Kunsttätigkeit in Rom unter Innocenz X*, Rome and Vienna, 1972

GOLZIO, 1935
Vincenzo Golzio, 'Lo 'studio' di Ercole Ferrata', *Archivi d'Italia e Rassegna Internazionale degli Archivi*, II, 1935, pp.64–74

GONZÁLEZ-PALACIOS, 1970
Alvar González-Palacios, 'Bernini as Furniture Designer', *Burlington Magazine*, CXII, 1970, pp.718–23

GOULD, 1981
Cecil Gould, *Bernini in France: An Episode in Seventeenth-Century History*, London, 1981

HAMMOND, 1994
Frederick Hammond, *Music and Spectacle in Baroque Rome: Barberini Patronage under Urban VIII*, New Haven and London, 1994

HASKELL, 1980
Francis Haskell, *Patrons and Painters. A Study in the Relations between Italian Art and Society in the Age of the Baroque*, (second, revised edition) New Haven and London, 1980

HIBBARD, 1965
Howard Hibbard, *Bernini*, London, 1965 (reprinted 1990)

HIBBARD, 1971
Howard Hibbard, *Carlo Maderno and Roman Architecture, 1580–1630*, London, 1971

HOOG, 1989
Simone Hoog, *Le Bernin Louis XIV: une statue 'déplacée'*, Paris, 1989

JACOB, 1975
Sabine Jacob, *Die Italienischen Handzeichnungen der Kunstbibliothek Berlin*, Berlin, 1975

JONES, 1988
Mark Jones, *A Catalogue of the French Medals in the British Museum, Volume II, 1600–1672*, London, 1988

JONES, 1992
Mark Jones (ed.), *Designs on Posterity: Drawings for Medals* (papers read at FIDEM 1992), London, 1992

KANSAS CITY, 1993
Kansas City, Nelson-Atkins Museum of Art (and two other American venues), *Three Centuries of Roman Drawings from the Villa Farnesina, Rome*, exhibition catalogue by Simonetta Prosperi Valenti Rodinò, Alexandria (Va.), 1993

KAUFFMANN, 1970
Hans Kauffmann, *Giovanni Lorenzo Bernini: Die figürlichen Kompositionen*, Berlin, 1970

KIRWIN, 1997
William Chandler Kirwin, *Powers Matchless: The Pontificate of Urban VIII, the Baldachin, and Gian Lorenzo Bernini*, New York, 1997

KRAUTHEIMER, 1985
Richard Krautheimer, *The Rome of Alexander VII 1655–1667*, Princeton and Guildford, 1985

KRAUTHEIMER AND JONES, 1975
Richard Krautheimer and Roger B.S. Jones, 'The Diary of Alexander VII', *Romisches Jahrbuch für Kuntsgeschichte*, 15, 1975, pp.199–233

LAVIN, 1968 (1)
Irving Lavin, 'Five new Youthful Sculptures by Gian Lorenzo Bernini and a Revised Chronology of his Early Works', *Art Bulletin*, L, 1968, pp.223–48

LAVIN, 1968 (2)
Irving Lavin, *Bernini and the Crossing of St Peters*, New York, 1968

LAVIN, 1972
Irving Lavin, 'Bernini's Death', *Art Bulletin*, LIV, 2, 1972, pp.162–71

LAVIN, 1973
Irving Lavin, 'Afterthoughts on Bernini's Death', *Art Bulletin*, 55, 1973, pp.429–36

LAVIN, 1980
Irving Lavin, *Bernini and the Unity of the Visual Arts*, 2 vols., New York and London, 1980

LAVIN, 1985
Irving Lavin (ed.), *Gianlorenzo Bernini: New Aspects of His Art and Thought*, University Park and London, 1985

LAVIN, 1975
Marilyn Aronberg Lavin, *Seventeenth-Century Barberini Documents and Inventors of Art*, New York, 1975

LIGHTBOWN, 1981
Ronald Lightbown 'Bernini's busts of English Patrons', in *Art the Ape of Nature: Studies in Honor of H.W. Janson*, Moshe Barasch and Lucy Freeman Sandler, New York, 1981

LIZZANI, 1970
Goffredo Lizzani, *Il Mobile Romano*, Milan, 1970

LONDON, 1974
London, British Museum, *Portrait Drawings: XV-XX Centuries*, exhibition catalogue edited by John Gere, 1974

LONDON, 1986
London, The Queen's Gallery, *Master Drawings in the Royal Collection*, exhibition catalogue edited by Jane Roberts, 1986

LONDON, 1990
London, Harari & Johns Ltd., *An Exhibition of Italian Old Master Drawings*, presented by Trinity Fine Art Ltd. and Compagnie des Beaux-Arts Ltd., 1990

MAHON, 1947
Denis Mahon, *Studies in Seicento Art and Theory*, London, 1947

MAGNUSON, 1982–86
Torgil Magnuson, *Rome in the Age of Bernini*, 2 vols., Stockholm, 1982–6

MARDER, 1997
Todd A. Marder, *Bernini's Scala Regia at the Vatican Palace: Architecture, Sculpture, and Ritual*, Cambridge, 1997

MARTINELLI, 1994
Valentino Martinelli, *Gian Lorenzo Bernini e la sua cerchia – Studi e contributi*, Naples, 1994

MARTINELLI, 1996
Valentino Martinelli (ed.), *L'Ultimo Bernini, 1665–1680: Nuovi argomenti, documenti e immagini*, Rome, 1996

MATITTI, 1994
Flavia Matitti, *Il Baciccio illustratore*, Rome, 1994

MERZ, 1991
Jörg Merz, *Pietro da Cortona: Der Aufstieg zum führenden Maler im barocken Rom*, Tübingen, 1991

MONTAGU, 1985
Jennifer Montagu, *Alessandro Algardi*, 2 vols., New Haven and London, 1985

MONTAGU, 1989
Jennifer Montagu, *Roman Baroque Sculpture: The Industy of Art*, New Haven and London, 1989

MONTAGU, 1996
Jennifer Montagu, *Gold, Silver and Bronze: Metal Sculpture of the Roman Baroque*, New Haven and London, 1996

NOEHLES, 1970
Karl Noehles, *La Chiesa di SS. Luca e Martina nell' opera di Pietro da Cortona*, second edition, Rome, 1970

NUSSDORFER, 1992
Laurie Nussdorfer, *Civic Politics in the Rome of Urban VIII*, Princeton, 1992

PARKER, 1956
Karl T. Parker, *Catalogue of the Collection of Drawings in the Ashmolean Museum, Volume II: The Italian Schools*, Oxford, 1956

PASTOR, 1955
Ludwig von Pastor, *Storia dei Papi Dalla Fine del Medio Evo* (translated from German); vols.x–xiii, Rome, 1955–61

PERLOVE, 1990
Shelley Karen Perlove, *Bernini and the Idealization of Death: The Blessed Ludovica Albertoni and the Altieri Chapel*, University Park and London, 1990

PETRUCCI, 1987
Francesco Petrucci, *Santa Maria Assunta, Collegiata Insigne ed altre chiese minori in Ariccia*, Ariccia, 1987

PIGNATTI, 1977
Terisio Pignatti (ed.), *I grandi disegni italiani nelle collezione di Oxford: Ashmolean Museum e Christ Church Picture Gallery*, Milan, 1977

POLLARD, 1970
Graham Pollard, 'La medaglia con ritratto di epoca barocca in Italia', in *La Medaglia d'Arte: Atti del Convegno Internazionale di Studio sulla Medaglia*, Udine, 1970 (published 1973), pp.139–62

POPE-HENNESSY, 1963
John Pope-Hennessy, *Italian High Renaissance and Baroque Sculpture*, 3 vols., London, 1963

POPE-HENNESSY, 1964
John Pope-Hennessy, *Italian Sculpture in the Victoria and Albert Museum*, 3 vols., London, 1964

POPELKA, 1994
L. Popelka, *Castrum Doloris, oder 'trauriger Schauplatz'. Untersuchungen zu Entstehung und Wesen ephemeren Architektur*, Vienna, 1994

PRADO AND VILLALPANDO, 1596
Girolamo Prado and Giovanni Villalpando, *In Ezechielem explanationes et apparatus urbis ac templi Hierosolymitani*, 3 vols., Rome, 1596–1604

PRINCETON 1981
Princeton, Art Museum (and five other American venues), *Drawings by Gianlorenzo Bernini from the Museum der Bildenden Künste Leipzig, German Democratic Republic*, edited by Irving Lavin, Princeton, 1981

QUIRK, 1998
Jason Quirk, 'Papal Self-promotion and Architecture: The Medals of Pope Innocent X', *The Medal*, 32, 1998

ROME, 1981
Rome, Musei Vaticani, *Bernini in Vaticano*, exhibition catalogue, 1981

ROME, 1986
Rome, Gabinetto Nazionale dei Disegni e delle Stampe (Villa Farnesina), *Diegni decorativi del barocco romano*, edited by Giulia Fusconi, 1986

ROME, 1991(1)
Rome, Palazzo Ruspoli (Fondazione Memmo), *Alle origini di Canova: le terrecotte della collezione Farsetti*, exhibition catalogue by Sergej O. Androsov, 1991–2

ROME, 1991(2)
Rome, Museo Nazionale del Palazzo di Venezia, *Scutture in Terracotta del Barocco Romano*, exhibition catalogue by Maria Giulia Barberini, 1991

ROME, 1992
Rome, Palazzo Ruspoli (Fondazione Memmo), *Old Master Drawings from the Ashmolean Museum*, exhibition catalogue by Christopher White, Catherine Whistler and Colin Harrison, English edition, Oxford, 1992

ROME, 1997 (1)
Rome, Palazzo Venezia, *Pietro da Cortona*, exhibition catalogue edited by Anna Lo Bianco, 1997

ROME, 1997 (2)
Rome, Istituto Nazionale per la Grafica and Accademia di San Luca, *Pietro da Cortona e il Disegno*, exhibition catalogue edited by Simonetta Prosperi Valenti Rodinò, 1997

SCHILLING AND BLUNT, 1971
Edmund Schilling, *German Drawings in the Collection of Her Majesty the Queen at Windsor Castle*, and Anthony Blunt, *Supplements to the Catalogues of the Italian and French Drawings*, London and New York, n.d. [1971]

SCOTT, 1991
John Belden Scott, *Images of Nepotism*, Princeton, 1991

SCRIBNER, 1991
Charles Scribner III, *Gianlorenzo Bernini*, New York, 1991

SELLA, 1997
Domenico Sella, *Italy in the Seventeenth Century*, London and New York, 1997

STUTTGART, 1993
Stuttgart, Staatsgalerie, *Von Bernini bis Piranesi, Römische Architekturzeichnungen des Barock*, exhibition catalogue by Elisabeth Kieven, 1993

SUTHERLAND HARRIS, 1977 (1)
Ann Sutherland Harris, *Selected Drawings of Gianlorenzo Bernini*, New York, 1977

SUTHERLAND HARRIS, 1977 (2)
Ann Sutherland Harris, *Andrea Sacchi*, Oxford, 1977

THELEN, 1967
Heinrich Thelen, *Francesco Borromini, Die Handzeichnungen*, 2 vols., Graz, 1967

TOKYO, 1996
Tokyo, National Museum of Western Art, and Nagoya, Aichi Prefectural Museum of Art, *Italian 16th and 17th Century Drawings from the British Museum*, exhibition catalogue edited by Michiaki Koshikawa and Hidenori Kurita, 1996 (with an English language supplement)

TORONTO, 1985
Toronto, Art Gallery of Ontario, and New York, Pierpont Morgan Library, *Italian Drawings from the Collection of Duke Roberto Ferretti*, exhibition catalogue by David McTavish, 1985–6

TURNER, 1980
Nicholas Turner, *Italian Baroque Drawings in the British Museum*, London, 1980

TURNER, 1999
Nicholas Turner, *Italian Drawings in the Department of Prints and Drawings in the British Museum: Roman Baroque Drawings*, London, 1999 (forthcoming)

VAN KESSEL AND SCHULTE, 1997
Peter Van Kessel and Elisja Schulte (eds.), *Rome–Amsterdam. Two Growing Cities in Seventeenth-Century Europe*, Amsterdam, 1997

VARRIANO, 1987
John Varriano, 'Alexander VII, Bernini, and the Baroque Papal Medal', in *Studies in the History of Art Volume 21: Italian Medals*, Washington, National Gallery of Art, 1987, pp.249–60

VITZTHUM, 1963
Walter Vitzthum, 'Disegni di Alessandro Algardi', *Bolletino d'Arte*, XLVII, 1963, pp.75–98

WARD-JACKSON, 1980
Peter Ward-Jackson, *Italian Drawings Volume Two: 17th-18th century (Victoria and Albert Museum Catalogues)*, London, 1980

WEIL, 1974 (1)
Mark S. Weil, *The History and Decoration of the Ponte S. Angelo*, University Park and London, 1974

WEIL, 1974 (2)
Mark S. Weil, 'The Devotion of the Forty Hours and Roman Baroque Illusions', *Journal of the Warburg and Courtauld Institutes*, XXXVII, 1974, pp.218–48

WHITMAN AND VARRIANO, 1983
Nathan T. Whitman and John L. Varriano, *Roma Resurgens: Papal Medals from the Age of the Baroque*, catalogue of an exhibition held in 1981 at Mount Holyoke College, University of Michigan (and two other venues), Ann Arbor, 1983

WITTKOWER, 1951
Rudolf Wittkower, 'Works by Bernini at the Royal Academy', *Burlington Magazine*, XCIII, 1951, pp.51–6

WITTKOWER, 1961
Rudolf Wittkower, 'The Vicissitudes of a Dynastic Monument. Bernini's Equestrian Statue of Louis XIV', *De Artibus Opuscula XL, Essays in Honor of Erwin Panofsky*, edited by Millard Meiss, New York, 1961

WITTKOWER, 1966
Rudolf Wittkower, *Gian Lorenzo Bernini: The Sculptor of the Roman Baroque* (second, revised edition), London, 1966

WITTKOWER, 1980
Rudolf Wittkower, *Art and Architecture in Italy, 1600–1750* (third, revised edition), London, 1980

WITTKOWER, 1981
Rudolf Wittkower, *Gian Lorenzo Bernini: The Sculptor of the Roman Baroque* (third, revised edition), New York, 1981

WITTKOWER, 1990
Rudolf Wittkower, *Bernini: The Sculptor of the Roman Baroque*, revised edition, Milan, 1990

WITTKOWER AND JAFFÉ, 1972
Rudolf Wittkower and Irma B. Jaffé (eds.), *Baroque Art: The Jesuit Contribution*, New York, 1972

WORSDALE, 1978
Marc Worsdale, 'Bernini Studio Drawings for a Catafalque and Fireworks, 1668', *Burlington Magazine*, CXX, 1978, pp.462–6

Notes and References

'Exceeding every expression of words': Bernini's Rome and the Religious Background

CHRISTOPHER F. BLACK
PAGES 11–21

In writing this essay I would particularly like to thank Tricia Allerston, Alastair Dunning and Aidan Weston-Lewis for information, critical comment and stimulating encouragement. A draft version was issued to students in my special subject course 'Art and Music Patronage in the Seventeenth Century'. Feedback from those writing essays on Bernini and his environment (Jilly Boid, Elisabeth Halstead and Joe Traynor), has been helpful and is also gratefully acknowledged. The quotation used here as a title is taken from Lelio Guidiccione's description of Paul V's funerary catafalque in his *Breve racconto della trasportazione dei corpo di Papa Paolo V*, Rome, 1623. Bibliographic citations are largely restricted to references not included in the entries on individual exhibits, and some recent publications which have been especially helpful in connection with this essay.

1 See Sella, 1997, especially chapter 4; Van Kessel and Schulte, 1997, chapters I, V, XVIII.

2 Krautheimer, 1985, especially pp.3–7, 12–14, 47–73, 131–47, and Fagiolo dell'Arco, 1967, pp.45–75, 136–9.

3 Eugenio Sonnino, 'The Population in Baroque Rome', in Van Kessel and Schulte, 1997, pp.50–70. Parish records in the Archivio di Stato (Stato Civile – Cam. III: Libri Parrochiali) and the Archivio Storico del Vicariato in Rome, strongly reinforce the impression of a very mobile society in the early seventeenth century.

4 For attitudes to the poor, the concept of Good Works, and the responses of confraternities see Black, 1989, especially chapters 1.3, 7, 8.1.

5 Delumeau, 1957–9, especially pp.221–363; Fagiolo and Madonna, 1985 (1), pp.197–208; Krautheimer, 1985, *passim*.

6 Discussed in detail in Alastair Dunning's forthcoming Ph.D. thesis on Roman festivals for the Courtauld Institute of Art, University of London. See also Michele Fak, 'Piazza Navona: Trionfi, feste da gioco, feste stellari', in Fagiolo, 1997, I, pp.182–202; D'Onofrio, 1977, especially pp.450–503.

7 Bernini, 1713, pp.48–50, 95–7; Baldinucci, 1966, pp.28, 41–3; Krautheimer and Jones, 1975, especially pp.204, 213.

8 Haskell, 1980, pp.162–3; Krautheimer, 1985, pp.126–30; Nussdorfer, 1992, especially pp.239–58.

9 On Bernini and St Peter's see, most recently, Avery 1997, chapters 6 and 7.

10 Krautheimer and Jones, 1975, pp.203–5

11 Montagu, 1985, I, pp.38–51, 138–46.

12 Avery, 1997, pp.114–17.

13 On the patronage of the religious orders, see Haskell, 1980, pp.63–93.

14 Sutherland Harris, 1977 (1), p. xxii; Francis Haskell, 'The Role of Patrons: Baroque Style Changes', in Wittkower and Jaffé, 1972, pp.51–62; Lavin, 1972, pp.163–5.

15 See Paolo Prodi, 'Ricerche sulla teoria delle arti figurative nella Riforma Cattolica, *Archivio Italiano per la Storia della Pietà*, 1965, 4, pp.123–212; Wittkower and Jaffé, 1972, pp.29–31, 39–41, 51–62: Thomas Buser, 'Jerome Nadal and Early Jesuit Art in Rome', *Art Bulletin*, LVIII, 1976, pp.424–33: Olivier Bonfait. 'De Paleotti à G.B. Agucchi: théorie et pratique de la peinture dans les milieux ecclésiastiques à Rome du Caravage à Poussin, in *Roma 1630. Il trionfo del pennello*, exhibition catalogue, Rome, Villa Medici, 1994, pp.83–96.

16 On confraternities, see Black, 1989.

17 Fagiolo and Madonna, 1985 (1), especially pp.232–3, 242, 243–9, 268–70; Paolo Brezzi, *Storia degli Anni Santi. Da Bonifacio VIII ai nostri giorni*, Milan, 1975, chapters VI-IX: Black, 1989, pp.117–21, 194–6.

18 Jean Delumeau, *Sin and Fear: The Emergence of a Western Guilt Culture 13th – 18th Centuries*, translated by Eric Nicholson, New York, 1990, chapters 11–13; Piero Camporesi, *The Fear of Hell. Images of Damnation and Salvation in Early Modern Europe*, translated by Lucinda Byatt, Cambridge, 1991, chapters 1–5; Philippe Ariès, *Images of Man and Death*, translated by J. Lloyd, Cambridge (Mass.) and London, 1985, *passim*.

19 Lavin, 1972, p.184; Avery, 1997, p. 127. See also Blunt. 1978, pp.77–9; Perlove, 1990, pp.28–9.

20 Fagiolo, 1997, II, pp.26–38, 210–22.

21 Wittkower (1980, pp.315–16) characterised the Bolognetti tombs in this church as a field of action for the dead.

22 Black, 1989, pp.99–100, 272; Renato Diez, 'Le Quarantore: Una predica figurata', in Fagiolo, 1997, II, pp.84–97.

23 Vittorio Casale, 'Gloria ai beati e ai santi. Le feste di beatificazione e di canonizzazione', in Fagiolo. 1997. I, pp.124–41; idem., 'Addobbi per beatificazioni e canonizzazioni: La rappresentazione della santità', in Fagiolo, 1997, II, pp.56–65.

24 Pastor, 1961, XIII, pp.93–5.

25 The designation *beata* was applied to holy women, 'living saints', working in contact with ordinary laity and not enclosed in convents. Often under the suspicion of the authorities for their excessive popular veneration as visionaries, healers and forecasters, they were as likely to end up accused of heresies in life as to become canonically beatified after death.

26 See Blunt, 1978, pp.79–80; Perlove, 1990 chapters 2, 6–7; Careri, 1995, pp.82–5.

27 See, however, Montagu, 1985, I, pp.179–204.

Bernini: A Mercurial Life and its Sources

CHRISTOPHER BAKER
PAGES 23–27

1 Bauer, 1976, p.41.

2 Filippo Baldinucci, *Vita del Cavalier Gio Lorenzo Bernino, scultore, architetto e pittore*, Florence, 1682. For an English translation see Baldinucci, 1966; for extracts in Italian with English translations, see Pope-Hennessy, 1963, III, pp.123–136, and Robert Enggass and Jonathan Brown, *Italian and Spanish Art, 1600–1750. Sources and Documents*, Illinois, 1992 edition, pp.109–22.

3 Domenico Bernini, *Vita del Cavalier Gio. Lorenzo Bernino* Rome, 1713. For extracts in English see Bauer, 1976, pp.24–41.

4 Cesare D'Onofrio, 'Priorità della biografia del Dom. Bernini su quello del Baldinucci', *Palatino*, X, 1966, pp.201–8.

5 Both Domenico and Baldinucci include this verse; it is Baldinucci who names the author.

6 For an exemplary analysis of how Vasari constructed his biographies, see Patricia L. Rubin, *Giorgio Vasari, Art and History*, London, 1995.

7 Bauer, 1976, p.33.

8 Bauer, 1976, p.25.

9 For Baldinucci see Edward L. Goldberg, *After Vasari – History, Art and Patronage in Late Medici Florence*, Princeton, 1988, chapter 4.

10 Quoted in Torgil Magnuson, *Rome in the Age of Bernini*, Stockholm, 1986, II, p.345.

11 In an essay (*La veglia. Dialogo Sincero Veri in cui si disputano e si scolgono varie difficoltà pittoriche*, Lucca, 1684), which takes the form of a dialogue, Baldinucci discussed among other things how sources should not be taken at face value. See Enggass and Brown, *op. cit.* at note 2, pp.56–9.

12 For the *Self-portrait* see Fagiolo

dell'Arco, 1967, no.104; for the bust of Costanza, Wittkower, 1990, cat.no.35, p.256.

13 Domenico also makes much of such devotion, which becomes fundamental for an understanding of the sculptor's last works (see Lavin, 1972).

14 For the most sophisticated discussion of the *bel composto*, see Lavin, 1980, I, pp.6–13. Domenico Bernini also describes this phenomenon.

15 For Bellori and Queen Christina see Magnuson, *op. cit.* at note 10, II, pp.288–90.

16 For the development of biography in relation to seventeenth-century art theory, see Claire Pace, *Félibien's Life of Poussin*, London, 1981, pp.13–23.

17 See G.A. Popescu, 'Historical-Critical Note: Wittkower and Studies on Bernini', in Wittkower, 1990, pp.315–6.

18 Jennifer Montagu, 'Bernini Sculptures Not by Bernini' in Lavin, 1985, p.26. It was G.B. Passeri, in his *Vite*, who first noted Finelli's involvement, although his book was not published until 1772.

19 See Montagu, 1989, especially chapter VI, pp.126–50.

20 Bauer, 1976, p.29.

21 Avery, 1997, pp.274–6 for a useful discussion of this incident.

22 See Marder, 1997, pp.209–10.

23 For the two principal publications of the *Diary*, see Chantelou, 1885 and Chantelou, 1985. See also Gould, 1981.

24 Gould, 1981, p.13, and Appendix.

25 Haskell, 1980, chapter 6.

26 Bauer, 1976, pp.46–53. For the bronze reduction of the statue illustrated here, see Nicholas Penny, *Catalogue of European Sculpture in the Ashmolean Museum, 1540 to the Present Day, Volume 1: Italian*, Oxford, 1992, pp.15–16, cat.no.12.

27 Haskell, 1980, p.162.

28 William L. Barcham, 'Some new documents on Federico Cornaro's two chapels in Rome', *Burlington Magazine*, CXXXV, 1993, pp.821–2. 12,089 scudi was paid for the Cornaro Chapel in Santa Maria della Vittoria, whereas Borromini's entire church of San Carlo alle Quattro Fontane cost only 11,678 scudi.

Bernini and Britain

DAVID HOWARTH
PAGES 29–35

I would like to thank Malcolm Baker and John Ingamells for their help in the writing of this essay.

1 Lightbown, 1981, pp.439–52.

2 Wittkower, 1966, cat.no.39.

3 Howarth, 1989, p.95 and n.124.

4 W.L. Spiers,1918, p.170.

5 For a full account of Baker's career as collector and country gentleman see Lightbown, 1981, pp.453–68.

6 De Beer, 1955, II, pp.264–5.

7 *Ibid.*, p.404.

8 Sir Charles Petrie (ed.), *The Letters of King Charles I*, London, 1935, p.273.

9 Richard Ollard, *The Image of the King*, London, 1979, p.25.

10 Vertue, 1929, I, p.93, and II, p.123.

11 J. Douglas Stewart, 'Sir Godfrey Kneller as a painter of histories and portraits *historiés*' in *Art and Patronage at the Caroline Courts*, edited by David Howarth, Cambridge, 1993, pp.255–60.

12 Ingamells, 1997, p.82.

13 Lord Balcarres, *The Evolution of Italian Sculpture*, London, 1909, pp.325–6.

14 For Byers in Rome, see Ingamells, 1997, pp.169–70.

15 *Ibid.*, p.874

16 *Ibid.*, p.556.

17 Collier, 1968, p.438.

18 Reynolds, 1975, p.61.

19 *Ibid.*, pp.183–4.

20 Margaret Whinney, *Sculpture in Britain 1530–1830*, London, 1988, p.96.

21 Katharine Gibson, '"The Kingdom's Marble Chronicle": The Embellish-ment of the First and Second Buildings, 1600–1690', in 'The Royal Exchange', edited by Ann Saunders, *London Topographical Society*, 152, 1997, pp.147–50.

22 *Ibid.*, p.105.

23 *Ibid.*, pp.146, 152.

24 David Bindman and Malcolm Baker, *Roubiliac and the Eighteenth-Century Monument*, New Haven and London, 1995, pp.81–4.

25 John Flaxman, *Lectures on Sculpture*, London, 1838, p.289.

26 Whinney, *op. cit.* at n.19, p.341.

27 For Westmacott's views, see Sir Richard Westmacott, *Handbook of Sculpture Ancient and Modern*, Edinburgh, 1864, pp.310–14.

28 Fritz Saxl and Rudolf Wittkower, *British Art and the Mediterranean*, London, 1948, p.68.

Roman Decorative Arts in the Age of Bernini

TIMOTHY CLIFFORD
PAGES 37–44

This article depends heavily on the pioneering work of three scholars: Alvar González-Palacios, Jennifer Montagu, and Giulia Fusconi. It does not pretend to be comprehensive, but should provide an introduction for understanding sculptors, painters, and architects closely involved with the 'arti minori'. I have deliberately omitted discussing the engraved work of a professional ornament designer like Filippo Passarini (1638–1698) and the designer-goldsmith Giovanni Giardini da Forlì (1646–1721), simply because neither of them was directly a fine art practicioner. Neither have I discussed night-clocks, although they were a Roman invention, with their faces painted by distinguished artists like Maratti, Trevisani, Lauri, and Baciccio, because the cases were not necessarily designed by these artists; however, for a bibliography, see my article 'Another Clock painted by Baciccio?', *Burlington Magazine*, CXVIII, 1976, pp.852–5.

1 Montagu, 1989, p.115.

2 Baldinucci, 1847, V, pp.579–704.

3 Baldinucci, 1847, V, p.587.

4 Chantelou, 1985, *passim*; Gould, 1982, *passim*.

5 Bernini, 1713, p.158.

6 For example, we know of only two autograph *bozzetti* by Bernini for his *St Longinus*, yet Joachim von Sandrart tells us that Bernini showed him twenty-two small models for this figure alone (see Wittkower, 1990, pp.250–51, under cat.no.28).

7 Wittkower, 1966, p.268, cat.no.81(17).

8 Lavin, 1975, p.6, doc.42; Montagu, 1989, p.116 and n. 61.

9 Lavin, 1975, p.7, doc.48; Montagu, 1989, p.116 and n.62.

10 Montagu, 1989, p.116 and n.64.

11 The silver relief was destroyed (see Fraschetti, 1900, p.229; Wittkower, 1990, p.302, cat.no.81(39)).

12 On 28 October 1640 Remigio Chilazzi was paid 75 *scudi* for 'quattro cornici d'ebano e tartaniga, fatti da lui conforme il disegno e stima del Signor Cav. Bernino': see Oskar Pollak, *Die Kunsttätigkeit unter Urban VIII*, Vienna, 1931, II, p.399. The carved frame made to Bernini's design and gilded by Daret for Paolo Bernini's marble relief of *The Christ Child* was published by Marc Worsdale in *Revue de l'Art*, LX 1, 1983, pp.61–72. See also Chantelou, 1985, pp.217, 220 and 248–9.

13 Vincenzo Golzio, *Documenti artistici sul Seicento nell'archivio Chigi*, Rome, 1939, p.348; Wittkower, 1966, p.296, cat.no.37. Bernini also did drawings for fire-dogs of Venus and Vulcan: see Montagu, 1989, pp.118–21, figs.145 and 147.

14 Wittkower, 1966, p.269, cat.no.24.; Pollak, 1931, I, p.173; Wittkower, 1966, p.269, cat.no.30.

15 Georgina Masson, *Papal Gifts and Roman Entertainments in honour of Queen Christina's Arrival*, in *Queen Christina of Sweden: Documents and Studies*, Stockholm 1966, pp.244–51; Montagu, 1989, pp.188–90.

16 Krautheimer and Jones, 1975, pp.199–233.

17 Chantelou, 1985, p.283; Giulia Fusconi, 'Disegni Decorativi di Johann Paul Schor', *Bolletino d'Arte*, 1985, 33–4, pp.159–80.

18 Rome, 1981, pp.241–2, cat.nos.241–2.

19 González-Palacios, 1970, pp.718–23. For the marble, see Wittkower, 1990, p.231, cat.no.3.

20 George L. Bauer, 'Bernini's Organ-Case for Sta Maria del Popolo', *Art Bulletin*, 1980, pp.115–23.

21 Quoted in González-Palacios, 1970, p.720.

22 Per Bjurström, *Feast and Theatre in Queen Christina's Rome* (Analecta reginensia III), Stockholm, 1966, p.53.

23 Wittkower, 1966, pp.211–12; Fagiolo dell'Arco, 1967, cat.no.232; Montagu, 1989, p.119, figs.144 and 146, and nn.68–9.

24 Montagu, 1989, pp.124–5, fig.157.

25 Alvar González-Palacios, 'Avvio allo Studio della Mobilia Romana', in Lizzani, 1970, p.ix.

26 Rudolf Wittkower, 'Carlo Rainaldi and the Roman Architecture of the full Baroque', *Art Bulletin*, XIX, 1937, pp.278–93; Alan Braham and Hellmut Hager, *Carlo Fontana: The Drawings at Windsor Castle*, London, 1977.

27 See Lizzani, 1970, pls.XXVI, XXXVIII and figs.7, 40, 98, 105 and 107.

28 Montagu, 1989, pp.49–51, figs.56–8; Rome, Palazzo Venezia, *Mostra del Domenichino*, exhibition catalogue edited by Richard E. Spear, 1996–7, especially Giovanni Curcio, 'L'architettura esatta di Domenichino', pp.151–61, and Giampiero Cammarota, 'La 'Memoria Agucchi' in San Giacomo Maggiore a Bologna', pp.232–6.

29 Chantelou, 1985, p.326.

30 For Cortona as a designer of tapestries, see David Dubon, *The History of Constantine the Great, designed by Peter Paul Rubens and Pietro da Cortona: Tapestries from the Samuel H Kress Collection at the Philadelphia Museum of Art*, London, 1964; Oreste Ferrari, *Arazzi italiani del Seicento e Settecento*, Milan, 1982 (reprint of 1958 ed.).

31 See Rome, Gabinetto dei Disegni e delle Stampe, *Disegni di Pietro da Cortona e Ciro Ferri*, exhibition catalogue by Maria Giannatiempo, 1977, and Rome, 1986. See also Giulia Fusconi, 'Per la storia della Scultura Lignea in Roma: Le Carrozze di Ciro Ferri per due ingressi solenni', *Antologia di Belle Arti* (Nuova serie), 21–22, 1984, pp.80–97.

32 Montagu, 1985, I, pp.9–10 and p.237, n.3.

33 Montagu, 1989, p.115 and n.53.

34 Montagu, 1985, II, p.17.

35 *Ibid.*, I, p.69; II, p.460, cat.no.A.209, figs.54–5.

36 *Ibid.*, I, pp.34–5, figs.42–3; II, p.208, figs.23–4.

37 *Ibid.*, I, pp.67–8, fig.64; II, p.485, cat.nos.83–4 in the checklist of drawings.

38 *Ibid.*, I, p.87 and n.22; II, pp.258–9, cat.no.LA207.

39 *Ibid.*, I, pp.109–10, fig.122; II, p.484, cat.no.72 in the checklist of drawings.

40 *Ibid.*, I, pp.109–10, fig.120; II, p.484, cat.no.74 in the checklist of drawings.

41 *Ibid.*, I, pp.109–10, fig.121; II, p.485, cat.no.79 in the checklist of drawings.

42 Edinburgh, Scottish National Portrait Gallery, *John Michael Wright: the King's Painter*, exhibition catalogue by Sara Stevenson and Duncan Thomson, 1982, pp.25–9, 53 n.38. The 1688 English edition is entitled *An Account of His Excellence Roger Earl of Castlemaine's Embassy, From His Sacred Majesty James the IId to His Holiness Innocent XI. Published formerly in the Italian Tongue*, and was dedicated to Mary of Modena.

43 Montagu, 1989, pp.191–7; Georgina Masson, 'Food as a Fine Art in Seventeenth Century Rome', *Apollo*, LXXXIII, 1966, pp.338–41.

44 For an excellent survey, see Whitman and Varriano, 1983, pp.9–16.

45 Duc de Chaulnes, *Instructions données*, Rome, 1666, I, p.194.

46 In addition to the medal design discussed under cat.no.159, another design by Algardi for an unexecuted medal reverse is in the Art Gallery of Ontario, Toronto (see Montreal, Museum of Fine Arts, *Italian Drawings from North American Collections*, 1970, cat.no.48). It shows St Agnes with the lamb hovering in the sky to the left of the façade of Sant'Agnese in Piazza Navona. In spite of strong evidence to the contrary, I still suspect that the reverse of the large medal of Alexander VII showing *Androcles and the Lion* (cat.nos.166a and b) depends on a drawing by Cortona or one of his assistants.

CATALOGUE

I: Portraits of Bernini, Portrait Drawings and Caricatures

PAGES 47–63

1 Brauer and Wittkower, 1931, I, p.156, n.3 cited by Sutherland Harris, 1977 (1). p.x, n.21.

2 Chantelou, 1985, p.253 (5 October). It is not clear whether the promised portrait for Chantelou was ever forthcoming.

3 Sutherland Harris, 1977 (1), p.vii.

4 Wittkower, 1990, p.233.

5 Brauer and Wittkower, 1931, I, p.15.

6 Chantelou, 1985, p.69 (22 July); and especially p.229 (26 September).

7 Chantelou, 1985, p.258 (6 October).

8 Sutherland Harris, 1977 (1), p.xvi, cat.no.38; Princeton, 1981, p.297, n.1; Wittkower, 1990, p.253.

9 Brauer and Wittkower, 1931, I, pp.156–7 and n.1. Giovanni Francesco Grimaldi evidently used this or another portrait of Castelli by Bernini as the basis for his engraved frontispiece portrait of 1641, which credits the design to Bernini. See Sutherland Harris, 1977 (1), p.xvii cat.no.36. Other portrait drawings by Bernini may similarly have been made to be engraved, although no other corresponding prints are known.

10 Princeton, 1981, pp.294–301, cat.no.83.

11 Chantelou, 1985, p.40 and n.121 (23 June).

12 *Ibid.*, pp.43–4, and n.130 (28 June); p.89 (29 July); p.92 (30 July); p.165 (4 September).

13 Chantelou specifies that the self-portrait drawing executed in Paris for Colbert (see n.2 above) was drawn in red chalk.

14 See, for example, Chantelou, 1985, p.16 (5 June), and p.69 (22 July). See also Montagu's comments on this subject (1985, I, p.159).

15 Bernini's indebtedness to Carracci was noted by Brauer and Wittkower, 1931, I, p.14 and Sutherland Harris, 1977 (1), p.ix.

1

1 See Bernardina Sandi's entry in *The Dictionary of Art*, 1996, 19, p.205. Leoni's drawing of Bernini is reproduced in Princeton, 1981, p.28, fig.7.

2 See Brauer and Wittkower, 1931, I, p.15.

2

1 For this much published portrait see Parker, 1956, II, p.417; and, more recently, Rome, 1992, cat.no.31. Sutherland Harris alone has questioned the identification of the sitter (1977 (1), p.xv, cat.no.23).

2 Sutherland Harris, 1977 (1), p.viii.

3 Rome, 1981, p.22, fig.6.

4 See the detailed discussion in Wittkower, 1951, pp.51–2.

3

1 The handling of the pen and ink would be particularly well suited for translation into etching.

2 Rosa's authorship was rejected by Michael Mahoney, *The Drawings of Salvator Rosa*, PhD. Dissertation, 2 vols., 1965 (published 1977), II, p.792.

3 Rome, 1981, pp.40–41, cat.no.5.

4

1 For the Oxford drawing see Parker, 1956, II, p.418, cat.no.794; for the Holkham Hall version, and a discussion of the relationship between the two, see Christie's, London, *Old Master Drawings from Holkham*, 2 July 1991 (lot 33; unsold).

5

1 For the drawing see Blunt and Cooke, 1960, p.26, cat.no.54; Sutherland Harris, 1977 (1), p.xxii, cat.no.84; London, 1986, p.125, cat.no.85.

2 Chantelou, 1985, pp.14–15 (6 June 1665).

6

1 For another example see Rome, 1981, p.307, cat.no.324.

2 An unpublished and much larger profile image of Bernini in bronze, in the collection of Michael Hall in New York, may also depend on a model by Chéron. It is truncated just below the neck, and does not therefore reveal the considerable portion of the bust that appears in Chéron's medal.

3 Fausto Amidei (ed.) *Ritratti di alcuni celebri pittori del secolo XVII, Disegnati, ed intagliati in rame del Cavaliere Ottavio Lioni, Con le Vite de' medesimi tratte da varj Autori, accresciute d'Annotazioni ...*, Rome, 1731, p.123.

7

1 The painting appeared at auction at Sotheby's, London, 16 April 1980 (lot 298). It is listed, but not illustrated, in Fagiolo dell'Arco and Pantanella, 1996, p.50, cat.no.46, where it is dated to *c*.1679 and identified, probably erroneously, with a picture formerly in the Geymüller Collection, London, which is in turn stated (again, apparently without foundation) to have belonged to Queen Christina of Sweden.

2 For the document, see Enggass, 1964, p.182, who, however, saw no connection with the Rome portrait, which he dated to *c*.1673 (pp.151–2). Enggass reiterated this dating in his entry on Baciccio in the *Dictionary of Art*, 1996, 12, p.200. The identity of the documentary reference and the portrait in Rome was proposed by Busiri Vici, 1967, p.284. A good replica of the Rome portrait, with an early French provenance, was sold at Christie's, London, 9 April 1965 (lot 25), as Baciccio.

3 Busiri Vici, 1967, pp.282–7, discusses these versions. The purpose of Busiri Vici's article was to demonstrate the primacy of a smaller version of the present portrait (it excludes the sitter's hand) in a Roman private collection (in reality, his own). The emergence of the picture catalogued here, which is unquestionably autograph, suggests that the ex-Busiri Vici canvas must be at best an autograph replica by Baciccio. Nevertheless, many of the arguments he put forward in making his case may be transferred directly to the present canvas.

4 Fausto Amidei (ed.), *Ritratti di alcuni celebri pittori del secolo XVII, Disegnati, ed intagliati in rame del Cavaliere Ottavio Lioni, Con le Vite de' medesimi tratte da varj Autori, accresciute d'Annotazione ...*, Rome, 1731, p.145. Cited by Busiri Vici, *loc. cit.*, p.284.

5 By Busiri Vici, 1967, followed by Fagiolo dell'Arco and Pantanella (*loc. cit.*).

8

1 See, for example, London, 1974, cat.no.135; Turner, 1980, p.38, cat.no.10. Turner has since qualified his acceptance of the drawing, which will be published as 'Attributed to Bernini' in his forthcoming catalogue of Roman Baroque drawings in the British Museum.

9

1 For the full provenance and bibliography, see Tokyo, 1996, pp.196–7, cat.no.73, where Sutherland Harris's rejection of Bernini's authorship is refuted.

2 See Brauer and Wittkower, 1931, I, p.14, and, most recently, Tokyo, 1996, pp.196–7, cat.no.73. Turner, 1999 (forthcoming) is more cautious on this subject.

3 Wittkower, 1951, p.55 and n.22. His identification of this drawing as a youthful *Self-portrait* and consequent dating of it to 1610–12 are unacceptable.

4 Blunt and Cooke, 1960, p.26, cat.no.59. It is not certain that the form cradled in the youth's arms represents the head of Goliath, although this seems likely.

5 Fagiolo dell'Arco, 1967, cat.no.248(h).

6 Milan, Stanza del Borgo, 1970, *Visi e figure in disegni italiani e stranieri dal Cinquecento all'Ottocento*, cat.no.34.

10

1 For the drawing's provenance and previous exhibition history see London, 1990, pp.68–9, cat.no.28. The possibility that the sitter may be a girl rather than a boy should not be completely excluded. Bernini's famous portrait drawing of *Scipione Borghese* (fig.34) is not quite in strict profile.

11

1 See Brauer and Wittkower, 1931, I, p.16; Blunt and Cooke, 1960, p.26, cat.no.53. Sutherland Harris (1977 (1), p.xvii, cat.no.34) rejected this identification and dated the portrait to *c*.1635. Fagiolo dell'Arco, 1967, cat.no.248(m) puzzlingly rejected the attribution of the drawing to Bernini on the grounds of its high degree of finish ('l'eccessiva finitezza').

12

1 This identification was proposed by Brauer and Wittkower, 1931, I, p.14, but rejected by Blunt and Cooke, 1960, p.26, cat.no.55, and by Sutherland Harris, 1977 (1), p.xv, cat.no.24.

2 A conclusion arrived at by Fagiolo dell'Arco, 1967, cat.no.248(i); and Sutherland Harris (*loc. cit.*).

13

1 See Byam Shaw, 1976, p.170, cat.no.621; Mario Di Giampaolo and Nicholas Turner, 'James Byam Shaw: Drawings by Old Masters at Christ Church, Oxford' (review), *Prospettiva*, 14, 1978, p.75. Byam Shaw (*loc. cit.*) advanced several arguments in favour of Bernini's authorship of the drawing. As other examples in this exhibition demonstrate, Bernini's use here of red and white chalk alone was not as unusual as Byam Shaw suggested.

14

1 See Wittkower, 1951, p.55; Parker, 1956, pp.417–8, cat.no.793; Pignatti, 1977, cat.no.63. Fagiolo dell'Arco, 1967, cat.no.248(e), rejected the identification.

2 Parker (*loc. cit.*) bravely discerned a parallel between this drawing and Bernini's marble bust of Costanza Bonarelli, and accordingly dated the drawing to about 1635 (although the bust is now thought to date from a little later). Wittkower (*loc. cit.*) suggested an earlier dating to *c*.1628 on the assumption that it was a self-portrait.

15

1 The drawing is fully attributed to Bernini in Nicholas Turner's forthcoming catalogue of Roman seventeenth-century drawings in the British Museum, where Ann Sutherland Harris's view that it is a copy is noted and rejected.

2 Sotheby's, London, 21 May 1963 (lot 67) and Sotheby's, 30 October 1980 (lot 127). The earlier sale catalogue notes an inscription on the mount identifying the sitter as Pietro da Cortona, but this is not borne out by comparison with Cortona's documented *Self-portrait* in the Uffizi, Florence.

16

1 See Ann Sutherland Harris's entry in *An Exhibition of Old Master Drawings*, Colnaghi, New York, Paris and London, 1993, cat.no.30. I am grateful to Luca Baroni for supplying the photograph reproduced here.

17

1 Brauer and Wittkower, 1931, I, p.16.

18

1 Brauer and Wittkower, 1931, I, p.156, suggested that it dated from the late 1640s or early 1650s.

2 See Sutherland Harris, 1977 (1), p.xv, cat.no.22.

19

1 The drawing was published in *Old Master Drawings*, exhibition catalogue, Yvonne Tan Bunzl, London, 1984, cat.no.29.

20

1 For Carracci caricatures see Donald Posner, *Annibale Carracci: A Study of the Reform of Italian Painting around 1590*, 2 vols., London, 1971, I, pp.65–70.

2 See Mahon, 1947, especially pp.259–65. This publication would certainly have been known to Bernini since its author, Monsignor Giovanni Antonio Massani, was *Maestro di Casa* of Urban VIII, with whom, as is well known, the artist was on intimate terms.

3 On Bernini's caricatures see Ann Sutherland Harris, 'Angelo de' Rossi, Bernini, and the Art of Caricature', *Master Drawings*, 1975, XIII, 2, pp.158–60; and especially Irving Lavin, 'Bernini and the Art of Social Satire' in Princeton, 1981, pp.27–54.

4 Sutherland Harris (*loc. cit.*) convincingly challenged the traditional view that these are autograph caricatures by Bernini.

5 See Lavin's fascinating analysis of this caricature and its frame of references (*loc. cit.*, pp.40–46).

6 I am very grateful to Richard Hemphill for his helpful observations about these two caricatures.

II : Portrait Busts

PAGES 64–79

21

1 For the details, see Wittkower, 1990, pp.237–8, cat.no.13.

2 See Wittkower, 1990, p.233, cat.no.7.

3 Baldinucci, 1682, p.86.

4 Chantelou, 1985, pp.125–6 (17 August 1665).

5 Irving Lavin, 'Bernini's Portraits of Nobody', in *Past-Present: Essays on Historicism in Art from Donatello to Picasso*, Berkeley, 1993, pp.125–9, Appendix A.

6 As noted by Fioravante Martinelli, *c*.1662: see Hibbard, 1965, p.237, n.64.

7 See Justo Fernandez Alonso, *S Maria di Monserrato* (Chiese di Roma, 103), Rome, 1968, pp.103–6.

8 The bust was formerly in the collection of Sir Martin Wilson, Bart., and was sold at Sotheby's, London, 1 November 1991 (lot 322), and again on 2 July 1997 (lot 246).

9 See Chantelou, *loc. cit.* at n.4.

22

1 Sheila Rinehart, 'A Bernini Bust at Castle Howard', *Burlington Magazine*, CIX, 1967, pp.437–43.

2 Baldinucci, 1847, V, p.695.

3 Francis Haskell and Sheila Rinehart, 'The Dal Pozzo Collection: some New Evidence', *Burlington Magazine*, CII, 1960, p.323, Appendix 1, n.7.

4 *Ibid.*, p.323, Appendix 2.

5 Domenico Valla, 'Vita di Carlantonio dal Pozzo, Arcivescovo di Pisa', *Giornale dell' Accademia di Torino: Scienze Morali, Storiche e Filologiche*, 2nd series, LIII, 1908, pp.221–52.

6 We are extremely grateful to Arabella Cifani and Franco Monetti for sharing their archival discoveries with us, and for so generously allowing their first publication here. The archival reference to the death-mask may be found in the Archivio di Stato di Biella, Archivio Dal Pozzo Della Cisterna, Testamenti e Successioni, Mazzo no.6. The date given in the document, 1608, follows the Pisan calendar. This material, and that cited in note 9 below, will be published by Cifani and Monetti as part of a broader study of the patronage and collecting of the Piedmontese branch of the Dal Pozzo family.

7 See Lavin, 1968, pp.224–6, 244 (documents 1 and 3).

8 For the portrait of Antonio Coppola, we know that Bernini relied precisely on this combination of death-mask and painted portrait (*ibid.*). Jennifer Montagu (1985, I, p.171) has analysed the distinctive characteristics of Algardi's portraits based on death-masks, and her perceptive observations apply equally well to Bernini

9 These documents too were discovered and made available to us by Arabella Cifani and Franco Monetti. The 1607 references appear in a 'Nota delle Robbe' which are to be sent to Don Amedeo dal Pozzo in Florence, which forms part of the same archival bundle as that cited in note 6. The 1634 inventory, which contains later addenda, is entitled 'Inventaro di quadri di Pittura dell' Illustrissimo Signor Don Amedeo del Pozzo, Marchese di Voghera' and may be found in the Archivio di Stato di Biella, Archivio Dal Pozzo della Cisterna, Serie II, Mazzo 16.

10 Included in the exhibition *Livorno e Pisa: due città e un territorio nella politica dei Medici*, Pisa, Museo Nazionale di San Matteo, 1980, p.461, cat.no.B.IV.19.

11 See Donatella L. Sparti, *Le Collezione dal Pozzo: Storia di una famiglia e del suo museo nella Roma seicentesca*, Modena, 1992, p.178.

12 *ibid.*, p.37

13 The only other candidate as patron of the bust is Cassiano's younger brother and name-sake of the Archbishop, Carlo Antonio (1606–1689), with whom he later shared his Roman palace. However, he can safely be excluded as patron on the grounds that he was only a year old when the Archbishop died, and was still in his middle 'teens when the bust was carved.

14 For these busts and their dating, see Lavin, 1968, pp.239–43, who particularly stresses the stylistic links between the Dal Pozzo and Cepparelli busts (p.242, n.128).

15 See Irving Lavin, 'Bernini's Bust of Cardinal Montalto', *Burlington Magazine*, CXXVII, 1985, pp.32–8.

16 See Donatella L. Sparti 'The Dal Pozzo Collection again the inventories of 1689 and 1695, and the family archive', *Burlington Magazine*, CXXXII, 1990, pp.55–70. See also Sparti, *op. cit.* at n.10 above, pp.37, 135, 203, 212.

23

1 The medal has been discussed by Graham Pollard, 'Some Roman Seventeenth-Century Portrait Medals', *Studi Seicenteschi*, VII, 1966, pp.97–9 and fig.VI; and Donatella Sparti, 'Carlo Antonio dal Pozzo (1606–1689): An Unknown Collector', *Journal of the History of Collections*, II, 1, 1990, pp.7–19. In both cases the medal is attributed erroneously to Gaspare Mola. The present attribution to Travani was plausibly suggested on stylistic grounds by Aidan Weston-Lewis. It compares especially well, for example, with Travani's medal of Filippo Lauri (for which see Pollard, *loc. cit.*, p.151, fig.15).

2 For further details, see Sparti, *loc. cit.*, pp.9–10.

24

1 Avery, 1997, p.90, pl.101.

2 See Wittkower, 1990, p.243, cat.nos.19(4) and (4a), who specifies that the bronze formerly in Santa Maria di Monte Santo was cast by Girolamo Lucenti, although there is some doubt about this.

3 Avery, 1997, pp.88–9, pl.100.

4 Wittkower, 1990, p.243, cat.no.19(5).

25

1 Antonia Nava Cellini, 'Un tracciato per l'attivita ritrattistica di Giuliano Finelli', *Paragone*, 131, 1960, pp.9–30. Nava Cellini was the first to distinguish two principal phases in Finelli's earlier career, his Roman (1622–36) and Neapolitan (1637–47) periods.

2 See Pope-Hennessy, 1964, II, pp.609–11, who provides a detailed discussion of the provenance and attribution of the Bracciolini bust, together with biographical details of the sitter.

3 Notably Montagu, 1985, I, pp.132–3, 244–5, II, p.473; Claudio Pizzorusso, *A Boboli e altrove: Sculture e scultori fiorentini del Seicento*, Florence, 1989, pp.113–16; Montagu, 1989, pp.104–7; Damian Dombrowsky, *Giuliano Finelli: Bildhauer zwischen Neapel und Rom*, Frankfurt am Main, 1997

4 See Dombrowsky, 1997, p.330.

5 For a characterisation of Algardi as a portraitist, see Montagu, 1985, I, pp.157–78. The bust by Algardi which is perhaps most comparable to Finelli's *Francesco Bracciolini*, is the *Laudivio Zacchia* in Berlin, datable to 1637 or later (*ibid.*, I, pp.171, 175, II, pp.446–7, cat.no.131).

6 For the Buonarroti bust, see Nava Cellini, *loc. cit.*

7 On Cassiano's collection of portraits, see Francesco Solinas, 'Cassiano dal Pozzo (1538–1657): Il Ritratto di Jan Van den Hoecke e l'*Orazione* di Carlo Dati', *Bolletino d'Arte*, 92, 1995, pp.141–64. The portrait illustrated here is the only known painted portrait of Bracciolini, and may have been the subject of one of the poems by the Jesuit Ippolito Margarucci mentioned by Pope-Hennessy, 1964, II, p.611.

26

1 Gudrun Raatschen, 'Plaster casts of Bernini's bust of Charles I', *Burlington Magazine*, CXXXVIII, 1996, pp.813–16, pls.43–48

2 Avery, 1997, pp.225–8; Lightbown, 1981, pp.439–76.

3 I do not accept the attribution to Dieussart of the original bust from which the Windsor version was carved, *pace* M. Vickers, 'Rupert of the Rhine. A new portrait by Dieussart and Bernini's Charles I', *Apollo*, CVII, 1978, pp.161–69.

4 Raatschen, *loc. cit.*, pl.45.

27

1 For the circumstances of the bust's commission, its authorship and its subsequent history, see Pope-Hennessy, 1964, II, pp.600–606, cat.no.638; Wittkower, 1981, p.208, cat.no.40; Lightbown, 1981, pp.453–63; Avery, 1997, pp.225–30.

2 This is Wittkower's conclusion (p.208).

3 Remark recorded by Chantelou, 1985, p.185 (11 September 1665).

4 See Fagiolo dell'Arco, 1967, p.199 and Lavin, 'Bernini and the Art of Social Satire', in Princeton, 1981, pp.27–54.

28

1 For full discussion of the bust and the related tomb, see Montagu, 1985, I, pp.164, 171–4; II, pp.223–5, cat.nos.124 and 124.A.1.

2 It was included in Christie's sale of 18–19 July 1917, *Catalogue of Objects of Art, etc. ... being a portion of the Hope Heirlooms removed from Deepdene, Dorking, the property of Lord Francis Pelham Clinton Hope*, (lot 267): 'A Cardinal: A life-size bust, in statuary marble, the socle sculptured with his coat-of-arms'. It was bought for £110.5.0 by Mrs W. Burns. The bust was then offered on 6 May 1926 by Sotheby's, the property of Walter S. Burns, Esq., when it was presumably bought in, for it was then re-offered by Major-General Sir George Burns through Christie's at North Mymms Park on 24 September 1979 (lot 14). There it was bought by Thomas Agnew & Sons, with Manchester City Art Gallery as the under-bidder, and offered to the Metropolitan Museum of Art in New York. After its export was deferred, the bust was finally bought by Manchester with the help of a public appeal.

3 See Montagu, *loc. cit.*

4 For the Santarelli monument, see *ibid.*, I, p.178; II, pp.442–3, cat.no.174.

5 For this bust, see *ibid.*, II, p.441, cat.no.171.

6 *Ibid.*, II, p.424.

7 Sabine Jacob, *Italienische Zeichnungen der Kunstbibliothek Berlin: Architektur und Dekoration, 16 bis 18 Jahrhundert*, Berlin, 1975, p.79, cat.no.366 (as Roman, after 1640).

8 The source, cited by Montagu (*loc. cit.*), is Antonio Francesco Marmi's unpublished *Notizie di Professori del Disegno* (Florence, BN., II. II. 11°, f.54).

29

1 Pope-Hennessy, 1964, p.626, cat.no.660 (with full discussion under cat.no.659). The busts are probably identical with a pair in a sale of 1821 at Aix-en-Provence ascribed respectively to Algardi (Innocent X) and Bernini (Alexander VIII).

2 Montagu, 1985, II, p.431, cat.no.156, pls.143, 176.

3 *Ibid.*, II, p.431, cat.no.156.D1.; David Bershad, 'A Series of Papal Busts by Domenico Guidi', *Burlington Magazine*, CXII, 1970, pp.805–8; *idem.*, entry for Domenico Guidi in *The Dictionary of Art*, London, 1996, 13, pp.814–16.

4 Montagu, *loc. cit.* at n.2.

5 *Ibid.*, I, pp.158–59; Avery, 1997, p.90, pls.102–3.

6 *Ibid.*

30

1 The drawing has just been published, with an entry by Stephen Ongpin, in *Master Drawings*, exhibition catalogue, Colnaghi, New York and London, 1998. Jennifer Montagu has expressed reservations regarding the attribution of this sheet to Algardi.

2 Montagu, 1985, I, p.159 and fig.172; II, p.482.

3 *Ibid.*, II, p.481, fig.181.

4 Nicholas Turner, Lee Hendrix and Carol Plazzotta, *European Drawings 3: Catalogue of the Collections, J. Paul Getty Museum*, Los Angeles. 1997, pp.2–3, cat.no.1.

5 A direct connection with one of these medals is, however, precluded by the fact that both show the pope with the tiara rather than the papal cap visible in the drawing.

6 Montagu, 1985, II, pp.429–30, cat.no.154.

31

1 Luke I, 28.

2 St Bernard, *Il Perfetto Legendario*; see also the *Protevangelism*, IX, 7.

3 It is described twice: (i) 'The statuary in the library consists of … an exquisite piece of sculpture in the pure Cararra marble, toned with age, representing the half-length draped figure of a female saint, which was formerly fixed to the wall of a church near Rome, and is attributed to Bernini' (A.H. Millar, *The Historical Castles and Mansions of Scotland: Perthshire and Forfarshire*, Paisley, 1890); and (ii) 'In the library, a glorious apartment, there is some rare sculpture, including a Seventeenth Century bust by Bernini …' (Lawrence Melville, *The Fair Land of Gowrie*, Coupar, 1939, p.83).

4 Bacchi, 1996, pp.810–12, fig.479, quoting the *Zibaldone baldinucciano: scritti di F Ba*.*dinucci, L Berrettini, B De Dominici, G C Sagrestani, ed altri* (ed. B Santi), 2 vols., Florence 1980–81.

III : Paintings

PAGES 80–84

1 For this translation, see E.G. Holt (ed.), *A Documentary History of Art*, II, Princeton, 1982, pp.113–14.

32

1 The book Andrew holds possibly refers to the apocryphal *Acts of Andrew*. The story about Thomas derives from the fourth-century romance *The Acts of Thomas*, according to which he travelled to India as a missionary, where he is ordered by the heathen king Gundaphorus to design, build and pay for a palace.

2 Gabriele Finaldi kindly arranged for me to examine this and the following painting. For the Bernini see Valentino Martinelli, 'Le Pitture del Bernini', *Commentari*, I, 1950, pp.95–104; Fagiolo dell'Arco, 1967, pp.39, 42.

3 '*Un quadro con due teste di Apostoli, c[i]oe S.Andrea e S.Tomaso con cornice tuta dorata, alto plmi due e largo p.mi tre, di mano del Cavalier Bernino*' (Fraschetti, 1900, p.236). The picture remained in the Barberini collection until it was bought from Princess Henriette Barberini by Colnaghi's in 1967, from whom it was acquired by the National Gallery in the same year.

4 Cardinal Francesco Barberini paid Sacchi for this work on 16 June 1627: '*Un quadro, con due teste d'Apostoli*'. See Giovanni Incisa della Rocchetta, *L'Arte*, 1924, p.63; Lavin, 1975, p.38, no.303.

5 Michael Levey, *National Gallery Catalogues: The Seventeenth and Eighteenth Century Italian Schools*, London, 1971, p.206; Sutherland Harris, 1977(2), pp.51–2, cat.no.8.

6 Sutherland Harris, 1977 (2), cat.no.218: '*Un quadro con due Teste di S[an] Fran[ces]co e S[an] Antonio...*' ('A painting with two heads of Saint Francis and Saint Anthony…').

7 Both the Bernini and the Sacchi have been lined. Examination of the original canvases suggest that the Bernini was slightly cut down in order to match the Sacchi, perhaps at the time of the lining. The sizes of the two original canvases are similar, but the paint layer on the Sacchi bleeds away to the edges, whereas the Bernini has clearly been slightly cropped to the left and right in order to achieve these dimensions. Furthermore, the discrepancy between the sizes of the two paintings must originally have been even greater than this alteration implies because on the Sacchi there is an opened up tacking edge about 5.1cm in from the right edge of the original canvas, so it was at one point early in its history mounted on an even smaller stretcher. If works on this relatively small scale were intended to be pendants from the outset it would be reasonable to expect that their dimensions would be very similar. The lining of both paintings involved placing them on larger canvases, strips of which were left exposed to the left and right, and painted to match the colour and tonality of the original works. This was presumably carried out in order to make them conform with a new decorative or framing scheme in the Barberini household. The inventory numbers '40' and '41' begin on the lining canvases, and so must post-date this development. The canvas used for the lining of the Bernini shows traces of the work of another artist (an indistinct, foreshort-ened hand is visible at the lower left of the X-ray). There is one other factor which suggests the early histories of the two pictures were different: the Sacchi bears another inventory number on the opened up area of the original canvas, but there is no corresponding number on the Bernini.

33

1 For Sacchi see Sutherland Harris, 1977(2).

2 For an excellent discussion of this problem, *ibid.*, pp.30–33.

3 Levey, *op. cit.* at cat.no.32, note 5, pp.205–6; Sutherland Harris, 1977(2), pp.51–2, cat.no.8.

4 Sutherland Harris, 1977(2), pp.51–2, cat.no.8, with further discussion of this dating.

5 Levey, 1971, pp.205–6.

6 Sutherland Harris, 1977(2), Appendix II, cat.no.218.

7 Levey, 1971, p.206, n.4. The picture is more certainly recorded in the Barberini Palestrina inventory of c.1738 (see Hans Posse, *Der römische Maler Andrea Sacchi*, Rome, 1925, p.109, n.2). It remained in the possession of the Barberini family until 1966 when it was acquired from Princess Henriette Barberini by Colnaghi's, by whom it was presented to the National Gallery in 1967.

34

1 Anthony Blunt, 'Poussin Studies – I: Self-Portraits', *Burlington Magazine*, LXXXIX, 1947, pp.219–26.

2 Anthony Blunt, *The Paintings of Nicolas Poussin, A Critical Catalogue*, London, 1966, p.169, cat.no.R1; idem., *Nicolas Poussin*, London, 1967 (1995 re-print), fig.90., p.96; Fagiolo dell'Arco, 1967, p.27 and cat.no.38. Timothy Clifford, who negotiated the loan of the picture to this exhibition, firmly believes it to be by Bernini himself.

3 See Oxford, Ashmolean Museum, *A Loan Exhibition of Drawings by Nicolas Poussin from British Collections*, exhibition catalogue by Hugh Brigstocke, 1990, cat.no.24.

4 *Self-Portrait*, 1649, Staatliche Museen zu Berlin, Gemäldegalerie; *Self-Portrait*, 1649–50, Paris, Musée du Louvre.

5 Della Pergola, 1959, II, pp.72–4, cat.nos.107–9.

6 Chantelou, 1985, p.181; Louise Rice, *The Altars and Altarpieces of New St Peter's: Outfitting the Basilica, 1621–1666*, Cambridge, 1997, p.228.

7 Chantelou, 1985, pp.77–8, 110.

35

1 For Strange see Ingamells, 1997, pp.904–6.

2 The painting is not mentioned in Sutherland Harris, 1977 (2).

3 I am grateful to Pamela Robertson for tracking down this description and for arranging for me to examine the painting. It is cat.no.11 in the Christie's *Catalogue of a Collection of Pictures selected from the Roman, Florentine, Lombard, Venetian, and other Schools... The Whole collected during a Journey of several Years in Italy and France, By Robert Strange*, February 1771.

4 The attribution to Bernini was first suggested by Sir Denis Mahon (letter of 1952 in the Gallery files) and was accepted in New York, Knoedler Gallery, *Masters of the Loaded Brush*, 1967, cat.no.6. Later correspondence in the Gallery files includes attributions to a Dutch artist, or a painter working in the circle of Caravaggio. The painting has been exhibited on two other occasions: London, Kenwood House, The Iveagh Bequest, *The Hunterian Collection*, 1952, cat.no.10; London, Colnaghi and Co., *Glasgow University's Pictures*, 1973, cat.no.1.

5 The paper is mounted on canvas, although records in the Gallery file show that it was lifted in 1916–17 from a panel support, and only then laid on canvas, retouched and re-varnished. The area of the boy's eye and eyebrow in shadow have seemingly been strengthened, perhaps with ink rather than oil paint.

6 See, for example, New York, Lester Carissimi and Christian Lapeyre, *Italian Master Drawings and Oil Sketches* (Pandora Old Masters catalogue), 1998, cat.no.9.

36

1 See Alastair Laing, with a preface by Alec Cobbe, *The Cobbe Collection of Paintings*, National Trust and the Cobbe Foundation, 1992, p.13, cat.no.304. The attribution of the picture to Bernini is due to Sir Denis Mahon. Mr Cobbe kindly allowed me to examine the painting.

2 Della Pergola, 1959, pp.72–4, cat.nos.107–9.

3 Chantelou, 1985, p.165.

4 The painting was lightly cleaned when acquired by the present owner; examination under ultra-violet light showed that apart from old refills in the craquelure, there are only a few small paint losses to the upper left of the figure's head.

5 The subsequent provenance is as follows: The Earls of Amherst; Ian Greenlees; Christie's, London, 2 December 1993 (lot 51); Alec Cobbe.

6 The picture was exhibited as a portrait of Agostino by Annibale Carracci (see London, Agnew's, *The Seventeenth Century*, 1980, cat.no.7).

37

1 Catherine Whistler kindly provided information about this painting. Its provenance is as follows: Lord Belhaven and Stenton; Master of Belhaven sale, Sotheby's, London, 8 February, 1950 (lot 159), attributed to Velázquez; bought by Agnew's, from whom acquired by the Ashmolean Museum (France Fund) (1950.10). The picture was cleaned on acquisition; it has been lined and is in good condition, with only a few losses along the lower edge. The 1950 attribution to Velázquez, although completely unsustainable, is less odd than it may seem, since portraits linked with Bernini and Velázquez have been confused on a number of occasions in the past (see Enriquetta Harris, *Velazquez*, Oxford, 1982, pp.78–9).

2 Wittkower 1951, p.55, pl.21 (who argued that it is not a self-portrait). The attribution to Bernini was supported by Martinelli, 1953, cat.no.76 (who suggested the sitter might be Thomas Baker), and Fagiolo dell'Arco, 1967, cat.no.78. It has been exhibited as by Bernini as follows: London, Royal Academy of Arts, *Holbein and Other Masters*, 1950–1, cat.no.344; London, Wildenstein & Co., *Artists in 17th-Century Rome*, 1955, cat.no.6; London, Royal Academy of Arts, *Italian Art and Britain*, 1960, cat.no.377; London, Agnew's and Colnaghi's, *Horace Buttery Memorial Exhibition*, 1963, cat.no.25.

3 See Della Pergola, 1959, II, pp.72–4, cat.nos.107–9.

4 Rome, Villa Medici, *I Caravaggisti francesi*, exhibition catalogue, 1974, p.122; Jean-Pierre Cuzin, 'Jeunes gens par Simon Vouet et quelques autres. Notes sur Vouet portraitiste en Italie', *Revue du Louvre*, 1979, p.24, fig.22; Benedict Nicholson, *Caravaggism in Europe*, 2nd edition, revised by Luisa Vertova, 3 vols., 1990, p.200 (as Henry Traivel). A letter in the Ashmolean archive (1993) from Ann Sutherland Harris suggests the work might be an early painting by Vouet; Anne Bertrand (orally) suggests comparison with portraits from his Roman period, such as the one published by Stéphane Loire (ed.), *Simon Vouet, Actes du Colloque*, Paris, 1992, p.95 (the portrait illustrated on p.66, fig.1, also seems relevant). For Vouet-Bernini associations, see also Ann Sutherland Harris, 'Vouet, le Bernin, et la "resemblance parlante"', pp.193–208 in the same volume.

IV: Academic Nudes
PAGES 85–87

38

1 This inscription was revealed during conservation prior to this exhibition. Michele Maglia, or Michel Maille, was a French sculptor active in Rome between about 1678 and 1700. The identity of Cesare Madona has not been established.

39

1 For the Windsor drawing, see Brauer and Wittkower, 1931, I, p.10; Blunt and Cooke, 1960, p.26, cat.no.60; Sutherland Harris, 1977 (1), p.xiv, cat.no.8. For the privately owned drawing, see London, 1990, cat.no.27.

2 Sutherland Harris, 1977 (1), p.xiii, under cat.no.4.

3 The second drawing at Windsor (inv.no.5538) was catalogued by Blunt and Cooke (1960, p.81, cat.no.621) as by Pietro da Cortona, but it came from the Bernini volumes and is patently by the same hand as the *Male Nude seen from Behind* exhibited here. It is drawn on the same size and type of paper, is executed in the same two shades of chalk, and even carries an identical pencil inscription attributing it to Bernini. For the drawing in the Uffizi, see Sutherland Harris, 1977 (1), pp.xiii–xiv, cat.no.4.

4 See Sutherland Harris, 1977 (1), p.xiv, cat.no.7; Florence, 1997, p.177, cat.no.114. The dating of this sheet to twenty years before the fountain was executed seems unnecessarily to complicate matters.

5 It may be noted, however, that a partially draped model in another sheet in the Uffizi (Sutherland Harris, 1977 (1), p.xiv, cat.no.5) is posed against a lightly sketched stone wall which is presumably outside (in a courtyard?), since a plant is indicated growing from a crack between its stones.

6 For details of these events, see Noehles, 1970, pp.88, and 97, n.168–9. The frequently repeated assertion (see, for example, Bauer, 1976, p.127; Wittkower, 1990, p.306, Scribner, 1991, p.14) that Bernini was elected *Principe* of the Academy in 1621, the year of his knighthood, seems to be without foundation. Noehles (op. cit., pp.334–5, 362) publishes documentary evidence which seems to confirm that Paul Bril served as *Principe* in 1620 and 1621, followed by Pompeo Ferrucci in 1622 and Agostino Ciampelli in 1623.

7 In Paris, Bernini met one of his former pupils, Simon François de Tours, who reminded him that he had drawn at his school over a long period. See Chantelou, 1985, pp.301–2 (14 October).

8 One such 'accademia del nudo' evidently took place in the rooms of Cardinal Francesco Barberini; this may simply have been the venue for the life-drawing classes of the Academy. Another was run by Bernini's friend and patron Paolo Giordano II Orsini, Duke of Bracciano. For these, see Nikolaus Pevsner, *Academies of Art Past and Present*, Cambridge, 1940, pp.73–5.

9 Chantelou, 1985, p.55 (16 June).

10 *Ibid.*, pp.55–6 (16 June); and pp.280, 285–6 (10 and 11 October).

V: Small Bronzes, Reliefs and Reductions
PAGES 88–102

40

1 For the provenance and bibliography of both wooden reduction and marble original see Pope-Hennessy, 1964, II, p.609 and pp.596–600 respectively. For further copies of the original, see *ibid.*, p.600, and more recently S. Schütze in *Bernini scultore e la nascita del Barocco in casa Borghese*, exhibition catalogue edited by Anna Coliva and Sebastian Schütze, Rome, Galleria Borghese, 1998 (forthcoming).

2 Bronze versions of the group are in the Victoria and Albert Museum, the Galleria Borghese, the J. Paul Getty Museum and elsewhere. These evidently derive from a lost model by Bernini which consisted of the sea-god and a dolphin alone, rather than from the final marble. A fragmentary terracotta model for *Neptune*, differently composed, is in the State Hermitage Museum in St Petersburg (see Rome, 1991 (1), cat.no.13, pp.52–3).

3 Carla Benocci, 'Il giardino della Villa Peretti Montalto e gli interventi nelle altre ville familiari del cardinale Alessandro Peretti Montalto', *L'Urbe*, LV, 1995, pp.261–75; LVI, 1996, pp.117–31.

4 William Collier, 'New Light on Bernini's Neptune and Triton', *Journal of the Warburg and Courtauld Institutes*, XXXI, 1968, pp.438–40; Avery, 1997, p.180.

5 Archivio Storico Capitolino, Archivio Cardelli, Appendice 38, f.205: '20 marzo 1622, scudi 100 al cavaliere Gian Lorenzo Bernini quali si li paghano a bon conto d'una statua che lui fa per servitio del Giardino de Santa Maria Maggiore' ['20 March 1622, 100 scudi to Cavaliere Gian Lorenzo Bernini for payment on account for a statue he is making for use in the garden at Santa Maria Maggiore']; Appendice 55, f. 16v: '23 febbraio 1623. Signor Bonanni pagherete al cavalier Gio. Lorenzo Bonvino [sic] scudi 100 moneta, son per la statua fatta per il nostro giardino di Santa Maria Maggiore' ['23 February 1623. Signor Bonanni will pay to the Cavaliere Gio[vanni] Lorenzo Bernini 100 scudi, being for the statue made for our garden at Santa Maria Maggiore']. The complete set of payments can be found in Benocci, 1989, pp.83–6. For some of the dates assigned to Bernini's group see, for instance, Hibbard, 1965, p.39 (1619–20); Lavin, 1968, p.236 (1620–21); Wittkower, 1981, p.178 (1620). Faldi, 1954, p.43; D'Onofrio, 1957, p.188; Pope-Hennessy, 1964, p.600; and Avery, 1997, p.180 were instead already in favour of a later dating (1622–3).

6 Biblioteca Apostolica Vaticana, Archivio Barberini, Computisteria 29, Debitori e Creditori (di Maffeo Barberini), f.118: 'anno 1617 1 dicembre scudi 20 di moneta buoni al signor Roberto Primo pagati a ms. Pietro Bernino scultore per prezzo di una statuetta di marmo bianco di un putto sopra un drago marino' ['1 December 1617: 20 scudi paid by Signor Roberto Primo to Pietro Bernini, master sculptor, as the price of a statuette in white marble of an infant sitting on a marine dragon']; 'alli 29 dicembre 1617 scudi 50 moneta buoni al suddetto pagati al medesimo per prezzo di una statua di San Bastiano' ['On 29 December 1617: 50 scudi paid by the aforementioned [i.e. Roberto Primo] to the same person [i.e. Pietro Bernini] as the price of a statue of Saint Sebastian']. For previous opinions on the date of the Saint Sebastian see, for instance, Hibbard, 1965, p.29; Lavin, 1968, pp.233–4; Avery, 1997, p.31. Wittkower, 1981, p.174 suggested 1617-18. The firm dating to 1617 of the statuette of the Putto with a Dragon, which is now in the J. Paul Getty Museum (Fusco, 1997, p.4) suggests strongly on stylistic grounds that it is by Pietro Bernini rather than by Gianlorenzo. For further discussion of the implications of these payments see Schütze, loc. cit. at note 1 above.

7 See Lavin, 1985, pp.36–8.

8 Documents cited and discussed by Benocci, 1989, p.83.

41

1 The renown of these groups is attested by the numerous references to them in Chantelou's Diary. Among these there is mention of nine reductions in silver after Bernini statues, including Pluto Abducting Proserpina, commissioned by Colbert for Louis XIV.

2 For the Borghese group see Pope-Hennessy, 1963, catalogue volume, p.125; Wittkower, 1990, p.235, cat.no.10; Avery, 1997, pp.48–55.

3 See Avery, 1997, pp.48–9, figs.50–51.

4 Wittkower, 1990, pp.14–15, where it is suggested that the Pluto Abducting Proserpina, like the David, was indebted to Annibale Carracci's Galleria Farnese frescoes.

5 New York, Newhouse Galleries, Paintings from Emilia 1500–1700, exhibition catalogue, 1987, p.56, cat.no.13. The early provenance of Scarsellino's picture is unknown, but it is tempting to speculate that it may have been among the large number of Ferrarese paintings transferred to Rome after the annexation of the city by the Papal States in 1598. It is thought to date from relatively early in Scarsellino's career. I am most grateful to Adam Williams for supplying a photograph of the painting.

6 Peter Cannon-Brookes, 'Three Centuries of Sculpture', Apollo, LXXXVII, 1968, pp.255–6.

42

1 Wittkower, 1990, pp.239–40, cat.no.17; Avery, 1997, pp.55, 65–71, pls.70, 73–5.

2 See François Souchal, 'La Collection du sculpteur Girardon d'après son inventaire après-décès', Gazette des Beaux-Arts, LXXXII, 1973, p.62, under cat.no.92, fig.122. What may have been a wax reduction of Bernini's Apollo and Daphne is also recorded there. See also Montagu, 1996, p.4.

3 Fusco, 1997, p.4, where it is described as Italian, seventeenth century.

43

1 Wittkower, 1990, p.240, cat.no.18; Avery, 1997, pp.55–6, pls.61, 65–9.

2 Wittkower, 1990, p.253, cat.no.31; Avery, 1997, pp.86–8, pls.96–8.

3 See Jennifer Montagu, 'Bernini Sculptures not by Bernini', in Lavin, 1985, p.26 and n.3.

44

1 For this original set, see London, Victoria and Albert Museum (and then venues in Amsterdam and Rome), Italian Bronze Statuettes, exhibition catalogue by John Pope-Hennessy, 1961, cat.nos.187(a–d). Wittkower, 1966, p.271, cat.no.82(7), was initially reluctant to accept the attribution of these to Bernini.

2 See Franco Borsi, Cristina Acidini Luchinat, and Francesco Quinterio, Gian Lorenzo Bernini: Il testamento, la casa, la raccolta dei beni, Florence, 1981, p.108.

3 Wittkower, 1966, p.177, cat.no.7.

4 See London, Victoria and Albert Museum, and Edinburgh, National Gallery of Scotland, Master Drawings of the Roman Baroque from the Kunstmuseum, Düsseldorf, exhibition catalogue by Dieter Graf, 1973, cat.nos.5 and 6; Sutherland Harris, 1977 (1), p.xiv, cat.nos.11–12.

5 See Montagu, 1989, p.188, fig.261, who also lists other workshop versions of the head.

45

1 See Edinburgh, University of Edinburgh, Talbot Rice Art Centre, The Torrie Collection: an Exhibition to mark the Quatercentenary of the University of Edinburgh, catalogue edited by Duncan Macmillan, 1983, p.28, cat.no.48, pl.13.

2 Giovanni Pietro Bellori, Le vite de' Pittori, Scultori ed Architetti Moderni, Rome, 1672, p.282.

3 Published in the Galleria Giustiniana, II, Rome, 1633–7, p.84. Another engraving crediting the group to Duquesnoy is included in Joachim Sandrart, Admirandae Statuariae, Nürnberg, 1680, no.40.

4 See Olga Raggio in New York, Metropolitan Museum of Art, Liechtenstein, the Princely Collections, exhibition catalogue, 1985, cat.nos.49–50.

5 Hans Robert Weihrauch, Europäische Bronzestatuetten, Braunschweig, 1967, pp.370, 512, cat.no.380.

6 See Anthony Radcliffe in The Thyssen-Bornemisza Collection: Renaissance and Later Sculpture, with Works of Art in Bronze, London, 1992, pp.178–85, cat.no.28.

7 Willem von Bode, Collection of J.P. Morgan. Bronzes of the Renaissance, II, Paris, 1910, cat.no.215, pls.CLI, CLII.

8 Examples in the collections of the Fitzwilliam Museum, Cambridge; the Louvre, Paris; Newby Hall, Yorkshire; Mortimer Schiff, New York; Ferdinand Dreyfus, Paris; and formerly with Moatti, Paris, 1974.

9 Harald Olsen, Statens Museum for Kunst, Aeldre Udenlandsk Skulptur, Copenhagen, 1980, p.40, inv.no.5506.II.154 (recorded in the Royal Kunstkammer in Copenhagen in 1673–4).

10 Acc. no.66–26/2; see Ralph T. Coe, 'Small European Sculptures', Apollo, XCVI, 1972, p.51, pl.11.

11 See, most recently, R. Van N. Hadley (et al.), Sculpture in the Isabella Stewart Gardner Museum, Boston, 1977, cat.no.190, with discussion of another example formerly in Berlin, but lost in 1945. Another cast, lacking the horn, was sold at Christie's, London, 6 July 1993 (lot 108). A fine-looking marble version with a quiver and supporting tree-stump, was sold in Florence from the Gelli Collection in May 1910 (lot 270), pl.11 (as 'School of Bernini').

12 See Mariette Fransolet, François du Quesnoy, sculpteur d'Urbain VIII, Brussels, 1941, pl.XXXVI.

46

1 For the links between Campiglia and Bottari, see Pierpaolo Quieto, 'Giovanni Domenico Campiglia, Mons. Bottari e la rappresentazione dell'Antico', Labyrinthos: Studi e ricerche sulle arti nei secoli XVIII e XIX diretti da Gian Lorenzo Mellini e Sergio Ruffino, Annata III, 1984.

2 See Kansas City, 1993, p.140.

3 A group of Campiglia drawings from this source, including another copy of the Sta Susanna in black chalk, was sold at Christie's, London, 7 July 1987 (lots 203–13), where one of Sir Roger's diary entries is cited as follows: 'visited S.re Dom Campiglia painter my drawing master before – now 83 yrs old' (Arbury Papers, Warwick Office, CR136/A[606]).

4 See Charles Dempsey, 'The Greek Style and the Prehistory of Neoclassicism', in Pietro Testa, 1612–1650 Prints and Drawings, exhibition catalogue by Elizabeth Cropper, Philadelphia Museum of Art, 1988, pp.xxxvii-lxv. Norbert Huse, 'Zur 'S. Susanna' des Duquesnoy', in Argo: Festschrift für Kurt Bauch, Cologne, 1970, pp.324–35, observes that the St Susanna clearly reveals Duquesnoy's close study of the Cesi Juno. See also B. Lossky, 'La Ste Suzanne de Duquesnoy et les statues du 18e s.', Revue belge archéologique et historique de l'art, IX (1939), p.333.

5 Dempsey (as in previous note), p.lxi.

6 This suggestion is supported by the fact that another drawing in the series, Castor and Pollux, was probably drawn after a cast, as the original had been sold to Philip V of Spain in 1724 (see Haskell and Penny, 1981, pp.173–4).

7 It has not been established when the original statue lost the martyr's palm.

47

1 Montagu, 1985, II, p.405, cat.no.127.

2 Ibid., II, p.408, cat.no.127.L.D.2.

3 Prostabunt venalia sub hasta, Apud A. Langford, London (Covent Garden), 11 March 1755, p.219.

4 Matthew Maty, Authentic Memoirs of the Life of Richard Mead, M.D., London, 1755, p.8. Montagu shrewdly notes: 'The fact that it had not appeared in the previous editions of 1702 and 1708 need not necessarily mean that the bronze had been acquired later, since the third edition contained 'large additions' and was a far more lavish production than the previous editions, which had contained only scientific illustrations (and two standard culs-de-lampe in that of 1707).'

5 Hay's sale, Cock's, in the Great Piazza, Covent Garden, 4–5 May 1739.

6 Franks and Gruber, *Medallic illustra-tions of British History*, London, 1885, no.675/388; Christopher Eimer, *The Pingo Family and Medal Making in 18th century Britain*, London, 1998, Corpus no.51.

7 New York, Knoedler and Co., *The French Bronze, 1500–1800*, exhibition catalogue by Jacques Fischer, 1968, cat.no.64.

48

1 Montagu, 1985, II, p.416, cat no.134 (this example is cat.no.134.C.2).

2 *Ibid.*, II, p.417, cat.no.134. L.C.5.

3 Godfrey Evans, 'Italian Baroque Sculpture', in *Antique Collector*, March 1990, fig 3. The cast nonetheless appears to be a fairly early one. It was acquired by the Museum in 1867 at the sale in Edinburgh of the collection of the prominent Scottish landscape painter, Horatio McCulloch (1805–67).

49

1 Montagu, 1985, II, pp.389–90, cat.no.94.

2 Montagu, 1985, II, p.307, cat.no.4.C.2., fig.189. See also Robin Crighton in *Treasures from the Fitzwilliam*, Cambridge, 1989, p.65, cat.no.69.

3 Nothing is known of the history of this cast before its appearance in the collection of Mrs Alys Kingsley, from whom it was acquired in 1939.

4 Montagu, 1985, II, p.307, 478–9, cat.nos.3 and 15 in the checklist of drawings.

5 *Ibid.*, II, p.310, cat.no.7.

50

1 The drawing was published in Schilling and Blunt, 1971, p.47, cat.no.4. For the connection with the Fitzwilliam relief, see Montagu, 1985, II, p.307, under cat.no.4.

2 I am grateful to Jennifer Montagu for sharing her views about the iconogra-phy of this drawing. The finial on the lid of the formost vessel (chalices, it should be emphasised, would not normally have had lids) appears to be in the shape of a fleur-de-lys, which may (but not necessarily) suggest a connection with the Pamphili family. The sheet has been discussed most fully in Toronto, Art Gallery of Ontario, *Italian Drawings in the Collection of Duke Roberto Ferretti*, exhibition catalogue by David McTavish, 1986, pp.82–3, cat.no.35 (although he makes no comment about the iconography).

51

1 Donald Posner, *Annibale Carracci, A Study in the Reform of Italian Painting around 1590*, 2 vols., London, 1971, II, pp.23–5, cat.no.52.

2 The fact that the *Rest on the Flight* was once in the Carracci volumes at Windsor may add some weight to this argument (see Schilling and Blunt 1971, p.47, under cat.no.4).

3 See Florence, Istituto Universitario Olandese, and Amsterdam, Rijksmuseum, *Italian Drawings from the Rijksmuseum, Amsterdam*, exhibition catalogue edited by Bert W. Meijer, 1995–6, p.164, cat.no.78; Vitzthum, 1963, p.96, figs.20–1.

4 See Montagu, 1985, II, p.456, cat.no.A200(d).

52

1 Pope-Hennessy, 1964, II, pp.614, cat.no.546, fig.642; Montagu, 1985, II, pp.372–6, cat.no 69, pl.46, figs.56–7.

2 Montagu, 1985, II, pp.369–72, cat.no.68 pl.43, figs.51, 546.

3 Montagu, 1989, pp 68–9.

53

1 Georg Schurhammer, *Francis Xavier: His Life, His Times*, 4 vols., translated by M. Joseph Costelloe Rome, 1973, documents countless examples of Francis Xavier's baptisms of royal and ruling families throughout India, Indonesia, and Japan

2 See Enggass, 1964, fig 135.

3 For the fountain and the related terracotta in the Minneapolis Institute of Fine Art, see Montagu, 1985, II, pp.449–51, cat.no.191

4 Algardi has similarly chosen to depict the Huns not in 'Gothic' dress, but rather in Roman military costume.

5 See Montagu, 1985, II, pp.387–9.

6 Noted on the museum label of the Metropolitan relief. For Lorenzani, see Montagu, 1989, p.48.

54

1 Montagu, 1985, II, p.316, cat.no.9.C.2., notes that these cartouches are of similar design to some in Algardi's sketches for the papal galley 'Urbano'.

2 On an old photograph, the group is described as a 'Present made by the King of Saxony to his confessor Monsignor Alessi of P sa'; it was then in the hands of a Florentine dealer, and attributed to Pietro Tacca. It is probably the example that was previously in the Galleria Sangiorgi in Rome in 1913 (recorded in Dr. Barton's unpublished thesis as no.A.6). It was bought by the Fitzwilliam Museum from P. & D. Colnaghi, *Exhibition of Seventeenth and Eighteenth Century Italian Sculpture*, London, 1965, cat.no.7.

3 Montagu, 1985, II, pp.369–72, 439, cat.nos.68 and 167.

4 Montagu 1985, II, p.372, cat.no.68.B.1, pl.44.

5 Montagu, 1985, II, p.317, cat.no.9.C.7.

6 Montagu, 1985, II, p.319, cat no.9.C.23; J. Grabski, 'The Corsini *Flagellation* group by Alessandro Algardi', in *Artibus et Historiae, an art anthology*, VIII, Florence and Vienna, 1987, pp.9–23; Warsaw, Royal Castle, *Opus Sacrum, Catalogue of the Collection of Barbara Piasecka Johnson* exhibition catalogue by J. Grabski, 1990, pp 330–34, cat.no.64.

7 Sotheby's, London, 4 July 1996 (lot 43).

8 Inv no.D49/1974.

9 Montagu, 1996, pl.III.

55

1 For full details of the exhibited bronze and related works, including the provenance, see Montagu, 1985, I, p.150 II, pp.367–9. See further her introductory essay to the forthcoming *Walpole Society* volume cited at the end of this entry.

2 Bellori, 1976, p.412.

3 Vincenzo Golzio, 'Lo 'Studio di Ercole Ferrata', *Archivi*, II, 1935, p.71 (cited by Montagu, II, p.368, under cat.no.66.B.1.C.1.).

VI: Projects for St Peter's and its Piazza

PAGES 103–116

56–57

1 For details of this medal, see Whitman and Varriano, 1983, pp.52–3, cat.no.34 For Maderno's project, see Hibbard, 1971, pp.155–65; Christof Thoenes, 'Madernos St Peter-Entwürfe', in *An Architectura' Progress in the Renaissance and Baroque. Sojourns in and out of Italy. Essays in Architectural History presented to Helmut Hager on his Sixty-Sixth Birthday*, Papers in Art History from the Pennsylvania State University, VI I, I 1992 pp.170–93.

2 An initial foundation ceremony took place in the Cappella del Coro on 7 May 1607. See Hibbard, 1971, pp.158f.; Thoenes, *loc. cit.*, pp.170–93; Robert Stalla 'La Navata di S. Pietro sotto Paolo V La tradizione della forma architettonica', in Gianfranco Spagnesi (ed.), *L'architettura della basilica di S. Pietro. Storia e costruzione*, Rome, 1997, pp.269–74.

3 Louise Rice, 'La coesistenza delle due basiliche', in Spagnesi, *op. cit.*, pp.255–60.

4 For the most recent bibliography, see Spagnesi, *op. cit.*.

5 See Whitman and Varriano, 1983, pp.22–3, cat.no.4.

6 For additional examples of this medal see Whitman and Varriano, p.138, cat.no.121 and Rome, 1981, pp.306–7, cat.no.323.

7 Hibbard (*loc. cit.*) likens the portico and its decoration to a gallery in palace design.

8 For Hamerani family of medallists, see Friedrich Noack, 'Die Hameranis in Rom', *Archiv für Medaillen – und Plakettenkunde*, III, 1921–22, pp.23–40; Montagu, 1996, pp.73–91:

9 Whitman and Varriano, 1983, p.138, under cat.no.121.

58–60

1 For a full account see Wittkower, 1981, pp.189–90, cat no.21; Brauer and Wittkower, 1931, I, pp.19–22; Irving Lavin, *Bernini and the Crossing of St Peter's*, New York 1968; Kauffmann, 1970, pp.85–93; Avery, 1997, pp.95–100; and Kirwin, 1997, especially pp.79–188.

2 See Brauer and Wittkower, 1931, I, p.21, n.1; Blunt and Cooke, 1960, p.22, cat.nos.23–25; Thelen, 1967, I, pp.30–32, 85–6, cat.nos.24 and 72–3 (who dated cat.no.58 to 1625, and cat.nos.59–60 to 1631); Schilling and Blunt, 1971, p.54, cat.no.52; Kirwin, 1997, pp.134–5, 166–7, 171. Cat.no.58 was exhibited in Stuttgart, 1993, pp.50–51, cat.no.4.

3 See Kirwin, *op. cit.*, pp.134–5.

4 See illustrations in Avery, 1997, pp.95–9; and Kauffmann, 1970, pls.46–52.

5 Prado and Villalpando, II, pp.88–145, pl.3.

6 *Ibid.*, II, p.450. See also Marcello Fagiolo, 'Appunti per una ricostruzione della cultura di Borromini' in *Studi sul Borromini: Atti del Convegno promosso dall'Accademia Nazionale di San Luca, Roma*, 1967, II (published 1972), p.272.

7 See Prado and Villalpando, 1596, II, p.427; Alberti, 1955, I, p.188.

8 Prado and Villalpando, 1596, II, p.450.

62

1 For alternative examples of these medals see Whitman and Varriano, 1983, pp.67–68, cat.nos.49 and 50.

63

1 For the drawing and related project, see Vitzthum, 1963, pp.85–6, fig.26; Montagu, 1985, I, pp.39–51; II, pp.434–6, cat.no.161.

2 Montagu, 1985, I, p.42.

64–66

1 For this project and the related medals, see Brauer and Wittkower, 1931, I, pp.64–102; Timothy K. Kitao, *Circle and Oval in the Square of St Peter's: Bernini and the Art of Planning*, New York, 1974; Whitman and Varriano, 1983, pp.99–102, cat.nos.80–83.

2 Francesco Ehrle, *Dalle carte e dai disegni di Virgilio Spada*, Rome, 1928, p.34.

3 Diary of Alexander VII, entry for 13 August 1656: see Giovanni Morello, 'Bernini e i lavori a S. Pietro nel 'diario' di Alessandro VII', in Rome, 1981, p.322.

4 Material in Alexander VII's papers in the Biblioteca Apostolica Vaticana (Chigi H.II.22), especially Lucas Holstenius, 'De portici antichi e la loro diversità' (fol.127/128); G. Panzirolo, 'De Palestris et Stadijs' (fol.130f.); and excerpts from Vitruvius, 'De Architectura' (fol.124r).

5 See Kitao, 1974, pp.5–12; Krautheimer, 1985, pp.169–75.

6 Brauer and Wittkower, 1931, I, p.70, n.1.

7 *Ibid.*, p.70; Daniela Del Pesco, *Colonnato di S. Pietro. 'Dei Portici antichi e la loro diversità'. Con un' ipotesi di cronologia*, Rome, 1988, pp.63–5.

8 First publication by Kitao, 1974, fig.15 ('Split-circle' and 'second arcade design').

9 *Ibid.*, pp.31–5.

10 See Rome, 1981, p.323.

11 Biblioteca Apostolica Vaticana (Chigi R.VIII.c, fol.11): The letter reads: *Cosi starà il medaglione per porre nel fond. del portico triplice trionfale et farà la piazza, e condurrà a coperto a S. Pietro – nella cartella sotto vi caperanno sei o sette parole cioè da 40 a 50. Ciò Vs. pensi e me li mandi secondo il suo gusto, se può in più forme quantoprima.*

12 Del Pesco, *op. cit.*, 1988, pp.55f.

13 Krautheimer and Jones, 1975, p.206, entry no.130.

14 For a variant of this medal, with the same inscription on the reverse but placed around the circumference, and the date MDCLXI added in the exergue, see Rome, 1981, p.296, cat.no.298; Whitman and Varriano, 1983, p.102, cat.no.83.

67

1 These inscriptions will be fully transcribed in Turner, 1999 (forthcoming).

2 For this drawing and the project as a whole, see Brauer and Wittkower, 1931, I, pp.81–3; Turner, 1999 (forthcoming). Mattia de' Rossi's responsibility for the execution of most of this drawing is proposed here for the first time.

3 In fact, the existing obelisk which predetermined the centre of the Piazza is not situated exactly on the longitudinal axis of Piazza San Pietro, but slightly to the north.

4 See the analysis of the 'preforeshortened' circular piazza in Timothy K. Kitao, *Circle and Oval in the Square of Saint Peter's: Bernini's Art of Planning*, New York, 1974, p.55.

5 *Ibid.*, p.41.

6 See Hanno Walter Kruft, 'The Origin of the Oval in Bernini's Piazza S. Pietro', *Burlington Magazine*, CXXI, 1979, pp.796–801

7 An annotated proof impression of Bonacina's print in the Biblioteca Apostolica Vaticana will be published by the present writer in *Die Architekturzeichnungssammlung Alexanders VII Chigi* (forthcoming).

8 For example, De Tarade, *Desseins de touttes les sparties de l'Eglise de Saint Pierre de Rome, levés sur les lieux en M.DC.LIX. & presentés au Roy par feu*, Paris, 1713.

9 This view will be endorsed in Turner, 1999 (forthcoming). Chantelou (1985, pp.221, 249) twice records Bernini making interventions of this kind in architectural drawings.

10 Brauer and Wittkower, 1931, I, p.81.

11 Giovanni Battista Bonacina received payments in July and August of 1659 (documents published by Andreas Haus, *Der Petersplatz in Rom und sein Statuenschmuck*, Freiburg I. Br., 1976, p.125, n.76).

12 Commissioned by Alexander VII and executed by Lazzaro Morelli between April 1659 and January 1660 (see Brauer and Wittkower, 1931, I, p.81, n.6; Daniela Del Pesco, *Colonnato di San Pietro. 'Dei Portici antichi e della loro diversità'. Con un'ipotesi di cronologia*, Rome, 1988, p.77).

13 Rome, 1981, p.174, cat.no.150.

68

1 Fort Worth, 1982, cat.nos.5–6; Montagu, 1989, pp.145–50. See also Valentino Martinelli, *Le Statue del Colonnato di San Pietro*, Rome, 1987.

2 For the drawings, see Princeton, 1981, pp.208–18; Montagu, 1989, pp.147–8, fig.197.

3 Jennifer Montagu, 'Two Small Bronzes from the Studio of Bernini', *Burlington Magazine*, CIX, 1967, pp.566–71. Montagu (1989, p.147 and n.69) subsequently modified the conclusions she arrived at in her article, and now considers that the model of the *St Agnes* was not by Bernini himself. A document of 1661 recording payment to one of Bernini's assistants, Lazzaro Morelli, proves that models for at least some of the colonnade figures were provided by studio hands. It was quite possibly Morelli who was responsible for the execution of the travertine *St Agnes* (see Montagu, 1967, p.570 and n.13).

4 For the *St Catherine* statuette, see Montagu, 1989, p.147 and n.69; Avery, 1997, pp.214–15.

69–71

1 For this medal and the related drawing and model, see Pollard, 1970, pp.146–147, fig.11; Sutherland Harris, 1997 (1), p.xxii, under cat.no.79; Rome, 1981, p.296; Varriano, 1987, p.252, fig.5; Jones, 1994, p.266, cat.no.20 a–c.

2 Roberto Battaglia, *La Cattedra Berniniana di San Pietro*, Rome, 1943, pp.239–44; Maria Guarducci, *La Cattedra di San Pietro nella scienza e nella fede*, Rome, 1982.

3 Rome, 1981, pp.261–3, cat.no.264.

4 Helga Tratz, 'Werkstatt und Arbeitsweise Berninis', *Römisches Jahrbuch für Kunstgeschichte*, 23–24, 1988, pp.427–43.

5 Franciscus Maria Phoebeus (Francesco Maria Febei), *De identitade Cathedrae in qua Sanctus Petrus Romae primum sedit et de Antiquitate et Praestantia Solemnitatis Cathedrae Romanae dissertatio*, Rome, 1666.

6 *Martyrologium Romanum*, 18 January.

7 'Sedes Sumini Sacerdoti et Ecclesiae Caput … Principatus Orbis', in Febei, *op. cit.* at note 5 above, p.118.

8 For Bernini's drawings, see Brauer and Wittkower, 1931, II, figs.74a and b.

9 Windsor Castle, Royal Library, inv.no.5614. Brauer and Wittkower, 1931, II, fig.166a.

10 Fioravante Martinelli, *Discorso della Catedra chiamata di S. Pietro la quale si conserva nella Basilica Vaticana*, Rome, 1665 (illustrated with two drawings of the Cathedra by Francesco Borromini, published by Heinrich Thelen, *Francesco Borromini: Mostra di disegni e documenti Vaticani*, exhibition catalogue, Rome, Biblioteca Apostolica Vaticana, 1967, p.57, cat.no.50. Martinelli's manuscript is published in its entirety by Cesare D'Onofrio, *Roma nel Seicento*, Florence, 1969.

11 Battaglia, *op. cit.* at note 2 above, p.222, doc.454, pl.XXXVIII; see also Alexander VII's diary entry: '*la cattedra di S. Pietro, che facciam disegnare I suoi avorii tutti*', published in Rome, 1981, p.338.

12 For the genesis and Bernini's different proposals for the glory over the Cathedra, see Kurt Rossacher, 'Das fehiende Zielbild des Patersdomes; Berninis Gesamtprojekt zur Cathedra Petri', *Alte und Moderne Kunst*, 12, 1967, pp.2–21.

72

1 For another example of this medal, see Whitman and Varriano, 1983, p.105, cat.no.86.

2 See Sutherland Harris, 1977 (1), p.xxii, cat.no.79; Rome, 1981, pp.300–1, cat.no.304.

3 For a full analysis of the Scala Regia project, see Marder, 1997.

73–76

1 See Brauer and Wittkower, 1931, I, pp.10, 172–5; Wittkower, 1981, pp.260–63, cat.no.78; Avery, 1997, pp.114–17.

2 Blunt and Cooke, 1960, p.23, cat.no.32.

3 See Carlo Pietrangeli, *La Basilica Romana di Santa Maria Maggiore*, Rome, 1987, pp.224, 240–41.

4 See Brauer and Wittkower, 1931, I, pp.10, 173–5; II, pls.132b, 136a and b; Blunt and Cooke, 1960, p.31, cat.nos.28–30.

5 See Princeton, 1981, pp.317–35, especially cat.nos.93–4 and 96.

6 For these buildings see Wittkower, 1980, pp.181–4.

VII: Architectural and Decorative Designs and Architectural Medals

PAGES 117–135

77

1 In addition to the exhibited drawing, there are two designs in the Uffizi (inv.nos.A6734 and 6743) and two in the Albertina in Vienna (inv.nos.It. Az. Rom. 118–19). The project has been discussed by Thelen, 1967, II, pp.15–17, cat.nos.11–13; Hibbard, 1971, pp.146–55; and Kieven in Stuttgart, 1993, pp.46–9, cat.nos.2–3.

2 Kieven, 1993, p.48.

3 The Ashmolean sheet was first attributed to Borromini by Kieven, 1993, pp.48–9, cat.no.3. It was previously discussed, with an attribution to Maderno, by Thelen, 1967, II, p.16, cat.no.12; and by Hibbard, 1971, fig.47a.

4 Hibbard, 1971, pp.146–55, gives a full account of the building history.

5 See Stuttgart, 1993, pp.46–7, cat.no.2

6 Fioravante Martinelli, Roma ornata, Rome, c.1660–62, folio 17.

78

1 For a nineteenth-century variant re-strike of this medal see Whitman and Varriano, 1983, p.70, cat.no.52.

79

1 For the drawing see Andrews, 1968, pp.91–2; Merz, 1991, p.133, n.115.

2 For Cortona's frescoes, see Briganti, 1982, pp.167–70, cat.no.12; Merz, 1991, chapter V, pp.1:3–39, especially pp.131–34 (for the scene to which the Edinburgh drawing relates).

3 For this picture see Briganti, 1982, pp.164–5, cat.no 8; Merz, 1991, pp.96–7.

4 For the Rennes drawing, see Briganti, 1982, p.170 and fig.37; Modena, Galleria Estense, and Rennes, Musée des Beaux-Arts, Disegno: Les dessins italiens du Musée de Rennes, exhibition catalogue by Patrick Ramade, 1990, pp.158–9, cat.no.73.

80

1 See Blunt, 1958, pp.256–87. See also Patricia Waddy, 'The Design and Designers of Palazzo Barberini', Journal of the Society of Architectural Historians, 335, 1976, pp.151–85, which includes new documentary material.

2 Thelen, 1967, II, cat.no.C.42, was the first to attribute the drawing to Borromini, pointing out that it was worked up from another drawing for the façade in the Albertina (p.54, cat.no.C.41) See also Schilling and Blunt, 1971, p.54, cat.no.50. Wittkower, 1980, pp.112–14, argued that Borromini was here following Maderno's project. Waddy, 1976, p.179 made a case for Borromini's having contributed to the design.

3 Blunt, 1979, p.20.

4 The best-known engravings of Palazzo Barberini are the late-seventeenth century series by Alessandro Specchi, from Nuovo Teatro delli Palazzi di Roma, many of which are illustrated by Patricia Waddy, Seventeenth-Century Roman Palaces, Cambridge (Mass.), 1990, pp.263–71. For Cardinal Francesco Barberini's apparent endorsement of Borromini's claim that he had designed a significant part of the palace, ibid. p.392, n.222. Domenico de' Rossi's engraving describing Borromini as architect of the garden front is illustrated in Giovanna Curcio and Luigi Spezzaferro, Fabbriche e Architetti Ticinesi nella Roma Barocca, Milan, 1989, p.80.

5 Waddy, 1990, pp.173–9.

6 Recorded in a drawing in the Uffizi (inv.no.A.6720), illustrated in Hibbard, 1971, fig 95a.

7 Waddy, 1990, pp.223–4.

8 This feature is more clearly visible in Borromini's earliest ground plan: see Thelen, 1967, I, p.54, cat.no.C.40.

9 On this subject, see especially Scott, 1991.

10 Waddy, 1990, p.219, n.159.

11 I owe this observation to Louise Rice.

81

1 Schilling and Blunt, 1971, p.53–4, cat.no.48. See also Joseph Connors Borromini and the Roman Oratory: Style and Society, 1980, cat.no.41, pp.220ff., who established that the much later drawing in the Albertina (his cat.no.291) has no connection with this one, being a study for plate V of the Opus Architectonicum (1725) and showing an impossible and 'ideal' arrangement of the façade, with the principal seven bays isolated. Connors provides the definitive account of the entire commission, from which this summary is derived.

2 See Alberti, 1955, VII, p.151.

3 Borromini, 1725, p.11.

4 Ibid., p.11.

82–83

1 For the earlier medal, see Whitman and Varriano, 1983, p.78, cat.no.59. For the later medal, see Rome, 1981, pp.294–5, cat.no.294; Montagu, 1996, pp.80, 230 n.62, pl.VIII.

2 Contemporary with Urban VIII's building activities at the Quirinal were the construction of the Palazzo Barberini, the church and convent of Santa Maria della Concezione, the Chiesa della SS. Incarnazione, San Caio and San Carlino alle Quattro Fontane; under Alexander VII, Sant' Andrea al Quirinale and the Palazzo Chigi in Piazza SS. Apostoli were erected.

3 The purchase was made in 1625: see Jack Wasserman, 'The Quirinal Palace in Rome', Art Bulletin, XLV, 1963, p.239

4 Francesco Quinterio, 'Il Palazzo del Quirinale nel Seicento e nel Settecento', in Borsi, 1991, p.142.

5 Wasserman, loc. cit., p.239; Quinterio in Borsi, 1991 p.152, n.200.

6 Giacomo Lauro, Antiquae urbis splendor, Rome, 1612 (1st ed., published 1614), pl.159; published by Quinterio in Borsi, 1991, p.116, fig.180 (where it is dated to about 1620).

7 Among Maderno's other collaborators were Bartolomeo Breccioli, misuratore (Wasserman, 1963, p.239); and Filippo Breccioli and Domenico Castelli, periti (Quinterio, 1991, pp.142–3).

8 Vienna, Graphische Sammlung Albertina, inv.no.Az.Rom.1136; graphite on heavy paper, 67.6 × 45.6 cm; with scale and inscriptions: 'Strada che va alle 4 fontane'; 'Portone Principale di Palazzo a M.te Cavallo'; 'Piano terreno del Palazzo a Monte Cavallo' (added later); 'Un pezzo di Pianta De' Cortile di monte Cavallo' (verso).

9 Quinterio, 1991, p.144.

10 P. Totti, Ritratto di Roma moderna, Rome, 1638, p.278, mentions for the first time Bernini's name in relation to the 'Loggia delle Benedizioni'; see Wasserman, 1963, p.240, and Quinterio, 1991, p.196, n.161, with reference to Bernini's drawing in the Biblioteca Apostolica Vaticana, Chigi a.I.9, fol.193v.

11 For the bibliography and documents, Wasserman, 1963, pp.240–42.

12 See Brauer and Wittkower, 1931, I, p.114; II, figs.86b–88 (as studies for the Pope's palace at Castel Gandolfo).

13 The wing was completed in 1732 under Clement XII by Ferdinando Fuga. For the parts completed under Alexander VII, see, in addition to the engraving by Falda illustrated here, the drawings in the Biblioteca Apostolica Vaticana, Chigi P.VII.10, fol.39v/40r; 40v/41r.

14 Krautheimer and Jones, 1975, entries nos.426 and 449.

15 Montagu, 1996, pp.80; 230, n.62.

84

1 See Francesco Quinterio, 'Il Palazzo del Quirinale nel Seicento e nel Settecento', in Borsi, 1991, p.153.

2 Gianfranco Spagnesi, La piazza del Quirinale e le antiche scuderie papali, Milan, 1990, p.53; Quinterio in Borsi, 1991, p.162; Richard Krautheimer, 'Il porton di questo giardino', Journal of the Society of Architectural Historians, 42, 1983, pp.35f.; Krautheimer, 1985, pp.95, 182.

3 Jack Wasserman, 'The Quirinal Palace in Rome', Art Bulletin, XLV, 1963, pp.228–32; Sabine Jacob, 'Pierre de Cortone et la décoration de la Galerie d'Alexandre VII au Quirinal', Revue de l'Art, 11, 1971, pp.42–54.

4 See Krautheimer and Jones, 1975, pp.199–225, entry numbers.46, 56, 59, 97, 152, 155, 159.

5 Lieselotte Bestmann, Die Galerie Alexanders VII im Palazzo dei Quirinale in Rom und ihre Beziehung zum ikonographischen Programm der Decke der Sixtinischen Kapelle, Hamburg, 1992.

6 See Norbert Wibiral, 'Contributi alle ricerche sul Cortonismo a Roma', Bollettino d'Arte, 4th series, 45, 1960, pp.123–65 (who incorrectly attributes the Oxford drawing to Giovanni Francesco Grimaldi); Byam Shaw, 1976, I, cat.no.614; Laura Laureati and Ludovica Trezzani, Il patrimonio artistico del Quirinale, Milan and Rome, 1993, pp.191–207.

7 Pietro da Cortona's drawings for the ceiling decoration are in the Biblioteca Apostolica Vaticana (Chigi P.VII.10, fol.34v–35r and fol. 36v–37r). See Jacob Hess, Die Künstlerbiographien von Giovanni Battista Passeri, Leipzig and Vienna, 1934, p.369 n.4; Wibiral, loc. cit., pp.127, 149 n.20, figs.1–2. A ground plan of the gallery before the decoration is on fol. 38r.

8 For example, the three by Luigi Garzi mentioned in Jacob, 1975, p.98; Byam Shaw, 1976, cat.no.614, figs.39–40.

9 The Düsseldorf drawing was published by Vitzthum, 1963, p.95, n.21; Jacob, loc. cit., pp.42f. For the Berlin drawing, see Jabob, 1975, p.98 cat.no.451; Stuttgart, 1993, pp.126–7, cat.no.38.

10 The gallery was divided into three rooms by the architect Raffaele Stern (1809), which were furnished under the papacy of Pius IX (1847–9). Cortona's decorative framework was sadly destroyed as part of these alterations, although the biblical scenes were preserved.

85

1 Bellori, 1942, pp.61–2. See also Hans Posse, *Der Römische Maler Andrea Sacchi*, 1925, p.90; Blunt and Cooke, 1960, pp.98–9 (the exhibited drawing is their cat.no.805); Sutherland Harris, 1977 (2), pp.100–101, cat.no.81.

2 All but one of the drawings are at Windsor; the exception is in the Academia di San Fernando in Madrid (Sutherland Harris, 1977 (2), pl.158). I intend to discuss this series of drawings more fully in a forthcoming article on Sacchi's project for San Luigi dei Francesi.

3 Bellori, 1942, p.59, records that Sacchi particularly admired Raphael and Annibale Carracci.

4 Natoire's drawing for his ceiling fresco, still a *Glorification of St Louis*, is preserved in the Rothschild Collection, Waddesdon Manor, Aylesbury, Buckinghamshire.

5 This would explain Blunt and Cooke's observation (*loc. cit.*) that 'the drawings would not fit the architecture of the vault'.

86

1 For the building history, see Hans Ost, *'Studien zu Pietro da Cortonas Umbau von S Maria della Pace'*, Romisches Jahrbuch für Kunstgeschichte, XIII, 1971, pp.231–85. For a version of this medal with a different obverse, see Whitman and Varriano, 1983, pp.111–12, cat.no.93.

87

1 For this medal, see Whitman and Varriano, 1983, pp.112–13, cat.no.94.

2 See V. Poulsson, 'The iconography of S Ivo alla Sapienza', PhD thesis, University of Oslo, 1976; Jack Wasserman, 'Giacomo della Porta's Church of the Sapienza', *Art Bulletin*, XLVI, 1964, p.501ff.

88

1 The drawing was acquired following its sale at Christie's, London, *Old Master Drawings from Holkham*, 2 July 1991 (lot 31).

2 'È da noi Pietro da Cortona col disegno della Tavola di Sapienza' ('Pietro da Cortona came to see us with a drawing for the painting at the Sapienza'): Krautheimer and Jones, 1975, p.213, entry no.399.

3 The selection appears to have been St Luke for Medicine, St Jerome, the most learned of the Latin fathers, St Leo the Great for Theology, St Alexander because Pope Alexander VII Chigi gave some of his relics to the Church, and St Fortunatus, a patron of the Chapel.

4 A.E. Popham, *Old Master Drawings at Holkham Hall*, prepared for publication with an introduction by Christopher Lloyd, Chicago, 1986, p.55, cat.no.108.

5 Florence, 1997, pp.116–17, cat.no.72.

6 See Rome, 1997 (1), p.378, cat.no.59. What is clearly a copy of this sketch is in the Pinacoteca Comunale, Città di Castello (*ibid.*, p.430, cat.no.92; the plates of these two paintings are confusingly transposed in this catalogue).

7 *Ibid.*, p.430, quoting the Diary of Carlo Cartari.

89

1 For alternative examples of this medal see Whitman and Varriano, 1983, pp.110–11, cat.no.92, and Rome, 1981, pp.294–5, cat.no.295.

2 See Andrea Busiri-Vici, 'L'arsenale di Civitavecchia di Gianlorenzo Bernini', *Palladio*, V–VI, 1955–56, pp.127–36.

3 See Rome, 1981, p.295.

90

1 For another example see Whitman and Varriano, 1983, pp.116–17, cat.no.98.

2 Krautheimer and Jones, 1975, entry no.259

3 Brauer and Wittkower, 1931, I, pp.124–5; II, pl.95; Rome, 1981, p.298; Petrucci, 1987, fig.79.

91

1 For another example of this medal see Whitman and Varriano, 1983, pp.118–19, cat.no.100.

92

1 See Anthony Blunt, *Art and Architecture in France, 1500–1700*, 4th edition, London, 1980, pp.326–9; Gould, 1981, especially pp.1–15; William Bradford and Helen Braham, *Master Drawings from the Courtauld Collections*, London, 1991, pp.26–7, cat.no.9.

2 Gould, 1981, p.80.

93

1 For this medal see Jones, 1988, pp.224–26, cat.no.239.

2 Chantelou, 1985, p.306.

94

1 For a full discussion of these medals, see Rome, 1981, pp.305–6, cat.nos.316–18; Whitman and Varriano, 1983, pp.129–30, cat.nos.111–12. In both cases the obverse of Hamerani's medal shows variations from the exhibited example (cat.no.94A).

2 For a full discussion of this project, see Weil, 1974 (1).

95

1 For another example with different obverse, see Whitman and Varriano, 1983, p.137, cat.no.120.

2 See Furio Fasolo, *L'Opera di Hieronimo Carlo Rainaldi*, Rome, 1960, chapter XIV.

96

1 See Sabine Jacob, *Die italienischen Handzeichnungen der Kunstbibliothek Berlin*, Berlin 1975, cat.no.382; Berlin, Kunstbibliothek, *Architektenzeichnungen 1479–1979*, exhibition catalogue by Ekhart Berckenhagen, 1979, cat.no.74; Stuttgart, 1993, cat.no.33.

2 Vienna, Graphische Sammlung Albertina, Architekturzeichnungen (without inv.no.: recently acquired on the Roman art market). To be published by Elisabeth Sladek, 'Il soggiorno italiano di Johann Bernhard Fischer von Erlach (1656–1723): L'esperienza romana di architetti stranieri e le sue conseguenze', *Studi Romani*, 45, 1997 (forthcoming). The building measures about 48 meters in width, which corresponds exactly in size to another variant of this project designed by Fischer von Erlach (see Hellmut Lorenz, 'Das 'Lustgartengebäude' Fischers von Erlach: Variationen eines architektonischen Themas', *Wiener Jahrbuch für Kunstgeschichte*, 33, 1979, p.64, n.22), and also to a third example of the same design, the 'Pleasure Palace' built by Giovanni Battista Alliprandi in 1699 in Liblice, near Melnik (*ibid.*, p.62, n.15).

3 Lorenz, *loc. cit.*, pp.50–76; *idem.*, 'Eine weitere Zeichnung zu Fischers 'Lustgartengebäude', *Wiener Jahrbuch für Kunstgeschichte*, 33, 1980, pp.174–76.

4 Rome, Archivio dell'Accademia di San Luca, Verbali delle Congregazioni, 46–47. See Hellmut Hager, 'Carlo Fontana, progettazione effimera dell'erede del Bernini' in *Borromini e gli architetti ticinesi a Roma*, Acts of the international colloquium held at the Istituto Svizzero di Roma, 1997 (forthcoming).

5 Rome, Private Collection. See Rome, 1981, p.165.

6 See Paolo Portoghesi, *Borromini: architettura come linguaggio*, 1967, figs.XCV, XCVI, XCVII.

7 See Lorenz, 1979, *loc. cit.*, fig.61.

8 In 1684 Johann Adam Andreas von Liechtenstein became Count, and his heraldic device is present in the Milan drawing; in 1687 Fischer left Italy.

9 As noted in Edinburgh, National Gallery of Scotland, *Drawings by Architects*, exhibition catalogue, 1979, cat.no.11, fig.III; Irving Lavin, 'Fischer von Erlach, Tiepolo, and the Unity of the Visual Arts' in *An Architecural Progress in the Renaissance and Baroque. Sojourns in and out of Italy. Essays in Architectural History presented to Hellmut Hager on his Sixty-Sixth Birthday* (Papers in Art History from the Pennsylvania State University 8,1), 1992, p.501; Elisabeth Sladek, 'Der Italienaufenthalt Johann Bernhard Fischers zwischen 1670/71 und 1686. Ausbildung – Auftraggeber – erste Tätigkeit', in Friedrich Polleroß, *Fischer von Erlach und die Wiener Barocktradition*, Vienna-Cologne-Weimar, 1995, pp.150–52.

VIII : Designs for Fountains and Outdoor Monuments

PAGES 136–145

97

1 Brauer and Wittkower, 1931, II, pl.152c; Blunt and Cooke, 1960, p.24, cat.no.38. For the *Triton Fountain* see Wittkower, 1981, p.200, cat.no.32; Avery, 1997, pp.182–89.

98

1 For the 1649 foundation medal and another variant dating from 1651, see Whitman and Varriano, 1983, pp.93–94, cat.nos.75a and b.

99–100

1 See Cesare D'Onofrio *Acque e Fontane di Roma*, Rome, 1977, pp.152–63.

2 For the full history of the Moro and Lumaca fountains, see Wittkower, 1990, pp.272–3, cat.no.55; D'Onofrio, *op. cit.*, pp.504–13.

3 This drawing is catalogued by Brauer and Wittkower, 1931, I, pp.10, 50–53, II, pl.32; Blunt and Cooke, 1960, p.24, cat.no.40; Sutherland Harris, 1977 (1), p.xix, cat.no.50.

4 Documents published by Garms, 1972, p.66, no.239; the *Lumaca* is illustrated in D'Onofrio, *op.cit.*, p.507.

5 Sutherland Harris, 1977 (1), p.xix, cat.no.56; Blunt and Cooke, 1960, p.24, cat.no.41, Brauer and Wittkower, 1931, I, pp.10, 50–53, II, pl.33.

6 See Rome, 1991 (1), pp.60–61, cat.no.17.

101–103

1 Brauer and Wittkower, 1931, I, pp.52–4, II, pls.36–8, 159a; Blunt and Cooke, 1960, p.25, cat.nos.44–5; Sutherland Harris, 1977 (1), p.xix, cat.nos.52–4; Ward-Jackson, 1980, II, cat.no.628; Wittkower, 1981, p.265, cat.no.80; Avery, 1997, pp.207–8.

104

1 The only time the drawing has been published is in A.E. Popham, *Catalogue of Drawings in the Collection formed by Sir Thomas Phillipps, Bart., FP.S. now in the Possession of his Grandson T. Fitzroy Phillipps Fenwick*, Cheltenham, 1935, I, p.126, cat.no.1 (as attributed to Bernini). It will be included as an autograph sheet in Turner, 1999.

2 Wittkower, 1990, p.268, cat.no.49.

3 See Sutherland Harris, 1977 (1), p.xix, cat.no.55.

105–106

1 The drawing was hitherto attributed to Raymond La Fage (1656–84). It shares with Algardi's other drawing in Edinburgh (cat.no.146) a provenance from the Scottish collector David Laing.

2 For the fountain and the various visual records of it, see Montagu, 1985, I, pp.108–9, fig.119; II, pp.452–53, cat.nos.L.A.194 and 194.E.1

3 Montagu, 1985, I, p.110.

107

1 Giacinto Gigli, *Diario di Roma*, edited by Manlio Barberito, 2 vols., Rome, 1991, I, pp.191–2 (May 1630).

2 See Brauer and Wittkower, 1931, I, pp.145–7; II, pl.14a; Blunt and Cooke, 1960, p.24, cat.no.37.

3 See Brauer and Wittkower, 1931, I, pp.10, 143–7; II, pl.14a; Fagiolo dell'Arco 1967, cat.no.170 (who erroneously date the design to 1658); Wittkower, 1990, p.287, cat.no.71; Avery, 1997, pp.190–92.

4 Cesare D'Onofrio, *Gli Obelischi di Roma*, Rome, 1965, pp.190–92.

5 William S. Heckscher, 'Bernini's Elephant and Obelisk', *Art Bulletin*, 1947, pp.155–82, gives a full account of the symbolic meaning of elephants during this period.

6 See the views of Pliny and Girolamo Cardano quoted by Heckscher, *loc. cit.*

108–109

1 On the statue and its history see Wittkower, 1961, pp.497–531; Robert W. Berger, 'Bernini's *Louis XIV Equestrian*: a Closer Examination of its Fortunes at Versailles', *Art Bulletin*, LXIII, 2, 1981, pp.232–48; Guy Walton, 'Bernini's Equestrian Louis XIV', *Art Bulletin*, LXIV, 2, 1982, pp.319–20; Hoog, 1989.

2 Chantelou, 1885, p.263; translated and transcribed by Wittkower, 1961, pp.514, 528 (document 63)

3 Chantelou, 1985, pp.117–18 and n.78 (13 August 1665)

4 Letter from Colbert to Bernini, 5 December 1669; transcribed by Wittkower, 1961, p.521 (document 23)

5 Wittkower, 1961, p.505.

6 There is no firm evidence that a full-scale model for the statue was prepared, but this seems likely given that relatively inexperienced students were largely responsible for the execution of the statue.

7 Letter from Colbert to the Duc D'Estrées, 19 February 1682 transcribed in Wittkower, 1961, p.529 (document 71). Colbert's remark about the different accounts suggests that he had not seen a drawing of the statue before, even though he had asked an artist in Rome to send him a sketch of it 'if the Cavalier [Bernini] allows you to make one': letter from Colbert to Coypel, 27 October 1673; transcribed in *ibid.*, p.527 (document 58).

8 Domenico Bernini, *Vita del Cavalier Gio. Lorenzo Bernini*, 1713, p.150f. Bernini originally planned to make a steep and rocky cliff in a separate piece of marble to serve as a pedestal.

9 *Ibid.*, pp.150–51.

110

1 For another example of this medal, see Rome, 1981, p.309, cat.no.328.

2 *Ibid.*, pp.308–9, cat.no.327.

IX: Designs for Tombs and Church Monuments

PAGES 146–161

111

1 See Blunt and Cooke 1960, p.36, cat no.29 (as Ciro Ferri); Walter Vitzthum, 'Roman Drawings at Windsor Castle', *Burlington Magazine*, CIII, 1961, pp.513–18 (as Pietro da Cortona); and, most recently, Rome, 1997, p.460, cat.no.110. The drawing includes alternative proposals for the upper aedicule surround, and for the columns and pilasters at the rear of the central recess and at the extreme left and right of the altar.

2 For Borromini's work at San Giovanni dei Fiorentini, see Blunt, 1979, pp.201–4.

3 The history of Cortona's project and the marble ordered for it was analysed by Julia Vicioso in a paper delivered at the Pietro da Cortona conference, Rome, November 1997, and will be published in a forthcoming article.

112

1 See Bacchi, 1996, p.803, who lists the other terracottas of Faith: Rome, Museo di Palazzo Venezia; Hamburg, Kunstgewerbemuseum (inv.1969.143; Toledo (Ohio), Museum of Art; Rome, Palazzo Barberini, formerly in the Museo Artistico Industriale; and Florence, Massimo Vezzosi Collection. For the Fitzwilliam *bozzetto*, see also *National Art Collections Fund Review*, 1989, pp.175–6. For Ferrata's inventory, see Golzio, 1935.

2 Montagu 1989, p.14.

3 Rome, 1991 (2), pp.53–4.

113

1 For the tomb and the related drawing, see Eugenio Battisti, 'Una tomba ed un busto del Bernini', *Commentari*, IX, 1958, pp.38–43; Wittkower, 1966, pp.271–2, under cat.no.82(8) (who first published the drawing); Sutherland Harris, 1977 (1), p.xix, cat.no.49.

2 Transcribed in Vincenzo Forcella, *Iscrizioni delle Chiese ed altri edifici di Roma dal Secolo XI fino ai giorni nostri*, Rome, 1877, X, p.280, no.797.

3 Published by Battisti, loc. cit. p.39.

4 By Wittkower, loc. cit., followed by others.

5 Montagu, 1985, II, p.441, cat.no.171.

114

1 See Enggass, 1964, pp.36–7.

115

1 See Wittkower, 1981, pp.216–18, cat.no.48; Sutherland Harris, 1977 (1), p.xx, cat.no.60; Stuttgart, 1993, pp.120–21, cat.no.36.

2 Wittkower, 1990, pp.273–4, cat.no.56.

116

1 First published in Schilling and Blunt (1971, pp.47–8, cat.no.7), the drawing and the related monument are fully discussed in Montagu, 1985, I, pp.124–8; II, pp.430–31, cat.no.155, and p.482, cat.no.54 in the checklist of drawings. See further Montagu, 1989, p.103, fig.126.

2 For the 1650 festivities, see Fagiolo and Madonna, 1985 (3), pp.36–7.

3 See M.M. Lumbroso and A. Martini, *Le Confraternite Romane nelle loro Chiese*, Rome, 1963, pp.425–8.

4 See Fagiolo and Madonna, 1985 (3), pp.85–90.

5 For Pope Innocent X's visit to the hospice on 12 April 1650, see Montagu, 1985, I, p.124. Although the erection of the monument is described as an act of gratitude on the part of the Trinitarians, it had in reality been planned well in advance.

6 Fagiolo and Madonna, 1985 (3), p.89.

7 Carla Benocci, 'Il complesso assistenziale della SS. Trinità dei Pellegrini: ricerche sullo sviluppo architettonico in relazione ad alcuni anni santi', in Fagiolo and Madonna, 1985 (3), pp.101–8.

8 Montagu, 1985, II, p.430.

9 *Ibid.*, II, pp.430–31, cat.no.155.

10 *Ibid.*, I, p.126.

11 *Ibid.*, I, pp.115–18.

117

1 For an example of this medal with variant obverse see Whitman and Varriano, 1983, pp.94–5, cat.no.76.

2 For the construction history, see Blunt, 1979, pp.156–60

3 See Quirk, 1998, pp.19–20.

118

1 Sotheby's, London, *Old Master Drawings, including Drawings from Corsham Court*, 3 July 1996 (lot 137). Its autograph status was first recognised by Timothy Clifford, and it was bought by Colnaghi on behalf of the National Gallery of Scotland. See Stephen Ongpin in Colnaghi's *Master Drawings* exhibition catalogue, New York and London, 1997, cat.no.29. It is the subject of a forthcoming article by Axel Christoph Gampp, '... onde il Bernino e restato il factotum: Ein unbekannter Entwurf Berninis für ein Papstgrabmal im Kontext der Baugeschichte von S. Agnese', *Römisches Jahrbuch der Bibliotheca Hertziana*, 34, 1999.

2 The tips of the finials on the throne could, at a stretch, be read as *fleurs-de-lys* (compare cat.no.144).

3 For a summary of the history of the construction of the church, see Blunt, 1982, pp.3–5. For a detailed discussion of the projected tomb and the two Bernini workshop designs for it, see Rudolf Preimesberger, 'Das dritte Papstgrabmal Berninis', *Römisches Jahrbuch für Kunstgeschichte*, 1978, pp.157–81; Montagu, 1985, II, pp.433–4.

4 Discussed in detail by Gampp in his forthcoming article (see note 1).

5 Spotted by Luca Baroni at Christie's, South Kensington, 5 December 1997 (part of lot 38). It was subsequently purchased by the Gallery in 1998 in Paris; its inventory number is D5444.

119

1 Two terracotta *bozzetti* of this subject are recorded in the inventory of Ferrata's studio: see Golzio, 1935, pp.64–74. For the present version, see Italo Faldi, 'Ercole Ferrata: un bozzetto della pala della Santa Emerenziana', *Paragone*, 87, 1957, pp.69–72; London, Heim Gallery, *Baroque Sketches, Drawings & Sculptures*, 1967, cat.no.81; Evelyn Silber, *Sculpture in the Birmingham Museum and Art Gallery: a Summary Catalogue*, Birmingham, 1987, p.36; and Bacchi, 1996, p.803, who also provides the most up-to-date bibliography of Ferrata (pp.804–5). For the commission, see also Lina Montalto, 'Ercole Ferrata e le vicende litigiose del Bassorilievo di Sant'Emerenziana', *Commentari*, VIII, 1957, pp.47–68.

2 *Bibliotheca Sanctorum*, IV, 1966, pp.1162–7.

3 For a thorough history of the church, see Gerhard Eimer, *La fabbrica di S.Agnese in Piazza Navona*, 2 vols., Stockholm, 1971.

4 For full details of what follows, see Montalto, *loc. cit.*, 1957, pp.47–68.

120

1 For the drawing, see Blunt and Cooke, 1960, p.39, cat.no.146. For the commission, see Enggass, 1964, pp.9–15, 140–41.

2 See Christie's, London, *Old Master Drawings from Holkham*, 2 July 1991 (lot 58).

3 For Domenichino's frescoes, see Richard Spear, *Domenichino*, 2 vols., New Haven and London, 1982, I, pp.271–4, cat.no.101; II, pls.327–31.

4 See Robert Enggass, 'Baciccio: A New Fresco and Two Modelli', *Burlington Magazine*, CXVIII, 1976, pp.589–90.

5 Enggass, 1964, pp.13–14.

6 *Ibid.*, p.182.

121

1 Blunt and Cooke, 1960, p.77, cat.no.592 (as Pietro da Cortona); Noehles, 1970, pp.110–11 (as Ciro Ferri). The latter examines the full history of Cortona's tomb in the church of Santi Luca e Martina, with which this drawing has been associated.

122

1 Wittkower, 1990, pp.261–2, cat.no.43.

2 See Veronika Birke and Janine Kertész, *Die Italienischen Zeichnungen der Albertina: Generalverzeichnis*, IV, p.2568, inv.no.35671.

123

1 See Fraschetti, 1900, p.256; Wittkower, 1981, p.211; Avery, 1997, p.130.

2 Condition notes kindly provided by Saša Kosinova of the Victoria and Albert Museum Sculpture Conservation Department.

124

1 For a full account of the commission see Wittkower, 1981, p.257, cat.no.76; and Perlove, 1990, especially pp.3–20. The exhibited *bozzetto* was published in a Supplement to the *Burlington Magazine*, CXXIII, 1981, p.63, fig.99; by Mezzatesta in Fort Worth, 1982, cat.no.10; by Perlove, *op. cit.*, p.17, pls.29–31, 53; and by Avery, 1997, p.152, fig.200.

2 See Fort Worth, 1982, cat.no.10, n.3; Perlove, 1990, p.72, n.10; Rome, 1991(1), pp.72–3, cat.no.24; Avery, 1997, p.152. The Louvre version, inv.no.RF2454, and may be identical with the one listed as in Dijon in Rome, 1991 (1), *loc. cit.*

125

1 For Baciccio (the nickname is the Genoese contraction of Giovanni Battista) see Enggass, 1964.

2 For the latest discussion of Bernini's involvement with this project, see Jennifer Tonkovich, 'Two Studies for the Gesù and a 'quarantore' design by Bernini,' *Burlington Magazine*, CXL, 1998, pp.34–7.

3 The location of this painting was unknown to Enggass, but he dated its pendant (fig.138) to c.1680–85 on stylistic grounds (1964, p.122). When acquired by the Fitzwilliam Museum in 1987, the picture was cleaned and found to be in excellent condition, with only a few small abrasions at the upper right and a small area of overpaint at the lower right. I am grateful to David Scrase and John Culverhouse for providing me with information for this catalogue entry.

4 The pose of the more central of Baciccio's angels also bears a striking resemblance to that of one of the rejected models, now in the Pinacoteca Vaticana, for the angels flanking the chair in the Cathedra Petri (see Avery, 1997, p.112, fig.139).

5 Baciccio painted the altarpiece for this commission, showing *The Virgin and Child with Saint Anne*, which is still *in situ*.

6 Two studies for the seated angel, one of them with a study for the Magdalen on its verso, are in Düsseldorf: see Dieter Graf, *Kataloge des Kunstmuseums Düsseldorf (III.2): Die Handzeichnungen von Guglielmo Cortese und Giovanni Battista Gaulli*, 2 vols., 1976, I, p.100, cat.nos.258–9; II, figs.342–3. For the Ashmolean drawing, which has a study for the Mary in the centre on its verso, see Hugh Macandrew and Dieter Graf, 'Baciccio's Later Drawings: a Rediscovered Group acquired by the Ashmolean Museum', *Master Drawings*, X, 3, 1972, p.249, fig.11 and plate 9b.

7 Matthew, 28: 1–8; Mark, 16: 1–8; Luke, 24: 1–11; John, 20:1–12.

8 See Enggass, 1964, fig.44, and Pittsburgh, Frick Art Museum (and three other venues), *Italian Paintings from Burghley House*, exhibition catalogue by Hugh Brigstocke, 1995, p.72, cat.no.17.

9 According to a manuscript at Burghley, the 5th Earl of Exeter is said to have acquired the two pictures for 20 crowns.

10 Quoted by Brigstocke, *op. cit.* at note 8.

11 The known provenance for the *Three Maries at the Empty Sepulchre* is as follows: acquired in Rome, 1684–5, by John, 5th Earl of Exeter; recorded in the Burghley inventory of 1738; by descent to William, 3rd Marquess of Exeter; sale, Christie's, 9 June 1888 (lot 196, as Le Sueur), bought by Donaldson; anonymous sale, Christie's, London, 23 March 1973 (lot 16), bought by Leggatt on behalf of an American collector; sale, Sotheby's, London, 10 December, 1986 (lot 1), bought by Somerville and Simpson; from whom acquired by the Fitzwilliam Museum in 1987. The attribution to Eustache Le Sueur appears three times in nineteenth-century guides to Burghley.

X: Designs for Ephemera
PAGES 162–70

126

1 For the drawing, see Blunt and Cooke, 1960, p.77, cat.no.591; Stuttgart, 1993, p.124, cat.no.37; Rome, 1997, p.459, cat.no.109 (with full bibliography). For documents relating to the project, see Karl Noehles, 'Architekturprojekte Cortonas. Zum 300. Todesjahr des Kuenstlers', *Münchner Jahrbuch der bildenden Kunst*, XX, 3, 1969, pp.171–206. See also Renato Diez, 'Le Quarant'Ore, una Predica figurata', in Fagiolo, 1997, II, pp.84–97.

2 For a history of Quarantore, see Weil, 1974 (2), pp.218–48.

3 For instance, the apse decoration of Santa Maria in Campitelli by Carlo Rainaldi of 1667. For the influence of stage design on this Quarantore, see Fagiolo dell'Arco and Carandini, 1977, I, p.82.

4 Noehles, 1970, p.14.

5 Montagu, 1996, pp.59–60; Karl Noehles, 'Teatri per le Quarant'Ore e altari barocchi', in Fagiolo and Madonna, 1985 (1), pp.88–108.

6 Weil, 1974 (2), pp.220 ff.

7 Rome, 1997 (1), p.459, cat.no.109.

8 Weil, 1974 (2), p.223.

9 Montagu, 1989, pp.178–80.

10 Hammond, 1994, p.269.

11 Rome, 1997 (1), p.459, cat.no.109.

127

1 For the drawing, see Byam Shaw, 1976, p.169 cat.no.613; Montagu, 1985, I, pp.128–9; II, p.484, cat.no.71 in the checklist of drawings (with full bibliography). I would like to thank Tommaso Manfredi for his stimulating discussion of this drawing.

2 Montagu, 1985, I, p.128.

3 *Idem*.

4 See, for example, Pietro Paolo Salamonio, *Diario delle cose occorse l'anno santo 1650*; Giovanni Simone Ruggeri *Diario dell'anno del Santissimo Giubileo MMDCL…*, Rome, 1651.

128

1 *Dizionario Biografico degli italiani*, VI, Rome, 1964, pp.170–71 (entry by A. Merola)

2 Unpublished *avvisi* in the Biblioteca Apostolica Vaticana (Urb. Lat.1100, fols.119v., 128r. and v., 129r., and 137r. and v.) describe Don Carlo's death and the service at San Petronio. See also Berendsen, 1961, p.202.

3 Biblioteca Apostolica Vaticana (Urb. Lat.1100, folio 129r.).

4 Montagu, 1985, II, p.402, cat.no.123; Wittkower, 1990, p.250, cat.no.27.

5 See Olga Berendsen, 'I primi catafalchi del Bernini e il progetto del Baldacchino', in *Immagini del Barocco, Bernini e la cultura del Seicento*, Rome, 1982, p.137. Bernini also designed a memorial plaque to Don Carlo for the inner façade of the Aracoeli: see Wittkower, 1990, pp.249–50, cat.no.26.

6 See Berendsen, *loc. cit.* at previous note, pp.133–43.

7 Fagiolo dell'Arco and Carandini, 1977, I, pp.79–80, where the various contemporary accounts of the event are cited.

8 For example, the Jesuits planned to spend 12,000 scudi to build a church which they considered 'not big, but comfortable with five altars' next to their seminary on the Quirinal: see Christoph Ludwig Frommel, 'S. Andrea al Quirinale: genesi e struttura', in *Gian Lorenzo Bernini Architetto e l'Architettura europea del Sei-Settecento*, Roma, 1983, p.212.

9 Algardi was responsible for four of the statues on the catafalque: see Montagu, 1985, II, p.421, cat.no.L.139.

10 Hammond, 1994, p.265.

129–131

1 For cat.no.129, see Vitzthum, 1963 p.76, fig.7; Catherine Johnston, *I Disegni dei maestri: il Seicento e il Settecento a Bologna*, Milan, 1971, p.71, fig.16; Nicholas Turner, 'Review of Ashmolean Museum, Oxford, Catalogue of the Collection of Drawings, III Italian Schools: Supplement by Hugh Macandrew', *Burlington Magazine*, CXXIV, 1982, pp.161–3 Montagu, 1985, II, p.482, cat.no.50 in the checklist of drawings. For cat.no.130, see Turner, 1982, *loc. cit.*, p.162. For the Ashmolean drawing (cat.no.131), see Hugh Macandrew, *Ashmolean Museum, Oxford, Catalogue of the Collection of Drawings, III, Italian Schools: Supplement*, 1980, p.89; Turner, 1982, *loc. cit.*, p.162. The Algardi drawings are discussed in the context of the project as a whole in Montagu, 1985, I, pp.74–7; II, p.422, cat.no.140.

2 Sebastiano Rolandi, *Funerale celebrato nella chiesa de' bolognesi in Roma dall'Illustrissimo Senato di Bologna al Signor Marchese Lodovico Fachenetti Ambasciatore Residente per quella città appresso Nostro Signore Urbano VIII…*, Rome, 1644.

3 For a building history of SS. Giovanni e Petronio, see F. Lombardi *Roma: Chiese, Conventi, Chiostri*, Roma, 1993, p.170; Luigi Salerno, Luigi Spezzaferro and M. Tafuri, *Via Giulia: una utopia urbanistica del '500*, Roma, 1973, p.489; Jack Wasserman, *Ottaviano Mascarino and his Drawings in the Accademia di San Luca*, Rome, 1966, p.51; *Guide Rionali di Roma: Rione Regola, Parte III*, edited by Carlo Pietrangeli, Rome, 1974, p.58.

4 A preparatory drawing attributed to Algardi for the figure of Fame is in Naples: see Montagu, 1985, I, p 75; II, p.481, cat.no.41 in the checklist of drawings.

5 *Ibid.*, I, pp.75–76.

6 The draperies in the cupola may have been designed to mask the fact that the dome was unfinished.

7 For Algardi's *Crucifix*, see Montagu, 1985, I, p.76; II, pp.325–6, cat.no.L.15. For his criticism of Domenichino's altarpiece, which is now in the Brera in Milan, *ibid.*, I, pp.61–2.

8 See Fagiolo dell'Arco and Carandini, 1977, I, pp.116–18.

9 For the catafalque for Augustus II of Poland see Fagiolo, 1997, II, p.27, fig.3; for that for Philip III, which was designed by Orazio Torriani, see Fagiolo dell'Arco and Carandini, 1977, I, p.45.

132

1 For the drawing, see Worsdale, 1978, pp.462–6; Tokyo, 1996 pp.98–99, cat.no.74. For the catafalque as erected, see Fagiolo dell'Arco and Carandini, 1977, I, p.246.

2 For a history of the catafalque, see Olga Berendsen, *Italian Sixteenth and Seventeenth Century Catafalques*, Ph.D. dissertation, New York University, 1961; and L. Popelka, *Castrum Doloris, oder, "trauriger Schauplatz". Untersuchungen zu Entstehung und Wesen ephemeren Architektur*, Vienna, 1994.

3 Of interest in this connection is that Muzio's forebear, Ciriaco Mattei, had in 1584 been given an obelisk by the Senators of Rome, which had formerly lain outside Santa Maria in Aracoeli on the Capitoline Hill, and which he erected at his villa on the Celimontana.

4 Berendsen, *op. cit.*, p.5.

5 Worsdale, *loc. cit.*, p.465. For the drawing, see Brauer and Wittkower, 1931, I, pp.161–2.

133

1 For the drawing, see Brauer and Wittkower, 1931, I, pp.161–2; Sutherland Harris, 1977 (1), p.xxiii, cat.no.89; Turner, 1980, pp.6–7, cat.no.9. For the catafalque and the requiem mass, see Fagiolo dell'Arco and Carandini, 1977, I, pp.248–52; Rome, 1981, pp.258–9.

2 Bernini's 'bel composto' is discussed by Lavin, 1980, I, pp.6–16.

3 Brauer and Wittkower (loc. cit.) suggested, for both the Mattei and Beaufort catafalques, that the fact that the bodies of the deceased were not present may have had a liberating effect on Bernini's designs, for there was no compulsion to incorporate a sarcophagus.

4 Published in Rome, 1997 (2), pp.262–5, cat.no.15.1.

5 See Turner, *loc. cit.*

134

1 The drawing and project was first discussed by Per Bjurstrom, 'Feast and Theatre in Queen Christina's Rome', *Analecta Regnensia* III, Stockholm, 1966, pp 48–51. New documents and interpretation supplied by Worsdale, 1978, pp.462–6. See also Fagiolo and Carandini, 1977, I pp.242–3; Montagu, 1989, pp.185–7.

2 For the history of the Peace, see Ludwig von Pastor, *Storia dei Papi*, XIV, Rome, 1961, pp.614–18.

3 On the four elements as subject of this design, see Fagiolo, 1997, II, p.231.

4 Worsdale, 1978, p.466.

5 Luigi Zangheri, 'Alcune precisazioni sugli apparati effimeri di Bernini', in Fagiolo and Madonna, 1985, p.115.

6 See the description in Worsdale, 1978, p.466.

7 See Brauer and Wittkower, 1931, I, p.139; Blunt and Cooke, 1960, p.27, cat.no.64; Fagiolo and Carandini, 1977, I, p.242 Worsdale, *loc. cit.*, p.465, fig.29, published a copy of the present drawing belonging to the Archive des Affaires étrangères in Paris.

XI: The 'Arti Minori' and Designs for Applied Art Objects and Engravings
PAGES 171–183

135

1 Ludwig von Pastor, *Storia dei Papi*, XIII, Rome, 1961, p.258, n.2.

2 The engraving was intended as part of the appendix to the second (1647) edition of Girolamo Teti, *Aedes Barberinae* (first edition, Rome, 1642), which was dedicated to Cardinal Mazarin (I am grateful to Sebastian Schütze for this information). This engraving appears in some copies only, along with eleven other portraits of cardinals known collectively as the 'Purple Swans' (on account of their purple cassocks), who met as a cultural academy at the Barberini Palace. See further Scott, 1991, p.194, n.13.

3 For the exhibited drawing see Ward-Jackson, 1980, II, pp.42–3, cat.no.681. See also Karl Noehles, 'Die Louvre-Projekte von Pietro da Cortona und Carlo Rainaldi', *Zeitschrift für Kunstgeschichte*, 1961, p.54, fig.14; Montagu, 1996, p.216, n.78. For the other two designs for Cardinal Antonio's mace, see notes 8 and 9 below.

4 For Cardinals' processions and the duties of a *mazziero*, see Marcus Voelkel, *Römische Kardinalshaushalte des 17. Jahrhunderts*, Tübingen, 1993 pp.337, 404.

5 See Montagu, 1996, pp.12–14. Montagu, 1996, p.216, n.78.

6 The picture is *Paul V's Audience for Prince Savelli*, 1620 now in the Harrach Collection, Rohrau, Austria. See Rome, 1997 (1), pp.305–6, cat.no.17.

7 Alvar González-Palacios, *Fasto Romano*, Rome, 1991, cat.no.190.

8 Merz, 1991, p.107, n.169.

9 Florence, 1997, pp.41–3, cat.no.19.

10 See Ward-Jackson, 1980, II, p.43, cat.no.682.

11 Cortona, 1956, p.59, cat.no.54, pl.LVIII.

12 On Cortona's bottega and house, see Donatella Livia Sparti, *La Casa di Pietro da Cortona; Architettura, Accademia, atelier e officina*, Rome, 1997.

136

1 Blunt, 1958, pp.286–7, fig.32b.

2 For Romanelli's work at Palazzo Barberini, see Scott, 1991, pp.33–7. The first payments to Romanelli are from 1631 from Taddeo Barberini's account ledgers and he continued to work for the Barberini until his death in 1662.

3 Scott, 1991, p.59.

4 Scott, 1991, p.44.

5 On the ceremonial hanging of tapestry series, see Scott, 1991, pp.186–9, n.34.

6 Urbano Barberini, 'Pietro da Cortona e l'arazzeria Barberini', *Bollettino d'Arte*, 35, 1950, pp.43–51, 145–52; *idem.*, 'Gli arazzi e i cartoni della serie 'Vita di Urbano VIII' della arazzeria Barberini', *Bolletino d'Arte*, 53 1968, pp.92–100.

7 For a *portiera* design by Cortona comparable to Romanelli's, see Blunt, 1958, p.286 and fig.32d.

137–138

1 As suggested by Montagu. For these two drawings, see Vitzthum, 1963, p.82; Montagu, 1985, I, pp.187–88; II, p.484, cat.nos.69 and 70 in the checklist of drawings. For cat.no.137, see also Tokyo, 1996, pp.204–5, cat.no.77.

2 By Montagu, *loc. cit.*; her view will be endorsed in Turner, 1999 (forthcoming).

3 See Montagu, 1985, I, pp.187–88, fig.217.

139–141

1 For a full discussion of the Villa and its decoration, see Montagu, 1985, I, pp.94–108; II, pp.454–55, cat.no.A.198 (with earlier references).

2 For this drawing, see *ibid.*, I, p.104, fig.110; pp.480–81, cat.no.31 in the checklist of drawings.

3 For this drawing see *ibid.*, I, pp.102–3, fig.105; II, p.481, cat.no.32 in the checklist of drawings.

4 For this drawing, see *ibid.*, I, pp.103–4, fig.109; II, p.482, cat.no.47.

142

1 The full provenance is as follows: Sir Paul Methuen (by 1760); by descent to Lord Methuen; his sale, Christie's, 9 May 1899 (lot 139), bought Colonel Sir Charles Wyndham Murray; by descent to his cousin, Miss Marian Gasford, MBE, who bequeathed it to the Order in 1941. See John Gash and Jennifer Montagu, 'Algardi, Gentile and Innocent X: A Rediscovered painting and its frame', *Burlington Magazine*, CXXII, 1980, pp.55–60, 63.

2 Montagu, 1985, II, p.457, cat.no.A.204, fig.69 and colour plate VIII; Montagu 1989, p.116, fig.143.

144

1 For this drawing, see John Pope-Hennessy, *The Drawings of Domenichino in the Collecton of his Majesty the King at Windsor Castle*, 1948, p.121, cat.no.1743 (as Domenichino); Schilling and Blunt, 1971, p.47, cat.no.6 (as Algardi); Rome, 1981, pp.262–3, under cat.no.265; Montagu, 1985, II, pp.458–9, cat.no.I.A.207, and p.484, cat.no.78 in the checklist of drawings.

145

1 See Blunt and Cooke, 1960, p.28, cat.no.78 (as follower of Bernini); Montagu, 1985, II, p.485, cat.no.87. The drawing was formerly in one of the Domenichino albums at Windsor, and the attribution to Algardi was first proposed by Ann Sutherland Harris.

146

1 The drawing, which belonged to William Young Ottley and Sir Thomas Lawrence, was first published as Algardi by Andrews, 1968, I, p.2, cat.no.D900. See further Montagu, 1985, I, pp.189–90; II, p.483, cat.no.61 in the checklist of drawings.

2 Montagu, 1985, I, p.190.

3 See Montagu, I, pp.181, 183, fig.209.

4 See Lizzani, 1970, p.25, fig.53. There is a drawing for a cradle supported on dolphins by Schor at Windsor Castle: see Rome, 1986, p.14, fig.8.

5 Montagu, 1989, p.192, fig.269, and p.219, n.88.

147

1 For another example of this medal, see Whitman and Varriano, 1983, p.96, cat.no.77.

148

1 See Ward-Jackson, 1980, II, p.23, cat.no.631.

2 Bernini, 1713, p.103.

3 By Ward-Jackson, *loc. cit.*

4 See Georgina Masson, 'Papal Gifts and Roman Entertainments in Honour of Queen Christina's Arrival' in *Queen Christina of Sweden: Documents and Studies* (Analecta Reginansia I), edited by Magnus von Platen, Stockholm, 1966, pp.244–61; Per Bjurström, *Feasts and Theatre in Queen Christina's Rome*, Stockholm, 1966, pp.117–22, 134 n.3.

149

1 See Rome, 1986, pp.61–4, 127–9.

2 *Ibid.*, p.65, fig.59.

3 See Marco Fabio Apolloni, 'Wondrous Vehicles: The Coaches of the Embassy of the Marquês de Fontes', in Washington, National Gallery of Art, *The Age of the Baroque in Portugal*, exhibition catalogue edited by Jay A. Levenson, 1993–4, pp.89–100.

150

1 For the drawing, see Brauer and Wittkower, 1931, I, pp.151, 171; Blunt and Cooke, 1960, p.25, cat.no.47; Wittkower, 1966, pp.211–12; Fagiolo dell'Arco, 1967, cat.no.232; González-Palacios, 1970, p.720; Montagu, 1989, pp.119–20, figs.144, 146.

2 Jennifer Montagu believes the Tessin drawing to be a faithful record of the work of art as executed.

3 Ward-Jackson, 1980, II, p.76, cat.no.797.

4 Wittkower, 1990, p.268, cat.no.49.

5 This interpretation was proposed by Philip Fehl at the Bernini symposium at Princeton University, New Jersey, in 1988.

151

1 For further information see Stockholm, Nationalmuseum, *Christina, Queen of Sweden* (Council of Europe exhibition), edited by Carl Nordenfalk, 1966, cat.no.772, pl.48.

2 See Montagu, 1996, p.74 and p.228 n.13.

152

1 Most of what we know about this drawing is due to the research of Jennifer Montagu, who was also responsible for identifying the related print. See Washington, National Gallery of Art, and Fort Worth, Kimbell Art Museum, 1990, *Old Master Drawings from the National Gallery of Scotland*, exhibition catalogue by Hugh Macandrew, pp.64–5, cat.no.22.

2 See William Ashworth, 'Divine Reflections and Profane Refractions: Images of a Scientific Impasse in Seventeenth-Century Italy', in Lavin, 1985, pp.179–207.

3 This is an independent sheet, not bound into a volume.

4 Merz, 1991, p.224, figs.319–20.

5 See Wittkower, 1980, p.234 and fig.141.

6 Toronto, 1985, pp.76–7, cat.no.32. The drawing was sold at Christie's, London, 2 July 1996 (lot 47).

XII: Medals and Designs and Models for them

PAGES 184–190

153

1 For another example of this medal see Whitman and Varriano, 1983, pp.64–5, cat.no.46.

154–155

1 For this medal see Whitman and Varriano, 1983, pp.120–21, cat.no.102.

2 The painting is recorded in Bellori's *Life* of Maratta (Bellori, 1976, pp.585–86). Information about the picture was kindly supplied by Stella Rudolph.

156

1 For full details of this medal, see Whitman and Varriano, 1983, pp.131–32, cat.no.113.

2 Varriano, 1987, pp.254, figs.9–10; 260, n.28.

157

1 See the silver example in Elena Corradini, *Museo e Medagliere Estense fra Otto e Novecento*, Modena, 1996, cat.no.48.9.

158

1 Montagu, 1996, p.79, fig.109.

159

1 See Montagu, 1996, p.79, fig.110. The drawing was sold at Christie's, New York, *Old Master Drawings: Italian and Spanish Schools*, 30 January 1998 (lot 74).

2 For another example of this medal see Whitman and Varriano, 1983, p.88, cat.no.70.

160

1 For another example of this medal see Whitman and Varriano, 1983, pp.87–88, cat.no.69.

161–162

1 For another example of this medal see Whitman and Varriano, 1983, p.97, cat.no.78.

2 For further discussion see Varriano, 1987, pp.251, 255. The provenance of this and the other wax models exhibited here (see cat.nos.70, 154 and 164) is: L.C. Wyon; Whitcombe Greene; presented to the British Museum by Sir George F. Hill, 1932.

163–165

1 For this coin, and the related drawings and model, see Pollard, 1970, pp.146–7; Rome, 1981, pp.290–91, cat.no.290; Whitman and Varriano, 1983, pp.108–9, cat.no.90; Varriano, 1987, p.252; Jones, 1994, pp.266–7, cat.nos.20d-f.

2 Examples included in Rome, 1981, pp.290–91, cat.no.290b; Whitman and Varriano, 1983, loc. cit.

166

1 For further examples see Whitman and Varriano, 1983, pp.98–99, cat.no.79, and Varriano, 1987, pp.254–5 figs.11 and 12. For specialised studies of this medal, see Hermann Voss, 'Eine medaille Lorenzo Bernini's, Zeitschrift für Numismatik, XXVIII, 1910, pp.231–5; Shelley Perlove, 'Bernini's Androcles and the Lion: A Papal Emblem of Alexandrine Rome', Zeitschrift für Kunstgeschichte, 45, 1982, pp.287–96.

2 See John Varriano, 'A Drawing by Bernini for a Print dedicated to Alexander VII', Master Drawings, 23–24, 1985–6, pp.54–5.

3 See Fagiolo dell'Arco and Carandini, 1977, I, p.230; Perlove, loc. cit., pp.289–90.

4 Krautheimer and Jones, 1975, entry no.290.

5 M. Piacentini, 'L'epistolario di L. Agostini e due notizie sul Bernini', Archivi d'Italia, 2nd series, 7, 1940, pp.71–80.

6 S. de Caro Balbi (Gian Lorenzo Bernini e la medaglia barocco romano'. Medaglia, VII, 1974, p.10) quite sensibly postulated Romanelli as the designer of the medal (pace Perlove).

167

1 See Rome, 1981, p.295, cat.no.296. The exhibited medal also has this attribution at the British Museum.

2 For the latter, see Whitman and Varriano, 1983, pp.117–118, cat.no.99.

3 See Krautheimer and Jones, 1975, pp.199–233.

168

1 This medallion is illustrated in Fagiolo dell'Arco and Carandini, 1977, I, p.319, (erroneously identified as Alexander VIII); also mentioned by Marc Worsdale in Rome, 1981, p.285. Subsequent to its purchase by the National Gallery of Scotland, Worsdale confirmed to the present writer his belief that it had very close affinities with Bernini.

2 That of Alexander VII is in the Biblioteca Vaticana (Rome, 1981, p.285), and another gilt-bronze example is with Michael Hall, New York; the Clement IX, in gilt-bronze, is also with Michael Hall; a good bronze cast of the Clement X, is in the Museo di Palazzo Venezia, Rome, and a less good one, with an inscription, is in the Metropolitan Museum, New York; the cast of Innocent XI under discussion is apparently unique.

3 Henry Lee Bimm, 'Bernini papal portraiture: a medallion and a missing bust', Paragone, 25, 1974, pp.72–6. Eleonora Villa, 'Un Episodio Sconosciuto della ritrattisca del '600: Clemente X, Bernini e Gaulli e altre Novità sulla Committenza Rospigliosi, Altieri e Odescalchi', in L'Ultimo Bernini: Nuovi argumenti, documenti e immagini, edited by Valentino Martinelli, Rome, 1996, pp.139–59, 290–91.

169

1 Pollard, 1970, p.144, figs.7a and 7b.

2 For the bust, see Wittkower, 1990, p.272, cat.no.54.

XIII: Miscellaneous Religious Compositions
PAGES 191–92

170

1 The drawing has been published by Anthony Blunt, 'A Drawing of the Penitent St Jerome by Bernini', Master Drawings, X, 1972, pp.20–22; Hugh Macandrew, 'Baciccio's Early Drawings: A Group from the Artist's First Decade in Rome', Master Drawings, X, 1972, p.117; Sutherland Harris, 1977 (1), p.xxiv, cat.no.96; Blunt, 1978, p.79. For its known provenance, see Sotheby's, London, 7 July 1966 (lot 11), where it is described erroneously as The Penitent Mary Magdalen.

2 For the Louvre drawing, see Brauer and Wittkower, 1931, I, pp.152–3; II, pl.117; Sutherland Harris, 1977 (1), p.xxii, cat.no.83. There is a studio drawing of St Mary Magdalen in the Kunstmuseum, Düsseldorf, which presents the figure in a similar pose to St Jerome: see Blunt 1972, loc. cit. at n.1, pp.20–22.

3 Bernini is known to have attended Mass every morning, taken communion twice a week and prayed at the Gesù every evening for forty years.

4 One earlier drawing by Bernini, the Design for the Tomb of Cardinal Domenico Pimentel (1653), employs the similar technique of applying wash over a graphite underdrawing (see Sutherland Harris, 1977 (1), p.xix, cat.no.57).

5 Macandrew, loc. cit. at note 1, p.119. The author also discusses the influence of Bernini's drawings of St Jerome on Baciccio's drawing style.

171

1 See London, Thos. Agnew and Sons Ltd., Old Master Drawings from Holkham, 1977, no.66; Chicago, Art Institute, Old Master Drawings from Holkham Hall, exhibition catalogue by A.E. Popham and Christopher Lloyd, 1985, no.129. The picture is discussed by Enggass, 1964, p.121.

2 Fagiolo dell'Arco and Pantanella, 1996, p.91 fig.53.

3 Ibid. pp.20–21, 115 (no.107).

4 Dieter Graf, Die Handzeichnungen von Guglielmo Cortese und Giovanni Battista Gaulli, 2 vols., Düsseldorf, 1976, I, p.124, no.367, and II, fig.470.

PHOTOGRAPHIC CREDITS